COMICS VERSUS ART

On the surface, the relationship between comics and the 'high' arts once seemed simple – comic books and strips could be mined for inspiration, but were not themselves considered legitimate art objects. Though this traditional distinction has begun to erode, the worlds of comics and art continue to occupy vastly different social spaces.

Comics versus Art examines the relationship between comics and the most important institutions of the art world, including museums, auction houses, and the art press. Bart Beaty's analysis centres around two questions: why were comics excluded from the history of art for most of the twentieth century, and what does it mean that comics production is now more closely aligned with the art world? Approaching this relationship for the first time through the lens of the sociology of culture, Beaty advances a completely novel approach to the comics form.

BART BEATY is a professor in the Department of English at the University of Calgary.

BART BEATY

Comics versus Art

UNIVERSITY OF TORONTO PRESS
Toronto Buffalo London

© University of Toronto Press 2012
Toronto Buffalo London
www.utppublishing.com
Printed in the U.S.A.

Reprinted 2013

ISBN 978-1-4426-4351-2 (cloth)
ISBN 978-1-4426-1204-4 (paper)

Printed on acid-free paper

Library and Archives Canada Cataloguing in Publication

Beaty, Bart
Comics versus art / Bart Beaty.

Includes bibliographical references and index.
ISBN 978-1-4426-4351-2 (bound). ISBN 978-1-4426-1204-4 (pbk.)

1. Comic books, strips, etc. – History and criticism. 2. Comic books,
strips, etc., in art. I. Title.

PN6710.B39 2012 741.5 C2012-901626-8

The University of Toronto Press acknowledges the financial assistance to its
publishing program of the Canada Council for the Arts and the Ontario Arts
Council.

This book has been published with the help of a grant from the Canadian
Federation for the Humanities and Social Sciences, through the Aid to
Scholarly Publications Program, using funds provided by the Social Sciences
and Humanities Research Council of Canada.

University of Toronto Press acknowledges the financial support of the
Government of Canada through the Canada Book Fund for its publishing
activities.

Comics will be the culture of the year 3794. So you have 1827 years notice, which is good. In fact, that leaves me the time I need to create a collage with these 80 comics that I am taking with me. This will be the birth of Comics-Art, and on this occasion we will hold a grand opening with my divine presence on March 4th, 3794 at precisely 19.00 hours.

<div style="text-align: right">

Salvador Dali, quoted in M. Patinax, 'Collectionner les bandes dessinées,' in *Les Aventures de la BD,* ed. Claude Moliterni, Philippe Mellot, and Michel Denni (Paris: Gallimard, 1996) 142.

</div>

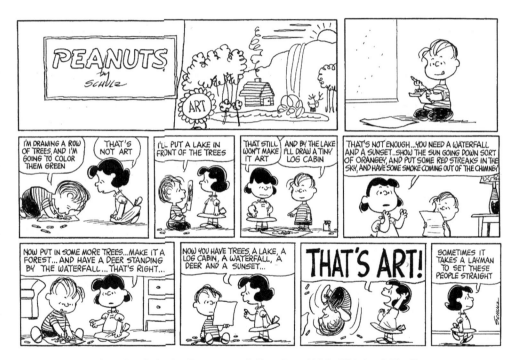

Charles Schulz, *Peanuts,* 13 October 1968. ©United Media

Contents

Acknowledgments

The research for this book was funded by a Standard Research Grant from the Social Sciences and Humanities Research Council of Canada, and I am deeply indebted to that organization and extremely grateful that they continue to fund inquiry-driven research. It is fair to say that without their generous support this book would never have been begun, let alone finished.

I have enjoyed a wonderful working relationship with the University of Toronto Press for many years, and finalizing this volume has only strengthened my faith in their contribution to scholarship in Canada. In particular, I would like to acknowledge the hard work of my editor, Siobhan McMenemy, for her generous suggestions about improving this work. I would also like to thank Frances Mundy and James Leahy for their attention to the final manuscript.

Of all the library and archival sources that I relied upon to complete this work, none was as supportive and useful as the Comic Art Collection at Michigan State University. I would like to thank Randall Scott and the staff at the library for making the collection available to me.

Versions of many of these chapters were presented at a number of conferences, including The Popular Print Conference at the University of Alberta, the annual meetings of the Canadian Communication Association and the Society for Cinema and Media Studies, and ComicCraze at the Banff Centre. I believe strongly that this work has benefited from the insightful feedback that I have received from colleagues at these events. Similarly, I was very pleased to be able to present preliminary drafts of several of these chapters at the various universities that were kind enough to invite me to speak to their students. I would especially like to thank my colleagues at Kansas State University, Memorial University

of Newfoundland, McGill University, the University of Alberta, and the University of Kansas for their kind hospitality.

An earlier version of the third chapter of this book was published in the *Canadian Review of American Studies* in 2004, and I am grateful to the editorial board for allowing me to expand upon it in these pages.

I have benefited tremendously from the support of the comics scholarship community that exists all over the world. It would be impossible to thank everyone who has contributed to the development of my thinking on this topic, but I must acknowledge Charles Hatfield for talking vinyl at the Murakami exhibition, Mark Nevins for his endlessly enthusiastic ability to place comics in the context of contemporary art, Marc Singer for his insights into the work of Chris Ware, and Rusty Witek for his constant and unwavering support. Mike Rhode's bibliographical contributions to this work were immense, and I owe him a great debt. Nick Nguyen, my partner in so many crimes of comics scholarship, was, as always, a perfect sounding board for so many of these ideas. To the entire comix mafia, and they know who they are, I extend my heartfelt thanks.

None of this work would ever have been completed without the support of my family. Rebecca Sullivan has discussed this work with me for years. She is the best editor, colleague, and wife I could ever have imagined, and I could accomplish nothing without her. I began researching this book in earnest around the time that my son Sebastian was born. He has shaped the way I think more profoundly than he will ever know. This book is dedicated to him.

COMICS VERSUS ART

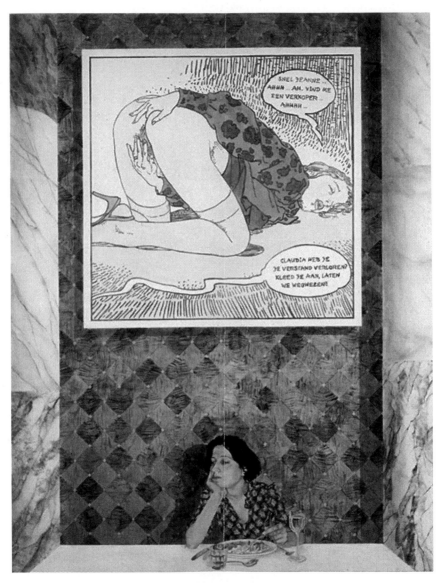

Lucy McKenzie, *Untitled* (2004). ©Lucy McKenzie, courtesy of the artist.

Introduction: Out of the Historical Dustbin – Comics and the Hierarchy of Genres

A woman in a gaudily decorated restaurant distractedly picks at her food. She wears a sensibly patterned blue blouse, and stares blankly into the distance. Above her on the wall a comics drawing depicts another woman, clad in high heels, stockings, and a patterned orange shirt, with her knees and face on the floor, masturbating. This second woman speaks in Dutch, begging, between gasps, for an unidentified woman named Jeanne to find her a salesman. From outside the frame the unseen Jeanne responds, urging the woman to get dressed and hurry on out from wherever they are.

What are we to make of Lucy McKenzie's 2004 painting *Untitled*? At first glance, we must necessarily wonder about the relationship between the two women depicted in the work, one bored and the other ecstatic. At the most basic textual level, the image itself tells us a great deal. The 'real' woman is seated in what appears to be a tackily ostentatious restaurant or dining room. The table is set formally, although there is no evidence that anyone else is present at the meal. She is surrounded on both sides by gaudy white marble columns, and the wall that supports the painting of the masturbating woman is covered in gold leaf. Our diner has seemingly opted for a restaurant that is the very height of contemporary vulgar design. The lack of subtlety is reinforced by the artwork above her table, with its graphic sexual excesses. The image of this woman, face down and genitals splayed to the viewer, indelibly reinforces the visceral distaste evoked by the decor. Moreover, the relative size of the diner dwarfed by her surroundings contributes a sense that she is overwhelmed by the ornamental horror of the room. The combined aesthetics – the dull, lifeless, and deadened composition of the room, and the showily crass and exploitative aspect of the embedded

image – contribute to a pointedly lurid sensibility. Her distracted non-chalance, head rested placidly on her palm, might be read as a testimony of the difficulty of shocking the contemporary cultural citizen; they have seen it all before.

That this painting addresses the contemporary art world as its subject is merely implied, yet the jaded reaction of the diner seems to confirm the suspicion. The enormous size of the comics image above her head visibly recalls the blown-up panels of Roy Lichtenstein, despite the fact that the choice of image and the rendering style are in no way suggestive of that artist. Insofar as Lichtentstein's comic book women often pined for absent men, we might note a connection born of longing and de-sire, but that association is stretched by the gratuitousness of this image. Indeed, the artist whose work is most seemingly referenced here is Jeff Koons, whose large and sexually explicit photographs in the *Made in Heaven* series (1990) have seemingly inspired McKenzie in this work.

If we move beyond the painting itself, and dive into the critical com-mentary about *Untitled*, a number of relationships are given greater weight. The catalogue for the 2006 Tate Triennial of New British Art, at which this painting was exhibited, confirms that the depicted scenario is based on McKenzie's experience in the restaurant of a private art foun-dation that had prominently displayed Koons's sexually explicit pho-tographs of himself and his porn star wife, Cicciolina. 'For McKenzie,' the catalogue tells us, 'this experience blurred the separation between a social space for dining and the rarefied space for contemporary art.'[1] Further, Sarah Thornton's 2007 *New Yorker* profile of the Turner Prize competition passingly mentions this painting in discussing artists who have declined to be nominated for the prize. In her fleeting citation of the artist, Thornton highlights the fact both that the painting is a self-portrait and that McKenzie had worked previously as a model in porno-graphic photos, thereby adding a rich new link between the depicted figures.[2] This new information invites the viewer to consider the piece autobiographically.

Placed in the context of McKenzie's career, the painting is more easily decoded. Reading about the artist in *Artforum*, for instance, one learns that her approach 'turns on her unerring knack for selecting the least promising source material,'[3] a description that might aptly describe the erotic comic book panel included in this work. This same article empha-sizes the fact that McKenzie struck the kitsch goldmine on a sojourn to Brussels, the capital of both French- and Dutch-language comic book production, where she discovered a comic book tradition that extended

from the adventure tales of Tintin all the way to the type of hardcore erotica found in *Untitled*. Certainly, McKenzie's work displayed in a solo show at the Chelsea gallery Metro Pictures in the fall of 2005 highlighted an interest in forms derived from comic books. Exhibited in that show were paintings including *Cheyney and Eileen Disturb a Historian at Pompeii* and *Lucy and Paulina in the Moscow Metro (Ploschad Revolutii)* whose visual styles recall the *ligne claire* storytelling pioneered by the Belgian cartoonist Hergé in the 1920s and popularized by the subsequent Brussels School of comic book artists. That show additionally featured a half-dozen of McKenzie's realist coloured pencil drawings of Hergé's Tintin, a figure that the Metro Pictures press release termed the 'epitome of an outdated 20th Century European identity,'[4] as well as monochromatic charcoal rubbings of concrete blocks whose geometric arrangement referenced Dutch modernist Piet Mondrian. Praising the show in the *Village Voice,* Jerry Saltz summed up McKenzie's contribution by noting 'she deploys dead, dormant, and suspect styles, combining early-20th-century cartooning, constructivism, and fascist neoclassicism in works on paper that initially seem like appropriations and tracings but are actually personal and invented.'[5] This may be true for Saltz, but the fact remains that it is only in Chelsea that Hergé's work is dead, dormant, and suspect; in the comic book stores of Brussels it is still very much alive, awake, and admired.

The same might also be said for the cartoonist whose work McKenzie appropriates in *Untitled*. Milo Manara, the Italian cartoonist whose 1983 book *Il gioco* (*Click!*) provides the source for the panel in question, is an award-winning and best-selling artist best known for erotic comics work and for his collaborations with the cartoonist Hugo Pratt and the filmmaker Federico Fellini. Few commentaries on *Untitled* identify the Dutch-language edition of *Il gioco,* translated as *De Schakelaar* by Drukwerk in 1984, as the source of the image, and fewer derive meaning from that source. Thus, critics tend to overlook the fact that Manara's story tells the tale of Claudia Cristiani, a woman married to a wealthy older man who, in a twist straight out of pulp science-fiction writing, is programmed to become sexually insatiable when a remote control device is activated. The connection between masculinity, wealth, and control that is so crucial to Manara's work is also alluded to in McKenzie's painting, but the centrality of that connection is potentially lost on viewers for whom the comics image is simply a signifier of crass vulgarity or indicative of McKenzie's ironic attraction to what Thomas Lawson defines as 'recherché styles, texts, and images pungently redolent of the historical

dustbin.'[6] That the Manara image might itself have an art historical specificity seems implausible, and in most commentaries his contribution to the work is reduced to the role of the producer of a found image, despite the fact that, within his field, he is among the most famous, most celebrated, and most easily recognizable of all living artists. One reading of *Untitled* might be to see it as a commentary on the relationship between Manara and McKenzie, however improbable that reading might be. Further, and on a larger level, it could be argued that the painting offers a reflection on the collision of the art world and the comics world that is lost on its primary (art world) audience and inaccessible to its secondary (comics world) one.

If we take the Manara image seriously in the context of *Untitled*, a psychological reading of the work is opened up. The positioning of the two images relative to each other, and the passive, pensive demeanour of the dining woman, presents the possibility of seeing the Manara image not merely as a gauche decoration, but as the imaginative inner life of the diner herself. If we imagined the entire painting to be participating in the logics and aesthetics of comics that the inset image evokes, it is possible to conceptualize the image of Claudia as an implicit thought balloon (minus the string of small bubbles that traditionally signifies the 'interior voice' of a character within a comics panel) within an autobiographical self-portrait. Following this logic, *Untitled* becomes not a painting of 'the ambitious artist as a disillusioned young woman,'[7] as Lawson would have it, but a work that pinpoints a confessional sexual desire masked by the disaffected posture of the protagonist. From this perspective, which proceeds from the relational positioning of the iconic elements so common within the aesthetics of comics, the direct connection between the images can be seen to highlight the psychological longing of the diner. Following this logic, McKenzie does not appropriate the comic book image so much as she signals a desire to be seen as Claudia is, or perhaps recalls her own modelling past. Might it be possible to then say that she even aspires to take on the life as it is depicted in the commodified comics image, however ironically?

The real irony, of course, is that comic book artists have long aspired to be treated with the seriousness that painters, sculptors, and even illustrators are accorded. In the dominant art historical readings of *Untitled* Milo Manara is treated as a non-entity, despite his relative fame in the much more minor field of comic books, while McKenzie, naturally, is accorded pride of place. In an interview with McKenzie published in *Parkett,* Isabelle Graw emphasized the way that certain of the artist's

works, such as the aforementioned *Cheyney and Eileen Disturb a Historian at Pompeii,* incorporate images of McKenzie's artist colleagues (in this case, Cheyney Thompson and Eileen Quinlan). For Graw, the act of incorporating these art world figures as subjects associates McKenzie with a 'cultural promise.'[8] Yet Manara seems to hold no such promise and generates no associations. His drawing is more akin to cultural waste. When Saltz observes that McKenzie views history 'as material, something to use without memory, allegiance, or judgment,'[9] he neglects the fact that images might be so created, but they are rarely so evaluated. Memory, allegiance, and judgment have been key factors in the ongoing symbolic exclusion of comics from the domain of consecrated art, a modernist legacy that persists even in these postmodern times.

This book both interrogates the specific historical and social processes that have led to the devaluation of comics as a cultural form and takes note of the recent rise to art world prominence of (certain kinds of) comics. It is not the purpose of this work to make an argument that comics are, at long last, finally a legitimate art (though they are increasingly that), nor to bemoan the 'shoddy' treatment of the Milo Manaras of the comics world by the Lucy McKenzies of the art world. While present circumstances have given many participants in the comics world reason to be optimistic about the status of comics in the hierarchy of arts for the first time, this book is not an argument about what comics should be. It is most assuredly not a manifesto calling for comics to be viewed as an art form. Instead, this work is interested in the specific hierarchies that are established not only in a work like *Untitled,* but in the day-to-day operation of what Pierre Bourdieu has termed the field of cultural production. This book uses the case of comics, in the North American or English-speaking context, to demonstrate how, in an increasingly postmodern world in which the distinction between high and low culture is often assumed to have been eroded, outmoded biases continue to persist in the shaping of how we understand culture broadly.

Organization of This Volume

The argument in this book unfolds over the course of nine chapters, each of which offers a case study in the process of the legitimation of comics. The path towards cultural legitimization for comics has not been a straight one. As such, this work eschews a strictly chronological ordering of the material, opting instead to draw attention to important similarities across time and space in a mosaic structure. To this end, each of

the chapters is organized around a series of pertinent issues contributing to the central analytic thrust. Chapter 2 turns the reader's attention to the question of the definition of comics in order to demonstrate the specific ways that comics have been, for so much of the twentieth century, excluded from the canons of art. This chapter opens with a consideration of the formal definitions of comics offered by a range of theorists and historians, concluding that the formalist analytic enterprise itself has contributed to the exclusion of comics from art history. Drawing on the formal relationship between comics and, on the one hand, illustrated picture books for children, and, on the other, the tradition of the 'artist's book,' this chapter argues that the confusion around these distinct forms necessitates a new conception of comics as a specific creative form. To this end, a new reading of comics rooted in the sociology of art is offered, which argues that comics are best understood as a distinct field of cultural production, or, following the example of Arthur Danto, George Dickie, and Howard S. Becker, a 'comics world.'

Chapter 3 advances the discussion of the place of comics within the hierarchy of the arts by examining the fraught relationship of comics and the traditional fine arts, specifically painting. This chapter interrogates the persistence of the high-low divide as it pertains to comics through close attention to the initial attempts to institutionalize comics not as a legitimated cultural form in its own right, but as the source material for high art to appropriate. Focusing primarily on the case of pop artist Roy Lichtenstein and his well-known appropriations of comic book imagery in the 1960s, this chapter addresses the gendered dynamics that are at play in the relationship between high and mass culture. In particular, this chapter draws upon the Nietzschean notion of *ressentiment* in order to examine the specific way that comics artists, critics, and fans reacted to Lichtenstein's work as if it were an insult or smear, and the resulting antagonism that has largely defined the comics-painting relationship since that time.

The fourth chapter turns from the place of the text to the role of the artist in both comics and the fine arts. Specifically, this chapter outlines the development of an argument, made initially within the comics world and later exported beyond its boundaries, that the cartoonist can be regarded as a significant artist. When Lichtenstein appropriated images from American comic books, he was repurposing work that, for all intents and purposes, was authorless. Nonetheless, the comics world has been particularly fascinated with questions of authorship and has frequently worked hard to assign retrospective credit to the creators of

comics material that was originally unsigned at the time of its creation. In this respect, the case of Carl Barks is central. Barks, the creator of the best-loved stories featuring Walt Disney's Donald Duck, worked for most of his career in total obscurity, his published work credited to Disney and his true identity known only to his publisher and editors. The efforts undertaken by a small group of fans to first identify and later lionize the specific contributions of Barks to the development of the American comic book form demonstrate the importance of authorship in the development of comics as an art form. Similarly, this chapter addresses the cases of Jack Kirby, the most celebrated of American superhero comic book artists, and Charles Schulz, the renowned creator of *Peanuts,* in order to emphasize how the differing status of comic books and comic strips in the post-Second World War era structured the conception of each man as significant creative personalities. The development of comics as a legitimate art form has necessitated the creation of a category that we can call the 'comics artist.' A similar process in film studies saw the director identified as the cinematic 'auteur,' and this chapter argues that, in comics, the penciller has come to be seen as the predominant creator in works where creative labour is collaborative.

Chapter 5 extends the discussion beyond individual artists to a consideration of significant key works in the comics form. Comics cannot be legitimated in the absence of canonical works. Importantly, the development of arguments about the legitimacy of comics has rested on the importance of a small handful of works hailed as masterpieces of the form. This chapter examines three important milestones in the development of the 'masterpiece thesis' in the comics world: George Herriman's *Krazy Kat,* Al Feldstein and Bernard Krigstein's short story 'Master Race,' and Art Spiegelman's *Maus.* It is in the developing critical writing around these works we can see the maturation of intellectual and aesthetic thought about the comics form, both within the comics world and outside of it. In particular, the tension between specifically fannish epistemologies about the comics produced within the comics world about 'Master Race' and the external, scholarly discourses generated in response to *Maus* is examined in order to draw attention to the persistence of legitimating hierarchies in the critical vocabulary.

Chapter 6 moves on to the final factor that has shaped the reception of comics as art. Specifically, this chapter draws on the example of comics creators who deliberately blur the boundaries between the comics world and the art world, often through their engagement with the so-called 'lowbrow' art movement that is playing a larger role in traditional

gallery scenes. Beginning with the work of Gary Panter, whose work in comics is emblematic of difficult aesthetics but whose work in the art world is seen as considerably more lowbrow, this chapter asks whether the most legitimated comics are, nonetheless, merely equivalent to some of the least legitimated paintings. By tracing the evolution of writing about both comics and lowbrow painting in the traditional art press, as well as in deliberately lowbrow journals such as *Juxtapoz*, we can still see a large degree of containment in the way comics are conceptualized by the art world. Further, this chapter expands the conception of comics by examining the relationship of cutting-edge comics such as *RAW*, contemporary illustration and design exemplified by *Blab!* and the explosion in the world of collectable vinyl designer's or artist's toys. The road from ambivalence to acceptance does not occur in a direct line but is supported by often unpredictable detours into related non-print elements of comics culture.

The seventh and eighth chapters provide a fuller consideration of the resources mobilized around comics in the art world. Chapter 7 examines the role of auction houses since the early 1990s in creating a space for the legitimation of comics by extending an economic rationale to the conceptualization of comics as art. By positioning comic books, and original comic strip and comic book art, as both collectable and investment worthy, auction houses, and particularly Sotheby's, helped transform the comics world. Nonetheless, the investment made by Sotheby's (and also Christie's) in the development of the comics collectables market in the 1990s did not appear out of thin air. Highly publicized comics auctions were themselves inspired by a legacy of press coverage about the economic value of old comic books beginning as early as the 1960s, as well as by the professionalization of the comics collecting market as it was established in the 1970s by the explosive growth of a network of comic book specialty stores as well as by the creation of the *Overstreet Comic Book Price Guide*. This chapter examines the source of value surrounding comics as cultural objects, particularly in light of theories of fetishization, nostalgia, and kitsch. Drawing on the scholarship surrounding the valuation of art, this chapter investigates the way in which value was added to comics in a very deliberate fashion and the fissures that were opened in the market for comic book collectables by the launch of *Wizard Magazine* in 1992, and the turn towards third-party certification services in 2000 that helped to synthesize competing notions of collectable comics objects.

The last major chapter of this book considers the consecration of comics within official culture through a detailed examination of the several

exhibitions at comic book museums and their catalogues. Beginning with the 1968 exhibition of comics at The Louvre, and moving through the Museum of Modern Art's famous High and Low show before concluding with the recent Masters of American Comics exhibition in Los Angeles, this chapter considers how comics have been institutionalized. A number of strategies that have been employed by curators to incorporate comics into museum settings, and their results, are evaluated here. In particular, specific attention is paid to the canonization of American underground cartoonist Robert Crumb, who has been the subject of more major museum retrospectives than any other American cartoonist. Through close attention to the specific mobilization of Crumb in museum settings, the tentative, but optimistic, accommodation that has been struck between comics and the traditional institutions of the arts is identified.

Finally, the conclusion of this book offers some thoughts on the future of comics in relation to the art world through an examination of the figure best poised to make the transition into the art world following Crumb, Chris Ware. The widely celebrated and award-winning cartoonist occupies a unique position in the comics world and is, alongside Art Spiegelman, arguably the leading contemporary exponent of the form to audiences outside the often constricting confines of the comics world. Specifically, this chapter examines a small but peculiar subset of Ware's creative output: his writings and comics about art. Ranging from the poster for the Whitney Biennale in 2002 to the catalogues that he has produced for museum shows in Omaha, Nebraska, and Phoenix, Arizona, and the essays that he has penned for the anthologies of contemporary comics that he has edited for McSweeney's and Houghton Mifflin, this chapter uses Ware as a lens through which the contemporary relationship of the comics world and the art world can be refracted.

Throughout the pages of this book, in the vast majority of cases, American examples have been used in discussions about the comics world. While it seems clear that many of the insights offered in this work could easily be applied in the European setting by substituting creators (Hergé for Jack Kirby, Marjane Satrapi for Chris Ware) or institutions (the Centre Pompidou for the Los Angeles Museum of Contemporary Art), the history of each comics world is markedly singular as a result of the differing ways in which comics themselves have evolved as an art form in various nations. Even when these comics worlds overlap, as with the influence of the Franco-Belgian album tradition on the development of the American 'graphic novel' or the rising importance of translated

manga in the United States during the 2000s, their particular historical specificities argue against an approach that seeks to totalize the comics world as a single internationalized field of cultural production. To this end, discussion of manga has been elided in this volume, since the regimes of cultural value in Japan differ greatly, as so much recent writing on Japanese visual art is quick to emphasize, from those in North America and Western Europe. Of course, the advantage of a narrowed concentration is greater analytic specificity. American cultural debates around comics have historically been freighted with larger social, and even legislative, concerns about the moral and educational purposes of the form. As such, it offers unique insights into how aesthetic forms are so often primarily valued according to sociological concerns about audience and industrial practices which are then translated back into the language of aesthetics.

This book is somewhat unusual in the context of the scholarly study of comics, which has been dominated by literary and historical analyses of the form. In particular, by relocating the institutional sites of the comics world away from the comic book store and the comics convention, by placing them in the auction house and the museum, this book challenges the prevailing orthodoxy in much of contemporary North American comics scholarship that suggests comics are best understood as a literary and fannish phenomenon, and, further, that scholarly approaches derived from the study of literature are the most appropriate tools for analysing comics as an art form. This work proceeds from the assumption that a sociology of the arts approach allows pertinent and pressing questions about comics and their place in the cultural industries to be asked, and, further, that the analytical frameworks that emphasize the crucial visual element of comics are particularly called for at the present moment. The analysis of McKenzie's *Untitled* notwithstanding, this work does not feature a wide range of the type of textual close readings that can be found in analyses rooted in the traditions of literature and art history. Instead, the discussion focuses on the broader discursive frames that relate to the comics field as a whole.

At its core, this book seeks to answer several important questions: Why were comics excluded from the domain of art history through so much of the twentieth century? Why, over the course of the past twenty years, have they begun to enter into the institutions that shape art history, including galleries, auction houses, museums, and universities? What does this transformation tell us about comics? More importantly, what does it tell us about these institutions? Several possible explanations

immediately come to hand. It seems possible that we are witnessing a landmark shift, both generational and demographic, in the make-up of the audience for 'serious' culture, producing an audience that has an unprecedented openness to traditionally marginalized cultural forms. At the same time, it seems possible that the change resides not so much with the public but with the form itself. Could it be as simple as the fact that comics have, belatedly, grown up? That they are, as so many newspaper and magazine headlines have suggested, 'not just for kids anymore'? In the simplest terms, it can be noted that over time either cultural institutions evolve to accommodate new forms or those forms adapt to the demands of the institutions. As this study unfolds, it will become clear that in the case of comics in the art world, both of these tendencies have played an important role in changing the relationship between the fields.

The changes that have restructured relations between the comics world and the arts world have been multifaceted, but far from all-encompassing. The culture of postmodernism has, in fact, created the possibility of conceptualizing comics as a site for serious artistic creation. At the same time, a small number of creators have moved to occupy the position of the comics artist, and an even larger number of critics have been prepared to accommodate them in this position. This, in turn, has created a context in which the most powerful legitimizing institutions in the traditional art world have been able to incorporate comics, albeit in frequently vexed and vexatious fashions, into their work. This book is about the collision of the art world and the comics world that began in the 1950s and which has accelerated so dramatically in the 2000s. At this point in time the relationship between these fields remains uneven, and, also, far from settled. For a long time, comics were deemed an anti-art world, a bastard of the art world or, indeed, anything but an art world. Now, it seems more and more that comics can be conceptualized as a sub-set of the art world, particularly given the successes that certain individual creators such as Art Spiegelman, Robert Crumb, Chris Ware, and others have found within it. Nonetheless, the comics world remains a challenge to the art world, a distinct field of creative endeavour that is still only tentatively welcomed. In the future, it seems likely that the firm distinction between the comics world and art world will seem quaintly old-fashioned, a thing of the past. That may well be the case, but the goal of this book is to explicate the ways in which the initial interactions of these two historically differentiated fields were filled with various kinds of antagonism.

Within this limitation, therefore, this book seeks to illuminate the shift in discourses about comics and art that has taken place since the modernist period, changes that should be attributed to the development of a pop aesthetic in the fine arts, the rise to prominence of postmodern theories of aesthetics, and changes within the comics world itself. The comics industry in the United States has its roots in a context of failure, in which marginally trained and poorly paid creators slaved anonymously in work-for-hire sweatshops churning out what they presumed to be disposable trash for an audience of children, while, at the same time, the most skilled, or most fortunate, of cartoonists earned lucrative wages working on comic strips that appeared daily in the most respected newspapers in communities around the world. The circuitous story of how comics creators transcended those origins in order to claim a space in respectable society is the complex and, frankly, fascinating tale at the heart of this book.

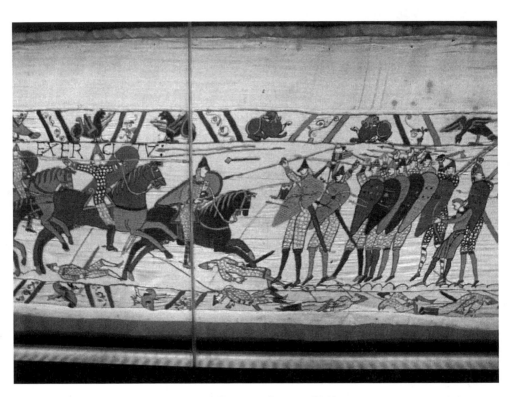

Bayeux Tapestry (1077–1082).

What If Comics Were Art?
Defining a Comics Art World

When asked if he feels that it's strange that students write academic stud-
ies of comic books, Lee says, 'I used to think 'What the hell are they so
interested in comics for? These are comic strips!' I've come to realize over
the past few years that I was wrong and these people who are interested in
comics are right. Because basically, why is it any less seemly to be interested
in comics than in movies or novels or the ballet or opera or anything else?
It's an art form.'

<div align="right">Tim Faherty quoting Stan Lee[1]</div>

The scepticism expressed by Stan Lee about the academic study of com-
ics touches on issues relating not only to the study of comics in the con-
temporary academy, but to the way in which comics are understood more
generally in our culture. Lee's observation was reported in a 1977 profile
of the famed comic book writer and editor in the *Princeton Spectrum,* and
he references the place of comics in university classrooms of that pe-
riod. To say that comics had little place in the humanities departments of
major American universities at that time would be a monumental under-
statement. Indeed, Lee's contention that it should be no less seemly to
be interested in comics than in the ballet or opera was not a view that was
widely shared by academics at that time, and probably still is not today.
Despite the many challenges to the stability of the canon of Western arts
that have been launched by cultural studies scholars since the 1970s, and
the successes that they had obtained with regard to the study of culture
as an everyday lived experience, conservative scholarly disciplines, and
even some of the newer contemporary fields of cultural scholarship, still
turn up their noses at the thought of seriously engaging with comics and

other aspects of so-called popular culture. To this end, the institutional-
ization of comics in the academy, such as it is, has most often come from
departments on the margins: American studies, popular culture studies,
communication studies, and, of course, cultural studies. Nonetheless, as
these fields, like cinema before them, became increasingly of interest
to graduate students and, in turn, professors in departments of English
literature, the tide began to turn in the direction that Lee describes. Sud-
denly, and dramatically, literature departments became the institutional
locus of comics studies in the United States, a situation that benefited
writers like Lee much more than it did his best-known artistic collabo-
rators, such as Jack Kirby and Steve Ditko. As art departments, and in
particular art history departments, lagged in the adoption of courses and
research on comics, the literary turn in the study of comics prevailed,
with hundreds of essays published on generic, thematic, formal, and nar-
rative concerns raised by a host of comics and works in the domain of
popular culture.

One of the significant consequences of the literary turn in the study
of comics has been a tendency to drive attention away from comics as a
form of visual culture. Comics have rarely been considered an art form
akin to painting, sculpture, or photography, and they are not commonly
taught in courses in art history. By recuperating comics initially through
the lens of popular culture, and in scholarly venues like the Popular
Culture Association, comics have been largely hived off from the tra-
ditions of the serious or consecrated visual arts, and those comics that
are examples of what I have elsewhere termed 'unpopular culture' have
been largely neglected in favour of analyses of the best-selling examples
of the form.[2] In this way, the study of comics has offered an interesting
inversion of traditional canon-defining practices in the humanities. Mat-
thew Arnold's call to study the 'best that has been thought and said' was
the norm against which cultural studies scholars rebelled in literature
and art history. The study of comics, originating as it does in a post –
culture wars climate, has, from the outset, granted attention equally to
acclaimed works such as Art Spiegelman's *Maus* as well as to the products
of the monthly superhero production factories, rarely discussed for their
strictly artistic merits. This is neither a failing nor a particular blessing
for the study of comics, and I raise it only to note that in contemporary
academic realpolitik the question of whether or not comics are an art
form is one that is diplomatically left aside.

Comics, many critics will tell you, are not art. They are many things –
'a poisonous mushroom growth' (Sterling North), 'self-interpreting

pictures' (David Carrier), or 'the tool of a few newspaper publishers who wanted to extend their power and their control of the market' (Reinhold Reitberger and Wolfgang Fuchs) – but, according to their critics, they are most assuredly not art.[3] In one of the classic statements on the art status of comics, Karl E. Fortress wrote: 'The comic strip artist is not concerned with art problems, problems of form, spatial relationships, and the expressive movement of line. In fact, a concern with such problems would, in all probability, incapacitate the comic strip artist as such.'[4] For critics like Fortress, the aesthetic and artistic issues raised by other forms are totally alien to comics, which exist on an entirely different plane. Of course, it is not only those outside the world of comics who hold an anti-art position relative to the form. Robert Crumb, for example, in a 1969 strip entitled 'Drawing Cartoons is Fun!' also rejected the idea that comics constituted an art form: ' "ART" is just a racket! A HOAX perpetrated on the public by so-called "Artists" who set themselves up on a pedestal, and promoted by pantywaste ivory-tower intellectuals and sob-sister "critics" who think the world owes them a living!'[5] While their concerns are different – one formal, one social – their conclusions are analogous. Fortress and Crumb are two sides of the same coin, each seeking to concretize a firm distinction between comics and 'Art.' As an anti-art, comics have traditionally flown, as Art Spiegelman is fond of saying, below the critical radar.[6] Largely ignored by critics and art historians, and consequently disdainful of the interests of those groups, comics have long revelled in their lowbrow, bad boy image. Nonetheless, in keeping with Lee's observation, it is clear that, in recent years, comics have become increasingly an interest of intellectuals, of both the ivory tower and pointy-headed varieties. These critics, curators, and art historians are increasingly coming to stress, contra Fortress and Crumb, that comics are indeed an important visual art.

In his 2006 book *Un Objet culturel non identifié* (*An Unidentified Cultural Object*), French critic Thierry Groensteen outlines what he perceives to be the five 'symbolic handicaps' that have contributed to the devaluation of comics as a cultural form. First, he argues that comics are a 'bastard' genre resulting from the 'scandalous' mixture of text and image; second, that they are intrinsically infantile and consumed by adults who are seeking to prolong their adolescence; third, that comics are associated with one of the most degraded branches of the visual arts, caricature; fourth, that they have not been integrated into the development of the visual arts throughout the course of the twentieth century; and, finally, that the images produced in comics do not command attention as a result

of their multiplicity and tiny format.[7] Considering each of Groensteen's proposed handicaps in turn provides an opening in which to address the historical exclusion of comics from the realm of legitimation within the larger world of the visual arts.

Groensteen's suggestion that comics fail to command respect because they are (predominantly) a mixed media form is limited because it remains fundamentally at the level of discourse. It is true that many of the classic formal definitions of comics start from the presupposition that the image-text relationship is central to the operation of the form, and the relationship between image and text is highly privileged in discussions about comics. Nonetheless, as Groensteen himself has demonstrated in other writings, the relationship between text and image need not be central to the understanding of comics and, indeed, need not exist at all.[8] Hundreds of examples of text-free comics exist – and a much smaller number of image-free as well – each of which demonstrates the commonsensical observation that hybridity is not necessary in the comics form. The persistence of this symbolic handicap stems from the ideology of artistic purity that gave form to the Enlightenment opposition of painting and poetry and later developed into the type of form specificity advocated by critics like Clement Greenberg in relation to inter- and postwar modernism. Interest in these types of purity have done comics few favours.

Modernist critics were rarely friends of comics. Greenberg's famous 1939 essay 'The Avant-Garde and Kitsch' is typical insofar as it pointedly dismissed comics as among the lowest forms of debased and industrialized pseudo-culture. In his 1960 essay, 'Modernist Painting,' Greenberg succinctly summarized key tendencies in modernism which he saw as growing out of, but differing from, Enlightenment criticism: 'The essence of Modernism lies, as I see it, in the use of characteristic methods of a discipline to criticize the discipline itself, not in order to subvert it but in order to entrench it more firmly in its area of competence.'[9] For Greenberg, this criticism derived from the specificity of various media. In painting, for example, these included the flat surface of the canvas, the shape of the support, and the properties of the pigment, each of which painters had previously regarded as limitations, but which were now seen as positive factors to be acknowledged openly. For artists working in comics, however, the combination of narrative and decorative elements problematized the possibility of locating form-specific methods and attributes. Elsewhere I have suggested that several European comics movements of the 1990s have sought to locate the formal specificity of

comics in the sequential placement of images, and this is an issue that is, as I will demonstrate below, central to many definitions of comics as a form.[10] Nonetheless, the hybrid nature of comics, which is seen by its proponents as one of its principle strengths, serves to mitigate against the modernist purity that Greenberg and others identified in artists like the abstract expressionists who eschewed representationalism. Further, that lack of purity becomes one of the key reasons for the exclusion of comics from canons of twentieth-century accomplishment in the fine arts. Following the logic of high modernism, comics fail to rise to the level of Art because they do not attend to the properties of the form in an informed and reflexive manner.

As far as it goes, Groensteen's argument on this point is convincing, but it fails to account for the many important hybrid art forms that have attained far greater levels of cultural respectability than have comics. How, for example, can we account for the respectability of opera and ballet in Western culture if they too are marked by hybridity? The answer can be found by considering the historical evolution of these arts over time. Taking the example of opera,, it is important to note, as Paul Dimaggio has so thoroughly detailed, that its consecration was the result of specific gentrifying efforts undertaken by cultural elites in the first half of the twentieth century.[11] Dimaggio's historical overview goes a step further than Groensteen's, moving past the strictly discursive distaste for hybrid forms that occupied critics like Greenberg in an effort to demonstrate the precise steps that were taken in an effort to 'rescue' opera from its degraded state as a form of popular entertainment and its associations with mass audiences. That such efforts have only recently been undertaken to any large extent for comics seems to me to be a more important factor in the ongoing processes of delegitimation than do the specific discursive legacies of Enlightenment and modernist era thinkers, however large their intellectual shadow might loom.

One important fact about hybrid art forms is that they are often recognized as being particularly complex works that unite disparate elements, thereby accruing values attached to each. This has not generally been the experience of comics, which have been most commonly dismissed, in the words of Sterling North, as 'badly drawn, badly written and badly printed,' rather than regarded as an integrative example of two forms working together to create a more substantial whole.[12] For Groensteen, the tendency to regard comics as a 'minor art destined for minors' stands in generally for the place occupied by comics within the overall critique of mass culture.[13] Drawing primarily, but by no means exclusively, on

the Franco-Belgian tradition, he notes that although the historic roots of comics in the nineteenth century can be found in publications destined for adult audiences, by the twentieth century the field was almost completely concerned with churning out work for children. While many commentators have regarded comics as little more than a specialized offshoot of children's literature, Groensteen emphasizes the way in which comics were co-opted primarily by the children's press in the twentieth century, thereby cementing certain associations between the form and its audience from that point forward. Of course, it is difficult to dispute that, for most of the twentieth century, comics, and, in particular, comic books, were primarily targeted to audiences of young people. While traditions of comics for adults persisted in the domain of newspaper strips it is true that the vast bulk of the material published during this period was, indeed, intended for children.

Yet, more to the point, the majority of comics published in this period were not simply intended for children, but were, in fact, products of a culture industry that was regularly derided as immature and dangerous by cultural critics of all political dispositions. To this extent, Groensteen has correctly identified the discursive trope that is used to punish comics but has unnecessarily restricted it in his emphasis. The products of mass culture, and the audience for it, have, indeed, been frequently dismissed as childlike, but this particular form of infantilization is also importantly classed, gendered, and racialized. To this end, Groensteen would be more accurate in his analysis were he to diagnose the problem of comics as their association with mass audiences and not merely children, with the infantile rather than with the infant. It is important to note that the wide-scale proliferation of comics in the first half of the twentieth century went hand in hand with the development and refinement of the mass culture thesis that suggested that the masses posed a revolutionary threat to the established social order in the nineteenth century and a totalitarian threat in the twentieth.[14] Before it was displaced in the postwar period by concerns over television (and, later, video games and the internet), comics served as the classic examples of all that was wrong with contemporary mass culture in the eyes of critics who championed aesthetic excellence, and parents who worried that their children were subject to negative influences from culture.

It was common in the mid-century period to encounter cultural commentators like the *Saturday Review*'s John Mason Brown dismissing comics as 'the lowest, most despicable, and most harmful sort of trash,' or novelist Marya Mannes declaring that 'comic books in their present form

are the absence of thought. They are, in fact, the greatest intellectual narcotic on the market.'[15] Consider this selection from a 1948 article written by the noted anti-comic book crusader Fredric Wertham:

> Some fathers have told me that it 'hasn't done any harm to my child; after all, when he reads Hamlet he doesn't see ghosts and want to put poison in my ear.' The answer is easy: first of all, comic books are not as artistic as *Hamlet*. Second, there's only one *Hamlet* (and most children don't read it), whereas comic books come by the millions. Third, there has been no other literature for adults or for children in the history of the world, at any period or in any nation, that showed in pictures and in words, over and over again, half-nude girls in all positions being branded, burned, bound, tied to wheels, blinded, pressed between spikes, thrown to snakes and wild animals, crushed with rocks, slowly drowned or smothered, or having their veins punctured and their blood drawn off.[16]

This passage includes all of the key tropes of the anti–mass culture argument as it was commonly applied to comics in the mid-century period. First, Wertham bluntly asserts that comics lack the artistic seriousness of the established canon of great works. Second, he derides comics, in much the same way a critic like Greenberg does, for their mass-produced ubiquity. Finally, he criticizes them for their sexually lurid and violent content, which, he asserts, was a contributing factor in the breakdown of postwar civil society in the United States. Thus, the use of familiar anti–mass culture rhetorical tropes in these examples highlights the manner in which comics were seen not merely as an infantilized aspect of culture, as Groensteen suggests, but as a massified one. The key distinction between these views rests in the assumption that children grow up and move on to other, more 'mature,' cultural forms, but the mass man, conceptualized by thinkers as politically diverse as Theodor Adorno and José Ortega y Gasset as alienated by the culture of kitsch, was mentally fixed by a lowest-common-denominator culture and therefore would remain a threat to the mature development of society.

The first two of Groensteen's five symbolic handicaps, the mixed nature of comics and their association with disreputable publics, relied heavily on the intersection of the form with pre-existing aesthetic discourses that had little to do with comics per se. It is important to note that both the modernist insistence on formal purity and the disdain for mass culture would have existed in much the same fashion even had comics never emerged as a distinct communicative form. The remaining

handicaps, however, owe a greater debt to the specific aesthetic prop-
erties and historical development of the form. To this end, one might
anticipate that these factors would be pre-eminent in the structuring of
the discursive dismissal of comics, but on closer inspection this does not
seem to be the case, as even Groensteen himself devotes less attention
to these elements than to his first two symbolic handicaps. He suggests
that the long association of comics with caricature and, by extension,
humour, a minor aspect of the arts, has taken a negative toll on the criti-
cal reputation of comics. While the bias against humour in the arts has
been frequently remarked upon, the connection between comics and
caricature is one that has just as commonly been used to justify comics as
to denigrate them. Similarly, when Groensteen suggests that comics suf-
fer because of their format, their small printed size and the multiplicity
of images, it is difficult to accord this factor any great weight. Groensteen
himself devotes very little attention to the suggestion and is not able to
mount a particularly compelling case for it. While monumentality has
been an important aspect of the visual arts for centuries, it does not seem
to follow that small-formatted works have been particularly disparaged
specifically for their size.

The last of Groensteen's symbolic handicaps, however, does strike me
as particularly worth considering. He remarks that the development of
comics throughout the twentieth century was largely divorced from the
development of the visual arts. In *Comics as Culture*, M. Thomas Inge makes
the extraordinary suggestion that 'nearly all modern artistic movements
and styles have either been anticipated by or reflected in the comics.'[17]
This seems to be a difficult assertion to credit given the vast differences
that existed between comics and high modernism in the first half of the
twentieth century, differences that were seemingly exacerbated by the
rise of minimalism and conceptualism in the visual arts, movements for
which there are very few comics equivalents. Indeed, with the notable
exception of pop art, which will be discussed in the next chapter, comics
have been largely at odds with art history. Certainly, comics perpetuated
the reign of figuration during a period in which it was increasingly under
siege and out of fashion within the field of painting. While it is a com-
monplace to argue that comics have suffered the neglect of the art world
because they so closely clung to the attributes negatively associated with
mass culture, it is also imperative to recognize that comics have not been
recognized as art largely because until recently, with a very few excep-
tions, they have not actively solicited that form of recognition.

Thus, of Groensteen's five symbolic handicaps, two are particularly relevant: first, the specific ways in which comics have been defined not as art, but as art's mass cultural 'other' by institutional forces in the art world; and, second, the tenuous and often distant relationship that exists between consecrated or emergent forms of fine art and comics. While this latter will be thoroughly interrogated throughout the course of this book, it is important to turn now to the first point by way of a consideration of the definition of comics. Specifically, it is imperative to understand the particular ways in which definitions of comics have so frequently tended to help reify the status of comics as not-art.

Comics: Defining Art's Other

In February 1952, near the apex of the anti–crime comic book movement in the United States, the New York state legislature passed a bill that called for a ban on crime comic books, which they defined as publications 'principally made up of pictures, whether or not accompanied by any written or printed matter, of fictional deeds of crime, bloodshed, lust or heinous acts, which tend to incite minors to violent or depraved or immoral acts.'[18] Governor Thomas E. Dewey vetoed the bill before it became law on the grounds that it was not likely to survive a challenge on constitutional grounds. Whether or not Dewey was correct in his reasoning is a question for legal scholars to debate, but from the point of view of comics scholarship it is clear that the definition put forward by New York legislators suffered from its ambiguity as well as its attempts to be all-encompassing. What they produced was not strictly speaking a definition of crime comic books, nor did it offer a plausible definition of comics generally. Yet these legislators should not have been discouraged by their failing, for the formal definition of comics is a topic that has vexed a great number of scholars and critics.

The first English-language writer to suggest a normative definition of comics may have been Martin Sheridan, whose 1942 book *Classic Comics and Their Creators* focused almost exclusively on newspaper comic strips rather than the newly emergent 'pulp paper books' which so concerned the elected officials of New York and which were, at the time he was writing, less than a decade old.[19] Sheridan's analysis of comic strips eschewed nearly all discussion of the formal, visual aspects of comics, focusing instead on content issues based on literary concepts such as character type, theme, and genre, which the author took to be the essential elements

of comics. Sheridan's distinction between comic strips and comic books reified a separation that was commonplace at the time he was writing, a bias that was repeated regularly in the earliest comics scholarship. In the mid-century period, and beyond, comic strips were considerably more prestigious than were comic books. Not only did newspaper syndicates pay significantly better than comic book publishers, thereby becoming the desirable destination for the most talented and sought-after creators, but the cultural capital of local newspapers, their credibility within communities, sanctioned the comic strip in a manner that was unavailable to the comic book. Thus, when anti–mass culture critics like Wertham condemned comics, most often they were concerned exclusively with comic books, while comic strips, appearing in daily newspapers that were read by the entire family, were widely regarded to be a healthy form of family entertainment and a key aspect in the development of print journalism. While strip cartoonists may not have been seen as important artists in the traditionally consecrated sense, they were, nevertheless, held to be wholesome popular entertainers. Notably, this was a distinction that strip cartoonists worked hard to preserve. When, in the spring of 1954, the United States Senate held hearings to investigate claims that crime and horror comic books contributed to juvenile delinquency, *Pogo* creator and National Cartoonists Society (NCS) president Walt Kelly drew a firm separation for the subcommittee between the positive comic strip and the more dangerous comic book. *Steve Canyon* creator Milton Caniff, appearing alongside Kelly, noted that the NCS valued Dr Wertham's opinion about the dangers of comic books 'very highly,' but also affirmed that comic strips served the public good through their ability to entertain and inform.[20] Appeals to the civic and patriotic aspect of the American comic strip, in opposition to the morally degenerating effects of comic books, were a hallmark of a great deal of thinking about comics in the United States over the ensuing decades.

Colton Waugh's *The Comics* (1947), published five years after Sheridan's book, shares much in common with its predecessor insofar as it features cartoonist biographies and is organized primarily by theme and genre. Waugh himself was a former strip cartoonist, having produced *Dickie Dare* from 1934 until 1944 (returning to the strip again after publishing *The Comics*), and he wrote with a great fondness for the form. Significantly, it was Waugh's book that offered the first important analytic definition of comics, relying heavily on the narrative content of the strip, which deeply influenced development of subsequent thinking on the subject. Waugh's definition of comics outlined three elements that he

suggested comics 'usually have.' These are: first, a continuing character who becomes the reader's dear friend; second, a sequence of pictures complete in themselves or part of a longer story; and, finally, speech included in the drawings enclosed by what he termed 'balloon lines.'[21] Crucially, Waugh's definition of comics avoided all reference to aesthetic claims and artistic status, focusing instead on issues of content (continuing characters) and form (sequential images and word balloons). Indeed, he notably diminished expectations that comics might be seen as a worthwhile art form in their own right by situating them squarely in the traditions of mass culture and mass communication: 'Comics, like the radio and movies, provide moments of pleasure for the large mass of people. In doing this, comics sell the medium which has presented them, whether newspaper or magazine.'[22] Importantly, Waugh's tendency to conceptualize comics as mass culture obscured the possibility that comics might, in fact, be a new art form. While Waugh conceded at the end of *The Comics* that artistic and literary development might be possible within the form, he was not particularly optimistic or forward-looking with this assessment. Although many critics have focused on the logical limitations of Waugh's definition of the comics form, the most significant failing of his work may have been its inability to imagine comics as art and its eagerness to situate comics within a discourse that would inevitably contribute to their cultural marginalization.

Despite its shortcomings, Waugh's definition proved highly influential, and his prejudices can be found in the work of a number of scholars working after him who adopted his narrativist bias. M. Thomas Inge, writing in *Comics as Culture* (1990), strongly echoed Waugh's thinking when he defined the newspaper comic strip as 'an open-ended dramatic narrative about a recurring set of characters, told in a series of drawings, often including dialogue in balloons and a narrative text, and published serially in newspapers.'[23] Bill Blackbeard, writing in *The Comic Book Century* (1995), suggested a definition that was only minimally differentiated from that of Waugh and Inge. The comic strip, he argued, was 'a serial sequential narrative in drawn panels featuring recurrent characters in an open-ended series of stories, told by explanatory dialogue balloons *within* the story panels with little or no narrative text.'[24] Definitions of comics that privilege content over form have numerous significant logical problems. The requirement of a recurring set of characters is self-evidently inadequate in terms of a formal definition as it substitutes a common element of the form developed to address marketing concerns for an absolute rule. Further, the requirement of dialogue would make

long-running works like Otto Soglow's *The Little King* and Carl Anderson's *Henry* something other than comics, and the demand for balloons would eliminate Garry Trudeau's *Doonesbury* and Berke Breathed's *Bloom County*. More importantly, these normative definitions are constructed in such a way as to bolster claims that the first recurrent comic strip character was Richard F. Outcault's *The Yellow Kid,* and that the birthplace of comics were the feuding Hearst and Pulitzer New York papers of the 1890s, thereby rejecting claims, initiated on behalf of Swiss writer Rodolphe Töpffer, that comics developed first in Europe. The Yellow Kid thesis, advanced most aggressively by Blackbeard, is rooted in an American chauvinism that seeks to claim comics as a national cultural form, tying comics to the democratic, pluralist, and family-oriented values that are held to exemplify the American character.

The erroneous idea that comics, like jazz and cinema, are intrinsically American has found tremendous currency among American critics, who rehearse the claims of Blackbeard and others endlessly. Jerry Robinson, for instance, has called the years leading to the twentieth century 'the cultural stew that nourished a new American art form which proved to be of unprecedented vigor and longevity: the comic strip,' and argues that 'America and the comic strip were made for each other.'[25] Similarly, Maurice Horn has suggested 'no other form (except the movies) holds such fascination and appeal for the general public, none is so American in its expression, yet none has suffered so much neglect, scorn, and ignorance from the American art establishment.'[26] And Art Spiegelman, opening a review of the Bill Blackbeard and Martin Williams – edited anthology *Smithsonian Collection of Newspaper Comics* (1977) for the *New York Times,* notes that 'one of our most vital artistic inventions, the comic strip, still struggles to break out of their cultural closet. In Europe, specifically France, the form's potency is much admired. The process of appropriating our indigenous forms, like movies and jazz, and returning them with a certificate of cultural validation is taking place once again. At home their true value is undermined by several prevailing attitudes.'[27] Each of these authors, and many others, connects two important observations: that comics are fundamentally American and that they constitute a neglected art form. This appeal to a patriotic conception of comics history bypasses discussion about the aesthetic qualities of the form in favour of a heroic narrative of comics as the hardy underdog struggling against the tyrannical forces of legitimate art. This mimics an image of America itself as the hardscrabble black sheep spawned by its European

parents. If, as many American critics argue, the art establishment disdains comics, then perhaps they might be validated in another manner: as folk culture.

The initial stage of comics appreciation marked by writers like Sheridan and Waugh was followed by critics who saw in the Americanness of the comics a reflection of American society generally. For these critics it is the insight into national character, rather than the artistic or aesthetic value of the works, that makes comics worthy of study. Richard Lupoff and Don Thompson locate the value of comics in terms of nostalgia, noting that 'for at least a quarter century, the comic book was the dominant element in the culture of American children,' and, consequently, it is comics that have shaped the American people.[28] The very title of Thomas Inge's *Comics as Culture* is indicative of the author's approach to the topic. He argues that 'a major reason for recognizing and studying the comics is the fact that they are one of the few native American art forms' and, consequently, can tell us a great deal about the culture that produced them.[29] In a similar vein, David Manning White and Robert H. Abel, in their suggestively titled *The Funnies: An American Idiom*, stipulate that the value of comics is located in their 'extraordinary cultivation of images, mirroring what we, as a people have been like throughout the past half-century and are like today.'[30] By legitimating comics primarily, or even exclusively, as a reflection of the stories that American society tells itself, comics scholars have effectively marginalized formal investigations and pushed aesthetic concerns to the margins of critical discourse.[31] The Americanization of comics seemed to carry with it the promise of evading the trap set by the mass culture critique. By positioning comics not as a narcotizing and alienating aspect of mass culture, as Greenberg and Adorno might, but as an articulation of the hopes, dreams, and opinions of the American people in a democratic society, comics scholars found a justification for their work in this field, albeit often at the cost of recognizing the specific aesthetic practices of comics. The line of argument for many scholars enmeshed in the sociological paradigm of societal reflection is: if comics cannot be art, it suffices that they are at least American.

The American tendency to eclipse or deny European and Asian contributions to the development of comics may have aligned with a Cold War era ideology relating to the superiority of American cultural forms, but it greatly obscured the possibility of conceptualizing comics as an art form with aesthetic as well as sociological value. The insistence on

the American origins of comics had the effect of removing comics from art historical traditions and situated the form squarely in the degraded domain of mass culture. Efforts to avoid the tainting aspect of the mass culture critique through an optimistic focus on comics as the vox populi of the American people contributed to the status of comics as a non-art. Further, the Americanization thesis necessitated certain peculiarities in the working definition of comics. Specifically, the problematic tri-partite definition suggested by Waugh and developed by his followers – sequential panels, recurrent characters, and word balloons – served less to specify the formal attributes of comics than it did to exclude certain non-American precursors to the form. Blackbeard's definition of comics in his 1995 book *The Comic Book Century,* for example, seems designed for a single purpose: to restrict the history of the form so as to locate its origins in the mid-1890s and thereby confirm the title of his book and the arbitrary anniversary that it celebrates. While it may be true that all formal definitions of media are self-interested and political, subsequent turns towards art historical approaches to the definition of comics re-vealed this one to be particularly so.

Efforts to push the origin of comics further into history than New York in the 1890s have been undertaken by a number of scholars, many of whom trace the development of comics and proto-comics back as far as the Stone Age and cave drawings. In his 1994 book *The Comic Book,* Paul Sassienie suggests that the use of pictures to tell a story stretches back almost to the dawn of humankind: 'It seems that once our ancestors had found food and shelter, their next task was to draw pictures on cave walls. Drawn with the vitality and elegance of great simplicity, they are our first picture stories.'[32] However, this conception of the cave painting as proto-comics did not originate with Sassienie. One of the earliest art exhibitions dealing with comics, 'The Strip, Its History and Significance,' held at the American Institute of Graphic Arts in 1942, showed a Span-ish cave painting that dated from approximately 3000 BC. Commenting on this show, Reinhold Reitberger and Wolfgang Fuchs note that 'cave-drawings, Egyptian hieroglyphics, Hokusai books, votive tablets and the Bayeux tapestry are of interest inasmuch as they prove that comics are not an isolated phenomenon in the course of history.'[33] This laundry list of influences was matched by Jerry Robinson, who argued in 1974 that 'if we consider cartooning a means of pictorial communication, as well as an art, then surely it all must have begun in the Paleolithic times.'[34] Rob-inson, who traces the evolution of comics from cave paintings through Egyptian, Greek, and Roman caricature and into the Middle Ages with

the Bayeux Tapestry, places an emphasis on the idea that comics constitute a legitimate art form. Indeed, this is a common theme found in the work of many critics who seek to valorize comics not as the expression of the American people, but as an independent art form with its own exceptional history and attributes. Moreover, it is clear that almost every attempt to define comics as a unique art, as opposed to a sociological indicator, begins with an appeal to incorporate cultural objects within a longer and more prestigious critical lineage.

Common to the art historical approach is the suggestion that the Bayeux Tapestry constitutes a significant precursor to comics or can even be defined as a comic itself. Robinson, Sassienie, Groensteen, Claude Moliterni and Philippe Mellot, and George Perry and Alan Aldridge have entertained this idea, among many others.[35] Scott McCloud, whose popular 1993 book *Understanding Comics* has done more to focus attention on the definitional issue in comics than any other single source, argues that prior definitions of the form had been too narrow, thereby failing to show that 'the potential of comics is limitless and exciting.'[36] In identifying an 'incredible wealth of ancient comics,' including the Bayeux Tapestry, McCloud can be criticized for playing status games with comics. Specifically, he appeals to the traditions of art history in a quest to identify important forerunners of comics by focusing on neglected or overlooked early examples of the form and key influences on their development. A condemnation of the aspirational nature of the search for art historical legitimacy was advanced by Les Daniels in the 1970s when he noted that 'defenders of the comics medium have a tendency to rummage through recognized remnants of mankind's vast history to pluck forth sanctioned symbols which might create among the cognoscenti the desired shock of recognition.'[37] At the heart of this debate about status anxiety is the question of definitional power. The question of whether the Bayeux Tapestry can meaningfully be considered to be a comic is dependent upon the definition that one chooses to employ. From the standpoint of the Americanists with their emphasis on recurrent characters and word balloons, the Tapestry is self-evidently not a comic. Nonetheless, from more generous perspectives the seventy-metre-long embroidery, which tells the tale of the Norman Conquest of England of 1066 through a combination of words and sequential images, could indeed be meaningfully regarded as a comic. One result of such a leap would be to negate the equation of comics with American mass culture, undermining the nationalist argument and opening up the possibility that comics transcend any single culture, as do the other arts.

Although he rejects the suggestion that the Bayeux Tapestry is a comic on the grounds that it was not mass-produced, art historian David Kunzle was the first to offer a sustained critical analysis of the origins of the comics form. His books *The Early Comic Strip* (1973) and *The History of the Comic Strip* (1990) have been particularly influential in terms of back-dating the history of the form. Nonetheless, the definition of comics proposed by Kunzle seems no less problematic than those he sought to counter, particularly insofar as it defines comics narrowly so as to de-limit the nature of his particular historical project. For Kunzle, there are four aspects of comics: '1/There must be a sequence of separate images; 2/There must be a preponderance of image over text; 3/The medium in which the strip appears and for which it was originally intended must be reproductive, that is, in printed form, a mass medium; 4/The sequence must tell a story which is both moral and topical.'[38] Kunzle's definition, particularly the third and fourth requirements, is problematic from an analytic standpoint because it is easy to find examples of comics that have not been reproduced, including unpublished comics, and comics that are neither moral nor topical are also quite common. Nonetheless, by placing comics in a continuum of other narrative arts, as he does in his second volume, he is able to completely obliterate the contention that comics originated with The Yellow Kid. Kunzle's attention to the work of Swiss cartoonist Rodolphe Töpffer (1799–1846), about whom he published a monograph entitled *Father of the Comic Strip,* has further expanded the historical understanding of the origins of comics. More-over, his work on nineteenth-century comics, broadsheets, and picture series helped to situate comics within a larger art historical context that included caricaturists such as William Hogarth (1697–1764), James Gill-ray (1737–1815), Thomas Rowlandson (1756–1827), George Cruikshank (1792–1878), and Honoré Daumier (1808–79), as well as illustrated jour-nals like *Puck, Judge, Fliegende Blatter, Images d'Epinal, Comic Cuts,* and *Ally Sloper's Half Holiday.* While these and other journals published works that used frames, captions, and word balloons long before the arrival of The Yellow Kid, and while Rowlandson created a regular character in Dr Syntax and, like Gillray, increasingly incorporated word balloons into his work, the proponents of the Yellow Kid thesis relentlessly sought to dispute the notion that these works were comics even as they were clearly shown to fulfill many of their definitional requirements. To this end, Horn heaped scorn on the 'many well-meaning but artistically naïve apologists of the form' who 'have claimed for the comics an ancient and noble lineage, from the cave paintings of Altamira and Lascaux through

the Egyptian bas-reliefs, the Babylonian steles, and the Pompeian murals to the Books of the Saints and the *Biblia Pauperum* of the Middle Ages.'[39] For Horn, the absence of word balloons in these works meant that they did not qualify as comics, and the separation of image and text, which was often located underneath the image, was sufficient to disqualify the contributions of Töpffer. Insofar as the question of origins has not been resolved between American proponents of the Yellow Kid, champions of Töpffer, and advocates of even more ancient histories, the definitional issue remains current in comics scholarship.

If history was unable to determine the definition of comics, others argued that the issue could be better addressed through an analysis of the unique properties of comics as a narrative form. Although initiated by Kunzle, the emphasis on narrative elements in definitions of comics has been significantly widened by the contributions of two scholar-practitioners, Will Eisner and Scott McCloud. Eisner, in his books *Comics and Sequential Art* (1985) and *Graphic Storytelling* (1995), conceptualized the idea of 'sequential art,' drawing a distinction between the general category of visual narrative (employed by Kunzle) and the 'specific forms of that medium,' comic strips and comic books. In conceptualizing comics as a unique form, Eisner focused his attention primarily on comics as a print medium. Indeed, the first chapter of *Comics and Sequential Art* is entitled ' "Comics" as a Form of Reading,' and in that chapter he argues that 'the format of the comic book presents a montage of both word and image, and the reader is thus required to exercise both visual and verbal interpretive skills. The regimens of art (e.g. perspective, symmetry, brush stroke) and the regimens of literature (e.g. grammar, plot, syntax) become superimposed upon each other.'[40]

The suggestion that comics are the product of the blending of art and literature or, in a more limited sense, of image and text, is quite common in analytic definitions, even as it has proved highly problematic. R.C. Harvey, for instance, has frequently advanced a similar notion, suggesting that comics 'weave word and picture together to achieve a narrative purpose. Comics are a blend of word and picture – not a simple coupling of the verbal and the visual, but a blend, a true mixture.'[41] Unlike Kunzle, whose definition insisted on the primacy of the image over the text in the comics form, Harvey's work, particularly in his books *The Art of the Funnies* (1994) and *The Art of the Comic Book* (1996), is largely concerned with the particular aesthetics of blending and the way in which certain works achieve what he considers an appropriate level of balance between text and image ('a measure of a comic strip's excellence

is the extent to which the sense of the words is dependent on the pictures and vice versa').[42] Nonetheless, given the ubiquity of wordless comics, essentialist definitions like those of Eisner and Harvey that rely on the integration of text and image are deeply problematic and highly unsatisfactory from an analytic standpoint. Furthermore, while they seem to privilege the blend between text and image, it is clear that the textual or literate qualities of comics tend to predominate. This can be seen in the widespread adoption of the term 'graphic novel' as a gentrifying replacement for 'comics.' With this term, as Catherine Labio has pointed out, the visual element serves primarily as an adjectival modifier for the literary element.[43] In other words, comics achieve their aesthetic value in these frameworks through the library, not the gallery. While Eisner's definition carries the virtue of pushing forward the notion of comics as art, and while Harvey's has served as a foundation for his highly idiosyncratic critical evaluations of the history of the form, neither makes a compelling case that blending is analytically integral to comics.

In *Understanding Comics* (1993), Scott McCloud adopts Eisner's term 'sequential art' as a starting point but quickly qualifies it in a number of important ways. Noting that Eisner's definition seems insufficient to distinguish comics from animation or other forms of sequentially ordered art, he proposes his own revision: 'juxtaposed pictorial and other images in deliberate sequence, intended to convey information and/or to produce an aesthetic response in the viewer.'[44] In his attempt to provide a normative and all-encompassing analytic definition of the form, McCloud abandons many of the attributes of comics proposed by earlier thinkers on the subject. He erases the debate about recurrent characters and word balloons first introduced by Waugh and his followers, and he eliminates three of the four requirements suggested by Kunzle (the preponderance of the image, mass production, and a moral and topical narrative). Although *Understanding Comics* is equally concerned with questions about the origins and history of comics, McCloud's definition attempts to reduce comics to strictly formal attributes. In eradicating history from his definition he moves the issue from what comics have been to what they could be. In so doing, however, he proffers a definition that appears at times to be both too narrow and too encompassing. By placing juxtaposed images at the centre of his definition, a starting point that he shares with almost every critic who has attempted to construct an analytic definition of comics, McCloud very deliberately rules out single-panel comics such as Gary Larson's *The Far Side* or Bil Keane's *The Family Circus*.

At the same time, the ahistoricism of McCloud's definition of comics can seem over-broad, particularly insofar as it encompasses proto-comics like the Bayeux Tapestry. For Aaron Meskin, the ultimate problem with McCloud's formal definition of comics is its lack of attention to art history: 'Although comics are an interesting artistic category, the category of spatially juxtaposed pictorial narrative does not appear to be of much art-historical or art-critical interest.'[45] Meskin correctly argues that McCloud's ahistorical definitions serve the single purpose of establishing an ersatz history of comics that is intended to legitimate their place in the world of art. Nonetheless, what is striking is that McCloud's definition, however flawed, is so starkly at odds with those proposed by earlier critics and scholars of the form. The transition from justifying the study of comics, and, indeed, comics themselves, as signifiers of American sociological phenomena to considering them an important and distinct art in their own right is a seismic discursive shift, and one that is central to the argument of this book.

Despite the opportunity that his work has opened up for conceptualizing comics as art, McCloud's definition remains troublesome from a number of perspectives. McCloud's insistence on strict formalism, and his suggestion that the essence of comics is the series of pictures, has, in its own way, helped to elide other potentially fruitful definitions of comics. Perhaps the most ironic of these is the way McCloud's definition tends to minimize the conception of comics as art. While his attention to formal properties has helped to reorient discussions of comics away from their strictly social function, McCloud's overly expansive conception of 'art' ('any human activity which doesn't grow out of either of our species' two basic instincts: survival and reproduction')[46] serves to obscure the aesthetic element of comics by regarding almost all human activities as art. When critic Greg Cwiklik criticized McCloud's arguments about art as 'childish' and 'threadbare,' McCloud responded that 'it would have been disastrous to include the word "art"' in his definition of comics, and although it would have allowed him to address the way comics are frequently derided by those outside the comics art world, the inclusion of such a loaded term would have distracted readers from focusing on the potential of the form, rather than its past accomplishments, on what can be done with comics rather than what has been done.[47] In this way, McCloud's definition of comics, certainly the best known and most cited of all such definitions, intentionally seeks to obscure the history of the form, its social significance, and notions of aesthetic worth, substituting in their place an essentializing formalism.

Towards a Theory of the Comics World

Since the publication of *Understanding Comics* in 1993, the definition of comics has become an increasingly pressing question in the area of comics scholarship. While Thierry Groensteen, Greg Hayman, and Henry John Pratt have offered significant challenges to, and revisions of, McCloud's definition, the search for a universally acknowledged functionalist definition of comics has not been satisfied.[48] At the same time, it needs to be acknowledged that, on this philosophical issue of definition, comics lag dramatically behind the general philosophy of the arts. Functionalist definitions of the arts were significantly undermined in the modernist era by avant-gardist works such as Marcel Duchamp's ready-mades, which seemed to lack aesthetic properties altogether, and by conceptualist works that defied notions of artefactuality and even perceptibility. As a result, contemporary definitions of art frequently emphasize the importance of the connection between a work and art history, or between a work and the institutions of the art world. One advantage of the institutional theory has been its ability to recognize avant-gardist and conceptual works as art by focusing on the social conditions required to sanction cultural objects and practices as artistic. Key to the institutional definition of art is the concept of the 'art world,' which Arthur Danto (who spells it as one word) defined as the social organization that provides the theories of art that all members tacitly assume in order for there to be objects that are actually considered art.[49] George Dickie, arguably the most prominent of the advocates of institutionalism, argues in his 1975 book *Art and the Aesthetic* that a work of art is an artefact presented to the art world public, and that the art world public is a set of individuals who are prepared in some degree to understand an object that is presented to them as art.[50] The circularity of Dickie's argument has been frequently criticized for its inability to distinguish the art world from similarly structured social institutions. Nonetheless, the definition of art proposed by Dickie has the advantage of not relying on the specific features of the art object and redirects our attention towards the social classification of art rather than its aesthetic quality.

Dickie's attention to artefacts that are presented to art world publics proves that not all candidates for appreciation are ultimately recognized as art. Unappreciated objects might fail because of some perceived flaw in the work itself or, perhaps, because the art world is not prepared at that moment to understand the value in the object presented to them. Certainly an argument can be made that the history of comics has been

one in which the art world has been unable, unwilling, or unprepared to recognize artistic value in comics. Indeed, the aesthetic value of comics has traditionally been celebrated nearly exclusively by a comics art world (or comics world) composed primarily of creators and fans rather than by gallery owners, museum curators, and the other patrons of the arts that Dickie suggests are the core personnel acting on behalf of the art world.[51] Following the argument proposed by Howard Becker in his book *Art Worlds* (1982), comics are better understood through the collective activities that constitute their production and circulation, not simply as discrete end products defined by the relation of juxtaposed images. Becker's emphasis on the cooperation between members of an art world in the creation of the system serves as a reminder that it is this system that constitutes the art object. Comics, following this logic, can be defined as objects recognized by the comics world as comics. From this vantage, the prevalence of works in comics shops that would not be regarded as comics from a functionalist perspective (art books, calendars, posters, etc.) is unsurprising. An institutional theory of the comics world has the advantage over McCloud's essentialist definition of recognizing a collection of Hank Ketcham's *Dennis the Menace* as a book of comics precisely because it so clearly participates in the common institutions of the comics world when the one-panel strip appears on the newspaper comics page, when it is collected by Fantagraphics and distributed to comic book stores, or when original drawings are sold at comics conventions to be hung in the buyer's home as a distinct piece of comics art.

Becker's definition of the 'art world' relies heavily on the recognition that the production of artistic or cultural works involves the activity of a great many people and that, absent this cooperation, the production of art is made difficult, or even impossible. He defines the art world as consisting of 'all the people whose activities are necessary to the production of the characteristic works which that world, and perhaps others as well, define as art.'[52] While Becker does not discuss comics in his work, extending his suppositions to that field is simple. Following Becker, we can define a comics world as one of many art worlds, and specifically as the collection of individuals necessary for the production of works that the world defines as comics. This division of labour would include, just on the level of production and circulation, writers, pencillers, inkers, colourists, letterers, editors, assistant editors, publishers, marketing and circulation personnel, printers, distributors, retailers, and retail employees. Each of these individuals plays an important role in the construction of the comics world, and the creation of works that we know as comics.

This conception places the artist 'in the center of a network of cooperating people, all of whose work is essential to the final outcome.'[53] One advantage of an institutional definition of comics as those objects presented to a comics world public as comics is that it goes a long way towards resolving a number of the difficult border cases that have so deeply troubled the functionalist definition, including the relation of comics to artist's books, to picture books, and to literature.

Becker notes in *Art Worlds* that 'art worlds do not have boundaries around them.'[54] Nonetheless, the practice of policing the boundaries of comics has been a hallmark of the functionalist approach to the definition of the form since at least the time of Martin Sheridan and Colton Waugh. Furthermore, in the current period it seems that the debate about boundaries has only intensified. Thus, while Becker sensibly suggests that 'art worlds typically have intimate and extensive relations with the worlds from which they try to distinguish themselves,' the drive to identify 'pure' examples of the comics form has reached often absurd heights.[55] For instance, in his essay on *Understanding Comics,* Dylan Horrocks notes that the author's belief that comics are a predominantly visual form 'sits guard at one of comics' most fragile frontiers – the one between comics and illustrated texts (children's picture books and so on),' but that McCloud fails to define this border at all.[56] Indeed, Mc-Cloud unproblematically offers a number of children's books, by artists such as Maurice Sendak, Jules Feiffer, and Edward Gorey, as examples of comics in *Understanding Comics,* but, in a *Comics Journal* interview with R.C. Harvey, seemingly contradicts this position by arguing that children's picture books in which there is a picture on each page and prose beneath the image are not comics: 'Not if the prose is independent of the pictures. Not if the written story could exist without any pictures and still be a continuous whole . . . If the pictures, independent of the words, are telling the whole story and the words are supplementing that, then that is comics.'[57] This represents a transformation of McCloud's previous definition. No longer are comics simply spatially juxtaposed images, but now the images must tell the whole story independent of the words, which supplement the pictorial narrative. McCloud's re-emphasis on the pictorial element of comics, and his desire to make an implicit exclusion of illustrated prose from comics, are typical of many definitional gambits that seek to distance comics specifically from children's literature, and the revision of his definition brings him closer to the position occupied by Kunzle. The impetus for this desire may stem from the historical reality that, as Groensteen suggests, comics have long suffered because of

their association with children's literature. Certainly McCloud's revised definition muddies the waters more than it clarifies. His forthright declaration in the interview with Harvey that Maurice Sendak's '*In The Night Kitchen* is a comic. Raymond Briggs' *The Snowman* is a comic' underlines the limitations of the formalist definitional strategy.[58]

Of course, the definition of children's literature is no less fraught than the definition of comics, and it is similarly caught up in the process of border patrolling. Zena Sutherland and May Hill Arbuthnot, in their widely used textbook *Children and Books,* note the difficulty of defining the key terms in the debate about children's literature, notably the very term 'child.' The authors argue that 'there are no rigid or absolute definitions [of children's literature] and there are differences of opinion among the experts.'[59] For their own part, the authors hold to the position that children's literature consists of books that are read by children, that have been written for children, and that meet 'high literary and artistic standards.'[60] The second clause in this definition is used by the authors to exclude writing not specifically targeted to children but which they might read, such as newspapers, text on television screens, ads on cereal boxes, and so on. The final clause, more importantly, is used to exclude undesirable texts. 'Does children's literature consist, then, of books that children read of their own volition?' the authors ask. 'Not comic books,' comes the answer.[61] For Sutherland and Arbuthnot, comics are categorically excluded from children's literature, just as, for McCloud and others, most children's literature is excluded from comics. While they might struggle over the question of who gets to keep Sendak's Caldecott-winning *In the Night Kitchen,* both sides agree that some kind of fence needs to be erected between the two neighbours.

Essentialist definitions of picture books, a particular subset of children's literature, throw the distinction between these forms even further into disarray. In 1976, Barbara Bader defined them thus: 'A picture book is text, illustrations, total design; an item of manufacture and a commercial product; a social, cultural, historical document; and foremost an experience for a child. As an art form it hinges on the interdependence of pictures and words, on the simultaneous display of two facing pages, and on the drama of turning the page.'[62] Bader's definition, obviously, recalls many of the definitions of comics that have already been discussed. Her insistence on the interdependence of text and images recalls the position taken by Harvey. The requirement of the manufacture of a commercial product recalls Kunzle's insistence that comics take a printed form as a mass medium. And her focus on the simultaneous

display of two facing pages is reminiscent, obviously, of Eisner and Mc-Cloud's attention to juxtaposed sequential images. Indeed, following Bader it is difficult to imagine how most objects currently understood as comics could not now be seen as a subset of picture books, other than her requirement on the 'experience for a child.' It is clear that the ambiguity of this definition serves to erode any clear-cut division between comics and picture books, and that the firmest distinction stems from the focus on the reader rather than the formal specificity of the text itself. Indeed, the criteria for the Randolph Caldecott Medal, presented annually by the Association for Library Service to Children for the most distinguished American picture book for children, specifically addresses the issue of audience in the development of their definition of the field of nominees: 'A "picture book for children" as distinguished from other books with illustrations, is one that essentially provides the child with a visual experience. A picture book has a collective unity of story-line, theme, or concept, developed through the series of pictures of which the book is comprised.'[63] Ultimately, of course, these definitions are circular, and qualifications such as 'essentially provides' are left deliberately vague in the interests of recognizing and celebrating the widest variety of innovative work in the field. Yet all of these definitions highlight the very real confusion that exists on the border of the picture book and the comic book, an uncertainty that is perhaps only resolvable through reference to presumed readers, the constituent members of the overlapping art worlds in this example. To further complicate matters, children also read comics, and there is an incredibly extensive custom of children's comics in almost every national comics tradition.

A similar confusion enters into the functionalist definition when comics are placed alongside another similar form which has been embraced by the art world, that of artist's books. As I have argued elsewhere, the boundary policing that exists between artist's books and comics books is one of the chief ways in which comic book artists have been erased from the traditions of art history.[64] In many ways, normative definitions of the artist's books are no more convincing than are those of comics. Dick Higgins has suggested, vaguely, that an artist's book is 'a book done for its own sake and not for the information it contains. That is: it doesn't contain a lot of works, like a book of poems. It *is* a work.'[65] Richard Kostelanetz offers: 'There is a crucial difference between presenting an artist's work in book form – a retrospective collection of reproductions – and an artist making a book . . . "Book art" should be saved for books that

are works of art, as well as books.'[66] Stephen Bury has proposed 'artists' books are books or book-like objects, over the final appearance of which an artist has had a high degree of control; where the book is intended as a work of art in itself.'[67] And Lucy Lippard, writing in *Art in America*, defined the artists' book as 'a work of art on its own, conceived specifically for the book form and often published by the artist him/herself. It can be visual, verbal, or visual/verbal . . . Usually inexpensive in price, modest in format and ambitious in scope, the artists' book is also a fragile vehicle for a weighty load of hopes and ideals.'[68] That Lippard could easily be defining comics with these phrases demonstrates the high degree of overlap that exists between the two categories. Nonetheless, the relationship between the two forms has often been fraught.

Because formal definitions of artists' books are, like definitions of comics, generally too vague or too specific, there seem to be more ways to define what an artists' book is not than what it is. Thus, when Bury enumerates genres of artist's books – children's books, diaries, encyclopedias, dictionaries, account books, bank books, ledgers, cheque books, stamp albums, programmed text, wallpaper, carpet or paint sampler – comics are notable in their absence.[69] For many scholars of the artist's book, it appears that comics remain largely outside the realm of consideration. Clive Phillpot, the one-time librarian to the Museum of Modern Art in New York, is one of the most persuasive voices in this debate. While Phillpot offered a number of shifting definitions of artist's books in various venues over the years one comment from his book *Artist/Author* is particularly relevant to this discussion: 'The status of comic books in the world of artist's books is awkward, because comic books are arguably the most successful verbi-visual book form with which artists of one sort or another are associated, and yet they have a quite separate existence. The comic books that have achieved a presence in the art world, such as Art Spiegelman's *Maus,* do not stand out as prominently in the world of comic books.'[70] Needless to say, and as Philpott's own example of *Maus* betrays, his contention that artist's books and comics have a clear-cut and readily understood separate existence is highly problematic on formal grounds, explicable only from a bias of cultural value in which some comics producers are denied as artists while authors such as Spiegelman are denied as specifically *comics* artists.

This troubling bias on the part of art critics is also apparent in Shelley Rice's contention that 'a number of artists – like Lynda Barry, Karen Fredericks, Gary Panter, and Mark Beyer – have, by the way, adopted the

comic book mode wholesale and use that popular form as a platform for their own ruminations about modern life,'[71] or Drucker's observation that 'the skills of many artists who have engaged with comics as a commercial, personal, or underground form in the 20th century have provided a rich legacy from which book artists may draw.'[72] In both of these instances a distinction between *artists who use comics* and *comics artists* is implied, and the boundaries between the two forms are reified, even when the same person may potentially inhabit both positions. While Drucker is more open than many critics to the possibility that comics artists might also be producers of artist's books, citing the likes of Eric Drooker, Lynd Ward, and Franz Masereel, for example, her focus remains largely on the appropriation of the traditions of the comics form by artists who exist largely outside the field.[73] Thus, in her discussion of Lawrence Weiner and Matt Mullican's 1991 book *In the Crack of the Dawn*, published by Mai 36 Galerie and Yves Gevaert and limited to an edition of one hundred copies, she suggests that 'part of its success' derives from the way it almost 'passes' as a comic book, clearly implying that while the book produced by these artists is not a comic, it merely has all of the formal attributes of one.[74]

One reason why *In the Crack of the Dawn* is not generally considered to be a comic book, despite its structural similarities, is that it circulated exclusively in the world of artist's books and not in the networks that constitute the comics world. Becker notes that fully developed art worlds provide structuring distribution systems to bring artworks to publics that will appreciate them.[75] In the fields of artist's books and comic books, these distribution systems are quite different. Artist's books circulate through a gallery network, and at a small number of specialist stores like Printed Matter in New York or BookArtBookShop in London. Comic books, on the other hand, have, since the 1970s, circulated primarily in a network of specialty stores known as the 'direct market,' which is serviced by distributors specializing in comics. While that network particularly emphasizes a culture industries framework that favours large commercial publishers, it does not necessitate this model, as is demonstrated by the openness, at least in some comics retail spaces, to handmade or small-scale productions such as mini-comics. Furthermore, there has been a high degree of overlap between the development of the direct market system in North America and the increasing cultural legitimation of comics. There is no question that comic book stores have frequently been stigmatized as scarily inbred homosocial worlds catering to

collectors at the expense of the art form (think, for instance, of the An-droid's Dungeon & Baseball Card Shop run by the obese and obnoxious 'Comic Book Guy' on *The Simpsons*). Yet, it was the development of this network that facilitated works that pushed the boundaries of the form in new directions and opened up the field to new avenues of production that would have been financially risky or even impossible in the news-stand distribution model. Becker emphasizes the way in which new busi-ness and distribution arrangements facilitate growth and change in art worlds, and it seems safe to say that the comics world, despite its deep his-torical roots and well-established consumer base, only really begins the movement towards cultural legitimacy once this particular distribution network is formed. In the period in which comics shared a newsstand distribution network with newspapers and magazines, both of which were larger cultural industries that predated the arrival of comics as a print genre, or, in the case of newspapers, actually incorporated comics as a subsidiary element, comics were widely regarded as something of a poor cousin to better-established print media. With the creation of a large network of comics specialty stores in the 1970s, it became easier to conceptualize comics not as a genre within mass print culture, but as a distinct art form.

Of course, to return to where we began, it has been the specific con-tours of the elements of that form that have so vexed theorists of comics in the search for a degree of definitional specificity. By conceptualizing comics as the products of a particular social world, rather than as a set of formal strategies, it is possible to highlight the various conventions that are frequently used by comics artists. While most theorists of comics have come to identify certain traits (sequential images, word/text rela-tions, continuing characters, reproducibility, word balloons, and so on) as essential to the comics form, given the difficulties presented by border cases, of which children's illustrated picture books and artist's books are but two, it seems much more productive to say that these traits are merely conventions of the comics form, rather than the defining elements of it. In other words, these conventions of the comics form are merely the pro-cesses that have historically allowed artists to get work done easily and which imposed a significant degree of constraint on the work and on the possibilities that artists could envision for the form. Over time these conventions have been reified by comics theorists as the absolute pre-conditions of the form.[76] By following the lead of Becker, Danto, Dickie, Bourdieu, and other sociologists of the arts who have contributed to our

understanding of art worlds or fields, it is possible to recognize that the failure of comics scholarship has not been its incapacity to establish a functional definition of the comics form, but its inability to conceptual-ize comics as a distinct art world. Following in the tradition established by these critics, the historical underachievement of comics is not caused by formal shortcomings, but is rooted in the differential power relations of art worlds competing for cultural resources and prestige. Significantly, shifting our attention towards the comics world, and away from the com-ics form, offers the possibility of revolutionizing our understanding of comics and how they have been ignored and marginalized by cultural gatekeepers.

Conclusion

One reason why comics have not been widely studied as a form of visual culture is that the most critically successful works in the field are most often valued as literature. For many critics and scholars, comics, despite their pictorial content, are fundamentally akin to narrative literary texts. Thus, Will Eisner has remarked that 'comics continue to grow as a valid form of reading,' and Charles Hatfield, whose book title, *Alternative Com-ics: An Emerging Literature,* signals his critical disposition, suggests that the core of his book 'is an interest in comics as a narrative form, in the broadest sense: fiction, recollection, reportage, exposition . . . I continue to be drawn to comics that tell stories.'[77] While both of these writers deal extensively with the visual element of comics in their respective works, it is noteworthy how easily each slips into the discourse of literariness while discussing an art form whose normative formal definitions, including, of course, that of Eisner himself, so frequently stress non-literary attributes. While narrative medium and literary medium are in no way synonymous, the two terms have coalesced over the years within the field of comics studies. Thus, critics like Maurice Horn are quick to constrain comics with literary terms: 'Functionally, the comics would seem to belong to some literary discipline, as they are chiefly meant to be *read* . . . Narra-tion, however defined, remains the essence of the comics: their purpose is to tell a story.'[78] The slippage in Horn's argument between narration and the literary has been central to the development of comics scholar-ship over the past two decades, particularly in the United States, a trend that was particularly accelerated, as noted earlier and again in chapter 5, since the publication of Art Spiegelman's *Maus* opened up comics as a serious arena for scholarly work in departments of English literature.

Many comics scholars, including several cited in this chapter, emphasize the interconnectedness of word and image in comics even insofar as they may individually depart from essentialist definitions that stress this particular aspect of the comics form, and even if their work may privilege the textual aspect of the work as a whole. R.C. Harvey's admonition is typical of the tendency of comics scholars to draw attention to the way both text and image are implicated in the construction of comics narratives:

> The emerging critical canon is . . . laced with discussions of plot, character development, theme, and all the rest of the apparatus of literary criticism. But this approach ignores the narrative function of the pictures in comics. In the best examples of the art of the comics, the pictures do not merely depict characters and events in a story: the pictures also add meaning – significance – to a story. The pictures are thus as much a part of the story as the plot line. No serious consideration of the art of the comics can overlook the narrative functions of pictures.[79]

Nonetheless, despite Harvey's admonition, there is a strong tendency not merely to overlook the functions of images in comics, but to ignore them altogether.

Much of the discussion about comics as literature is an inversion of earlier discourses about comics during the height of the anti–mass culture crusade of the mid-twentieth century. At that time, comics were widely regarded, as Fredric Wertham argued at the time, as 'death on reading.'[80] For Wertham, comics were both anti-literary and anti-educational ('reading is the greatest educational force that mankind has ever devised. Comics, on the other hand, are the greatest anti-educational influence that man's greed has ever concocted'), a mass cultural form that he regarded as dangerous not simply for its low content, but for its very structure.[81] In Wertham's eyes the word balloons, championed by critics like Waugh, Blackbeard, and Inge, and the sequential images, favoured by virtually every defender of a normative definition of comics, were themselves to blame for the sins of the form and for the interference with the development of 'proper' reading habits.[82] If the attack on comics marshalled by Wertham and others emphasized comics' poor relation to literature, as a significant strain of writing on comics in library journals did, then it seems perhaps natural that latter-day proponents of the form should seek to redeem it through reference to its literary potential. At the same time, however, there remains a

significant subset of comics critics who reject this aspirational discourse, preferring rather to revel in the charges levelled by Wertham and adopting the disdain of mainstream society as a badge of honour.

Art Spiegelman's suggestion that comics fly below the critical radar is particularly persuasive for a strand of criticism that seeks to connect comics not to fine art but to a subcultural do-it-yourself sensibility that was perhaps best characterized by the American underground comics movement of the 1960s. Les Daniels, writing under the influence of the underground movement, dated the origins of the comics, like Blackbeard, to the Yellow Kid, but suggested that the success of the feature, and, by extension, comics, could be located in its vulgarity: 'It radiated from his lurid garment and from his big-eared, bald, and beady-eyed countenance. He existed in a world that was crude, noisy, sordid and eccentric and he commented disdainfully upon it.'[83] Rob Rodi, writing twenty years later, described a comics art world that recalled the terms used by Daniels to detail Hogan's Alley. Rodi noted that in the mass cultural arena of comics 'the comics which have been most successful in the marketplace are, almost without exception, those that are least likely to impress a sophisticated reader.'[84] Roger Sabin echoed this sentiment when he suggested 'the most successful comics commercially have been those least likely to appeal to a "sophisticated" palette.'[85] Each of these critics goes on to question whether the failings of comics, their inability to attain the consecrated status of Art, is the fault of the form and its practitioners or of the external evaluators who have failed to recognize their importance, beauty, and vitality. The title of Rodi's essay, 'Why Comics Are Art, and Why You Never Thought So Before,' reveals his answer. He suggests comics are an art form because they are 'subversive,' and because, existing outside of the mass culture, with its tyranny of profit and loss statements, and also outside of the critical acclaim of the high arts, with the fatuity and self-importance that inevitably follow, comics are 'on the edge of artistic endeavor, with nothing to prove and nothing to lose. You might even call them dangerous in the way that true artists are always dangerous.'[86]

The idea that comics are inherently subversive is, of course, simply another in a long line of essentialist definitions of the form. Nonetheless, this particular essentialism is interesting insofar as it focuses attention on the social, rather than merely formal, relations that structure the way in which comics are understood. Maurice Horn has distilled this conception of comics to its purest form: 'It would seem that the less educated enjoy comics for their uncomplicated immediacy, while

the sophisticates have increasingly adopted the medium (first in Europe and now in the United States) for its anti-cultural qualities. If the medium is the message, then the message of comics, with their flouting of the rules of traditional art and of civilized language, can only be subversion.'[87] Horn's emphasis on audience expectations, the circulation of texts, and the formal and cultural requirements of differing artistic fields underlines one key way in which comics have been socially constructed as non-art. While Horn, Rodi, Sabin, Daniels, and others may be correct to highlight how comics have functioned as a deliberate anti-art, adopting, as Hatfield argues, a highbrow attitude while working in a lowbrow form, it is important to bear in mind that even this phenomenon is both relatively new and geographically constrained.[88] The subversion hypothesis, while compelling on the surface, nonetheless has a number of significant reservations, not the least of which would be that it is not always true that the best-selling comics have been those that would least impress sophisticated readers. The examples of Art Spiegelman's *Maus,* Hergé's *Tintin,* and the work of Osamu Tezuka in Japan, to take three very different examples of comic book best-sellers, are indicative of how comics can attain a relatively modest degree of artistic legitimation even within the confines of mass production and popular acclaim. Indeed, the social relations hinted at by Horn are far more complicated than what Rodi and Sabin have suggested in passing, and merit much fuller consideration.

The idea that comics are subversive of high-art norms seems to be little more than a defence mechanism. Condemned for much of their history by proponents of legitimated cultures, participants in the comics world have themselves adopted a rhetoric that purports to make a virtue of their marginalized social position. Nonetheless, at the present moment it is possible to see that a new logic is increasingly at play, namely the possibility that the comics world will be able to overcome the historical biases against comics and legitimate them as art. Increasingly, the question of value, in the sociological sense, has come to supersede the arid arguments over definition. Supplanting the hermetic debates over the minutiae of form that proceed from the misplaced assumption that any art form can be so neatly and finally categorized so as to eliminate exceptions is a new historicism emphasizing the social place of comics within the hierarchy of the arts. The dogged refusal of theorists from Colton Waugh to Scott McCloud to consider comics as an art harmed the reputation of the form as a whole. At present, any attempt to further the discussion of the conventions of comics in the absence of a larger

conceptualization of the art world would be fruitless. What is necessary for both comics and the art world today is a comprehensive accounting of the cultural assumptions and biases that have historically rendered comics a non-art. This process will begin by addressing the highly ambiguous way in which comics were institutionalized in the world of easel painting by the pop artists of the 1960s.

Robert Kanigher (?) and Irv Novick, 'The Star Jockey,' from
All-American Men of War 89 (January–February 1962).

Roy Lichtenstein's Tears: *Ressentiment* and Exclusion in the World of Pop Art

When we think of romance comics today, we think of Roy Lichtenstein and his mannered close-ups of tears dripping down a cheek. No comics publisher would have hired Lichtenstein – he wasn't good enough.

<div align="right">Everett Raymond Kinstler[1]</div>

The comics world's suspicion of the fine arts is nothing new. Indeed, as was demonstrated in the previous chapter, the modernist distinction between comics and the fine arts has historically structured the way we understand the two forms, and almost always to the detriment of comics. Given this historical trajectory, a certain amount of resentment is perhaps inevitable. Friedrich Nietzsche introduced the idea of *ressentiment* in *The Genealogy of Morals* (1887) in his account of the historical emergence of what he terms 'slave morality.' The term refers to what he diagnosed as a tendency to attribute one's personal failures to external forces. Nietzsche suggests that, among subordinated peoples, the ego creates the illusion of an enemy that can be blamed for one's inferiority, the rationalization that one has been thwarted by 'evil' forces, and the eventual creation of an 'imaginary vengeance.'[2] The analogy of contemporary cartoonists to the Jews under the Roman Empire, the inspiration for Nietzsche's commentary, is obviously far from perfect. Nonetheless, the notion that internalized bitterness defines how the comics world sees the larger art world is highly suggestive. Nietzsche argues that the creation of a slave morality necessitates a sphere 'different from and hostile to its own,'[3] and the conception of art and comics as mutually exclusive domains has been a commonplace that is only in recent years beginning to be deconstructed. To this end, it is common to find cartoonists who

perceive their chosen field as marginal and who have, as a result, apparently internalized the feelings of resentment and envy that Nietzsche describes. At present, it is common for these feelings to play themselves out as an absolute rejection of the art world by those working in the comics form.

Key to the Nietzschean conception of slave ethics is the differential power relation between subjects that are expressed as contempt and *ressentiment*. In a passage that seemingly anticipates the relationship of fine arts and comics as it has manifested over the course of the twentieth century, Nietzsche warns that 'we should remember that the emotion of contempt, of looking down, provided that it falsifies at all, is as nothing compared with the falsification which suppressed hatred, impotent vindictiveness, effects upon its opponent, though only in effigy.'[4] When, for example, Clive Phillpot offhandedly dismisses the possibility that works of comics might be classified as artist's books, the division between forms is presented as a self-evident commonplace barely requiring elaboration or argumentation. By contrast, the pent-up aggressive feelings towards the world of fine arts that characterizes many cartoonist's *ressentiment* can become an all-consuming passion that threatens to poison their work with an easily diagnosed bitterness.

The prevalence of an anti–fine art disposition is so common within the field of contemporary 'alternative' comics creators that it seems symptomatic of much larger issues. Peter Bagge stridently vocalized this position in a four-page strip published in the August/September 2004 issue of the libertarian magazine *Reason*. The doubled scare quotes in the title ' "Real" "Art" ' is highly suggestive of the piece's tone, in which Bagge reports on a trip to Seattle's Henry Art Gallery, a 'typically confusing concrete lump, housing equally incoherent art work.' Bagge, who identifies himself in the piece as an art school dropout and a practitioner of the 'least respected art form of all (comic books),' describes his feelings towards the art world as 'a mix of bemusement, resentment and contempt.'[5] Striking a tone of conservative populism in arguing against government funding for the arts, he decries the art world as a 'racket' in which any work that the 'average schmuck' can comprehend is decried by the art establishment, and diagnoses within that field a complete distaste for traditions of illustratorly craft: 'The fine art world claims that they value ideas, yet they tend to consider traditional craftsmanship to be antithetical to communicating "new ideas." To them, an artist who can skillfully paint representational images isn't really a "painter" at all, but a mere "illustrator." '[6]

Comics artist Dan Clowes strikes a similar stance in his four-page comic 'Art School Confidential,' which was originally published in the seventh issue of his comics magazine *Eightball* (1991) and then later loosely adapted by Clowes and director Terry Zwigoff into the film of the same name. Clowes contrasts the contemporary art school in which 'anyone with a trust fund can excel in classes that are little more than vague pep talks designed to keep enrollment up by tricking students into believing they have "potential"' and those of the 'old days' when art schools taught 'practical techniques to the eager dedicated few who possessed the temperament to keep up with a demanding curriculum.'[7] The bulk of Clowes's strip consists of a compendium of art school 'types' (the technological wizard, the hopeless case, Joe Pro, Mom, Mr Phantasy, the Macho Art-Sadist, etc.), to each of whom is attributed a specific set of cultural and aesthetic shortcomings. At the conclusion of the piece, Clowes highlights the general opposition that he perceives between art schools and comics artists with a sage piece of advice: 'One final word of caution: Never mention cartooning in art school because it is mindless and contemptible and completely unsuitable as a career goal.'[8]

The cinematic adaptation of Clowes's short story mines similar, yet slightly different, terrain while situating the critique of the fine arts within the framework of a very conventional Hollywood murder mystery. Importantly, Jerome, the lead character of the film, is not a comics artist, and the subject of comics is never broached by the film. Jerome, who aspires to be the next Picasso, is an art student with a keen interest in craft. He produces painstakingly detailed realist portraits in his life drawing classes, and is constantly dismayed by the attention that is paid to the less technically proficient work of his classmates. When Jonah, the undercover policeman, receives accolades for his naive and artless painting of a sports car ('It has the singularity of outsider art, though the conscious rejection of spatial dynamics could only come from an intimacy with the conventions of picture-making'), Jerome is enraged.[9] When his subsequent efforts to paint in Jonah's style are dismissed ('Jonah's seems totally original and authentic and Jerome's seems just lame'), he spirals increasingly out of his own artistic voice and turns to Jimmy, the washed-up alcoholic, for advice and, ultimately, paintings.[10] In the ironic logic of the film, it is Jerome's decision to steal the work of Jimmy that brings him fame and infamy. Not just a failed painter, Jimmy is also a serial killer who incorporates evidence of his crimes into his work. By appropriating these paintings, Jerome implicates himself as the killer and is imprisoned. Yet, of course, his (false) association with the murders makes him

a hot artist, a young man who is sought for interviews in *Artforum* and for whom the waiting list for new paintings has been cut off. Jerome's fame derives from the skill and notoriety of another man, whose work (and crime) he has appropriated as his own. This ironic ending, in which the killer gets the girl of his dreams, is difficult not to read, at least in part, as a commentary on processes of hierarchization within the art world. While *Art School Confidential* works through numerous layers of irony, including the fact that Jonah's outsider paintings were themselves created by Clowes, it suggests that the road to art world success is through coldly calculated malice and outright thievery.

One thread that the film touches upon without fully developing is the relationship between Audrey, the object of Jerome's desire, and her father, a famous painter. Donald Baumgarten is described by Jerome as 'an old pop art guy' and by his daughter as someone who 'should have given up thirty years ago.'[11] The discussion of pop art, which is not pursued by the film apart from this fleeting mention, is seemingly central to the resentment issues raised in the work of artists like Bagge and Clowes, particularly insofar as pop art's Jerome-like theft of comics-derived imagery is regarded by many comics artists and fans as having contributed to the murder of cartooning by painting. Pop art, with its tight relationship with comics and other aspects of consumer culture, is the seemingly perfect 'evil' in the mind's eye of resentful cartoonists. While most cartoonists of the first half of the twentieth century did not, as will be seen in the next chapter, generally regard themselves as working in a fine arts tradition and, consequently, did not exhibit the same levels of resentment as their more contemporary followers, for the generation of cartoonists who came of age in the wake of pop's dismantling of the high-low barriers in the art world the *ressentiment* is often palpable. As R. Kevin Hill has recently argued, contra Nietzsche, it is not social subordination itself that generates *ressentiment*. Hill suggests that Nietzsche overlooks the important role of expectations in the creation of *ressentiment*, particularly the failure of the world to meet expectations. Low expectations and stable situations, as might be ascribed to comic book artists working within the highly commercialized 'shops' of the postwar era, are coping mechanisms for the socially subordinate. Yet, for an increasingly middle-class population of artists, whose expectations are more expansive and mutable, *ressentiment* is a pressing reality. Aside from whatever else it accomplished, by highlighting the link between taste and symbolic power pop art has helped to open up the reading of popular culture by those who had the cultural capital to do so.[12] Now, in the wake of this

opportunity, it is common to encounter cartoonists who are resentful of the fact that the opportunities suggested by pop art have not been quickly or fully realized in the field of comics itself.

'Selectively disinterring and preserving recently discarded and eminently perishable phenomena': Comics Meet Pop Art

Elizabeth C. Baker's description of Roy Lichtenstein's creative process, quoted as this section header, is an example of the sort of dismissive statements that many in the comics community find so galling.[13] The suggestion that comics are discarded or eminently perishable denies the possibility that comics might themselves be a unique art form and relegates the creative work of cartoonists to the dustbin. Indeed, attitudes like Baker's have been so common within the world of legitimated art that pop art has become the primary locus of the *ressentiment* for cartoonists. Thus, in an untitled strip published on the back of the Uninked catalogue (2007), which he edited, Chris Ware depicts his disdain for the art world generally by focusing on pop art specifically. Ware's strip details a day in the life of a cartoonist responsible for the lowbrow gag newspaper strip 'Wingnutz.' Troubled by an aching back, concerned about the possibility that he is repeating himself in his work, the cartoonist wistfully muses that he 'should've studied to become a real artist.' Rushing to Dabbler's Art Supplies, he purchases hundreds of dollars worth of paint and an easel. On his way home he stops at the local art museum, 'a repository of the most tender ebbs and flows of man's soul,' for inspiration. Here he loses his faith in his ability to live up to the demands of his new direction when he is faced with the achievements of past masters. His eye is caught by a work near the exit of the contemporary wing: an enormous blow-up of one of his own panels, painted in bold primary colours. The explanatory text tells him: 'By recontextualizing the familiar title panel from the popular comic strip "Wingnuts" the artist frees the pictorial space from the tyranny of the viewed, while reasserting the hand of the artist by allowing the drips and mark-making process to challenge the strip's slick, commercial style.' Managing only a feeble 'B-but . . .' in response to this piece, the artist returns to his home and to his work on the comic strip with the pathetic rationalization: 'Oh well . . . At least it said nice things about my drawing style.'[14] Ware, a contemporary of Clowes and Bagge, all of whom have been published by Fantagraphics, the largest alternative comic book publisher in the United States, offers an exploration of the psychology of the appropriated comic book artist

that is filled with self-loathing, sharp parody, and bitter irony. It manages, in a single page, to succinctly convey the fraught relationship that exists between comics and pop art that has long used comics as a source of inspiration.

The relationship of comics and pop art has been much discussed, but it remains particularly troublesome for many who approach the relationship primarily from an interest in comics and cartooning. Nor is the issue particularly limited to artists of the 1990s alternative comics generation represented by Ware, Bagge, and Clowes. Consider, for example, this anecdote related by journeyman cartoonist Irv Novick, who worked in advertising and extensively for DC Comics beginning in the 1950s, as told by Steve Duin and Mike Richardson in their book *Comics between the Panels:*

> He had one curious encounter at camp. He dropped by the chief of staff's quarters one night and found a young soldier sitting on a bunk, crying like a baby. 'He said he was an artist,' Novick remembered, 'and he had to do menial work, like cleaning up the officers' quarters.
>
> 'It turned out to be Roy Lichtenstein. The work he showed me was rather poor and academic.' Feeling sorry for the kid, Novick got on the horn and got him a better job. 'Later on, one of the first things he started copying was my work. He didn't come into his own, doing things that were worthwhile, until he started doing things that were less academic than that. He was just making large copies of the cartoons I had drawn and painting them.'[15]

Novick's recollections of a wartime meeting with Roy Lichtenstein intersect with common assumptions about the cultural value of pop art in a number of fascinating ways. Lichtenstein, of course, is an artist who is best known for his ironic reworkings of panels taken from American comic books. Two particular comic book genres were emphasized by Lichtenstein – the war comic, with its scenes of battle that he presumably missed while doing menial work, and the romance comic, with its crying heroines, that is subtly recalled above. Novick evokes both of these genres in his anecdote. As an artist who himself specialized in war comics at DC Comics in the 1950s, Novick suggests that Lichtenstein's wartime experiences served as a psychological test for the artist. Furthermore, it is one that the artist seems to have failed according to the dominant criteria of masculinity. One further intersection bears mention, however, and helps to further elucidate the importance of Novick's intentions with regard to this unusual anecdote. When he began painting in a pop art style, Lichtenstein did indeed appropriate some of the images that

Novick had created for DC in his paintings, including *Whaam!* (1963) and *Okay, Hot-Shot* (1963). Novick's story seems to be an attempt to personally diminish an artist whose own career had eclipsed his own just as it drew upon his own. While Lichtenstein the painter trumps Novick the cartoonist, it was Novick who was the real man on the battlefield, according to the cartoonist's account. Novick's depiction of Lichtenstein as crying like a baby can be read further as a feminization of the realm of pop art vis à vis the world of comics. In characterizing Lichtenstein as someone who just couldn't cut it in war – and by extension in art – Novick acknowledges the fraught relationship between comic books and pop art, while attempting to gender the distinction in order to reverse the traditional valuation of the two realms.

Of course, the relationship between comics and pop art is even more complicated than it appears at first glance. As early as 1966 some critics suggested that comic books were a legitimate 'pop phenomenon' deserving respect, but this view remained a minority opinion.[16] Even as source material for high art painting practices, most critics were suspicious of comic books; as a distinct form they were most often dismissed outright. Harold Rosenberg summed up the distinction between pop and comics when he suggested that the difference between a comic strip of Mickey Mouse and a Lichtenstein painting of the same was art history, or that Lichtenstein paints with the idea of the museum in mind.[17] In a similar vein, Michael Lobel suggested that Lichtenstein's work could be understood through the functioning of two codes: the semiotic and the aesthetic. The former is a conventionalized set of rules, while the latter is the product of a unique, creating subject.[18] This type of distinction denied outright the possibility that the codified work of Irv Novick might also be the work of a creating subject, and seemingly banished comics forever from the realm of art. As the Novick anecdote cited above so ably demonstrates, this distaste is fundamentally rooted in submerged, gendered fears about the relationship of high and popular forms of culture. It is a debate that has raged in comics circles since the 1960s, with Lichtenstein as a crucial touchstone for criticism and complaint. Thus, even as the comics world has developed its own canons of key works over the past half-century, its marginal position in the hierarchies of American visual culture continues to rankle even those artists who, like Chris Ware, have been the subject of major museum shows independent of reference to pop artists like Lichtenstein.

The subject of Lichtenstein's relationship to comic books came to a head in the comics industry press in 1990 when Christie's auctioned the

painting *Torpedo . . . Los!* for $5.5 million. Why, comic book fans wondered, was that painting based on a single panel from a comic book valued so highly, when the entire fifty-two-page comic from which it was originally taken cost only a dime? In the introduction to the 1991 Misfit Lit show at Seattle's Center for Contemporary Art (which notably included the work of both Clowes and Bagge), Kim Thompson, the vice-president of Fantagraphics Books, again raised the question of Lichtenstein's role in the comics world. He challenged the notion that comic books are simply 'semi-anonymous art fodder' when he wrote:

> As bracing and exciting as Pop Art's celebration of the flatness, boldness and ubiquity of contemporary images was, one of its unfortunate side ef-fects has been to relegate comics art to the same cultural compost heap as urinals, bricks, and Campbell's soup cans.[19]

Here Thompson enunciates one of the two primary charges that comic book fans lay against Lichtenstein: that his success diminished the pos-sibility that comics could be taken seriously as a legitimate art form in its own right. By reducing comic books to source material, Lichtenstein is accused of having made the legitimization of comic books – already a dif-ficult task – that much more challenging. Lichtenstein, therefore, is seen not as honouring comics with his paintings but as further devaluing the entire form by reaffirming the long-standing prejudice against cartoon-ists that has existed in the world of high art. This prejudice, Thompson points out, was exemplified by the Museum of Modern Art's High and Low show in that same year, whose first section concluded with Lich-tenstein's *As I Opened Fire* (1964). *High and Low* focused on how comics have influenced developments in the fine arts, but not vice versa, and permitted only three cartoonists (Winsor McCay, George Herriman, and Robert Crumb) to be presented as artists in their own right rather than as source material for other, 'real' artists. According to the logic of High and Low, the vast bulk of comics history can only inspire art as a sort of mutely passive muse; it is not art itself. It was because of this apparent snub that Fantagraphics sponsored the Misfit Lit show, with the com-pany's founder, Gary Groth, acting as curator. Stemming directly from this perceived lack of respect, and exemplified by the discussion of the sale of *Torpedo . . . Los!* comics fans have long charged that Lichtenstein, like *Art School Confidential*'s Jerome, is nothing more than a thief. That Lichtenstein made millions exploiting the work of comic book artists who were paid extremely low page rates for their semi-anonymous work

seems particularly galling for an entire generation of comic book artists. In his comic book parody of *The New Yorker*, Kyle Baker's 'Goings on about Town' lists a show at the Whitney Museum of American Art in this way:

'Roy Lichtenstein: The Rich Man's Vince Colletta.' Lichtenstein made a bold statement about how the comic book industry ripped off its talent. He did this by not paying the artists who created his source material either. Features images ripped off from Jack Abel, Vince Colletta, Frank Giacoia, Alex Toth and Don Heck.[20]

Baker's satiric emphasis on the issues of credit and recompense derive their humour from the shared assumption among comic book fans that what Lichtenstein accomplished with his art came at the expense of the reputation of comic book creators and the comics form. For many in comic book fandom, Lichtenstein served as a nagging reminder of the failure of comic books to be taken seriously in contemporary art practices.

The Obsolescence of Desirability: Critical Reactions to Pop Art

John A. Walker has argued that there exist three dispositions of fine art towards popular culture: negative, positive, and mixed.[21] Walker suggests that pop art exemplifies the mixed response, with some artists celebrating the source material and others exhibiting a more critical or analytical stance.[22] In the case of Lichtenstein, the artist has specifically and adamantly insisted on his admiration for the work that he appropriated: 'In . . . parody there is the implication of the perverse and I feel this in my own work even though I don't mean it to be that, because I don't dislike the work that I am parodying. The things that I have apparently parodied I actually admire.'[23] Nonetheless, the dominant perception among comic book fans has tended towards suspicion and resentment, with these readers focusing on the critical aspect of the work that is, in fact, perceived as parodic and, therefore, negative. A primary irritant for many comic book readers was the fact that critics who challenged the legitimacy of the pop art movement did so in part by condemning its roots in mass culture, further disdaining comics as not-art. When Roy Lichtenstein held his first one-man show at Leo Castelli's gallery in 1962, the country was not yet quite ready for what he had to say with his paintings. Arriving at a time when abstract expressionism remained a dominant

American aesthetic, Lichtenstein's canvases were widely condemned by established art critics. The basis for much of the criticism was the fact that in drawing on images derived from comic books, Lichtenstein's paintings failed to rise to the level of aesthetic seriousness. The core problem was the way pop art foregrounded consumerism – a feminized trait – through its choice of subject matter. Alan Solomon noted in 1963 that 'the new art stirs such polar responses because it seems to make an active frontal assault on all of our established esthetic conventions at every level of form and subject matter.'[24] Throughout the 1960s, the challenge to established conventions leveled by Lichtenstein drew criticism not only of the individual artists associated with the pop art movement, but also of their subject matter. By objecting to the use of comic book panels as inappropriate subject matter for high art, it became necessary by extension to outline the problem with comics more generally. Art critics were not shy on this front. Gene Baro praised Lichtenstein for rising through technique beyond the limitations of his subject matter, which he found 'both uncomplicated and commonplace'; Otto Hahn suggested that Lichtenstein chose clichés for the basis of his paintings, 'a simple image in which, in a standard space, standard elements illustrate standard sentiments'; and Lawrence Alloway argued 'it makes no difference whether Lichtenstein invented or copied particular comic-book images (he worked both ways), because a reference to the general style of the comics is legible.'[25] For the critics of pop art, comic books were uncomplicated, simple, standardized, and of no particular relevance to the general conception of the work. These observations clearly derived from a bias against popular cultural forms that would recognize no merit in commercialized culture produced beyond the parameters of the gallery system. Indeed, the taint of commercialism that comic books and pop art brought to the gallery was a problem for many critics. Writing on Andy Warhol, for example, Hilton Kramer suggested that pop art was a form of aesthetic consumerism that threatened to expose high culture as a gag.[26] The tension between pop art and its sources was perfectly obvious, if not outright insulting, to those involved in the world of comic books. It was clear that it was the comic book's contribution to the work that was regarded as the greatest threat to the sanctity of the high art world, and this flatly ruled out the possibility that comics themselves might someday be regarded as a significant aesthetic contribution to American culture.

The ability of pop art to find champions in the art establishment of the 1960s was dependent on its capacity to incorporate elements of popular culture in a way that was transformative and enlightening. For

Lichtenstein's detractors the displacement of originality through the incorporation of found imagery did not constitute a significant alteration. Peter Selz wrote: 'These works leave us thoroughly dissatisfied . . . most of them have nothing at all to say . . . They are hardly worth the kind of contemplation a real work of art demands.'[27] Douglas McClellan, writing in *Artforum* in 1963, took this line of attack further, arguing that Lichtenstein's canvases failed to transform already weak material:

> Lichtenstein has seemingly rearranged nothing, he has stayed reverently close to the originals except for greatly enlarging the scale. He has avoided the risks of transformation and he has picked a cripple for a target . . . In the funnies, the world of human happenings is comfortably simplified by flaccid drawing, the only dimension is conveyed by mechanical dots, and life is represented by triumphant balloons of platitudinous speech rising from the mouths of the characters. It is like shooting fish in a barrel to parody a thing that has so long parodied itself.[28]

McClellan's criticism of Lichtenstein rests on the dual understanding that his source material is awful and that he has failed to do anything interesting with that material. For critics who examined pop art more closely, it was clear that McClellan and Selz had failed to grasp the tone of the paintings, and that they had overlooked the ironic commentary on Americana that could be found in the transformations of the sources. As early as 1962 Max Kozloff drew attention to a number of significant elements that could be found in the works of the pop artists, including their concern with formal problems, their use of irony, and the investigation of creativity.[29] Kozloff, while critical of pop art generally, suggested that the pathway to validation for pop art would be found in its tendency to rework found images from American culture in an ironic or detached manner. This required the disavowal of comic books in paintings that were ostensibly about comic books, a development that helped to further solidify the marginal status of the form within the world of American arts and letters.

Writing in support of pop art, Allan Kaprow argued that it was the gallery system itself that framed the distinction between commercial and high art. 'The difference between commercial art and pop art is that pop wrenches its commercial model from its normal context, isolating for contemplation an object that originally was not contemplative.'[30] Nonetheless, this perspective on the transformative power of the gallery system was not universally shared. Art historians have been at pains to

demonstrate how Lichtenstein thoroughly reworked the material that he painted in order to justify it as serious art and something fit for the gallery. Albert Boime focuses his examination of Lichtenstein's reworking of the comic book panel on the artist's particular deployment of the word balloon as the central communicative device. Boime argued that in a painting such as *Torpedo . . . Los!* Lichtenstein exploited dialogue enclosed in the word balloon in the interests of compositional structure.[31] Michael Lobel offers a much fuller elaboration of the artist's techniques in his 2002 book about Lichtenstein. He provides a number of intriguing readings of Lichtenstein's work, particularly focusing on the significance of how the artist heightened or diminished key elements of his source material in order to achieve various effects. Lobel's reading of Lichtenstein's 1963 painting *Image Duplicator* shows how Lichtenstein combines elements of two distinct comic book panels in the creation of his painting of a masked super villain in extreme close-up. The painting's text, 'What? Why did you ask that? What do you know about my image duplicator?' is taken from an unidentified comic book panel. The image, particularly the mask, is derived from a Jack Kirby drawing that can be found in *X-Men* #1 (September 1963), although Lichtenstein has altered this somewhat by exposing more of the character's forehead and eyebrows, which are seemingly borrowed from the same image as the text.[32] Lichtenstein's painting, therefore, is not simply an enlargement of the scale of the image, as McClellan and many in the comics world would charge, but a full-scale reworking of two distinct images whose synthesis is an entirely new image. Writing in the catalogue of the High and Low show at the Museum of Modern Art, Kirk Varnedoe and Adam Gopnik go so far as to argue that in combining elements from three distinct comic book images in the creation of *Okay, Hot-Shot* (1963), Lichtenstein 'assembles them into a kind of super-cliché which looks more like a comic than the comics.'[33] In this way, art historians are able to suggest that the reality of Lichtenstein's paintings is that they are only marginally related to their comic book sources. Much more crucially, they are the product of the artist's own creative way of approaching the material, the result of new methods of looking that privilege the aesthetic individuality of the artist while continuing to marginalize the cultural value of comic book producers such as Jack Kirby and Irv Novick.

One result of this type of transformation has been the consecration of the paintings for an audience that is quite different from the audience for the source images. Initial hostile reactions to pop art tended to focus on the possibility that the works might attract the wrong element – that

is, comic book fans – to contemporary art galleries or museums. In 1962, Kozloff wrote that 'the truth is, the art galleries are being invaded by the pinheaded and contemptible style of gum chewers, bobby soxers, and worse, delinquents.'[34] For those involved in the comic book industry of the time this charge would necessarily recall the critique levelled eight years earlier by Dr Fredric Wertham, which was discussed in the previous chapter. Wertham's suggestion in *Seduction of the Innocent* that comic books were a contributing factor in juvenile delinquency, the ensuing debate about the effects of comic books on American youth, and the Hendrickson-Kefauver Senate Subcommittee investigations helped to cement the association of comic book–derived paintings with the pinheaded delinquents described by Kozloff. Criticism of pop art in the 1960s clearly echoed the charges leveled against comic books in the 1950s and served as a reminder that 'comic book readers' was a shorthand for an entire stratum of the American population that was unwelcome in polite society. What made these people so conspicuously undesirable was that they were the most obvious culprits in what Sidney Tillim termed 'the decadence and destitution . . . of modern art.'[35] Pop art, which paid close attention to the commercialized aspects of American mass society, constituted a threat to the established hierarchies of the arts, as well as to established social hierarchies. Indeed, the success of pop art raised the possibility that the traditional status reserved for the fine arts might be done away with altogether and replaced with a degraded sensibility more commonly related to mass culture. In short, the work of Roy Lichtenstein, and others in the pop art movement, held the potential to dissipate the distinction between high and low to the possible detriment of the high. Put another way, Lichtenstein's incorporation of comic book elements in his paintings threatened to feminize the realm of artistic production.

A Comic Book Crisis of Masculinity in the World of Camp

In his essay 'Mass Culture as Woman: Modernism's Other,' Andreas Huyssen suggests that gendered theories of mass culture equating the 'commercial' or 'popular' with the feminine and 'high culture' with the masculine have been largely abandoned.[36] Pop art's relationship to comic books would seem to indicate otherwise. The key distinction between pop art and its comic book sources is derived from the masculinizing force of transformation that the pop artist is seen to bring to the canvas. This argument can be seen in Lucy Lippard's contention that the

first wave of pop artists employed 'hard-edge, commercial techniques and colors' while working 'at one remove from actuality.'[37] Lippard's choice of the term 'hard-edge,' with its unmistakably masculinist overtones, reinforces the association of pop art with traditionally legitimated high art production while reserving the sense of distance imperative to the specific gendering process in which Lichtenstein's work was engaged. Michael Lobel observes, for instance, that Lichtenstein 'can be seen as the masculine counterpart to Warhol's feminized dandy; in the face of Warholian excess Lichtenstein provides the figure of the hard-working artist who dutifully returns to the quiet, painstaking work of the studio.'[38] Cécile Whiting offers a similar reading, suggesting that in particular the formalist reading of Lichtenstein's paintings remasculinized the artist:

> Lichtenstein's persona as the white-collar professional and affable father recalled the description of the typical middle-class man, of the potentially emasculated American male. Yet Lichtenstein's performance in the role of the cool and disciplined artist could also allay fears that his domestic responsibilities or profession effeminized him. The cerebral and detached artist could be seen to reinfuse the normative male with a cool, masculine veneer. Likewise, his paintings, defended in formalist terms that abandoned some of the precepts of Abstract Expressionism, could demonstrate the masculine control that the professional artist exerted over his medium.[39]

It was clear, therefore, that Lichtenstein's success stemmed, at least in part, from the association of his work with masculine – that is to say, legitimated – values while his source material was held up as an example of the feminized traits in American (mass) culture that the artist had successfully recovered and repatriated.

While Lichtenstein was masculinized as an artist during the 1960s, his paintings were further calling into question a number of assumptions about the role of gender in the arts. It is important to note the way in which Lichtenstein's images emphasize gender distinctions and polarize the opposition between masculinity and femininity. Most of the artist's output that is based on comic book images can be placed into two categories: images of war and images of the home. These images, which predominantly feature men in the former and women in the latter, correspond in obvious ways to traditional American gender norms. By amplifying stereotypes, Lichtenstein places gender at the heart of the relationship between high art and consumer culture. This exaggeration is

accomplished largely through the deployment of iconography. Lichten-
stein's image of masculinity is derived from war comic books, although
the artist focuses primarily on moments of triumph in which the soldier
confronts and defeats his enemy. However, in the stories from which Lich-
tenstein borrows, masculinity is considerably more in flux. The comic
books frequently evince moments of setback or psychological weakness
that are excised from the canvases. Thus, Lichtenstein considerably min-
imizes the complexity of comic book stories in order to make a point
about American culture more broadly.

The success that Lichtenstein's male figures enjoy finds its corollary
in the failures of the women. The women in Lichtenstein's paintings
are troubled by inner voices, represented by the thought and word bal-
loons, that tend to exclude the external social world. In this way, the
artist's works call attention to the artifice of gender roles by downplaying
the naturalist conventions that can be found in the comic books and
highlighting stylized gender practices. Thus Lichtenstein is able to incor-
porate sources from popular culture while asserting specialized knowl-
edge about them and their traditions. He draws attention to the gender
codes that comic books seek to naturalize through narrative structure
and realistic rendering. Arguing along these lines, Whiting suggests that
'the paintings thereby offer their viewers the opportunity to perceive
and to parody the conventions of representation and gender that the
readers of comic books ostensibly accept as natural.'[40] Here, once again,
the distinction between high art and popular culture is played out as the
inadequacy of the comic book form and the comic book audience, a dis-
tinction that is clearly gendered in such a way as to diminish the interests
of comic book producers and consumers.

For those interested in the comics form, this casual dismissal came as
no surprise. As was seen in chapter 2, comic books have long suffered
the slings and arrows of art critics who have dismissed them out of hand.
Recall, for example, that Clement Greenberg defined comic books – the
form *in toto* rather than individual examples – as kitsch. Those involved
with the comic book industry have rarely suffered from the illusion that
the form is well regarded among the high-culture cognoscenti. What is
perhaps more surprising, however, was how the taint of the comic books
seemingly threatened to corrupt pop art – the legitimated face of com-
mercial culture – as well. Greenberg, for instance, dismissed pop – or
what he termed Neo-Dada – on purely formal grounds, arguing 'what-
ever novel objects they represent or insert in their works, not one of
them has taken a chance with color or design that the Cubists or Abstract

Expressionists did not take before them.'[41] Two years later he suggested that pop was a 'new episode in the history of taste' but not 'an authentically new episode in the evolution in contemporary art.'[42] For Peter Selz, the problem with pop art coincided neatly with Greenberg's definition of kitsch as pre-digested art. Pop art, Selz argued, was too easy to assimilate, requiring neither sensibility nor intellectual effort to create or admire.[43] The problem with pop was that it depended on a form of kitsch – the comic book – as its source. While proponents of pop argued that the paintings served to elucidate the clichés found in the comic book form, opponents maintained that any contamination by kitsch elements in the paintings essentially rendered the new works kitsch as well. For those coming to the debate from the perspective of the comic book industry, there were few opportunities to defend the form. Whether or not pop art was deemed kitsch, in the context of the larger debate there was no doubting the fact that the comic books were irredeemable on their own merits.

For many in the comics world what was worse was the possibility that comic books would be revealed not simply as kitsch – as beyond the boundary of good taste – but as feminized kitsch, or camp. The spectre of camp haunted comic book creators and readers in the 1960s, particularly owing to the success of the *Batman* television show, which drew heavily on a camp aesthetic influenced by the quick success of pop art. Harvey Kurtzman and Will Elder, creators of the *Playboy*-published comic strip 'Little Annie Fanny,' drew attention to the camp perception of comic books in a story that found Annie and Benton Battbarton 'camp-ing' with his pop art cartoon blowups and his complete set of unexpurgated Green Lantern comics.[44] This strip drew its inspiration, of course, from the well-known Susan Sontag essay 'Notes on "Camp."' Sontag's argument that camp is a modern phenomenon that encompasses a love of the unnatural and an apolitical aestheticism that extends from kitsch, without coinciding with it, easily incorporated comic books and strips. Indeed, two of the examples that Sontag gives as the canon of camp are comics: Lynn Ward's novel in woodcuts, *God's Man,* and the old Flash Gordon comics.[45] Sontag's suggestion that camp is old-fashioned and out of date, something that the critics of comic books argued of that medium, was something that the fans of comic books had come to increasingly fear by the 1960s. Moreover, her suggestion that camp is a 'snob taste' shared by 'mainly homosexuals, who constitute themselves as aristocrats of taste,' easily aligned with Harold Rosenberg's contention, in a 1965 article, that the new art

establishment was composed of cliques, and that a significant 'feature of the past four or five years has been the banding together of homosexual painters and their nonpainting auxiliaries in music, writing and museum work.'[46] With charges such as these it is perhaps easy to see why apprehensive comic book artists like Kurtzman and Wood would ridicule camp in the pages of *Playboy*, shoring up the boundaries of normative masculinity in one of its most public venues. Sontag problematizes pop art's authority by associating it with this emasculated taste culture, but then seeks to recuperate it at the expense of comics. Pop art 'embodies an attitude that is related, but still very different. Pop art is more flat and more dry, more serious, more detached, ultimately nihilistic.'[47] That is to say that pop art is more masculinized than camp, which is a celebration of feminized cultural objects. With Sontag's intervention into the debate about pop art, comic books moved from a degraded kitsch position to a gay-associated camp position that the homosocial world of comic book producers and fans found utterly terrifying. As an extremely masculinist subculture, comic book fans and producers worked diligently to thwart suggestions of homosexuality wherever they arose, policing boundaries and chafing at what they deemed to be inappropriate suggestions. Pop art, therefore, was a threat because it absconded with the one element that comic book fans assumed would never be in question: the red-blooded American masculinity that informed war and romance comics alike with their rigid adherence to patriarchal gender norms.

In 1967 Allan Kaprow argued that the success of pop art would change the functioning of the art world to such a degree that it would be 'inevitable . . . that museums and collectors will acquire examples of comic-strips and advertising; not in the patronizing manner of a Museum of Modern Art's "Good Design" show, but as works of the human spirit occupying a first-class place in the collections.'[48] This, as is evident from this chapter and the discussion in chapter 8, has not largely happened. While original comic book art is indeed increasingly collected, it is mostly by private buyers and only occasionally by museums. While comic strips and comic books have increasingly entered into museums, they are still frequently viewed as little more than a source for more consecrated works, like those of Roy Lichtenstein.

The *ressentiment* of the comic book industry is a response to the processes of institutional legitimization that have championed the work of Lichtenstein as a masculinized saviour of commercial culture, while dismissing the cultural and aesthetic import of popular forms as sentimental

and feminized. In the catalogue to the High and Low show Varnedoe and Gopnik go so far as to argue that 'Pop Art saved the comics,' citing the efforts of Stan Lee – Jack Kirby's collaborator on all of the early-1960s Marvel superhero comic books – to draw on the ironic detachment of pop art to sell his own work to new audiences as the decade wore on.[49] This observation accords nicely with the suggestion that, in an increasingly postmodern world, high culture has had the unanticipated effect of making low culture available to highbrow audiences. The suggestion that comic books might owe a debt of gratitude to pop art – rather than the other way around – infuriates many in the comics industry to this day. Further, comics fans and professionals are alert to the fact that the ongoing critical success of pop art limits the possibility that comics will achieve artistic legitimacy on their own terms.

Roy Lichtenstein's initial critical success stemmed from the way he worked to make comic book images strange and unfamiliar. If the status of comic books were to be elevated, the status of Lichtenstein would be thrown into question and possibly imperiled. From the point of view of someone like Art Spiegelman, in his criticism of the High and Low show, the rise of the underground generation of cartoonists should have significantly altered the status of comic books, as even Varnedoe and Gopnik admit Robert Crumb to the MOMA show as an artist in his own right. If comic books have seen some change in their fortunes as a result of the contributions of Crumb and his inheritors, the next logical step according to Spiegelman is to knock off Roy Lichtenstein and take his place in the masculinized world of high culture. For Nietzsche, the theory of *ressentiment* held the power to explain the overthrow of the Roman Empire by Christianity, as the ideal of martyrdom replaced the ideals of power and empire through a moral system that elevated pity over vitality. The question necessarily follows: can comics overthrow the empire of the fine arts? The desire of many cartoonists to efface Lichtenstein's contribution to art history – rather than simply to exist alongside him – derives primarily from a resentment that is born from the feeling that Lichtenstein has, as Irv Novick's previously cited quote suggests, unfairly altered the status of the work of other artists and placed them in a subordinated position. Bruce Glaser raised this issue in a 1966 interview with Lichtenstein, Warhol, and Claes Oldenburg in *Artforum:*

> Glaser: Well, even if there is a transformation, it is slight, and this has given rise to the objection that Pop art has encroached on and plundered the private pleasure of discovering interest in what are ordinarily mistaken as

banal subjects. For example, if one privately enjoyed aspects of the comics, today one finds this pleasure made public in the galleries and museums.[50]

To this charge Lichtenstein bluntly responded: 'I am crying.' It seems, therefore, that the vexed relationship between the masculine world of high art and the feminized arena of commercialized comic book production ultimately revolves around Roy Lichtenstein's tears.

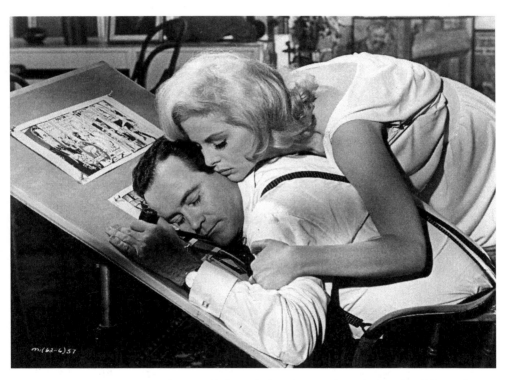

Still from *How to Murder Your Wife* (1965). ©United Artists, Courtesy of Photofest.

Searching for Artists in the Entertainment Empire

> Without becoming art, it could be no better. And if it became art, it would
> be far less than it is.
>
> Richard Kyle on *The Fantastic Four* (1969)[1]

Professional cartoonist was not a career that Hollywood found particularly rife with storytelling opportunities in the years after the Second World War. Even at the height of the popularity of the American comic book and newspaper strip, only two films used the creation of comics as plot devices: the Frank Tashlin – directed Dean Martin and Jerry Lewis musical comedy *Artists and Models* (1955), and Richard Quine's *How to Murder Your Wife* (1965), starring Jack Lemmon. Both of these films address issues of creativity and artistry in the comics industry within the framework of romantic comedy. *Artists and Models* follows twin romances: between failed painter Rick Todd (Martin) and successful comic book creator Abigail Parker (Dorothy Malone), and between the childlike aspiring children's book author and comic book addict, Eugene Fullstack (Lewis) and Bessie Sparrowbush (Shirley MacLaine), secretary for Murdock Comics and Parker's model for the popular superheroine Bat Lady. In *How to Murder Your Wife*, Stanley Ford (Lemmon) is the wealthy and famous cartoonist responsible for the Bash Brannigan adventure newspaper comic strip. When he awakens from a night of heavy drinking to find himself married to a woman who speaks no English (Virna Lisi), he changes his strip from a spy adventure to a domestic comedy incorporating his new wife. When he later decides to kill off that character, his wife reads it as an expression of an autobiographical wish and leaves him to return to Italy, leading to murder charges against Ford. While each of

these films has a screwball romantic plot, what merits attention here is the way in which the core conceptions of the role of the cartoonist in each film help illustrate the dominant conceptions of the place of the comics artist during this period.

Significantly, and not surprisingly given the fact that it was produced amid the anti – crime and horror comic book frenzy of 1954, *Artists and Models* presents, within the parodic context of Jerry Lewis-style slapstick humour, the comic book industry as almost unspeakably sleazy. Condemning Parker's latest Bat Lady issue, the publisher of Murdock Comics (Eddie Mayehoff) whines: 'Sixty-two pages of drawings and no blood? Not even an itsy-bitsy nosebleed? But suffering catfish, do you call this a Murdock Book for Kiddies with no stranglings, with no decapitations? Where are they?' When Parker refuses to capitulate, Todd, who steals his plot ideas from Eugene when the latter talks in his sleep, unceremoniously replaces her on the title. Eugene himself is presented, in a fashion typical of the Martin/Lewis formula, as a naive man-child. Appearing on a televised round table about the dangers of comic books, Eugene notes that 'I almost became a dope reading comic books and I realize that is why I'm now a little retarded.' In the logic of the film, comic book publishers are avaricious peddlers of horrific images to children, comic book readers themselves are mentally deficient, and the artists responsible for comic books, initially Abigail and later Rick, are nothing more than thwarted serious artists who work in the industry only because they are unable to find work elsewhere. Significantly, in *Artists and Models* not only is easel painting considered more prestigious and honourable than work in comics, but so too is advertising illustration. In the vision offered by the film, comic book creation is a shameful activity – it may pay Rick Todd's rent, but he nonetheless feels the need to hide the source of his income from those he cares about most.

The situation is quite reversed in *How to Murder Your Wife.* As the creator of a successful newspaper comic strip, Stanley Ford is a well-connected man of pronounced sophistication, a member of the best clubs who is a personal friend to the mayor of New York. He lives in a fabulously well-appointed brownstone, and his butler, Charles (Terry Thomas), caters to his every need. The Bash Brannigan strip, which is 'syndicated in four hundred and sixty-three newspapers' from Bangor, Maine, to Honolulu, Hawaii, has made Ford a wealthy and respected man, as popular with the neighbouring construction workers as with the judges who are members of his club. The only person in the film who casts any disdain on Ford's profession is his lawyer and best friend, Harold Lampson (Eddie

Mayehoff, ironically the same actor who played the blood-thirsty comic book publisher in *Artists and Models*), who teasingly credits the success of the strip to the fact that 'it's hardcore pornography, softened slightly, ever so slightly, by excessive violence and sadism.' Nonetheless, this is the only taste of high-culture snobbery towards the comic strip form evinced by the film, and Ford is otherwise the very model of the sophisticated upper-class bachelor until his life, and personal aesthetic, are upended by the intrusion of a woman into his apartment. The dilemma addressed by *How to Murder Your Wife* is the decline in masculine autonomy and authority. As was demonstrated in the previous chapter, one significant challenge for comics has been the way in which traditional fine arts have placed them in a feminized position. This is a theme running through this film as well, particularly insofar as Ford is the creator of a strip that circulates in a domestic newspaper, and his syndicate encourages him to make it even more family oriented so that they might cash in by licensing it to television, the most degraded of all domestic mass cultural forms. In this way, *How to Murder Your Wife* is another in a long line of cultural examples that conflate artistic virtue with masculinity. The film's focus on normative masculinity is explicitly laid out at its conclusion, when, during his trial for killing his wife, Ford argues 'too long has the American man allowed himself to be bullied, coddled, and mothered and tyrannized and in general made to feel like a feeble-minded idiot by the female of the species.' This sentiment seems in no way intended to reflect upon the state of the speaker's profession as a creator of comics, but the fact that it could be so read is uncanny.

If, drawing on these filmic examples and following that of pop art, we can suggest that a central historical problem of comics is a need for the masculinization of this mass cultural form; the options through which this might be permitted to occur are relatively narrow. While the death of the author was pronounced by Roland Barthes and confirmed by Michel Foucault only a few short years after the production of *How to Murder Your Wife*, the power and prestige of the author function continued to beckon to comics, holding out one possible avenue to respectability, legitimacy, and even masculinity.[2] While there are several ways to conceptualize the differing portraits of the comics artist in these two films, including the narrative requirements of the competing genres, the star personas of the actors involved, and the varying conceptions of the comic book relative to the comic strip in the postwar period, it seems that one of the most significant differences stems from the rapid transformation of the role of the comics artist in the decade that separates the

creation of the works. Indeed, one can easily argue that, in 1955 when *Artists and Models* was released, the profession of comic book artist barely existed. Certainly there were comic book writers, and illustrators who drew the pages of comic books, but they were not generally accorded the honorific of 'Artist.' To those who complain that artists like Roy Lichtenstein unfairly plagiarized the work of comic book artists whom he did not credit or acknowledge, one can offer the rejoinder that, at the time he created his most memorable comic book – derived works, comics creators were no more artists than was the graphic designer responsible for the distinctive Campbell's soup can that eventually garnered so much fame for Andy Warhol. Where those in the comics world often conflate artistry with the act of creation, the example of pop art reaffirms the insight provided by Marcel Duchamp that art is more precisely about what can be justified in the context of the art world. By that standard, in the decade following the end of the Second World War there were no comic book 'artists.' Nonetheless, in a post-Lichtenstein art world, and at a time of rapid transformation in the American comic book industry, the possibility of recognizing individual talents within the art world has developed. As *How to Murder Your Wife* suggests, however, this form of recognition depended on an overt assertion of masculine prerogatives and the disavowal of the mass cultural, the domestic, and, importantly, the feminine. In short, comics needed to be aligned with the 'heroic' traditions of art history in order to be considered art. This narrative is dependent first of all on the creation of the category 'comics artist' and, secondarily, on the identification of cultural workers who can be nominated into these roles.

Historically, this labour has fallen to comics fans. While an extremely small number of academic scholars were actively researching comics in the 1960s and 1970s (Donald Ault, M. Thomas Inge, David Kunzle, and John A. Lent among them), their numbers were insufficient, and their focus too widely divergent, to generate a substantial shift in the prevailing scholarly discourse about comics as morally and aesthetically abhorrent. Moreover, the efforts of these scholars were often informed by, and deeply intertwined with, the functioning of organized comics fandom. For Henry Jenkins, fandom, or fan culture, has at least five distinct dimensions: its relation to a particular mode of reception; its role in encouraging viewer or reader activism; its function as an interpretive community; its particular traditions of cultural production; and its status as an alternative social community.[3] For the purpose of this chapter, the way in which reception crosses over within the interpretive community

to create fannish epistemologies, or ways of conceptualizing and validating cultural works within fandom, is of particular interest. Of course, Jenkins himself addresses these issues in his work, highlighting the fact that the stereotypes of the fan, each of which (brainless consumers; cultivators of worthless knowledge; inappropriately fixating on devalued cultural material; social misfits; feminized or desexualized; infantile or immature; unable to separate fantasy from reality) can be easily read off of Jerry Lewis's performance of Eugene in *Artists and Models,* 'amounts to a projection of anxieties about the violation of dominant cultural hierarchies.'[4] For critics of fandom, the 'problem' engendered by fans is not merely that they champion the 'wrong' cultural objects (superhero comics, science-fiction films, television shows, and so on), but that they do so in ways that fail to privilege what Pierre Bourdieu has identified as the bourgeois aesthetic distance that has been traditionally associated with legitimate culture.[5]

The distance identified with the Kantian 'pure aesthetic' depends on a detached disinterestedness that is both a key component of autonomous production in the cultural field and a product of privilege.[6] This distance is absent in fannish criticism, which, though often hyper-critical, has an extremely high degree of affinity with, and affection for, its objects of inquiry. Significantly, fans see themselves as key participants in the fields that interest them, particularly insofar as the division between fan and professional in a field like comics can be slippery (as the example of fanzine writers who became professionals in the comics industry, such as Roy Thomas, attests). It is important to note that comics fans often envision themselves as participating in a larger social and cultural community and, more crucially, defending the interests of that particular community.[7] This defence frequently, but not always, takes the form of mimicking the institutions that are seen to be more legitimate than fandom. To this end, the identification of an author for mass cultural texts that otherwise might be regarded as authorless, and a subsequent explication of, or even justification of, the creator's point of view in particularly privileged ways functions as an attempt to align fandom with the dominant cultural hierarchies. Where Barthes argued against the incorporation of an author's biographical context and intentions in the understanding of a text, fannish epistemology particularly privileges just those elements and, in this way, hearkens back to the traditions of authorial interpretation. Jenkins argues persuasively that relations between fans and producers can often be 'charged with mutual suspicion, if not open conflict.'[8] It should be noted, however, that while this is

undoubtedly true, it is far more frequently the case that, in cases where fans establish a 'true' author for a work, when conflicts arise, these are perceived as stemming not so much from a distance between the author and the fan, but between a third party or interloper and the fan. In the case of *Star Trek*, for example, Gene Roddenberry is generally credited as the creator and 'author' of the work, with deviations from the author's vision blamed upon other producers (Rick Berman, Brannon Braga), television networks, actors, directors, writers, or other agents hired by Paramount to continue the franchise who are perceived to have violated the spirit of the author's intentions.

The fan's ability to recognize and delineate 'authors' in production contexts in which less invested observers find only 'hacks' is a key component of fannish epistemology. By asserting the birth of the author in fields such as comics, fans invert dominant aesthetic hierarchies and problematize the standards of judgment that prevail in areas like the academy. By relying heavily on interviews, biography, and gossip in the critical reading of texts, fandom can privilege authorial intention to an absurd degree. This fixation on authorship, particularly in the delegitimized realm of mass cultural production, emphasizes affective relations and tends to perpetuate the feminization of the field in the eyes of traditional scholars. Fans, who are already 'too close' to their preferred texts and creators, operate from a perspective that is feminized in relation to the styles favoured by the academy because they justify their interests without critical detachment and distance.[9] It could be argued, in fact, that, at some level, all critics and scholars are guilty of this tendency insofar as they are interested in justifying the value of a particular creator or work by paying attention to it. Nonetheless, the fannish tendency of the critic to align him or herself with a particular object of interest and, further, to assert the importance of an author-based interpretation of a work, is a key component of the way in which fandom approaches authorship. To this end, fans can frequently be conceptualized as advocates for the authors whom they champion. Therefore, a culture of collaborative work-for-hire production in which the 'author' of a text is not self-evident, the first line of the defence is usually the attribution of the honorific 'Author' or 'Artist.'

Retrieving the Discarded Comic Book Artist:
Fletcher Hanks and Carl Barks

In a 1994 *Artforum* article on the comic book artist Carl Barks, Diedrich Diederichson opened his comments by noting that 'it's an old story: the

Author rejected by high culture pops up in another part of the culture industry heretofore deemed vulgar.'[10] He suggests that, just as cinema began identifying 'authors' only after Roland Barthes had pronounced their death in literature, so too had a generation of comics fans resurrected the notion through the identification and celebration of cultural creators long forgotten. In recent years, the search for unheralded comics artists has taken on heightened levels of importance within the comics world, with publishers rushing long out-of-print (and, notably, out-of-copyright) material back to market. In his introduction to *Art Out of Time: Unknown Comics Visionaries, 1900–1969* (2006), for example, editor Dan Nadel argues that the history of comics is divided between 'competent journeymen' and 'brilliant practitioners: visionary artists whose drawings and ideas surpassed all boundaries, in a medium that – until recently – routinely ignored such talent.'[11] Nadel's anthology features the work of twenty-nine cartoonists working before 1969. This was the period that coincided with the consolidation of the American underground comics movement, when, he suggests, it first became possible for the comics world to fully recognize comics as 'a viable medium for personal expression.'[12] Among the artists presented in *Art Out of Time* is Fletcher Hanks, who is represented by a story about Stardust the Super Wizard, originally published in Fox Comics' *Fantastic Comics* #10 (1940). Hanks's career in the nascent American comic book industry was incredibly brief, spanning the years 1939 to 1941. Further, Hanks had already been rediscovered by a previous generation when the fifth issue of *RAW* magazine (1983) presented a Stardust story from *Fantastic Comics* #7. In addition, he was the subject of a two-volume career retrospective when Fantagraphics published the Paul Karasik–edited collections *I Shall Destroy All the Civilized Planets! The Comics of Fletcher Hanks* (2007) and *You Shall Die by Your Own Evil Creation!* (2009). The conceptualization of Hanks as a crucial yet neglected comics visionary is an instructive launching point for the consideration of the comics auteur working within the American entertainment industry of the mid-twentieth century. The critical discourse around Hanks seeks to separate and reconcile two competing conceptions of the man: that he was a hack and that he was genuine artist. Significantly, this reconciliation is contingent on finding a ground upon which both statements might be found to be true.

The suggestion that Fletcher Hanks was merely a hack is a commonplace in discussions of his career. Even Paul Karasik, the leading expert on his work, is obliged to note that 'Hanks was cranking these stories out at a breakneck speed, and the plots tend to be very formulaic.'[13] In a review of the book in *BookForum,* cartoonist Matt Madden termed Hanks

an 'obscure artist who briefly earned paychecks churning out pulps' and noted the artist's 'crude and distorted' drawing style, 'feeble' ability to draw anatomy, 'unwieldy and random' compositions, 'ham-fisted narration and dialogue,' and 'boilerplate' plotting.[14] Given these aesthetic defaults, by what criteria could Hanks be classified as an important cartoonist? Central to the reclamation project is Nadel's suggestive term: visionary. Karasik has suggested in interviews that he suspects Hanks's work was fuelled by 'egomaniacal anger and the whiskey bottle' and has praised the fact that the cartoonist's 'dynamic storytelling sensibility is undiluted' and filled with 'a righteous sense of retribution.'[15] In short, Karasik argues, Fletcher Hanks unleashed his creative id on the comic book page in a manner not unlike that of the 'visionary' productions of creators of *art brut* and naive and outsider art.

According to Karasik, the early years of the comic book industry were a 'free for all' in which there was no censorship, no creative guidelines, no house styles, and no marketing devices. Left to his own devices, Hanks, who, in contrast to the norms of the period, wrote, drew, and lettered his own material, produced work that is 'far more personal than the rest of the talented hacks' working at the time.[16] Interestingly, Karasik rejects the equation of Hanks with naive art, calling it a 'very narrow-minded appreciation of the man's work.'[17] On the contrary, he stakes a somewhat minority position when he argues that Hanks's output 'stand[s] up against the strongest work in comics,' rooting that defence in the artist's storytelling, as well as in his sense of design and colour. Nonetheless, the crucial element of the vindication of Fletcher Hanks can be reduced to the fact that he was a 'one man band': 'Given the assembly line approach to most comic-book making, it is very rare to find masterwork in comic books. Certainly there are a few exceptions: [Harvey] Kurtzman, [Gordon] 'Boody' Rogers, Walt Kelly, Carl Barks, Robert Crumb. All of these artists produced work that was fuelled by a single-minded purpose and towers over the rest of the schlock. Hanks belongs on this list.'[18] Thus, while Karasik rejects the conception of Hanks as an outsider artist, he crucially defends his work in terms often reserved for untrained cultural producers. Jean Dubuffet famously defined *art brut* as artistic works 'owing nothing (or as little as possible) to the imitation of art that one can see in museums, salons, and galleries . . . works which the artist has entirely derived (invention and manner of expression) from his own sources, from his own impulses and humors, without regard for the rules.'[19] This seems to be in line with Karasik's characterization of Hanks's appeal: the visionary comic book artist and alcoholic who

worked in the field for only three years. By appropriating the rhetoric of the naive artist, even while he disavows it, Karasik and, to a lesser degree, Nadel recover Hanks as the forgotten man and implicitly frame the question: What other great comics artists have been overlooked by art history?

The comics world, of course, has long shown interest in outsider artists. The work of Henry Darger, for instance, was featured in the cutting-edge comics anthology *RAW* and Chris Ware provided the title art for the Darger documentary *In The Realms of the Unreal* (2004). Indeed, as the example of Fletcher Hanks so ably demonstrates, the distinction between naive art and comics art can be razor thin. In a field in which so few cartoonists have been elevated to the status of art world insiders, it is not difficult to see how the conception of cartoonists in terms of outsider art might seem so appropriate. Take, for example, Don Ault's description of Carl Barks. Ault, one of the leading scholarly exponents of the best-loved Disney comics artist, argues that 'Barks' stories cry out to be included in the canon of American literature' because his work adds a 'fundamental critical perspective to the reader's intellectual exploration.'[20] At the same time, Ault praises the fact that Barks worked on 'an intensely intuitive, almost anti-intellectual level.'[21] Here, Ault's phrasing draws to life the caricature of the comic book creator portrayed by Jerry Lewis, who, while perhaps even 'a little retarded,' is able to channel compelling stories directly from his subconscious. Elsewhere, Ault characterized Barks's talents in this way:

> Barks himself was never able to acknowledge or understand consciously the full depth, complexity, and influence of his work. At some fundamental level – 'deep beneath the subconscious' as he once said – he recognized the power of his talent and the gift life had given him in the opportunity to use that talent to its fullest. And he accepted the awesome responsibility that accompanied this gift, bequeathed in part, but only in part, by Disney.[22]

While Ault means to flatter the directness of Barks's expression, his conception of comics artistry as intuitive supports the long-standing prejudices against the form that he is seeking to overthrow.

One of the fascinating aspects of the legacy of Carl Barks is that the most widely read study of his work, Ariel Dorfman and Armand Mattelart's *Para Leer al Pato Donald* (1971), never mentions his name. Writing about the ideologies embodied by the Walt Disney–branded comics circulating in Chile at that time, Dorfman and Mattelart credit the

work exclusively to Walt Disney. It is striking that the most sustained criticism of *How to Read Donald Duck* in the United States has not originated from the political right, who might be expected to object to the authors' Marxist leanings, but rather from Carl Barks's fans. For those fans, as Dana Gabbard and Geoffrey Blum point out, the authors 'err in treating the stories as authorless, the product of a corporate entertainment machine.'[23] Of course, the comics *were* the product of the Disney corporate entertainment machine, one of the largest and most influential media production companies ever created. Further, Barks's work was, throughout his career, attributed to Walt Disney (who 'signed' the comics stories) and vetted and approved by editors at Western Publishing who supervised that company's licensee relationship to Disney and published the work under the Dell imprint. It is only from the point of view of the Disney comics connoisseur that Barks can be regarded as an autonomous, or at least semi-autonomous, author. When Barks died in 2000, the *New York Times* obituary described him as 'the once anonymous "duck man" for Walt Disney whose draftsmanship and writing gained him a cultlike following among artists and fans of Donald Duck comic books.'[24] That cult arose from the identification of Barks by organized comic book fandom in the 1960s. Long heralded as the 'good duck artist' by readers who could distinguish his distinct visual signature within the constraints of the anonymous Disney machine, Barks's identity was revealed to fandom in the late 1960s with articles published in fanzines by J. Michael Barrier, Don and Maggie Thompson, and Malcolm Willits. As Ault noted in his collection of Barks interviews (2003), it was primarily through personal contacts – letters and interviews – that the mask of anonymity was cracked, and it was the circulation of those interviews that created a 'worldwide community of people who found that they all had one thing in common – a love for the work of Carl Barks.'[25] The example of Barks illustrates one of the first, and central, accomplishments of organized comics fandom – the identification of individual creators within the entertainment industry, the compilation of bibliographies of their works, and the recognition of their creative labour.

Barks, who left the Disney animation studios, where he had been employed as a story man, and began working for Western by drawing Disney comics in 1942, passed a quarter-century of his life labouring in complete anonymity without any contact or recognition from his millions of readers. During the 1940s, he was one of the most widely read authors in the United States, although his name was completely unknown except to his employers. Ault has termed Barks's best work 'pure Disney' but also

notes that, since the comic books were one of the few areas where non-collaborative work could occur, Barks recognized that the fullest expression of his talent required the intersection of the instantly recognizable Disney characters and his own ability to exploit the possibilities of the comic book format.[26] Although he was one of a small number of cartoonists charged with writing and drawing his own work during this period, claims for Barks as an early example of the auteur are complicated by his submission to the Disney format. Importantly, Barks learned the storytelling techniques that he used in his comics while working for Disney's animation division, and his characterization and figure drawing were largely dictated by the established Disney house style.[27] Further, Barks's autonomy was significantly restricted by the requirements of his editors who, for example, wanted to see all the major characters (Scrooge, Donald, the nephews) on each cover in order to ensure maximum exposure, or who cut his stories to make space for advertising, an act that Barks termed 'heinous butchery' in a letter to one fan.[28]

Given the complex interplay of factors involved in publishing a comic book based on licensed characters, even when a single cartoonist is responsible for the creation of the work, it can be difficult to establish notions of artistic integrity. In *Carl Barks and the Art of the Comic Book,* Michael Barrier implies that editorial interference from Western Publishing, rather than the artist's personal changes or creative failings, contributed to the late-career decline of Barks's work. Nonetheless, Barrier, like other fans and critics of Barks, is eager to celebrate the cartoonist, as his book title suggests, as an 'Artist.' He notes that 'artists of this kind are rare in any medium; that one should have flourished in comic books is incredible.'[29] What makes it incredible is the simple fact of corporate control of the material, which is frequently assumed to lead to uninspired hackwork. While Barks could be accused of this in the late 1950s, when he began to recycle plot and gag ideas from earlier in his career ('no doubt because he had to turn out a steady stream of such stories for monthly publication,' Geoffrey Blum writes), his proponents tend to offer only the most generous readings of his work, or those that are most conducive to reading his career as the maligned great artist working within the Disney machine.[30] That Barks was poorly paid and was always, as he told Barrier in an interview, 'working too close to my poverty level,' amplified this conception insofar as it so neatly accords with the popular image of the neglected and abused creative genius struggling in obscurity.[31] Thus, in the eyes of his fans, Carl Barks was transformed from a company man into an artist because his work had a distinctly

recognizable personal style and evinced a high level of craft within the aesthetic constraints of children's humour and adventure comic books and the factory-like working conditions of the Disney empire. Significantly, it was the efforts of fannish comic book historians in the 1960s that identified Barks's authorship, allowing a specific fandom to crystallize around him. The consequent recognition of his comics as a form of creative self-expression rather than as mass-produced pulp widgets allowed them to be republished in a comprehensive fashion on multiple occasions, including as *The Carl Barks Library* (Another Rainbow, 1984–90) and *The Carl Barks Library in Color* (Gladstone, 1992–8). These expansive auteurist collections have ensured Barks's consecration as one of the most important masters of the form, despite the fact that he had no success outside the Disney formula. Nonetheless, given the distance that still pervades between the comics world and the art world, Diederichson remains correct when he observes, 'only in the art world, it seems, does Barks remain virtually unknown.'[32]

Jack Kirby: Anointing the King of Comics

In 1994, *USA Today* titled Jack Kirby's obituary 'Jack Kirby, a Hero among Superheroes,' and the *New York Times* suggested that he was to comics what Louis Armstrong was to jazz.[33] Mark Evanier, who at one time worked as the artist's assistant, titled his biography of the man *Kirby: King of Comics*.[34] The foreword to the fourth collected volume of the *Jack Kirby Collector,* by Tom Ziuko, elevated the praise even higher: 'A Man amongst Gods, A God amongst Men.'[35] Hero, innovator, king, and god – these are the terms regularly mobilized to describe Jack Kirby, the most lavishly praised of all American comic book artists. Kirby's influence on American comic books, particularly American superhero comic books, looms as large and powerful as one of his own splash pages. Comic book industry professionals routinely pledge their fealty to Kirby, reminding readers of his place in the pantheon. The cartoonist and filmmaker Frank Miller has written:

> In the history of American comic books, there has been no single talent of greater importance and influence than that of Jack Kirby. It would be impossible to exaggerate his contribution to the evolution of the superhero, or to calculate exactly how much he personally advanced the art form. He created, with Stan Lee, the creative bedrock upon which Marvel Comics was built. Single-handedly, he developed the visual dialect, tone and spirit

of the modern superhero comic. He brought a sense of operatic drama and mythological scope to a genre that was fat, bloated, old and dying. It could easily be argued that his vigorous creative lifeblood kept the comics industry alive through decades of infertility, apathetic management and dwindling distribution.[36]

Comic book writer Neil Gaiman echoed a similar sentiment when he suggested 'Jack Kirby created part of the language of comics and much of the language of superhero comics. He took vaudeville and made it opera. He took a static medium and gave it motion.'[37] Significantly, these tributes share a number of common concerns – the creation of a specifically comic book – oriented visual style, references to operatic storytelling, and a conflation of the superhero genre with comics of all types. Yet more than this, they share the assumption that Kirby remains the most important figure in the history of the American comic book industry.

It is a testament to the taken-for-granted nature of this belief that one of the central debates in the commentaries about Kirby is not about the general value of his work, which is generally accepted within comics fandom, but the issue of whether he can be properly termed a 'genius.' Writing in the *New York Times* in 2007, Brent Staples called Kirby '[Marvel's] principal artist and in-house genius,' indicating how widely the label is applied even beyond the narrow confines of organized fandom.[38] It is striking that such a casual claim could be made in the *Times,* given the historical disdain afforded artists working in the form. The notion of a 'comic book genius' carries with it a host of embedded assumptions that are a legacy of Immanuel Kant's *Critique of Judgement:* that comic books can be organized on auteurist grounds, that comic books have produced works of great intelligence and innovation, and that Kirby himself possessed this innate superior talent and originality. It is fair to say that more than almost any other American cartoonist, Jack Kirby is the subject of a cultish fandom that has generated a large number of publications about the artist. Since 1994, the year of his death, there has been a regularly published fan magazine devoted to his life and work, *The Jack Kirby Collector,* which described itself in the first issue as '*for* and *by* collectors of Jack Kirby's work' and later as an 'ongoing tribute to Jack that will expose many people to his genius.'[39] The articles in the *Jack Kirby Collector* exemplify the fannish epistemologies that have already been described. Special issues have been dedicated to individual Kirby works as well as subjects that can encompass his entire career. A review of the *Collected Jack Kirby Collector* published in *Booklist* noted that the

magazine 'may strike nonfans as bordering on the obsessive.'[40] The focus is almost exclusively on praise, generally of the effusive variety, and the magazine attempts to bring fans 'closer' to Kirby through an unrelenting focus on biographical information in the form of a large number of interviews with the artist, gossipy interviews with his wife and daughter, as well as stories by fans about visiting the family home in California.[41] If the alignment of the fan's perspective with a creator's intentions is the central tenet of fannish epistemologies, Kirby fandom is the example par excellence of this tendency. Central to the fannish project is a legitimizing aspiration: to have the object of fan devotion widely recognized and acclaimed, thereby validating the fan's investment in the artist or object. In this regard, fandom has been especially productive in the case of Kirby, erecting an edifice that supports the claim not only that he is a serious artist within the comic book field, but, perhaps, that he is the most serious.

Nonetheless, claims about Kirby's genius are at least somewhat troubled by the particularities of his place in the history of comic books, not least because almost none of his work can be viewed as the creation of a solitary artist. In this respect, he is especially well suited as a case study of the rise of auteurism within the comics field. When the critics of *Cahiers du Cinéma* attributed the author function to a film's director in the 1950s, they provided a model for the attribution of artistry and intentionality to collaborative works, particularly those that are products of so-called mass culture. In opting somewhat haphazardly for the director as arbiter of a cinematic sensibility, the auteurists minimized the importance of screenwriters, actors, and producers, thereby highlighting cinema's visual elements over the purely textual, performative, or organizational. In comics, the division of labour has made it harder to assign the auteur role to a consistent position such as writer, penciller, or editor across either national traditions or historical eras. For artists who draw their own images and write their own words, as is often the case with comic strip creators, this attribution is much simpler. However, in collaborative comics creation assigning creativity and originality is much more complex and ad hoc.

Beginning with the creation of the category of superstar comic book writers since the rise of Alan Moore in the 1980s and Neil Gaiman in the 1990s, one strong tendency of criticism and comic book marketing has been to emphasize the creative role of the writer, often relegating the artist to the position of technician who realizes that artist's vision (akin, perhaps, to the role of the cinematographer in classic conceptions of

auteur-driven cinema). At the same time, comic book fandom has historically been organized around favourite artists. In many eras the greatest attention of fans has been placed on the role of the comics artist and of schools of visual styles often centred around specific publishers. Indeed, in the early 1990s and at the height of the post-Moore writer-oriented comics movement that made stars of Gaiman, Grant Morrison, Garth Ennis, and others, the biggest celebrities in the American comic book industry were the founders of Image Comics (Todd McFarlane, Jim Lee, Rob Liefeld, and others), who realized great success with titles that were widely derided as incoherently written even by the artists themselves. Of course, a middle ground which acknowledges the creative interaction between artist(s) and writer(s) on collaboratively produced comics is possible and, to many, preferable. Yet the demands of Kantian notions of genius do not accord well with credit sharing, and, as the case of Jack Kirby so clearly highlights, the construction of an artist position is frequently implicated in the disavowal of shared ideas.

Glen David Gold notes in his *Masters of American Comics* essay that there is 'very little pure Kirby in the world,' by which he means that the artist almost never worked alone on his comics.[42] Even in the 1970s when he turned to scripting his work at DC and, later, upon his return to Marvel, he did not ink his drawings, nor did he provide the lettering or colouring, but always worked with other creators who took on these tasks. Significantly, when he was at his artistic pinnacle in the 1960s working at Marvel, the vast bulk of his work was created in collaboration with writer-editor Stan Lee, himself a candidate for auteur status, and someone who has cannily managed his reputation to maximum effect. Together the two men were responsible for the creation of the 'Marvel method' of comic book assembly, in which writer and artist would meet in story conference to outline the broad strokes of a plot, Kirby would pencil the action of the story and return the pages to Lee, who would add the dialogue. The final pages would then be lettered, inked, and coloured by other creators. One advantage of this working method is that, in its Fordist structure, it was highly efficient and allowed Lee to exercise a great deal of editorial and authorial consistency across the so-called 'Marvel universe' of titles. One disadvantage was that it has generated significant confusions among fans seeking authorial traces in the work, particularly given that Lee and Kirby, and other artists working at Marvel at the time, have muddied the historical waters in disputes over the inspiration for the creation of signature characters such as Spider-Man and the Fantastic Four. Thus, in *The Comics Journal's* special retrospective issue on Kirby,

R.C. Harvey minimizes the influence and importance of Lee when he argues 'midway in his course, [Kirby] almost single-handedly revitalized a withering medium,' while in the very next article, whose title, 'Once and for All, Who Was the Author of Marvel?' implies the long-standing nature of the debate, Earl Wells suggests that 'Kirby is not the author of Marvel' and that the position belongs to Lee.[43] Harvey's claims for Kirby were largely revisionist at the time he was writing, although they have become dominant. During the period when Kirby and Lee worked together, Marvel aggressively promoted Lee as an author while downplaying the role of the individual artists drawing the comics. The 1974 reprint book, *Origins of Marvel Comics,* is credited solely to Lee and depicts his hands as he types the creation of characters like the Hulk, Spider-Man, Thor, Dr Strange, and the Fantastic Four. Further, Lee, who has proven himself an accomplished promoter and self-promoter (later parodied by Kirby as Funky Flashman in DC's *Mister Miracle*), was the subject of innumerable newspaper articles that positioned him as the driving force behind Marvel's success and the new relevance of comic books in the 1960s and 1970s. Two of Kirby's biographers emphasize that he was especially upset by one such article, published in the *New York Herald-Tribune Sunday Magazine* in January 1966, which concluded with a depiction of a story meeting between Lee and Kirby where the writer is portrayed as a bundle of manic creative energy tossing out ideas and infecting his colleague with contagious enthusiasm, while the artist is described as 'a middle-aged man with baggy eyes and a Robert Hall-ish suit . . . if you stood next to him on the subway you would peg him for the assistant foreman in a girdle factory' whose contributions are limited to 'ummh,' 'I see,' 'right,' and, when Lee finishes, 'great, great.'[44] Nonetheless, Kirby's defenders argue that as Marvel grew as a publishing force he would produce plots on his own, writing notes about the dialogue that Lee 'would merely paraphrase.'[45] Bitter about the lack of a writing credit, Kirby left Marvel for rival DC Comics in late 1970 on a five-year contract that would allow him to take fuller control for the work he produced.

For Charles Hatfield, a leading commentator on Kirby's work, the question of authorship matters because 'giving credit where it's due' allows one to read individual works within the broader continuum of his oeuvre, that is to say as distinct from Lee's work and that of Marvel as a totalizing corporate entity.[46] For Hatfield, it was Kirby's work on the 'Fourth World' books at DC in the 1970s that represented the fullest flowering of his genius and his truest engagement with the comics form, an extension of some of the themes that he had explored in his work

with Lee that 'went Marvel one better' in terms of originality, variety, and subtext.[47] Kirby's arrival at DC in 1970 was a critical step in the process of institutionalizing him as a major comic book artist. DC trumpeted his arrival in an unprecedented fashion with ads in their comics announcing that 'The great one is coming!' 'Kirby is coming!' and, finally, 'Kirby is here!' Nonetheless, while Kirby was granted a greater degree of autonomy in his role as editor of the 'Fourth World' titles (*New Gods, Mister Miracle, The Forever People*), it was far from total. While DC had promised Kirby greater artistic control, the publisher largely treated him as a journeyman. Importantly, DC offered him no ownership participation in his characters or royalties for his work. He was contracted to provide fifteen pages per week to DC. Notably, while working on *Superman's Pal Jimmy Olsen*, DC had Superman's faces redrawn by other artists to bring his depiction more in line with their house style. When his titles did not meet sales expectations, they were cancelled and he went to work on titles where his editorial duties and creative autonomy were gradually eroded. By the time he left DC to return to Marvel, his reputation had been damaged by the failures of his solo material, a result that tended to reinforce the importance of Lee's hand in the creation of much of Kirby's most memorable works.

One other form of collaboration also complicates assertions of Kirby's genius – the fact that his published art is, in the vast majority of instances, the result of collaboration with an inker. In the field of comics, while the roles of penciller and inker are complementary, a hierarchy nonetheless exists between the two. A 1971 *New York Times* article on what was perceived at the time as the 'new relevance' of superhero comics and which featured profiles of both Lee and Kirby among others, succinctly outlined the situation: 'Artists fall into two categories, pencilers and inkers. Pencilers are slightly more highly reputed than inkers but, with few exceptions, nobody in the business has much of a professional reputation, and most are poorly compensated.'[48] If the *Times* errs, it is in underestimating the degree to which fans draw a distinction between practitioners of the two crafts, tending to view the penciller as the artist and the inker as a technician who merely fills in the picture according to the penciller's dictates, much like the letterers and colourists. *The Jack Kirby Collector*, with its fascination with mining minute differences in Kirby's published work, has paid a great deal of attention to the various differences between inkers as well as to differences between photocopies of Kirby's pencil drawings and the inked published versions.[49] While the relationship between penciller and inker could often be harmonious,

more contentious relationships serve to highlight the manner in which inkers are regarded as mere functionaries in the service to a celebrated master. Take, for example, the much-maligned Vince Colletta, who enraged fans when he refused to stop erasing pencilled parts of Kirby's pages.[50] Given the pre-eminence of the penciller within the logic of comics, and given the devotion to Kirby as an expressive genius in the epistemology of fandom, it is not surprising that Colletta is a controversial figure whose erasures, which have been carefully catalogued in Kirby fandom, are regarded as an act of desecration. Arlen Schumer, author of *The Silver Age of Comic Book Art,* has bluntly stated that he 'detested' Colletta's 'scratchy hackwork,' and the *Jack Kirby Collector* ran a round table on 'The Pros and Cons of Vince Colletta' that was weighted much more strongly to the negative view of his work.[51] In the judgment of fandom, figures like Colletta stand in opposition to artists like Kirby, drawing attention to the difficulties faced by the artists in the assembly-line logic of corporate work-for-hire comics construction. For Kirby to be conceptualized as an important auteur, that is to be credited with the overall look of the printed page, the creativity and contribution of his inkers, colourists, letterers, and even writers must be minimized or even obliterated in the same way that artist's assistants have been obscured throughout art history. It is significant that when his original art was exhibited at the UCLA Hammer Museum as part of the Masters of American Comics show in 2006, Kirby's inkers were not credited by the curators – even on splash pages which, when they housed credits, included the inker's name on the displayed image. Of course, neither did the labels credit Stan Lee for his writing.

As the confusion over collaboration suggests, the context in which Kirby produced his work helped contribute to his difficult position as a recognizable artist. Throughout his career, Kirby toiled in a work-for-hire industry in which companies like Marvel and DC retained the copyright on his work and the trademarks on the characters that he created. Although characters that he helped to establish and define – including the X-Men, the Hulk, Iron Man, Captain America, and the Fantastic Four – have generated billions of dollars in revenue through comic book sales, and film, television, and toy licensing royalties, Kirby was paid a flat page rate for his work and nothing else. Significantly, under the provisions of American work-for-hire legislation, the employer, rather than the employee, is considered the 'author' of a work, and this serves to complicate arguments about Kirby as an author. This issue was forcefully brought to the fore in the 1970s when a market began to emerge

for pages of original comic book art, particularly at comic book conventions. Because there was very little market for original comic book art prior to this point, it had been regularly destroyed in the same way that old scripts had been discarded. The vast majority of Carl Barks's pages, for example, were destroyed after the comic books were printed by Western, and Kirby's pages, once submitted to Marvel in the 1960s, were alternately destroyed by the company or stolen by visitors to the offices. According to biographer Ronin Ro, Kirby requested that his art be returned to him as early as 1968 without success, and the struggle to have the pages returned to him became a major element in the ultimate consecration of Kirby as an artist.

While Kirby laboured under a work-for-hire agreement that prevented him from claiming copyright on the stories that he produced, he was, in point of fact, legally entitled to have his physical artwork returned, as publishers purchased only the rights to reproduce the work, not the actual physical object itself. Nonetheless, as of 1984 Marvel had not returned any of the approximately 13,000 pages of original art that Kirby produced there in the 1960s, and many stolen pages had begun to circulate openly among comic book collectors. The debate over Kirby's art erupted in 1984 in the pages of *The Comics Journal*, which reported that Marvel had announced plans to return all of the original art in its warehouse to the artists who created it. Marvel had begun handing back artwork to artists in 1975, but pages drawn prior to that date had not been retroactively returned. Their plan to return the original art came with a number of strings attached. The most significant of these was that artists were required to sign a one-page waiver that acknowledged that the pages had been drawn as part of a work-for-hire agreement. Changes to the work-for-hire legislation in 1978 had called the provenance of some of Marvel's best-known characters into legal question. If artists who had worked on Marvel's comics in the 1960s could demonstrate that they were freelancers at the time and were not working under an explicit work-for-hire agreement, they could theoretically challenge Marvel's copyright claims when they came up for the initial twenty-eight-year renewals. The first of these renewals would be for the Fantastic Four, created by Lee and Kirby, and due for renewal in 1989. By pressuring artists to sign a retroactive work-for-hire agreement in exchange for the return of their property, Marvel hoped to stave off potential challenges to their copyright.[52]

The significance of such an agreement was particularly pressing in the case of Kirby, who had co-created so many of Marvel's most successful

characters. While it is not clear that Kirby could have won the rights to these characters in court, it was also not entirely clear to Marvel that he could not have. Accordingly, Marvel offered Kirby a return of a small portion of his art – 88 pages out of more than 13,000 that he had drawn for the company in the 1960s – if he agreed to sign a specially written four-page waiver renouncing any claim that he might have to the characters that he had helped to create. Referring to the agreement as a 'humiliating experience' and to the corporation as a 'bully,' Kirby refused to sign.[53] Marvel's attempts to strong-arm Kirby into signing the special agreement led to an unprecedented public backlash against the company in the fan press. *The Comics Journal* printed dozens of outraged letters from fans and professionals in the ensuing months, and hundreds of prominent comic book creators signed a petition calling for the immediate return of Kirby's art.[54] Ultimately the two sides came to terms on a new one-page waiver that Kirby agreed to sign, and the company returned almost 1,900 pages of his original art, with the remainder was presumed lost, destroyed, or stolen. At the same time as he agreed to sign the retroactive work-for-hire agreement, Kirby vowed to continue fighting for credit in the books whose characters he had originated.[55]

The fight for the return of Kirby's art played a key role in consolidating fannish conceptions of the moral rights of comic book artists. For a large and vocal segment of comic book fandom, Marvel's shabby treatment of the man they considered to be a monumental figure in the history of the form was appalling. The situation recalled the entire history of comic book publishing organized as an exploitative system that treated creative talent as interchangeable, replaceable, and disposable, privileging the maintenance of corporate trademarks over the aesthetic demands of interesting storytelling. Marvel's actions highlighted for many the lack of respect that artists working in the comics form faced, even from within the industry itself. As such, the debate brought to light the maligned status of the comic book artist. Interestingly, the same issue of *The Comics Journal* that most directly addressed the Kirby-Marvel dispute also contained a manifesto by Canadian comic book artist Dave Sim. He called for an end to the publisher-artist arrangement altogether in favour of self-publishing. While in other fields a self-published book is often seen as a 'vanity press' production and considered mildly unseemly or a tacit admission of failure on the part of the creator, in the comic book field, which offered artists meagre page rates, no copyright and no royalties, the practice took on an ethical dimension. Moreover, self-publishing had made Sim one of the wealthier cartoonists working in comic books, and

in the early 1990s the model was adopted by the Image comics founders, many of whom became instant millionaires when their first books came to market.[56] The debate over creator's rights in the comics field that was foreshadowed by Marvel's treatment of Jack Kirby, and honed by the success of Dave Sim and other self-publishers, structured much of the discourse about comics as a legitimate art form within fandom over the next decade. Significantly, it was by demonstrating to other artists the peril of corporate contractual issues that Kirby was elevated beyond the confines of the entertainment machine. Simply put, the story of Kirby the artist is not based on his visual talent so much as his status as an underdog in a vicious system of conformity and power-brokering that usefully affirms the mythology of the artist as oppressed by a scheming, disinterested corporate machine. The debate about creator's rights that played out in the American superhero comic book industry in the 1980s and 1990s was fundamentally a battle about economic power couched in moral terms and vindicated through claims of aesthetic greatness. It reified the image of the artist as a lone fighter struggling against greater powers. So powerful was this image of the new figure of the comics artist as suffering martyr that it would be appropriated and applied even to those who achieved great financial success and artistic independence in their lifetime, as is evidenced by the career of Charles Schulz.

Charles Schulz as Tragic Figure

The best-selling critical analysis of any single comics work is undoubtedly Robert Short's 1964 volume *The Gospel According to Peanuts*, a 'reading out of' the work of Charles Schulz that, as the back of later editions proclaim, sold more than 10 million copies.[57] In that book, and in its more fully elaborated sequel, *The Parables of Peanuts* (1968), Short treats Schulz's work as what he terms an 'art-parable,' defined as the 'creation of man with no practical use except to communicate meaning indirectly through forms that capture one's attention.'[58] Invoking the traditional anti – mass cultural distinction between 'art' and 'entertainment' ('All art involves "entertainment" of sorts, but not all entertainment is art. Mere entertainment leads us away from reality' etc.), he notes that the art-parable 'always has something to say.'[59] For Short, what *Peanuts* has to say is that Schulz has 'penned down' the problem that his readers face, and, through the use of allegory in his comic strip, he also alludes to the solution: God.[60] Short's conclusion is certainly bolstered by the fact that, in his commentaries on the strip, Schulz, who was a lay minister in the

Church of God, has been so open about its religious and theological underpinnings, noting 'I am . . . the first to use extensive theological references' in a daily newspaper comic strip, and that he attempts to present scripture in his work with 'dignity and, of course, with much love.'[61] For Short, the importance of Schulz's work is precisely the fact that it is not fine art, that it is popular. 'The popular arts,' he argues, 'are important precisely because they are popular,' that is to say they are enjoyed by the same audience that Jesus sought to attract, 'everyone.'[62] In a later volume, *Short Meditations on The Bible and Peanuts* (1990), Short noted that 'The Bible and Peanuts are excellent go-togethers,' as the Bible accords well with the humility of the comic strip form: 'The trouble with fine art and sacred art is that they have a tendency to become too "fine" and too "sacred." But a comic strip modestly takes its place among the popular arts. And if there was ever a book that likewise strives ceaselessly to be popular and down-to-earth and graphically engaging, it's the Bible.'[63]

Short's extensive written commentary on *Peanuts* approaches the work through its Christian utility, celebrating its distance from 'fine art' and praising its enduring popularity. If popularity is essential to the success of the art-parable, Short could have found no better ally than Charles Schulz. Indeed, it seems likely that no other single cartoonist can rival the career accomplishments of Schulz, who, upon his death in February 2000, was praised by President Bill Clinton for giving voice 'day after day, to what makes us human,' and, in June of that year, posthumously awarded a Congressional medal in recognition of 'his lasting artistic contributions to the Nation and the world.'[64] When he passed away, *Peanuts* was, alongside Jim Davis's *Garfield,* the most widely syndicated comic strip in history, published in more than 2,600 newspapers, and even after his death reruns of the strip continued to be carried by more than 2,400 of those papers.[65] Having begun his career in 1950 with only seven newspapers carrying his work, Schulz saw more than 200 million copies of his books printed during his lifetime, making him one of the most widely read authors of all time. Further, film and television adaptations of his work, as well as the ubiquitous merchandising of his characters, contributed to the *Peanuts* brand worldwide.[66]

Unlike Barks and Kirby, each of whom created new characters and stories within an entertainment empire from which they benefited exclusively as salaried employees, Schulz controlled the entertainment empire that he built with his partners at the United Media syndicate. In the United States, as a consequence of their tight association with

well-regarded and community-based newspapers, comic strip artists have traditionally enjoyed better working conditions and greater respect as creators than comic book artists. Jack Kirby aspired to a career in comic strips, working for H.T. Elmo's Lincoln Features Syndicate in the 1930s because he was unable to crack the 'top-end' syndicates, before he went to work for the Eisner-Iger comic book sweatshop.[67] For those, like Schulz, who succeeded in cracking the major syndicates and establishing large client lists, the rewards could be astounding. Seven years into his almost fifty-year run on *Peanuts,* Schulz was earning more than $90,000 per year (at a time when the average annual wage was $3,641). By the end of his life the *Peanuts* empire generated more than $1 billion in revenues, and Schulz's annual salary exceeded $40 million.[68] Even after his death, Schulz continued to earn enormous sums, with *Forbes* listing him in 2007 as the third highest-earning deceased celebrity (trailing only pop stars Elvis Presley and John Lennon), with an annual income of $35 million.[69] Of course, only a small portion of this income was derived directly from the syndication of the strip, with the bulk coming from the global branding industry Schulz created from his characters. Schulz began licensing the *Peanuts* gang to advertisers, notably the Ford Motor Company, in the late-1950s, and, working with Connie Boucher, he took an active interest in the merchandising of his work. When *Peanuts* migrated to television in 1963, it became a multi-platform media property and, increasingly, an important brand for children rivalled only by Disney and, later, *Sesame Street* in that demographic. If Short found in the success of *Peanuts* a parable for Christian faith, it seems equally clear that it can also be read as an example of capitalist media expansion and market saturation.

For Schulz, the expansion of consumer products related to his characters was an important part of his overall career trajectory, and not something that he regarded as incommensurate with the role of the artist. Writing in *Peanuts Jubilee,* a book commemorating his first quarter-century of working on the strip, Schulz wrote:

> We have covered the world with licensed products – everything from sweatshirts to lunchboxes to toothbrushes – and have been criticized many times for this, although for reasons that I cannot accept. My best answer to such critics is always that the feature itself has not suffered because of our extracurricular activities. I have drawn every one of the 10,000 strips that have appeared and I have thought of every idea. Not once did I ever let our other activities interfere with our main product – the comic strip.[70]

It is clear from Schulz's comments that he took his role as a cartoonist – as the single guiding creative force behind *Peanuts* – extremely seriously, but, particularly insofar as he openly embraced the mercantile aspect of his work, he brings himself up short of the classic mythology of the economically disinterested and autonomous artist described by Pierre Bourdieu and others. Nonetheless, because of his steadfast refusal to employ art assistants ('I have too much pride to use anyone else's ideas'), Schulz is frequently singled out as an outstanding example of the comics artist. At the same time, Schulz himself never declared a strong interest in art world recognition: 'It is important to me,' he wrote, 'when I am discussing comic strips, to make certain that everyone knows that I do not regard what I am doing as Great Art.'[71] For Schulz, the factors that mitigated the comics' claim towards 'Great Art,' and his own claims as a 'Great Artist,' were fundamentally the lack of autonomy. Comic strips, he noted, are produced on low-quality paper that means that much of the beauty in the drawing is not captured by reproduction; the artist is forced to serve many masters, including syndicate and newspaper editors (Schulz himself is said to have disliked the name *Peanuts,* which was forced upon his strip by United's editorial director Jim Freeman); and the work is compromised by its small size and the intrusion of things like copyright stickers. 'The true artist,' Schulz declared, 'working on his canvas, does not have to put up with such desecrations.'[72]

While Schulz may have disavowed aspirations to Great Art, others have been quick to step in and make the claim on his behalf. Writing of Schulz in the catalogue for the Masters of American Comics exhibition, John Carlin cited Schulz's near-total control of his strip as a remarkable thing that 'gave his work a unified psychological tone and a consistent visual style,' effecting a sort of minimalism that elevates the work beyond the mundane comic strip (in the spatial-temporal logic of the two-part Masters show, *Peanuts* is presented as the last great American comic strip).[73] Contemporary critics of *Peanuts* have found in it not, as per Robert Short, the uplifting word of God, but a singularly downbeat drone. In recent years, for example, *Peanuts* has been termed 'a comic strip at bottom tragic' by John Updike and a strip for 'all of us who ate our school lunches alone' by Chip Kidd; Walter Cronkite has declared that '*Peanuts* has caused me almost as much anguish as has been suffered, through vast disappointment or the dastardly doings of fate, by so many of Charles Schulz's wondrous characters'; and novelist Jonathan Franzen has been led to wonder 'was Charles Schulz's comic genius the product of his psychic wounds?'[74] Many are quick to answer Franzen's question

in the affirmative. David Michaelis, author of the best-selling 2007 biography *Schulz and Peanuts,* argues that there are fifty years of clues to Schulz's psychic state embedded in his strip. He depicts Schulz as a man seething with petty resentments and driven by remorse, arguing that he 'used cartooning to take "a sort of revenge on the world." '[75] Members of the Schulz family, who had previously cooperated with the author on his book, have angrily disputed Michaelis's depiction of the cartoonist. They denounced the biography in pre-publication articles in the *New York Times* and *USA Today.* In a fifty-page rebuttal of the book published in *The Comics Journal,* Monte Schulz called Michaelis's work 'unintellectual and amateurish,' rife with factual errors and deliberate mistakes.[76] Schulz's son writes that he had asked Michaelis 'not to repeat that worn out description of my father as perpetually dour and depressed, plagued by constant insecurities and identifiable fears. That wasn't the Charles Schulz I knew.'[77]

While it may not have been the Schulz his son knew, it is certainly the image of the man that has been constructed in contemporary efforts to position Schulz as a significant Great Artist. It is notable that so many contemporary comics artists working in serious, downbeat, or depressive traditions, including Chris Ware, Ivan Brunetti, and Dan Clowes, have appropriated a narrow element of the *Peanuts* mythology at the expense of its vast heterogeneity. This strategy is an important element in the process of distancing the mass cultural work from its original audience, a historically necessary step in the process of legitimating popular works that can be found in the examples of William Shakespeare and Charles Dickens. In the case of Schulz, it should be noted that the comprehensive chronological reprinting of every *Peanuts* strip in hardcover volumes, *The Complete Peanuts,* signals its status as a connoisseur's product largely by its subdued colour scheme and morose cover images (Charlie Brown frowning, Lucy crying, Snoopy wailing), which are at odds with the mass market softcover editions of Schulz's work that have proliferated for decades. To many, the *Complete Peanuts* books seem like an incongruous way to celebrate the work of a man who sold more than a million copies of a book titled *Happiness Is a Warm Puppy.*

Ultimately, of course, the question of whether or not Charles Schulz was the depressive figure that Michaelis depicts is an issue of limited value. Readers of his work, particularly his earlier work, may be struck by how different its tone is from the light-hearted comics that frequently fill the rest of the page, but, at the same time, it is difficult to reduce such a varied strip to a single melancholy note. Over the course of its

half-century run the strip adopted so many different points of view, shifts in tone, and narrative reframings that it is almost impossible to read through a single lens. Given the vast breadth of the strip's contents, it is not a work that reveals Schulz's 'true' personality, as his biographers and children might suggest. Rather, the debate over Schulz's character, and the way it shapes the interpretation of the strip and the way the strip is then positioned as art, entertainment, or even philosophy, has to proceed as if there is a transparent relation between artist and work if the ideology of genius is to be made manifest.

Conclusion

It is significant that none of the artists discussed here publicly proclaimed themselves as artists in the classic sense of the term. Carl Barks, who worked in complete anonymity behind the mask of Walt Disney before being discovered by fandom as his career was winding down, was not especially bitter about his status as what he termed 'a share-cropper on old Marse Disney's animal farm.'[78] Barks acknowledged that he was but one cog in a complex creative machine with strong editorial oversight and control by the licensor. He suggested that, were a typical comic story to fully recognize the contributions of all who worked on it, it might look like this:

> 'Halp! Halp! My Scalp!'
> Story suggestion by Oliver Oldhat
> Story script by Bleakwhistle J. Morningfog
> Pencil roughs by Smearcase Smudgefinger
> Dialogue lettering by Grimlips Firmhand
> Pen Inking by Scratchmore Vividly
> Brush inking by Eustace B. Sloppy
> After this monumental title would follow four panels of pratfalls by Pinhead Pigeon. I doubt that the public would know which of the formidable array of contributors most deserved an accolade of whatever was handy.[79]

Even Jack Kirby, who laboured in semi-anonymity for much of his career before becoming frustrated by the growing fame of his collaborator, Stan Lee, accepted the fact that comics operated as an entertainment engine, churning out stories in which individual actors were easily replaced. Refusing to join the Society for Comic Book Illustrators organized by Bernard Krigstein in the early 1950s, Kirby took what he saw as a realist

stance in regard to his place in the order of things: 'An artist had to be humble, an editor must be officious, and a publisher must be somewhere out in the galaxy, enjoying godhood. It was a caste system, pure and simple.'[80] These attitudes are indicative of how, in the early days of the comic book industry, even the most popular and highly praised cartoonists failed to conceptualize their work as capital A 'Art.' Rather, it was only retroactively, notably in the wake of the pop art explosion and the simultaneous, but unrelated, rise of the underground comics movement (discussed in chapter 8) that the possibility of taking cartoonists seriously as artists became fully possible, as comics artists began the process of masculinization seemingly required by the art world.[81] It is not surprising, therefore, that so much of the effort to lionize Kirby is built around the work that he did beginning in the 1960s, which featured hypermasculine superheroes created for a predominantly male audience of comic book fans rather than, for instance, his work on Prize's *Young Love* romance comics of the 1940s that were read by young women and girls.

Significantly, almost all claims about the importance of these cartoonists as artists have arisen retroactively and originated within comics fandom. A particularly striking example of the tendency to reposition and valorize comic book artists in light of the influence of pop art was the book *Maximum FF*, published in 2005 by Marvel Comics. An oversized hardcover with an elaborate fold-out dust jacket, *Maximum FF* is a 234-page version of the first issue of *Fantastic Four*, by Stan Lee and Jack Kirby, originally published as a twenty-five-page comic book in 1961. The entire project, described as a 'visible exegesis of *Fantastic Four* #1,' was 'conceived and orchestrated' by the crime novelist Walter Mosley, designed by Paul Sahre, and included essays by both Mosley and Kirby biographer Mark Evanier. Mosley and Sahre expanded the original work almost ten-fold by dramatically restructuring it: by disaggregating the individual panels and presenting them one per page, one per double-page spread, and even, on two occasions, as quadruple-page gatefolds. The effect is to destroy the original integrity of the page layouts of an artist who was particularly admired for his contribution to the development of the language of the comics page and to replace it with a book composed entirely of 'splash' pages.[82] The splash page, an entire comic book page (or even double-page spread) composed of a single image, are particularly valued by collectors of original comic book art because they often present characters drawn on a larger scale than is typical for a comic book and, consequently, are more impressive when framed.[83] For

some collectors, the splash page and the comic book cover are the most valuable parts of the comic because they are most akin to traditional gallery and museum aesthetics – they are not tainted by the sequentiality that is often held to define the comics form. Mosley, in is essay in *Maximum FF,* subscribes to this viewpoint: 'I would like to see these images blown up to even larger proportions and hung in art museums so that comic enthusiasts, young and old, can see their tastes and their underpinnings celebrated as art.'[84] Like Lichtenstein, Mosley transforms Kirby's work first by stripping it from its context, and second by expanding its size and scope, in the hopes that this will render it 'art' ('the drawings themselves must, I feel, be seen as art,' he writes).[85] Yet, at the same time, Mosley hopes to invert the power relations implicit in the relationship between the fields of comics and fine art. Where Lichtenstein's painting *Image Duplicator* (1963) appropriates the likeness of Magneto from *X-Men* #1 in order to depict a generic superhero villain drawn by an artist whose own history is seen as unimportant, Mosley ventures to place Kirby on the same lofty pedestal as the rival who once duplicated his drawings.

Ultimately, the efforts of comics fandom to establish the credentials of Schulz, Kirby, Barks, and even Hanks is a battle for control of the discourse surrounding these works. Mosley states quite bluntly that *Maximum FF* is 'about the art and our perception of it,' and he is correct insofar as perceptions are what is really at stake.[86] The drive to create full-fledged and self-conscious comics 'Artists' places the creative labour of certain select cartoonists in opposition to the industrial and corporate structures in which they created the works for which they are most famous. Furthermore, these efforts seem to be as much about demonstrating the power of organized comics fandom as they are about the amelioration of the reputation of the artists. For example, without the efforts of Disney fandom, Barks would never have been acknowledged as the creator of those works. Indeed, when he was discovered and first interviewed by comics fans, the publication of that interview was delayed for several years until after the death of Walt Disney because there was a desire on the part of the publisher to maintain the facade that Disney actually created the work until the point that it would have been self-evidently impossible for him to have done so.[87] That Barks became successful as a painter of the Disney ducks in his retirement, and that he was so widely known as an artist, is almost exclusively to the credit of comics fans and their ability to recuperate the reputations of preferred cartoonists. Similarly, in the case of Jack Kirby, the fact that he has been hailed

as a genius in as dignified a patron of mainstream culture as the *New York Times* is testament to the influence of fandom in the critical recirculation of comic books. At the same time, however, fandom did not make the reputation of Charles Schulz, who was both tremendously well-known and exceptionally popular during his lifetime thanks to the ubiquity of his work. In that case, the specific recasting of Schulz as a depressive artist reflects the need of fandom to shift the basis of his reputation from one rooted in popular acclaim to one that flatters connoisseurs of the history of the form.

The validation of the comics form, which is an essential aspect of fannish epistemology, can take many paths. One of these paths would be the outright rejection of the conservative basis of much of modernist art history, with its conflation of masculinity, artistry, and genius, and the adoption and promotion of new aesthetic standards that would recognize the importance and vitality of feminized mass cultural forms. Another, far less revolutionary, route would be a capitulation to the dictates of modernist art history and the nomination of a select few cultural workers to the position of Artist or Author. In the wake of pop art, it was this latter approach that was most commonly, and effectively, utilized by comics fandom, as they worked to export the idea of the comics artist beyond the limitations of the comics world. From this vantage point, the fact that the *New York Times* accorded Jack Kirby an obituary at all can be regarded, within fandom, as a victory for comics. Simply, it follows the dominant logic of art history that, in the battle for legitimacy, the success of the best and brightest will pave the way for the recognition of the form as a whole. This logic, which depends on the discursive creation of a manageable number of artists and masterpieces, remarkably mirrors the logic expounded by Stanley Ford at the conclusion of *How to Murder Your Wife*. Faced with the certainty that he will be erroneously convicted of disposing of his wife's body in the concrete of a New York construction site, Ford 'confesses' the crime but pleads with the all-male jury to set aside the verdict for their own sakes. Facing a dozen hen-pecked husbands, he pleads with them: 'If one man, just one man, can stick his wife in the goop from the gloppa gloppitta machine and get away with it, oh boy, we got it made, we have got it made, all of us.' By the same token, if one cartoonist, just one cartoonist, can be termed a genius in the pages of the *New York Times,* oh boy, we got it made, cartoonists have got it made, all of them.

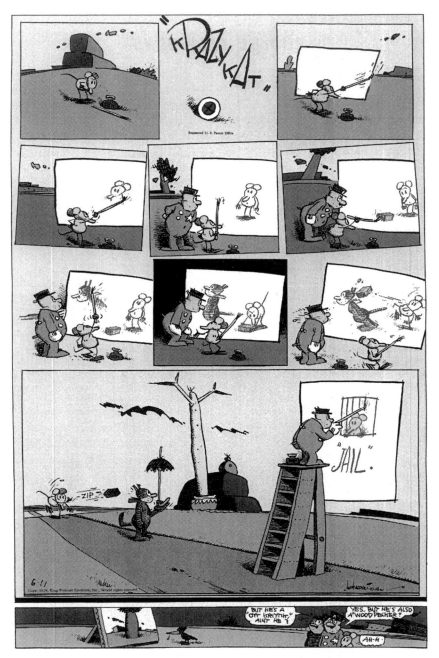

George Herriman, *Krazy Kat*, 11 June 1939. ©King Features Syndicate, Inc.

Cartoons as Masterpieces:
An Essay on Illustrated Classics

I've been designated not as a comic book artist because I did something that got a Pulitzer Prize.

Art Spiegelman[1]

In 1952, the American poet Delmore Schwartz published an essay in *The Partisan Review* titled 'Masterpieces as Cartoons: An Essay on *Classics Illustrated*' in which he sought to come to terms with the phenomenon of the then-popular *Classics Illustrated* comic book line, adaptations of canonical literary works in comic book form.[2] Schwartz, a fervent opponent of mass culture, argued that with these bastardizations of the classics 'the bottom of the pit has been reached.' Echoing the comments of Clement Greenberg on the minimal demands that 'kitsch' makes of its audience, Schwartz suggested that the 'intention [behind the comics], I suppose, is to help the reader as much as possible and keep him from being in the least perplexed or from feeling that he has to make any serious exertion beyond keeping his eyes open.'[3] Schwartz draws a stark line between what he perceives as the triviality of the *Classics Illustrated* comics and the 'genius' of the works upon which they are based. At the height of the postwar mass culture debates, it would have been absurd for a writer like Schwartz to find any sort of equivalency between Fyodor Dostoevsky's *Crime and Punishment* or William Shakespeare's *A Midsummer Night's Dream* and their comic book adaptations; more than likely, that has not changed even today. The gulf between the reputations of these works and their comic book versions is so vast as to be virtually unbridgeable. Yet the question that Schwartz does not even think to pose in his

essay is this: What would it require for a comic book or strip to be seen in the same light as the great novels and plays of the Western tradition?

Schwartz's title has been inverted here so as to reverse the premise of his initial question by asking what would be required for individual comics works to be considered 'masterpieces.' Several answers naturally suggest themselves. It would be possible to suggest, for instance, that individual works might be recognized as masterpieces within the comics world without necessarily elevating the general social status of the form as a whole. To that end, a small number of comics works have been widely praised beyond the field of comics, opening interesting avenues of exploration relating to how and why certain works are seen to transcend the limitations of their form. One explanation would be that these comics have 'risen' to the lofty standards demanded of other, cognate, art forms, thereby demonstrating their relevance and importance. That said, as more and more works reach this pinnacle it becomes possible to suggest that the terms of the debate have shifted to such a degree that previously maligned forms, such as comics, have become a legitimate part of contemporary cultural discussions. The real question, then, becomes: Have the criteria of value changed in this postmodern period, or have comics artists finally begun to create works that meet the pre-existing criteria for greatness implicit in Schwartz's article?

To resolve this issue, it seems useful here to return for a moment to the work of Howard Becker. He reminds us in his chapter on aesthetics, aestheticians, and critics that the stabilization of values and the regularization of practice requires 'a coherent and defensible aesthetic' that will generate a consensus around objects.[4] This aesthetic, Becker argues, is provided by aestheticians, who 'provide that element of the battle for recognition of particular styles and schools which consists of making the arguments which convince other participants in an art world that the work deserves, logically, to be included within whatever categories concern that world.'[5] One problem in the case of comics has been the fact that, as was discussed in chapter 2, aestheticians have primarily, though not exclusively, given the bulk of their attention to the formal definition of comics *tout court*, rather than championing specific styles or schools of creation. That is to say, they tend to focus on the question of whether a work is or is not a comic, rather than on what rank it should hold within the field. A second problem stems from comics' dependence on a socially marginalized audience, fans, as proponents of the particular aesthetic values associated with comics. Henry Jenkins's conception of

fans as a 'powerless elite' brings to mind the way that competing forms of writing and publishing are differentially valued.

In a 1983 article that analyses how literary works become masterpieces, C.J. van Rees provides a useful framework for analysis with the contention that there are three distinct forms of critical arts writing: journalistic criticism published in newspapers and general-interest magazines, which offers a quick evaluation of a work; essayistic criticism published in specialty magazines, which focuses on longer and more in-depth coverage; and scholarly criticism published in academic books and journals, which aims at a highly specialized audience of researchers and teachers.[6] Van Rees argues that critics are co-producers of a text insofar as they not only guide the adoption of a book, but also frame its analysis by highlighting what is important about the work.[7] For Van Rees, the three critical forms complement each other and share numerous traits insofar as they are all simultaneously descriptive, interpretive, and evaluative, and all lead to the hierarchical classification of texts. It is important to note how each stage of criticism narrows the conception of the field. The sheer bulk of comics production means that journalistic critics can not review all comics, and an even smaller number of releases become the subjects for essayistic critics. Academic critics will take up only a tiny fraction of overall production and are therefore the most important players in the struggle for prestige and legitimation.[8] Significantly, van Rees conceptualizes the relationship of criticism not to power, as Jenkins does, but to the passage of time. Journalistic critics are most focused on contemporary works (new releases), whereas academics, who claim to be more selective and hold to a higher set of criteria, draw on creators from the past based on a conception of artistic worth that can be reconciled within specific theoretical frameworks.[9]

The strict application of Van Rees's categories is problematic in the comics world because, unlike cinema, television, music, and literature, comics do not have a particularly strong tradition of journalistic criticism and, indeed, are only infrequently the subject of newspaper and magazine coverage outside the comics world itself. Instead, comics do have a specialized equivalent of journalistic criticism in the form of fan-run websites and blogs whose central purpose is to help formulate the comics-reading community, often at a distance.[10] While this type of writing is sometimes critical, it is, as noted in the previous chapter, most often defined by its celebratory nature by virtue of the absence of disinterested critics. While most media forms are evaluated by professional critics,

comics are most frequently reviewed by readers who have already chosen to spend their own money on the product, a process that weeds out the majority of potentially negative commentary. The presence of a modified, tripartite discursive model in comics necessarily raises an important question, and one that this chapter seeks to partially resolve, namely: What is the relationship between the celebratory exegeses of fandom and academic writing on comics, which, according to the demands of that field, aspires to disinterestedness? To unpack the tight connections that exist between comics fandom, comics scholars, and writers and critics concerned with the arts broadly, it will be instructive to examine a selection of comics works routinely held to be 'masterpieces' of the form. In so doing, it will be easier to perceive a transformation of the comics object than a shift in the legitimating logic of the art world brought on by a new attention to comics. Indeed, it is still fair to say that, for the most part, there is almost no thought given to comics, as a form, by the art world, but that singular works, often perceived as *sui generis,* are nonetheless welcomed within the field of legitimate culture. This phenomenon cuts to the heart of what Art Spiegelman means when he says that he has been designated as something other than a comic book artist, and it is crucial in terms of the understanding of the social position occupied by comics as an art form.

Krazy Kat: The First Comics Masterpiece?

In a 1946 book review for *Partisan Review,* Robert Warshow described the adherents of 'Lumpen culture' as 'those who have no real stake at all in respectable culture. These are the open enemies of culture . . . these are readers of pulp magazines and comic books, potential book-burners, unhappy patrons of astrologers and communicants of lunatic sects, the hopelessly alienated and outclassed.'[11] For Warshow – one of the signature conservative thinkers commonly grouped among the so-called New York Intellectuals and an intellectual contemporary of Schwartz – the aesthetic alienation of the comic book reader was so extreme that the political consequences appeared dire: 'They are ready to be assured and irresponsible, they are ready to say: Shoot the bankers, or Kill the Jews, or Let the Nazis come.'[12] Of course, the author's equation of comic book reading with the worst attributes of what José Ortega y Gasset had termed the 'mass man,' was merely an extreme example of the anti–comic book rhetoric that characterized the pages of many respected journals of opinion in the post – Second World War era. At the same time, however,

Warshow saw a larger issue at play. Despite its self-evident atrociousness, he argued, when the 'Lumpen culture' displays itself in mass culture it 'can occasionally take on a certain purity and freshness that would almost surely be smothered higher up on the cultural scale.'[13] To this end, he suggests that George Herriman's comic strip *Krazy Kat*, collected that year into book form by Henry Holt, occupied the privileged space between cultures, essentially a highbrow work in a lowbrow form: 'Where no art is important, *Krazy Kat* is as real and important a work of art as any other.'[14] While contending that the strip could sometimes become 'mechanical,' he suggested that Herriman's work was a radical departure from the standards of the comic strip page, the unique artistic achievement that promised to elevate not only the comic strip form, but its apparently Nazi-welcoming audience as well.

In his appreciation for the strip, Warshow was far from alone. The artists Pablo Picasso and Willem de Kooning are frequently cited as admirers of Herriman's work, and, of course, in the 1960s Swedish pop artist Öyvind Fahlström created a number of works in his *Performing K.K.* series incorporating elements from the strip. Along similar lines, Gilbert Seldes, the New York intellectual most frequently drawn to defences of the popular arts, rhapsodized about the work in a 1922 article for *Vanity Fair* titled 'Golla, Golla, the Comic Strips Art!' Here he suggested 'the correct thing to say about *Krazy Kat* is How wonderful that such a delightfully fantastic creature should be found in the company of the vulgar comic strip,' and, further, 'at the risk of making all my claims seem ridiculous' that Herriman is 'a fine artist.'[15] Two years later, in *The Seven Lively Arts*, Seldes placed Herriman in the company of Charlie Chaplin, Al Jolson, Irving Berlin, and Ira Gershwin as significant artists working primarily or exclusively in the maligned popular arts, going so far as to suggest that *Krazy Kat* is 'the most amusing and fantastic and satisfactory work of art produced in America today.'[16] In a 1939 essay, Damon Runyon heaped praise on Herriman, terming him an 'artist's artist' ('He may not be the greatest draughtsman in the world but he has the imagination of a Grimm and the lyrical expression of the poet') whose strip is the work of 'a genius.'[17] Similarly, in the introduction to the 1946 book of *Krazy Kat* strips that attracted the attention of Warshow, the poet e.e. cummings penned an homage to Krazy Kat, the character rather than the strip per se, extolling his or her value as a romantic ideal: 'Yet the truth of truths lies here and nowhere else. Always (no matter what's real) Krazy is no mere reality. She is a living ideal. She is a spiritual force, inhabiting a merely real world – and the realer a merely real world happens to be,

the more his living ideal becomes herself. Hence – needless to add – the brick.'[18] For these artists and critics, it is clear, Herriman's *Krazy Kat* was a significant aesthetic accomplishment – a masterpiece of the comics form – something so singular among the degraded and degrading comics culture that it shone like a beacon, an exemplar of the potential that was so regularly squandered by practitioners of the comic strip.

If *Krazy Kat* were to be considered a masterpiece according to the critical standards of the first half of the twentieth century, by what criteria could this claim be substantiated? What were the characteristics of the strip to which these writers and artists so favourably responded? Martin Sheridan, author of *Comics and Their Creators,* suggested in 1942 that 'the highest-browed critics in the world have joined with the masses in acclaiming his distinctively original style of art,' while, in *The Comics,* Coulton Waugh deemed Herriman the only cartoonist worthy enough to be given his own chapter, arguing that the artist was 'always experimenting, searching for the perfect expression of his unique personality.'[19] For these early critics of the comic strip form, Herriman's genius could be best located in the work's formal elements, particularly in the drawings. Nonetheless, other critics singled out the strip's themes, as we have seen with Seldes and cummings, as well as its use of language. In *Comics as Culture,* M. Thomas Inge praised the strip for its 'free and footloose way with the English language,' and in an article in the *Journal of Popular Culture* comparing Herriman to Erasmus of Rotterdam, Tim Blackmore noted that the cartoonist is 'both aware of and in love with language.'[20] Celebrated equally for his innovations in both drawing and writing, *Krazy Kat* was slighted only occasionally for the thinness of its plot, which revolved largely around three characters: Krazy Kat, who, in an inversion of the natural order, longed for romantic love with Ignatz Mouse, who in turn, sought only to brain the cat with bricks, and Offissa Pup, the dog who protects the cat, whom he himself loves, by jailing the mouse. As Seldes noted, the brick, charged with emotions, is not an element of violence but is itself a powerful symbol. Moreover, he argues, 'the theme is greater than the plot.'[21] Inge also regards the plot as largely incidental, focusing instead on what he sees as the strip's key characteristics: 'a childlike simplicity and sense of wonder, an aggrandizement of the unreasonable, a reversal of the logical order of things, a denial of common sense, a continuous transmutation of objects and landscapes, and a disorientation for the reader with regard to a rational frame of reference.'[22] Thus, in sum, *Krazy Kat* is acclaimed for its formal inventiveness, its spirited open-mindedness, its creativity and innovation within the limitations of the

comic strip form. All of these elements, which endeared it to serious art-
ists and critics, also tended to make it esoteric and inaccessible to most
comic strip readers. While the work was long-running because it had a
strong champion in newspaper magnate William Randolph Hearst, it
was never particularly popular and, in its later years, might have been
cancelled were it not for the dedicated support of the syndicate owner.
Patrick McDonnell, Karen O'Connell, and Georgia Riley de Havenon,
whose book *Krazy Kat: The Comic Art of George Herriman* is the most sus-
tained analysis of the merits of the strip, have argued that *Krazy Kat* was a
'brilliant work of nonsense, farce, and whimsy, touched with heart' and,
further, that Herriman was 'a poet' of the comic strip form, a term that
has come to connote unparalleled artistry in the face of popular indif-
ference.[23] Thus, in the era before the formation of organized comics
fandom, critics could single out exemplary works of comics, but did so
by aligning them with standards imported from other art forms. As late
as the mid-1940s, an era in which 'Lumpen culture' was still seen to be
a significant social concern, there was virtually no effort made, nor even
possible, to enumerate an aesthetic position that could justify *Krazy Kat*
in terms of its contributions to the comics form. That would change with
the rise of organized comics fandom in the decade that followed.

EC Comics and the Aesthetics of the
Comic Book Masterpiece

While Robert Warshow's interest in comics did not run deep, he did
return to the subject almost a decade after he praised Herriman. In a
1954 essay on his son, Paul, that touches upon EC Comics fandom and
the movement against horror comics exemplified by the writings of
Dr Fredric Wertham, Warshow softened the sharpness of earlier criticisms
of mass audiences while nonetheless holding to his position against mass
culture. Reading his son's EC Comics, the critic suggests that the works
'display a certain imaginative flair.'[24] Comparing the satire of American
popular culture offered by *Mad* and *Panic* to the clowning of Jerry Lewis,
he acknowledges that the magazines are apparently popular among col-
lege students and admits to reading them 'with a kind of irritated plea-
sure.'[25] EC's crime, horror, and science-fiction stories, on the other hand,
display the same 'undisciplined imaginativeness and violence without the
leavening of humor,' and the result is an 'utter lack of modulation' that
feeds into a child's desire to receive immediate satisfaction.[26] In the end,
having considered the magazines themselves, Paul's arguments in their

favour and Wertham's case against them, Warshow concludes: 'I don't like the comic books – not even *Mad,* whatever I may have unguardedly allowed myself to say – and I would prefer it if Paul did not read them.'[27] Thus, where the author could find things to celebrate in the artistry of George Herriman, he feels let down by EC Comics and optimistic that his son will simply outgrow his fascination with comics.

Much of the rest of Warshow's essay is given over to a critique of the writing of Fredric Wertham, whose 1954 book *Seduction of the Innocent* was the most visible artefact in the so-called war on the crime and horror comics of the 1950s. While Warshow is sympathetic to many of Wertham's conclusions about these comics, he has serious reservations about the tone ('Dr Wertham pursues his argument with a humorless dedication') and what he regards as his failure, a sentiment echoed by the comic book publishers of the period, to distinguish between bad comic books and good ones.[28] As Warshow notes, 'Dr Wertham is largely able to ignore the distinction between "bad" and "good" because most of us find it hard to conceive of what a "good" comic book might be.'[29] With this, the critic puts his finger on the greatest irony of the anti-comics debate: the comics published by EC that he has just dismissed as 'undisciplined imaginativeness and violence' are most frequently held to be artistic highpoints of the comic book medium at the time Warshow was writing. Indeed, few comic book companies have been as widely and elaborately praised as has been EC. Writing in a special issue of *Print* dedicated to comics, Gary Groth argued that 'the first comics publisher to take a genuine pride in the level of craft was William Gaines,' whose science-fiction, horror and war comics are 'generally considered the best mass-market comic-book line ever produced.'[30] In particular, it was the New Trend titles of the early 1950s that were most widely praised. At the time, EC published work in the horror (*Tales From the Crypt, The Vault of Horror, The Haunt of Fear*), science-fiction (*Weird Science, Weird Fantasy*), crime (*Crime Suspenstories*), and war (*Frontline Combat, Two-Fisted Tales*) genres. Each title featured a selection of short stories, often written by editors Al Feldstein and Harvey Kurtzman in collaboration with publisher Gaines. Typical of the EC format was the surprise or twist ending, modelled on the short fiction of O. Henry (William Sydney Porter), which was often condemned as formulaic.[31] While the standardized and pulpish plotting (editor Al Feldstein wrote four stories per week for nearly five years) had its fans, it was EC's dedication to idiosyncratic illustration styles that cemented the company's reputation in the eyes of its most devout fans. Among the artists who worked for the company during its glory years

were Jack Davis, Will Elder, Jack Kamen, Johnny Craig, Wally Wood, Graham Ingels, John Severin, Al Williamson, George Evans, Alex Toth, and Frank Frazetta, each of whom has come to be regarded as an important figure in the history of American comic book illustration even while, for the most part, they remain largely unknown outside the circles of comics fandom. Further, because EC was among the earliest comic book companies to consistently credit their artists' work, the relative fame of these artists was heightened among comic book fans of the period. Evidence of the continuing interest in EC as the best publisher of its time can be seen in the fact that its catalogue of works has been republished no fewer than eight times, including as a series of artist portfolios published by Russ Cochran from 1971 to 1977, as a comprehensive EC Library of hardcover black and white books beginning in 1978, and, beginning in 2006, as a newly re-coloured collection of hardcover books known at the EC Archives. Significantly, each of these many reprint efforts positions the EC output as an entire collection, suggesting that it is the *entirety* of the EC line that is important within the history of the American comic book industry, rather than selected works of individual writers or artists.

At the same time as they have been widely praised within comics fandom, the EC titles have been the source of controversy. As early as 1954, Warshow addressed the postwar campaign against crime and horror comics as a battle between Fredric Wertham and William Gaines, and that framing of the issue has largely held over the ensuing half-century. In April 1954, both Wertham and Gaines testified in New York before the United States Senate Subcommittee on Juvenile Delinquency on the issue of the relationship of comic books to youth criminality. Wertham maintained, as he argued in *Seduction of the Innocent,* that crime and horror comic books were a contributing factor in the rise of juvenile delinquency. Gaines, speaking after Wertham, refuted this charge. The televised hearings were widely publicized at the time, and Gaines's poor performance in front of the committee (he testified that a cover image illustrating a woman's decapitated head with blood coming from her mouth was in 'good taste') had the effect of convincing many comic book publishers, including Gaines, to adopt a self-censoring production code. When Gaines's comics fell afoul of the newly implemented code, and when changes in the magazine distribution landscape left him fewer opportunities to sell his publications, Gaines abandoned his New Trend titles for New Direction. These titles, much less widely acclaimed and much less financially successful, were unable to support the company, and in 1955 EC converted the successful *Mad* to magazine format and

abandoned the comic book field. For many fans and historians, this decision marked the turning point in American comic book history, the moment at which the most unique and challenging comic book publishers left the field. Indeed, David Hajdu, whose popular history *The Ten Cent Plague* casts the anti-horror comic book story precisely as a showdown between the heroically noble Gaines and villainously censorial Wertham, has argued that the death of EC Comics coincided with the moment when comics lost their idiosyncratic appeal to young people.[32] Positioned as the aesthetic highpoint of the periodical comic book, the EC story is traditionally read by the comics world as a tragedy in which outside forces extinguished the brightest ray of light within the field.

The acclaim accorded EC Comics is not simply a matter of historical revisionism. The attention paid to the company stems in large measure from the fact that its major works have been continuously reprinted (something that is not true of the vast majority of American comic books of the period). It must also be noted that, even at the time they were actively publishing new work, EC generated a much more organized fan following than did their competitors. In part, the company itself facilitated this fandom. Lacking ongoing characters in their titles like Superman or Batman that would spur repeat purchases, EC used a clubhouse strategy in their titles to generate fan identification with the small company. Crediting individual artists was one strategy that would humanize the creators and make them seem approachable to readers, encouraging reader identification with EC as a small, outsider publisher striving to raise the level of the form. Beginning in 1953, EC took this a step further by organizing the EC Fan-Addict Club. For the cost of twenty-five cents, EC fans received a membership kit and the *Fan-Addict Bulletin*. About 23,500 fans became members of the club. Printed on both sides of a single sheet of paper, the *Fan-Addict Bulletin* provided news about upcoming EC publications and gossip about the personal lives of the artists. The first issue (November 1953), for example, noted that George Evans's wife had just given birth to a daughter, that the Kamens were expecting their third child, and that the Craigs had adopted a Scotch terrier named 'Scruff.'[33] Perhaps the most important feature of the first *Bulletin* was the creation of a back-issue trading post in which readers were encouraged to write in with their name and address if they had old copies of EC back issues for sale or trade. Dozens of names and addresses were published in the second issue (March 1954), facilitating the creation of a correspondence network among EC fans. At the same time, the first issue of the *Bulletin* announced the release of two issues of Bhob

Stewart's *EC Fan Bulletin,* a self-published fanzine available for ten cents, and organized EC fandom was born.

Bhob Stewart launched *The EC Fan Bulletin* in the summer of 1953 from his home in Texas, producing it on a hectograph and selling it to eighty subscribers. The *Fan Bulletin* was among the earliest fan-produced magazines (fanzines) dedicated exclusively to comic books, and its publication helped to cement the association between fan connoisseurs and collectors. Martin Jukovsky and George Snowden, the latter of whom provided a physical description of the EC offices, contributed the news in the first issue. A second issue was mailed to subscribers in October 1953, and the project then ended because of Stewart's dissatisfaction with the hectograph process. In June 1954, Stewart, working with Ted White and Larry Stark, launched a second EC fanzine, *Potrzebie.* Inspired by a comment made by Wertham in *Seduction of the Innocent* ('Every medium of artistic and literary expression has developed professional critics . . . the fact that comic books have grown to some ninety millions a month without developing such critics is one more indication that this industry functions in a cultural vacuum'), Stewart envisioned *Potrzebie* not as akin to science-fiction fanzines, but to the 'little magazines' that published the likes of Robert Warshow.[34] When the fanzine was profiled, along with three others, in the fourth issue of *The EC Fan-Addict Bulletin,* Stewart received several hundred letters of inquiry but was reportedly appalled at their juvenile quality and consequently abandoned work on the second issue; the title was taken over by Larry Clowers. The other fanzines promoted by *The Fan-Addict Bulletin* included Mike May's *EC Fan Journal,* which ran six issues in the 1950s and included contributions from M. Thomas Inge long before he wrote about *Krazy Kat* in *Comics as Culture,* Barry Cronin's *EC Scoop,* and the *EC Slime Sheet* by Ernie Crites. The importance of these fanzines in creating a sense of community among readers, however fleeting, was touched upon by Mike Britt. Writing in the eleventh issue of *Squa Tront* (itself a second-generation EC fanzine originated by Jerry Weist in 1967 that has been edited by John Benson since the fifth issue [1975], becoming, in 2002, a glossy magazine published by Fantagraphics that caters to the nostalgia market), Britt detailed how, as a teenager, his life, and that of his friend Robert Crumb, was changed by the discovery of *Spoof,* a fanzine dedicated to the Kurtzman-edited humour magazine *Humbug.* These fanzines, Britt recalls, made the boys eager to begin producing, with the help of Charles Crumb, their own work in the form of a fanzine called *Foo,* which included some of the earliest published work by the Crumbs.

Aside from the corporate promotion, community-building, and social-networking aspect of the fanzines, it is important to note that they also performed a central role in establishing the earliest comics world discourses pertaining to artistry in the form. While public intellectuals like Warshow and Seldes made contributions to the appreciation (or dismissal) of comics before the arrival of comics fanzines, and while Sheridan and Waugh had established some dialogue on the comic strip, it was the fanzine publishers and contributors who were the first to offer a sustained analysis of comics, and in particular comic books. To this end, Stewart's self-conceptualization of *Potrzebie* as a 'little magazine,' and his disappointment upon learning the actual age and interests of his readership, is indicative of the way in which fandom has historically organized itself in parallel to public intellectualism and arts criticism. In such a marginalized field, and at a time when it was all but impossible to conceptualize a serious literary or art historical analysis of comics in an academic forum, fans took it upon themselves to organize these forms of knowledge by creating their own venues for what Van Rees terms essayistic criticism. Thus, just as Disney fans tracked down and revealed the man behind the best Donald Duck comics, so too did they undertake the initial steps in the process of evaluating and debating the artistic merits of comics producers.

It was in the fan-produced publications dedicated to EC Comics in the 1950s that fandom took the first tentative steps towards outlining a theory of the value of comics. Importantly, they did so in publications that, by the very nature of their limited range of appropriate subjects and their highly restricted audience, take the value of their object of critical interest as an a priori given. Readers of *Squa Tront* or *Potrzebie* are, by the very fact that they are readers of EC fanzines, presumed to be fundamentally interested in the EC product and do not have to be convinced of the general virtues of contemplating the subject. Thus, there is little need to justify the merits of the work, which are assumed by the readership, except in instances where a contrary position is deliberately staked out. Further, fanzines are seemingly more dedicated to expounding the point of view of their subjects than of their producers. This is particularly evident in the case of the *Jack Kirby Collector*, which, as was seen in the previous chapter, has a deep and abiding interest in revealing the 'truth' about Kirby's interests and intentions through interviews, notes, or testimony of his colleagues and friends. Similarly, in the case of the EC fanzines, emphasis is placed on the transcription of interviews and panel appearances, the unearthing of preparatory material, sketches and

uninked pencil drawings, all of which are regarded as testifying to the truth behind the work. Indeed, it is typical of fanzines that statements made by the subjects of the 'zines are seldom challenged as to their truth or authenticity. The reverence for the creators of artworks in fanzines can be near totalizing; thus, intentionality becomes the central organizing episteme, particularly of textual analyses. It is important to note, as well, that active comic book fandom comprised only a small fraction of the overall comic book readership. Stewart's fanzines were purchased by fewer than one hundred fans, while the EC comic books themselves sold hundreds of thousands of copies each month. Thus, while perhaps 10 per cent of all EC readers subscribed to the company's official fan club, fewer than 1 per cent of all EC readers were significantly dedicated to pursue the fan-produced publications advertised in EC comic books. This small percentage constituted the elite fan base, self-conceptualized as connoisseurs and dedicated to the identification and explication of significant works in the EC tradition.

No single story published by EC exemplifies the connoisseurist impulse to explain an author's intentions as well as 'Master Race.' Originally a six-page story written by Al Feldstein, it was reformatted by artist Bernie Krigstein as an extended eight-page work and published in the first issue of the New Direction comic book *Impact* (April 1955). Harvey Kurtzman described Krigstein as EC's 'fine artist' because he majored in art at Brooklyn College and aspired to a career as a painter before moving into comics in order to pay his bills.[35] Greg Sadowski, whose biography, *B. Krigstein,* is the most extensively detailed examination of the artist's life and career, supports Kurtzman's recollections. Sadowski quotes Krigstein as saying: 'I had a prejudice that comic books, as a form of art, were beneath my serious attention,' and, describing his work for Fawcett in 1947, 'These were 32-page stories appearing monthly. I believe I handled the chore almost single-handedly, including the covers. I never signed them; they were hack work of the purest distillation.'[36] Despite being mired, by his own admission, in the hackwork of low culture, Krigstein had greater aspirations, both politically and aesthetically. In 1952 he organized the Society of Comic Book Illustrators and was elected president of the organization, which was to be a short-lived attempt to unionize comic book artists in order to win group health benefits, the return of artwork to artists, and a minimum page rate.[37] Aesthetically, Krigstein always maintained the dream of being recognized for his paintings. He left the comic book industry shortly after EC stopped publishing comic books and turned to a career as an art teacher and painter, the latter with

limited success. A 1964 *New York Times* review of his work at the Salpeter Gallery on 57th Street read in its entirety: 'A show that gives the impression of an illustrator trying to be an artist, with the help of a good color sense. The recognition of subject matter immediately switches most of these pictures into banality. One that survives recognition is "Orestes." '[38] With reviews like this, Krigstein was unlikely to be well remembered for his paintings, no matter how much Harvey Kurtzman may have thought him a fine artist. Instead, he is remembered almost exclusively by comics fandom, and almost entirely for his work on 'Master Race.'

Krigstein was not one of the core EC artists, having come to the company later than many of his contemporaries. He produced only 251 pages for EC, in comparison to more than 1,200 each for Davis, Ingels, and Kamen, but eight of those pages are among the most celebrated in comics history, or, as Sadowski puts it, 'the story that assured his comics immortality.'[39] Drawn in March and April 1954, literally at the peak of the anti – horror comics controversy, 'Master Race' tells the story of Carl Reissman, a paranoid man who descends into the New York subway system only to be confronted by someone from his past. A flashback reveals that Reissman was involved in the Holocaust, and at the story's climax, the reader learns that he commanded the Belsen concentration camp. The man from his past is a Holocaust survivor now seeking vengeance; as he flees, Reissman stumbles to his death under the wheels of an oncoming subway train. While its subject matter, with its explicit references to Nazi atrocities, is unusual for a children's comic book, the narrative itself, which leads the reader to initially misidentify Reissman as a survivor only to reveal him as the commandant, is typical of Feldstein's 'twist ending' approach to storytelling. Despite its heavy theme, there is not much to distinguish the script, whose twist does little to illuminate the narrative situation, comment upon the characters, or provide insight into the atrocities of the Second World War. Further, Krigstein fundamentally altered the plotting and the pacing of the work by re-editing it on the drawing boards and expanding it by one-third its original length. Thus, it seems that virtually everything that is frequently praised in 'Master Race' is a contribution of the artist and is derived from the visual side of the comics form.

Krigstein himself recognized 'Master Race' as an important piece in his comics career. In a 1962 interview with Bhob Stewart and John Benson, he indicated that the story was his 'one favorite' and that 'in that one I think I reached a high point in developing my breakdown ideas . . . I happen to be extremely proud of it; I think it's a very serious effort.'[40]

The notion of breakdown, or page layout and design, is central to Krig-stein's conception of the story and crucial to his demand for additional pages so that the relation of image to text would be restructured. In his words: 'What I was fighting against all the time was that the text should be expanded at the expense of the story. What I would have wanted to do would be to expand the story so that the pictures would take up more room. In other words, in [Feldstein's] five pages stories, I would have wanted to do that in about fifteen pages.'[41] The importance of the artist's contribution relative to that of the writer was widely recognized in discussions of 'Master Race' in the fan press. Certainly the most notable piece of essayistic criticism on the story, 'An Examination of "Master Race"' by John Benson, David Kasakove, and Art Spiegelman, published in *Squa Tront* #6 (1975), makes that case explicitly. Calling it 'one of the finest stories ever to appear in the comics form,' the authors note that it is 'obvious that it is the artist's contribution that lifts the story out of the context of the twist ending comic book story and makes it a memorable artistic experience.'[42] The analysis presented by the authors, originally written by Spiegelman as a college term paper and later expanded by Benson and Kasakove, is a highly detailed page-by-page formalist reading of the techniques used by Krigstein in the story. The authors argue that the style used in 'Master Race' is the antithesis of traditional comic book illustration, downplaying exaggeration and frequent close-ups in favour of a more distanced and objective portrayal of events. Specific formal devices used throughout the short story are singled out for praise, including the sense of depth, the conceptual unity of images across tiers, the juxtaposition of text and image, the undermining of realist tendencies during moments of heightened intensity or trauma, the use of a flashback narrative structure, the utilization of subjective time, the transformation of panel sizes to heighten drama, and implicit references in the story to painters such as Piet Mondrian and Edvard Munch.[43] In all, the authors identify formal and thematic significance in virtually every panel of the eight-page story, constructing an argument that the 'layers of meaning and detail both in its form and visual content' that will reward attentive multiple re-readings of the work.[44]

Despite the acclaim afforded 'Master Race,' Krigstein was not a uniformly beloved figure within EC comics fandom. A letter from Gary Arlington in the sixth issue of *Squa Tront,* an issue that was entirely dedicated to Krigstein and which included the lengthy examination of 'Master Race,' indicated simply: 'I will make it a point not to include this issue as part of my life,' and the letters published in the seventh issue

in response were somewhat divided on the artist's merits.[45] In an essay published in *EC World Press* #4 (August 1954), Bhob Stewart had offered an 'evaluation and defense' of Krigstein, a title which indicates the fact that he occupied a controversial position even within EC fandom.[46] In the letters responding to the special issue of *Squa Tront*, Krigstein was accused by Bill Spicer of exemplifying an 'ivory tower point of view' and by Landon Chesney of lacking spontaneity ('I think Krigstein's concept of his own artistic integrity – and his compulsion to somehow be different – has quite often led him astray').[47] Nonetheless, it was precisely these qualities – the dedication to an idiosyncratic and uncompromising attitude about visual storytelling in comics – that have made Krigstein a central figure in the most restricted, connoisseurist realms of comics fandom.

Art Spiegelman's appreciation of Krigstein's contribution is particularly telling in this regard. Defended by Stewart in 1954, and then interviewed by Stewart and Benson in *Talk with B. Krigstein,* a special edition fanzine which distributed only 200 copies in 1963, Krigstein might have disappeared from the attention of fandom were it not for Spiegelman's close reading of 'Master Race' published in 1975. Since that time, Spiegelman has published several articles about the artist, further cementing his reputation as an important stylist and neglected voice in the field. In a 1988 special issue of *Print* dedicated to comics, Spiegelman described Krigstein as 'cool, analytic and intellectual,' compared him to Munch, and noted his techniques borrowed from modern painting and illustration, saying, almost in passing, that 'Master Race' is 'one of the great achievements in comics.'[48] Two years later, in a Krigstein obituary published in *The Comics Journal,* Spiegelman noted that comics for adults were finally flourishing and that the industry had finally caught up to what Krigstein had been doing more than four decades earlier. Calling him an 'explorer, a discoverer, a pioneer, a visionary,' he suggested that Krigstein had 'the misfortune to be an Artist with a large capital A working in an Artform that only considered itself a Business.' Speaking of 'Master Race,' he elevates the work to the status of 'masterpiece' and compares reading it in the 1960s to being struck by lightning.[49] Finally, reviewing Sadowski's Krigstein biography for *The New Yorker* in 2002, Spiegelman further strengthened his claim in support of 'Master Race,' calling it 'an accomplishment of the highest order – a masterpiece' and noting that the story has become 'justly famous among the comics literate.'[50] But not, of course, beyond the comics connoisseurs, that small percentage of comics readers who, like Spiegelman, become dyed-in-the-wool

members of organized fandom. Few artists owe so much of their critical reputation to a single work, to a single analysis of that work, or to a single commentator as Krigstein owes to 'Master Race' and its explication by Spiegelman. Of course, because of this, Krigstein's rise to relative fame is also inextricably tied to Spiegelman's own ascent up the hierarchy of artistic legitimacy. What is seemingly less commented upon, however, is how Spiegelman's own credentials are shaped by the critical position occupied by Krigstein.

Academe Discovers the Comics World: The Canonization of Art Spiegelman's *Maus*

Despite the fact that he has worked in comics for more than four decades, Art Spiegelman is actually known for only a small number of works: as the co-editor of the late-underground comics anthology *Arcade* (with Bill Griffith) and of the avant-garde new wave comics anthology *RAW* (with Françoise Mouly), and as the author of *Maus* (1986, 1992) and *In the Shadow of No Towers* (2004). *Comics Journal* editor Gary Groth contrasted Spiegelman with Robert Crumb, citing the latter as a 'landmark cartoonist' and the former as someone who has produced a 'breakthrough work,' which is to suggest that Spiegelman lacks Crumb's natural drawing gifts but has, on the whole, produced a more significant piece upon which to hang his overall reputation.[51] Indeed, it may be fair to say that outside the comics world Spiegelman is known almost exclusively for *Maus*, his widely praised and best-selling autobiographical comic book about his relationship with his father, a survivor of Auschwitz. *Maus*, serialized in *RAW* from 1980 to 1991 and collected in two volumes by Pantheon Books, is the most celebrated comic book ever published in the United States (and arguably the world), having won all the significant awards within its field, as well as a special Pulitzer Prize in 1992. The book relates the story of Art interviewing his father Vladek about his experiences during the Holocaust, mixed with extensive flashbacks. Significantly, Spiegelman adopts an anthropomorphic visual approach in the work. Drawing on the legacy of 'funny animal' comics, including, of course, Herriman's *Krazy Kat*, he depicts the Jewish characters in his book as mice, the Nazis as cats, the Poles as pigs, and so on. This approach, the subject of substantial controversy in discussions about the book, served as a marketing tool, stressing the work's uniqueness in the realm of Holocaust narratives, just as the seriousness of the subject matter set the work apart within the field of comics.

Because it was serialized in *RAW* for years before it was collected and presented to a public beyond the confines of the comics world, *Maus* was widely discussed within comics fandom long before it was taken up by journalistic critics and essayists in the mainstream press or in the academy, although writers in both realms subsequently devoted significant attention to the book's forms and meanings. Spiegelman himself has long been the subject of approving critical discourse in the pages of *The Comics Journal,* the magazine that most strongly advanced the form of essayistic criticism within comics fandom and which was most responsible for championing a vision of comics as a legitimate art form. In a 1978 article in the *Journal* John Benson, co-author with Spiegelman of 'An Examination of "Master Race,"' noted 'at some future time it may well become apparent that Art Spiegelman is perhaps the most innovative talent of the comics form in this decade.'[52] Many would argue that Benson misses the mark only with his tentative 'perhaps.' Reviewing the first issue of *RAW* two years later, Bill Sherman praised Spiegelman's ability to 'contrast pulp convention and academic aestheticism,' while Dale Luciano described him as 'the opposite of a hack' because 'he seems never to execute a piece of work until its concept and direction are clear in his mind.'[53] Thus, in the pages of *The Comics Journal,* Spiegelman was quickly established as the creative force behind the most important art comics magazine of its era ('everything in this magazine reads through the filter of Spiegelman's unique perspective') and as an avant-garde synthesizer of the interests and histories of fine art and comics.[54] The critical debate over the merits of *Maus* in *The Comics Journal* played a key role in developing that magazine's aesthetic orientation and, consequently, refined the connoisseurist position in the fan press.

Of all the *Journal*'s critics, it was Dale Luciano who first recognized the potential importance of *Maus.* Reviewing the second issue of *RAW,* which included the first chapter of *Maus,* he notes that if Spiegelman ever completes the entire work it 'could well end up a masterwork.'[55] In the coming years Luciano, now acting as associate editor of *The Comics Journal,* maintained his enthusiasm for the work, arguing, in a review of *RAW* #4, that the *Maus* chapter displays an 'uncommon intelligence' and a 'clearheaded purity in the plotting and drawing,' together with an absence of sentimentality and platitudinous sermonizing.[56] When the first volume of *Maus* was released in book form in September 1986, the first and second print runs (totaling 35,000 copies) sold out in less than two months and a third printing was rushed to stores.[57] Luciano reviewed the work for a third time in *The Comics Journal.* He opened his review by

arguing, 'Art Spiegelman's *Maus* is among the remarkable achievements in comics. It is a book that redefines the hitherto constricted boundaries of the comics medium; its creator's realization of the possibilities implicit in the graphic storytelling form is uncompromised. It is a work that will be recollected and argued about for years, a watershed event against which future advances in the medium will be measured.'[58] This exuberant praise of *Maus* is noteworthy for the fact that it is not simply a commentary on that particular work, but on the nature and history of the comics field up to that point in history and also an explicit declaration of the aspirations for the field and the form, held by an editor of fandom's most self-consciously 'serious' publication. The terms with which Luciano praises Spiegelman in the remainder of his review are similarly telling: the work is 'achingly honest'; the author is 'among the most talented of contemporary cartoonists' who 'doesn't release work until he's satisfied that he's evolved a form and style for the piece that are indigenous to the subject matter'; there is 'acute observation and skill in [the] writing'; and the work trades in 'ambiguity.'[59] In the end, Luciano returns to the type of effusive praise with which he opened his review, seeing the work as a vindication for the comics form as a whole: 'After *Maus,* nobody will ever be able to say that the graphic story medium isn't well-suited to convey the complexity and delicacy of human emotion. The goddamn thing is brilliant.'[60] The extent of the work's brilliance continued as a topic of debate over the next several years, with autobiographical comics legend Harvey Pekar arguing the limitations of the work in two lengthy essays, and a bitter back and forth with critic R. Fiore.[61] Pekar offered one of a very small number of dissenting opinions on *Maus,* suggesting that it was 'substantial and effective, but not without flaws.'[62] Pekar identifies several minor problems (Spiegelman's prose is 'often stiff'; the narrative 'sometimes rambles') and, more importantly, two major faults with *Maus:* first, its use of animal metaphors perpetuates negative stereotypes; and, second, Spiegelman denigrates his father in order to make himself look like a better person and the hero of the book.[63]

In his final commentary on *Maus* in *The Comics Journal,* Harvey Pekar suggests, 'since I'm virtually the only person, to my knowledge, to discuss its faults at length, you'd think scholars and critics would welcome my views, even if they disagreed with them.'[64] However, few scholars publishing on *Maus* in academic books and journals have turned to Pekar's opinions, even as the questions he addressed are among those that most frequently arise in the scholarly discussion of the work. Reviewing

Considering Maus, the only scholarly anthology dedicated to the book, Ole Frahm laments the fact that the field of comics scholarship is over-run and often directed by scholars from 'outside' the comics world, who share little deep knowledge of or affinity for it.[65] That significant insights into the comics as an art, industry, or cultural formation could be revealed by, say, scholars of the Holocaust, or of memory, or of Jewish identity does not seem to occur to Frahm, who conceptualizes comics scholarship largely as an extension or deepening of existing fandom and their epistemologies. While academic writers on *Maus* often addressed the same questions as fan critics, their conclusions were frequently quite at odds with the interests of the fans, to whom they naturally felt no allegiance.

Among the dozens of scholarly publications on *Maus* one of the most discussed aspects of the work is the subject that so greatly troubled Harvey Pekar, the use of anthropomorphic figures to tell the tale. Dominick LaCapra, for instance, agrees with Pekar when he writes that 'the representation of Jews, Germans and Poles presents serious problems.'[66] He argues, perhaps unusually, that it is unfair to animals to present them in the guise of humans, but also that it is dubious to represent entire peoples as bestial stereotypes. Nonetheless, as he notes, the representations are themselves problematized in the text. Indeed, it is likely that no page in *Maus* has been more discussed than the opening page of the second volume, in which Art and Françoise discuss how he will draw her (as a mouse? as a French frog?). Amy Hungerford notes that his presentation of her with a mouse head raises the issue of whether she is a mouse because she converted to Judaism, or because, through her husband, she is connected to the Holocaust. For Hungerford, it is clear that both general and particular identities in *Maus* are dictated by history.[67] Marianne Hirsch finds a similar lack of fixity in the anthropomorphism when she notes that while *Maus* may come close to duplicating Hitler's refusal of assimilation or cultural integration, it is clear that the characters in the work are only animals in relation to each other, to the Holocaust, and to its memory – not immutably.[68] Hirsch's article focuses largely on the use of photographs within *Maus,* a topic also taken up by Judith Goldstein, who suggests that, ironically, for many readers and art critics viewing *Maus* in a museum context, the use of animal heads increases the human dimension of the character, and, further, they provide an emotional distance for readers who find the events of Holocaust too painful to address directly.[69] From this standpoint, the use of animal masks is a positive value in the work. Arlene Fish Wilner conceptualizes it as such,

suggesting that the artist's decision has a 'brilliance' to it insofar as it underscores the grim moral underpinnings of the fable tradition (might makes right, the strong exploit the weak), and invigorates the Nazi use of figures as an instrument of the Final Solution.[70] Yet, of course, it is not only in fables that a might-makes-right tradition is prominent – it is also apparent in the history of American comics. While Wilner, and others, may overlook this association, it is imperative to note that they conceptualize the anthropomorphism of *Maus* as fundamentally unnatural, that is to say, arbitrary and self-aware. Hillel Halkin, reviewing *Maus* for the conservative Jewish journal *Commentary,* is arguably the most outspoken critic of Spiegelman's anthropomorphism and what he sees as its fundamental determinism: 'Why did the Germans murder the Jews, who did not fight back, while third parties like the Poles let it happen? For the same reason that cats kill mice, who do not attack cats, while pigs do not care about either: *because that's the way it is.*'[71] Yet in highlighting the ways by which Spiegelman problematizes and contextualizes this deterministic metaphor, scholars have contributed to understanding the fact that representations in comics are not always as straightforwardly realist as Halkin and Pekar would have it. It is perhaps fundamental to bear in mind that in the world of Herriman's *Krazy Kat,* it is the mouse that pursues the cat, and that in comics relations between species are not always so cut and dried.

As most critics and scholars of *Maus* have noted, the narrative is also far from straightforward. One of the most common frameworks through which scholars discuss *Maus* is that of the relationship of oral and written testimony in Holocaust survival narratives, and the tension between early and late testimonies. As Alan Rosen points out, *Maus* is a mixture of oral (Vladek) and written (Art) testimony in which issues of chronology are often vexed by the chronological incoherence of Vladek's narrative.[72] James Young takes this further, emphasizing that the structure of *Maus* is actually tri-partite: Vladek's history, his discussions of that history with his son, and Art's reflections on the issues concerning the formal construction of the work.[73] Nonetheless, the complexity of the narrational system is mitigated by the use of illustrations and text. To this end the past and present are interconnected in *Maus* through the constancy of voice-over captions and Spiegelman's ability to create a visual equation between an event and Vladek's retelling of it.[74] For Hirsch, who conceptualizes the book as a striking example of post-memory, the comics structure of *Maus*, composed as it is of individual framed fragments connected chronologically, is akin to documentary traditions, and the

flashback structure is ruptured only by the irreconcilable arrival of photographic evidence.[75] For Linda Hutcheon, '*Maus*'s double narrative line simultaneously asserts the validity of the testimonial and questions the reliability of representation: it accepts both the truth and the vagaries of memory.'[76] Thus, scholars have generally regarded Spiegelman's task as imposing, through his use of the comics form, a structure upon his father's oral testimony and his own process of constructing that structure. Further, comics are widely regarded as an appropriate or even necessary form through which Spiegelman can unite disparate elements (past and present) into a 'testimonial chain.' At the same time, of course, not all links in that chain are given equal weight. Significantly, while the panels illustrating the contemporary aspects of *Maus* are generally presented in a traditional grid pattern, those set in the past are much more open to unusual layouts. It was Spiegelman himself who highlighted the fact that in 'Master Race,' another kind of Holocaust survivor narrative that uses a flashback structure, the shape and size of panels contribute functional elements to the subjective use of time and memory in the comics form, something that he seemingly draws upon to structure his own work.

The attention Rosen and others have given to *Maus* as oral narrative fixes another of the poles around which the book has been read in contemporary scholarship. For many critics, there is little doubt that Spiegelman's telling of his father's tale constitutes an important contribution to the oral history of the Holocaust, and the work is seen to be groundbreaking not as a comic book but as a Holocaust memoir – for its content rather than for its form. Michael Staub stresses that 'despite its unusual status as a comic book, *Maus* remains remarkably traditional in its documentary strategies for relating its oral narrative,' and a significant part of those traditions is the idea that Spiegelman's text records dialogue and accent accurately.[77] Pekar, in his critique of *Maus,* argued that Spiegelman was selective in his use of accents, stressing it when portraying Vladek but omitting it completely for characters like Françoise.[78] Other critics, however, do not always follow this lead. Writing in the *Oral History Review,* Joshua Brown acknowledges that Spiegelman has not provided a verbatim transcript of his father's testimony but, nonetheless, suggests that his use of language 'is remarkable in its exactitude and lack of bravado.'[79] Similarly, Alice Yaeger Kaplan argues 'one of many extraordinary features of *Maus* is that Spiegelman gets the voices right, he gets the order of the words right, he manages to capture the intonations of Eastern Europe spoken by Queens. He puts us in the cultural space of those impossible father-son dialogues without ever being obvious about

it.'[80] Alan Rosen insists that Spiegelman's work challenges the fitness of the German language to represent the Holocaust, and, by placing fluent colloquial English in the foreground in the flashback sequences, he moves that language from the outside to the inside of the Holocaust while, at the same time, positioning English as foreign in order to frustrate American readers and move them from inside to outside the Holocaust.[81] For Rosen, the fact that the Vladek of Rego Park is the only character in the book with an accent, that it is 'for him alone that Spiegelman reserves the distortions of syntax, the malapropisms, the quirky idiom,' contributes to the authority that is granted to Vladek's testimony throughout the text.[82] Finally, Michael Rothberg argues that '*Maus* is a comic book driven by the word.'[83] In focusing on the use of dialogue in the work, Rothberg, drawing on the tapes of Vladek recorded by Spiegelman, notes that the son alters the statements made by the father. For instance, in the book Vladek says 'How amazing it is that a human being reacts the same like this neighbor's dog,' while on the tape he said only 'How amazing it is that a human being is like a dog.'[84] Since this change, insofar as it is an expansion of Vladek's text, cannot have been made simply to accommodate the restricted space of the word balloon, Rothberg suggests Spiegelman alters the testimony to keep up with the changing language habits of contemporary English-speaking Jews. Rothberg suggests that this subtle gentrification that registers 'the uneasiness at the heart of Jewish identities, as well as their susceptibility to change over time' can be read either as a possible form of Jewish self-hatred or, alternately, as a form of irony.[85]

The ambivalence identified by Rothberg, the tension between irony and moral authority that is implicit in Spiegelman's use of fractured English in his father's oral testimony, resides at the centre of the scholarly discussion of *Maus*. Specifically, conceptions of postmodernism have been crucial to reading *Maus* in a critical manner. For many critics, it is the very fact that Spiegelman has crafted a 'Holocaust comic book' that makes the work quintessentially postmodern. Daniel Schwarz, for instance, suggests that 'by using cartoon figures to present the Shoah, Spiegelman creates in his *Maus* books a wildly inventive bibliocosm that invites us to look on the major *topoi* of the Shoah from a radically innovative formal perspective . . . In their use of comic-book forms, the *Maus* books are experimental, postmodern, and radical.'[86] For Schwarz and others, the comics form seems wildly inappropriate to the subject, instantly creating a clash of high seriousness (the Holocaust) with low culture (the comic book, with its traditionally escapist or humorous

traditions). Thomas Doherty, while conceding that Spiegelman has created a work that is 'moving, absorbing and enlightening,' suggests that the very notion of this work is 'obscene on its face.'[87] Alison Landsberg, meanwhile, regards the scene in which Vladek picks up a piece of discarded telephone wire from the trash with the intention of repurposing it as a metaphor for the work as a whole, arguing that the recirculation of the story in a different, that is to say comic book, form highlights the potential usefulness of the Holocaust in America.[88] That Landsberg's metaphor positions the comic book form, like the telephone wire, as garbage goes almost without saying. A different approach is offered by James Young, who counters writers like Schwarz by noting that comics, as a form, are not intrinsically postmodern but that Spiegelman's use of the form is.[89] For Young, *Maus* is particularly concerned with problematizing Jewish memory through a compulsive, postmodern inquiry into the possibility of its own production. As *Maus* feeds on itself, recalling its own production, the formal elements, such as the shakiness of his hand's line in the drawings, underdetermine the pictures so as to inflect the book with the 'dislocutions, associations, and paralysing self-reflections' that are a part of memory-telling.[90]

The notion of memory raised by Young, and by so many other scholarly commentators, is central to Dominick LaCapra's reading of the book, a reading that highlights many of the central critical scholarly concerns pertaining to *Maus*. LaCapra argues that, although comics now have 'more or less high-brow and low-brow forms,' there remains a shock associated with Spiegelman's 'risky, even foolhardy attempt to bring Auschwitz to the comics.'[91] Nonetheless, he suggests that the enthusiastic critical reception of *Maus* stems from its postmodernity: 'We are . . . ready to be deliriously laudatory when a work shocks us and at the same time blurs distinctions, especially the distinction between popular and elite culture.'[92] For LaCapra, *Maus* contains a 'carnivalesque' humour that derives from its scandalous premise of bringing the imposingly high to the putatively low. Despite what he sees as some significant flaws, including the tendency of the child of the survivor to convert the Holocaust into a founding trauma, LaCapra suggests that the actual victory won by *Maus*, through its use of the carnivalesque, is that it 'raises' comics to the level of the ' "highest" and most "serious" art or thought.'[93] This suggestion brings us back to the question that initially opened this chapter: is the comics masterpiece the result of changes in the form, or has the category been created by the ability of academics to recognize certain theoretical and critical models in an exemplary work such

as this? The scholarship on *Maus* strongly suggests that it is the latter. Van Rees contends that academic critical discourse is 'always based on an explicit appeal to a conception of literature currently favored by an important group of academic critics.'[94] From this perspective, one can argue that *Maus*, with its postmodern framework and focus on issues involved in identity politics, strongly benefited from its arrival at a point at which American humanities scholars were wrestling with precisely these issues. Harvey Pekar alleged that if Spiegelman had written a book 'five times as good as *Maus* about anything but the Holocaust, it wouldn't have garnered him nearly the acclaim he's gotten.'[95] This may or may not be true, but we might also add that had he published the book in advance of the development of organized comics fandom and the development of a theoretical framework in the humanities that would be welcoming of this work, his work might not have enjoyed the extensive critical success that it did and would not now be considered the first true comics masterpiece.

Conclusion: The Consequences of the Comics Masterpiece

If the scholarly responses have tended to consecrate *Maus* by providing a theoretical, social, and aesthetic context whereby it can be integrated into the university classroom, and, thus, set on a road to canonization, it was enthusiastic responses to the work in the mainstream press that initially established the book as a significant object of intellectual inquiry. Moreover, the success of *Maus* was widely held to benefit not only the reputation of Spiegelman, but of the comics form as a whole. Joseph Witek, the first scholar to publish a book on Spiegelman and his work, notes that the 'unprecedented critical reception of *Maus* has changed, perhaps forever, the cultural perception of what a comic book can be,' while cartoonist Harvey Kurtzman added: 'Grown-ups can read "Maus" and feel a respect for Spiegelman's writing; they can read "Maus" as if they were reading a novel. Spiegelman has opened an avenue of interest that's a real service to the medium.'[96] Adam Gopnik echoed these sentiments in *The New Republic* when he noted, 'that, for the first time, educated people are coming to have an opinion about cartoons is largely due to the influence of one remarkable work.'[97] And, while many were welcoming *Maus* into the field of literature, Robert Storr was welcoming it to the world of visual art. Specifically, Storr organized an exhibition of all of the original pages from *Maus*, plus preparatory work, at the Museum of Modern Art in New York from December 1991 through January

1992, just as the work was climbing the best-seller lists. Significantly, and despite this widespread acclaim and attention, however, a residual bias against the comics form was revealed in a number of prestigious middle-brow venues.

Easily the most quoted opening gambit of any review of *Maus* is Lawrence Langer's suggestion in the lead article of the *New York Times Book Review* that 'Art Spiegelman doesn't draw comics.'[98] Langer contends that *Maus* is a work that 'resists defining labels,' and categorizes as existing outside the formal and aesthetic traditions of which it so clearly partakes. Similarly, Elizabeth Hess, reviewing the *Maus* exhibition at the MoMA for the *Village Voice,* contended 'Spiegelman is an original, a hybrid artist who has genuinely created a new form. Up until this moment, *Maus* has been difficult to classify as art, popular culture, history, or biography. It's a book, but it's lived in a kind of limbo, albeit a respected one. Comic books are not considered literature, yet this one hit the fiction and nonfiction best-seller lists. (Even the *New York Times* was confused). But *Maus* is not exactly a comic book, either; comics are for kids.'[99] The same attitude was evinced in *The New Yorker* by Ethan Mordden, who argued 'of all the art forms invented or uniquely transformed by Americans, the comic book is the only one that has not undergone vigorous development in the last fifty years.'[100] The explicit assumption made by Langer, Hess, and Mordden in these influential venues for commentary on art, that Spiegelman's work is utterly unique and the concept of comics for adults is not just revolutionary but an aberration from the form, crystallizes the remains of the anti-comics sentiment that thrived in 'respectable' arts newspapers and magazines and that, if Witek is correct, *Maus* helped to definitively banish. The arguments positing *Maus* as an exceptional breakthrough work tend to reduce the history of the comics masterpiece, and the influence of that history on the prestige of the form as a whole, to the influence of the Great Man. Positing Spiegelman as a genius who transformed the field with a single work minimizes the complex interactions that structured the book's success. The success of *Maus* needs to be conceptualized against, at the very least, the development of new publishing and marketing strategies in the book trade, the rise of an increasingly postmodern visual culture, and, in academia, the twinned influences of cultural studies and postmodernism at the time that it was released. Moreover, *Maus* was simply one of many works acclaimed as masterpieces that have dotted the history of comics, even if it was the first to be so acclaimed by so many powerful actors outside the comics world ('Is the fact,' asked LaCapra, 'that I am writing about *Maus*

within an elitist academic market a sign of my "descent" into popular culture, my contribution to the attempt to "elevate" the comix to "serious" thought or high art, or my own modest effort at hybridization and the creation of a different audience that is cross-disciplinary and possessed of some potential for social and political practice?').[101]

Maus is undeniably the comic that best characterizes the masterpiece tradition in the American comics tradition; nonetheless, it is imperative to retain the sense that it is only one of several works to be so acclaimed. Whereas Robert Warshow could not imagine a world in which adult readers could possibly know what a 'good comic' would look like, Spiegelman's work clearly draws upon his familiarity with previous masterpieces of the form. In his catalogue essay for the MoMA show, Robert Storr notes how *Maus* draws upon the traditions of the form: 'In his determination to "get it right" the artist becomes a practical scholar of his medium,' and Gopnik argues that Spiegelman's work demonstrated what is possible in the comics form by working 'within its richest inheritance, and exploring the deepest possibilities unique to the form.'[102] Or, as William Hamilton put it in the *New York Times*, *Maus* uses all 'the quack-quack wacko comic strip conventions with the thoroughness and enthusiasm of a connoisseur.'[103]

Among the quack-quack wacko conventions used by *Maus*, as has already been suggested in passing, are those that are importantly derived from Herriman's *Krazy Kat* and Krigstein's work on 'Master Race.' Spiegelman's admiration of Krigstein's story has already been demonstrated, but it is worthwhile noting as well his connection to Herriman, whom he termed the 'poet laureate of comics,' or, more precisely, 'the comics laureate' because '*Krazy Kat* wasn't much like anything that had ever happened in any other medium.'[104] Jay Cantor, who based a novel on Herriman's characters, has suggested that *Maus* 'poses questions to *Krazy Kat*.'[105] One of the most interesting of these is what it might mean to constitute a comics masterpiece at any particular historical moment. Cantor suggests of Krazy that she was raw material awaiting the high art apotheosis offered by Philip Guston, Öyvind Fahlström, and, quite frankly, Jay Cantor.[106] Despite the acclaim of critics ranging from Seldes to Warshow, *Krazy Kat* remained intellectually and aesthetically marginal, recognized by only the smallest coterie, and can only be considered a masterpiece proper in retrospect, when a work like *Maus* has fully authorized such a position. Similarly, 'Master Race' remains largely unknown beyond the confines of the comics world, a highly specialized work that is appreciated exclusively by a relatively small contingent of connoisseurist comics

fans. Nonetheless, it is easy to read the influence of both of these works on *Maus,* and not simply because, as Sarah Boxer reported in the *New York Times,* Spiegelman keeps an original *Krazy Kat* daily on the wall of his studio.[107] Among the traits that *Maus* shares with Herriman's work is a non-traditional use of animals and a highly distinctive and disjointed use of the English language. With 'Master Race,' *Maus* shares a subject matter as well the highly structured use of flashbacks to present images of the Holocaust. One could reasonably suggest, therefore, that *Maus* is some sort of hybrid of these two earlier works that are widely acclaimed within fandom. Of course, such a reading would be ridiculously reductive. Rather, it is more fruitful to note how historical circumstances aligned to open, for the first time, the possibility that a comics 'masterpiece' might be recognized as such beyond the confines of the comics world.

A mere forty years after Delmore Schwartz bemoaned the decision to make great literature into poor comic books, Spiegelman created a work that frequently resides on undergraduate syllabi alongside Dostoevsky and Shakespeare. While the development of organized comics fandom went a long way towards enunciating specific aesthetic standards for comics that would enable a work like *Maus* to be recognized as a significant achievement, as it was from its very first appearance in the pages of *RAW* #2, the lesson to be taken from Spiegelman is that he succeeded by elevating a single comics work over the threshold for aesthetic greatness established by the fields of literature, visual arts, and academic criticism in such a way that his own creation seemed alien, to many critics, from the very tradition that had spawned it. Thus, *Maus* demonstrates the persistence of established aesthetic norms in the art world, even as it demonstrates the possibility that individual comics works might be recognized as masterpieces outside the confines of fandom's 'powerless elite.'

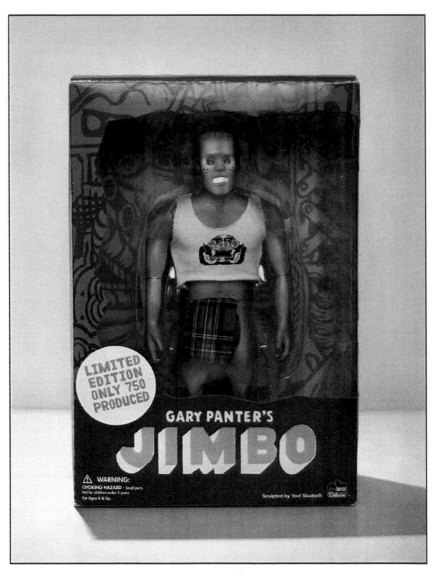

Gary Panter, *Gary Panter's Jimbo* (2007). ©Gary Panter,
courtesy of the artists.

Highbrow Comics and Lowbrow Art?
The Shifting Contexts of the Comics
Art Object

All this stuff is mashed together in my brain in a vein marked: Ultra-kannootie, hyper-wild, ultra-groovy, masterfully transcendental beauty stuff.

Gary Panter[1]

In the thirty-two-page booklet that accompanies Gary Panter's Limited Edition vinyl Jimbo doll, the artist includes a number of design notes and sketches that he sent to the sculptors at Yoe! Studios who crafted the maquette. According to these notes, Jimbo is six heads high; he should look more like Tubby from the *Little Lulu* comic book series than the warrior/adventurer Conan; and ideally he would come across as something between a toy by Bullmark, the Japanese company that produced soft-vinyl Godzilla toys in the 1970s, and the more recent vinyl toys designed by Yoe! Studios based on old Kellogg's cereal characters.[2] In one of the longest exchanges recorded in the book, Panter takes an entire page to comment on the design of the doll's penis, which on the original clay model 'seemed a little high.'[3] With reference to classical figure drawing, Panter approaches the problem with a series of sketches, noting that if the penis sticks out too much 'it will always be a joke,' but that if it's too little 'guys will rib him at the gym.'[4] In the end, the artist has his way, and the Jimbo doll, limited to only 750 units, is produced with a prominent phallus, contained by a plaid loincloth held in position with a rubber band, and an unnatural pink paint colour that recalls, as the closing photo in the book points out, the colour scheme used on one of the many Hedora vinyl figures produced in Japan. In all then, the Jimbo doll knowingly melds hyper-masculinity, nostalgic collector culture, punk rock aesthetics, and Japanese toy monsters into one item. All of these

elements meet at a critical juncture between the comics world and the art world. In other words, the Jimbo doll triangulates the precise status of comics art within the matrix of art and entertainment worlds. Indeed, the movement of Panter and his art through various circulatory regimes offers a significant opportunity to assess the contemporary status of comics as art.

Panter, of course, is one of the most controversial of contemporary American cartoonists, and the reception of his work is often polarized. Writing in the PictureBox-produced catalogue of Panter's paintings in 2008, the Los Angeles-based contemporary artist Mike Kelley argued that 'Gary Panter is the most important graphic artist of the post-psychedelic (punk) period' and further that 'Gary Panter is godhead.'[5] Contrast that with the comments of Andrew D. Arnold, longtime comics critic for *Time* magazine, who derided Panter's comic book *Jimbo in Purgatory* as the worst comic book of 2004 because it was 'no fun' and subsequently elaborated on that comment in a letter published in *The Comics Journal:* 'I think *Jimbo in Purgatory* fails because it denies its audience a key function of its form: readability . . . *Jimbo in Purgatory* cannot be read in any involving way. It can only be looked at . . . Were *Jimbo in Purgatory* presented on the walls of a gallery, rather than a book, it would be inarguably remarkable. But in its chosen form, with the pretense of a story and characters but no reasonable entrée into them, the book fails in spectacular fashion.'[6] Arnold's disdain for works that blur the boundaries of the gallery art world and a literary-minded comics world may be more widely shared than Kelley's exuberant celebration of the genre-busting cartoonist, but it is a poor conceptual match for an artist who claims that 'I'm aware of Picasso from beginning to end, just as I am aware of monster magazines and Jack Kirby. The intersections between them, in line, form, and populism provided the foundation for my artistic beginnings,' and 'I make the rules of the game that becomes my art.'[7]

In the comics world, Panter is known as a significant progenitor of 'difficult' works and is the most public face of a ratty aesthetic that he pioneered and which has subsequently been adopted by artists affiliated with the small cutting-edge art cooperative Fort Thunder and with contemporary comics anthologies like *Kramer's Ergot* and *The Ganzfeld*. One of the most important avant-gardists in American comics, Panter began contributing comics featuring Jimbo to the Los Angeles punk 'zine *Slash* in 1977, and soon thereafter self-published his first comic book, *Hup*. In 1981, Panter began publishing in Art Spiegelman and Françoise Mouly's avant-garde comics anthology *RAW* with the third issue, for which he

also provided the cover. Jimbo stories appeared in subsequent issues, and in 1982 Raw Books and Graphics published their first one-shot, a collection of Jimbo material on newsprint with a cardboard cover and duct-tape binding. Two years later, Panter published *Invasion of the Elvis Zombies,* the fourth RAW one-shot. At the time, Panter was working on a long-form graphic novel, *Cola Madness,* for a Japanese publisher, but that work was not published in English until 2000. The first of Panter's Dante-inspired Jimbo works, *Jimbo: Adventures in Paradise,* was published in 1988 by Pantheon. At the time, the artist was best known for his work as the designer on the long-running children's television series *Pee-Wee's Playhouse* (1986–91). From 1995 to 1997 he published seven issues of *Jimbo* with Zongo Comics, a company owned by his friend and *Simpsons* creator Matt Groening. This series reprinted Panter's earlier Dal Tokyo magazine strips and also launched his Divine Comedy material that was collected by Fantagraphics as *Jimbo in Purgatory* (2004) and *Jimbo's Inferno* (2006).[8]

For all of his work in the comics world, Panter remains, as Arnold's comments suggest, a somewhat marginal and liminal figure in the field. Panter himself has stated, 'I still feel like a visitor to comics, but it's a place I keep returning to in order to tell my stories.'[9] Significantly, in addition to his comics work, Panter has maintained a career as a painter, with dozens of solo and group exhibitions to his credit, and works as a commercial illustrator. His paintings display the influence of his generational compatriots (Keith Haring, David Wojnarowicz, Jean-Michel Basquiat, and Kenny Scharf), as well as figurative artists of the 1960s (Eduardo Paolozzi, R.B. Kitaj, Öyvind Fahlström, Richard Linder, and Saul Steinberg), artists with a love of popular culture (H.C. Westermann and Jim Nutt), psychedelic-era collage artists (Wes Wilson, Rick Griffin, Victor Moscoso, Alton Kelley, and Stanley Mouse), and the underground comics movement of the 1960s and its key figures such as Robert Crumb.[10] By incorporating the examples of these extremely heterogeneous influences, ranging from lowbrow popular culture to esteemed modernist artists, Panter positioned himself, as he himself suggests, on the cusp of postmodernism, collapsing the distinctions between high and low culture.[11] Despite these affinities with contemporary gallery painting, he told critic Robert Storr, 'I think I've always been a wannabe in the art world' because he was too shy to participate in much of the social scene that exists in that particular field.[12] Thus, while he may be the outsider star in the less consecrated field of comics, Panter remains, by his own admission, merely marginalized in the field of gallery art. Examining the

entirety of Panter's creative output, as the PictureBox-published cata-
logue of his work does, foregrounds the fact that his work across a num-
ber of creative fields is the product of a singular vision, even as that work
occupies very different positions in each field. The fact that his reputa-
tion varies as his work circulates in different regimes is a stark reminder
of how status in one field significantly impacts reputation in others.

RAW: Low Culture for Highbrows

The subtitle for the final issue of *RAW,* 'High Culture for Lowbrows,'
sought to sum up the position occupied by artists like Gary Panter.[13] Yet
it can be convincingly argued that the historical relations between the
comics world and the art world indicates that editors Art Spiegelman
and Françoise Mouly inverted their key terms. For all intents and pur-
poses, the primary audience for *RAW* was never lowbrow comics fandom;
rather it was a world of cultivated art world highbrows. Michael Dooley
argued in *The Comics Journal* that *RAW* ran the risk of 'becoming the dar-
ling of the yuppie hipsters' that sought in this comics anthology an outlet
for cutting-edge, low-culture graphics.[14] The distinction is not merely
semantic, since it highlights the way in which the magazine is conceptu-
alized and valued by its audience. Circulating in the art world more than
the comics world, *RAW*'s audience was primarily an art world audience
'slumming' in the bleeding-edge margins of punk graphics. It was most
assuredly not a magazine looking to bring a certain intellectual and cul-
tural cachet to the lowbrow, juvenile audience long affiliated with the
dominant American comic book traditions.

Best known as the venue in which Spiegelman serialized *Maus,* his
award-winning autobiographical comic book, *RAW* was launched in
1980, four years after the death of *Arcade,* the late-era American under-
ground anthology edited by Spiegelman with Bill Griffith. *RAW*'s first
volume, comprising eight issues, was self-consciously at odds with both
the mainstream American comic book tradition dominated at the time
by superhero comics, and the underground's sex and drugs counter-
cultural sensibility. This difference was most strikingly marked by the
magazine's size, which owed a debt to Andy Warhol's *Interview* and other
publications targeting New York's fashionable class. *RAW* was an over-
sized (10½" × 14") magazine format ranging from thirty-six to eighty
pages. Most issues carried a full-page ad for the School of Visual Arts, at
which Spiegelman taught and some of the contributors studied, on their
back cover, and later issues featured a series of small ads in the interior

but were otherwise free from the taint of commerce. The first volume performed well outside of comics networks, including in record stores, and quickly sold out its print run of 5,000 copies. By the third issue, the print run had been expanded to 10,000.[15] Several issues in the first volume contained notable features, including bound-in booklets for 'Two-Fisted Painters' and the individual *Maus* chapters by Spiegelman, as well as for 'Red Flowers' by Yoshiharu Tsuge. Other 'collectables' included Mark Beyer's *City of Terror* bubblegum cards in #2, a flexi-disc of Ronald Reagan speeches in #4, and a corner torn from a different copy of the same magazine in issue #7. Although the indicia claimed it would be published 'about twice a year,' after the second issue *RAW* was, in actuality, published annually until 1986, when it went on hiatus. The anthology returned in 1989. The second volume of *RAW* was published by Penguin Books as a series of three smaller digest-sized (6" × 8½") anthologies of more than 200 pages. The later volume was entirely free of ads and circulated in both comic book stores and traditional book retailers. The second volume, by virtue of working with a publishing giant, had sales as high as 40,000 copies per issue and circulated as a Book-of-the-Month Club selection.[16]

RAW focused on three types of comics: the historical avant-garde, contemporary international avant-gardes, and the American new wave comics sensibility, the last of which it largely came to define. Of these, historical works were clearly the least evident although in some ways the most important. The first issue of *RAW* contained a 1906 *Dream of the Rarebit Fiend* strip by Winsor McCay printed across two pages in which a suicidal man dreams of jumping from a bridge, only to bounce off the water and into the arms of a waiting police officer. Subsequent issues contained comics by the nineteenth-century French caricaturist and satirist Caran D'Ache (Emmanuel Poiré), Milt Gross, Fletcher Hanks, Basil Wolverton, Gordon 'Boody' Rogers, Gustave Doré, and, on two occasions, George Herriman. These selections allowed the editors to position *RAW* within a particular comics lineage that was at once international, highly formalist, and, given the interests and reputation of mid-century cartoonists such as Wolverton, Rogers, and Hanks, irreverently outside the mainstream of American comics publishing.

The international aspect of *RAW* was considerably more pronounced than its historical component, with a large number of non-American artists featured in every issue. Artists such as Joost Swarte, who provided two of eleven *RAW* covers, Jacques Tardi, Javier Mariscal, Kamagurka and Herr Seele, and Ever Meulen appeared regularly in the pages of the

magazine. These artists, whose work clearly derived from the clear line style associated with Hergé, even as they radically reworked that style in their own unique ways, foregrounded a cosmopolitan comics heritage. At the same time, the aggressively pictorial work of the Bazooka Group (Olivia Clavel, Lulu Larsen, Bernard Vidal, Jean Rouzaud, Kiki and Loulou Picasso), Caro, and Pascal Doury pushed the magazine towards a highly self-conscious outsider aesthetic rooted equally in the poster art of the French punk music scene and situationist graphics. These works, which included some of the most non-traditional pieces ever published in *RAW*, situated the new wave graphics that the magazine championed as nothing less than a transnational movement. A similar effect was achieved when, in the seventh issue, *RAW* included Gary Panter in its special Japanese comics section (featuring work by Teruhiko Yumura, Yosuke Kawamura, Shigeru Sugiura, and Yoshiharu Tsuge) because his tote bags, drinking mugs, notebooks, and T-shirts are made and sold in Tokyo, and 'he is the only *RAW* artist to have a snack bar in a Japanese department store named after him.'[17]

Panter was not only an important linkage to the Japanese artists associated with the influential arts manga *Garo,* but was arguably the artist, aside from Spiegelman, most closely associated with *RAW.* Of course, Spiegelman himself, and many of the *RAW* cartoonists (Robert Crumb, Justin Green, Kim Deitch, S. Clay Wilson, Bill Griffith, and Carol Lay) were products of the underground comics movement of the 1960s and early 1970s, and many had published in the seven issues of *Arcade.* Nonetheless, *RAW* was perhaps best known for helping to launch the careers of a significant number of post-underground cartoonists, several of whom had been Spiegelman's students and colleagues at SVA, including Drew Friedman, Mark Beyer, Kaz, Jerry Moriarty, Richard McGuire, Mark Newgarden, Ben Katchor, Charles Burns, Chris Ware, Sue Coe, Richard Sala, Robert Sikoryak, and David Sandlin. Of this generation, none was more integrated with *RAW* than Gary Panter, whose first work appeared in the pages of, and on the cover of, the third issue. One of only three artists to produce two covers for *RAW,* Panter published work in eight of the eleven issues, much of it featuring Jimbo, and authored two of the *RAW*-published books.

Blab! Comics as Illustration

In several ways, not the least of which is the roster of artists that it supports, *Blab!* is an heir to the *RAW* project. Created by Monte Beauchamp

in 1986, the same year as the final issue of *RAW*'s first volume, *Blab!* is almost the inverse of *RAW*. The first seven issues (1986–92) were published in a small book format not unlike the size and shape of the second volume of *RAW*, but, starting with the eighth issue (1995), it expanded to a larger (10" × 10") format that would better accommodate Beauchamp's growing interest in the relationship of comics, illustration, and contemporary design. Unlike *RAW*, which demonstrated a remarkable aesthetic purity over its run and an extremely consistent and singular editorial vision, *Blab!* has changed considerably over its more than two decades of publication. The first, self-published, issue was a nostalgic *Mad* fanzine. Opining from its opening pages that comics aren't as good as they were in the 1950s when Bill Gaines was the publisher of EC Comics, Beauchamp recalled the earliest of organized comics fanzines when he reiterated the traditional fannish history concerning the damage done to the American comic book industry by Fredric Wertham and the 'accursed comics code.'[18] The rest of the issue was taken up by a series of written reminiscences about *Mad* from key figures in the underground comics movement, each testifying to the seminal influence that the satirical magazine had on the development of their thinking (Robert Williams: 'I was SEDUCED! RAPED! I say more like KIDNAPPED, MOLESTED, and FOREVER PERVERTED! They poisoned a generation. I'M A LIVING TESTIMONY!').[19] The second issue was similar to the first, featuring an article on the *Mars Attacks* trading card set, a comic by Dan Clowes lampooning Fredric Wertham's book *The Show of Violence,* and more written appreciations of *Mad,* this time from key figures in the emerging American new wave and alternative comics tradition, including *RAW* contributors such as Jerry Moriarty, Charles Burns, Mark Marek, Lynda Barry, and, of course, Gary Panter. Panter's statement of influences in this issue (which include, among many others, *Mad, Famous Monsters of Filmland,* Piggly-Wiggly bags, Robert Crumb, Rick Griffin, Robert Williams, the Hairy Who, Henry Darger, toy robots, Jack Kirby, Claes Oldenburg, Walt Disney, George Herriman, and Pablo Picasso) was one of his earliest published statements about the diversity of influences, both high and low, that have structured his particular aesthetic point of view.[20] Nonetheless, Panter, who published on only two other occasions in *Blab!* is not the major cross-over figure from *RAW* to *Blab!* With its third issue, now published by Kitchen Sink Press, the magazine became more evenly split between publishing comics by a mixture of new wave creators (Burns, Clowes, Richard Sala), underground artists (Spain), and outsider painters (Joe Coleman), alongside fanzine articles (Bhob Stewart on *Bazooka*

Joe, and underground creators on the influence of Crumb). By the fifth issue (1990) the comics completely dominated the pages of the magazine, while the occasional essay or short fiction piece filled out the pages. Thus, over the first five years of its publication, *Blab!* elaborated a particularly forceful historical teleology that posited *Mad* as the root of American comics transgression and creative flowering, suggesting that it directly flowed into the undergrounds of the 1960s and that the new wave cartoonists of the 1980s were the obvious heirs to each of these legacies.

Having laid this foundation through its written articles, *Blab!* began the process of positioning itself as the specific heir to the traditions that it championed with its eighth issue (1995). Given a larger publishing format and better-quality paper, Beauchamp transformed *Blab!* into a showcase for new wave comics working at the intersection of commercial illustration and cutting-edge narrative forms. The eighth issue, in addition to work by regularly appearing cartoonists such as Sala, Spain, Chris Ware, and Doug Allen, reproduced celebrity magazine illustrations by *RAW* alumnus Drew Friedman and featured contributions from Gary Baseman, an illustrator significantly influenced by Panter. Baseman returned as the cover artist for the ninth issue (now published by Fantagraphics Books, after the bankruptcy of Kitchen Sink Press) and provided the end papers for the tenth, as he became a regular fixture in the magazine. Over the course of the next several years *Blab!* increasingly cultivated appearances by artists who, like Baseman, were loosely affiliated with the lowbrow painting movement influenced by Panter. Mark Ryden painted the cover for the eleventh issue, whose contents included work by the Clayton Brothers, Laura Levine, and Jonathon Rosen. Tim Biskup debuted in the twelfth issue, and Camille Rose Garcia and *RAW* alumnus Sue Coe both became regular contributors starting with the thirteenth. Around this time *Blab!* became increasingly less interested in traditional narrative comics and much more aligned with cartoony tendencies in illustration and non-traditional approaches to comics storytelling (exemplified by the work of Finnish cartoonist Matti Hagelberg and Swiss cartoonists Helge Reumann and Xavier Robel). While classically formatted comics continue to persist in *Blab!* in the work of Greg Clarke, Steven Guarnacia, Peter Kuper, and others, the magazine is increasingly dominated by works that would, by the normative definitions of comics discussed in chapter 1, be deemed 'not comics' for their unusual word-image balance, lack of panels, absence of storytelling techniques, and other general weirdness. To this end, contemporary-era *Blab!,* even more

than *RAW,* has pushed the boundaries of the comics form and helped to expand the conception of what constitutes legitimate avenues of expression in the comics world.

This tendency is even more pronounced in the books published by *Blab!* Beginning in 2005, *Blab!* like *RAW* before it, began publishing stand-alone books in a branded series. Significantly, the first of these, *Sheep of Fools,* featured the art of Sue Coe alongside the text of Judith Brody. Coe was firmly associated with *RAW* and had published two of the RAW one-shots, *How to Commit Suicide in South Africa* (with Holly Metz) and *X* (with Judith Moore). Similarly, the fifth *Blab!* book, *Old Jewish Comedians,* featured the work of *RAW* contributor Drew Friedman. Significantly, neither of these books would be classified as comics by traditional definitions of the form offered by critics and aestheticians like Scott McCloud, despite the fact that each features the work of artists long affiliated with the comics industry, and both are published by a leading comic book publisher (Fantagraphics). Indeed, other books in the series do little to address the traditions of the field. *Shag: A to Z* by Shag (Josh Agle) and David Sandlin's *Alphabetical Ballad of Carnality* are each postmodern alphabetical primers, while Walter Minus's *Darling Chéri* is a collection of softcore erotic drawings with a loosely attached text. The remaining books in the series, *Struwwelpeter* by Bob Staake and *The Magic Bottle* by Camille Rose Garcia, each draw on the illustrated text tradition more closely affiliated with children's books, although their sexualized and violent adult content means that neither of these falls comfortably into that category. Thus, by rejecting the dominant formal traditions of comics, the books cement the transformation undertaken by the *Blab!* project, marking a particular historical lineage that culminates in the intersection of comics, art, and commercial illustration popularly known as lowbrow art. Ultimately, through the rejection of normative conception of comics, while remaining rooted in an ironic countercultural sensibility, *Blab!* positions a comics avant-garde through the embrace of what, in the world of painting, is known as lowbrow.

From Authentic Kitsch to Retro Kitsch: Lowbrow Art

In his *New Yorker* article on Bernard Krigstein, Art Spiegelman argued that the cartoonist's paintings 'looked back to representational values that were at least fifty years out of date; his comics were visionary and looked ahead at least that far.'[21] Following Spiegelman's logic, a one-hundred-year gap existed in the mid-1950s between cutting-edge comics

and the currents of contemporary art, and a single figure was able to oc-
cupy the position between fields. It is significant, therefore, to note how
the gap between comics and painting had closed some forty years later
as *Blab!* manifested a lowbrow painting aesthetic in comics form. That
said, it is clear that, with a few exceptions, comics remain beyond the
purview of the traditional art press and are, consequently, symbolically
excluded from the larger art world. While coverage of comics artists in
the art press has expanded in the wake of theories of postmodernism
and the perceived collapse of high-low distinctions, reviews of comics
exhibitions and studies of major cartoonists remain rare. The most inclu-
sive art magazine in this sense has been *Beaux Arts Magazine,* which ran a
regular column on (primarily French) comics alongside other recurring
features on architecture, cinema, and books. They also released several
special issues on the state of comics and co-produced, with the Belgian
comics publisher Casterman, the short-lived comics and art review *Bang!*
in 2003 and 2004.[22] Typically, when the contemporary art press turns to
comics it does so through the form of a special issue dedicated to comics
as a whole, as both the French magazine *Art Press* and the British *Modern
Painters* did in 2005, and the Tate Museum's *Tate Etc.* did in 2007. These
ghettoized publications have, for the most part, constituted the bulk of
serious attention paid to the form by the arts press. Indeed, art critic
Doug Harvey credits his initial awareness of the work of Gary Panter, for
example, to a photo report of one of his gallery shows in the pages of
the skateboard magazine *Thrasher* or the pot journal *High Times,* noting
dismissively that he 'was already finished with *Artforum,*' and, of course,
that *Artforum* would never stoop so low.[23]

 Artforum, as it turns out, has had no problem 'stooping' to talk about
Panter, and it has reviewed his shows on two occasions, in 1989 and in
2005. The first review, by Carlo McCormick of a show at the Gracie Man-
sion Gallery, situated the artist's work in precisely the context that has
been discussed here. He writes:

> Writing about Gary Panter's art seemed a whole lot easier a few years ago
> than it is today. Certainly, part of this new, increased difficulty can be attrib-
> uted to some changes in esthetic discourse within the art world itself; nota-
> bly, that the distinction between 'high' and 'low' culture has become like a
> swampy muddle of co-optation, resistance and retrenchment . . . While the
> battle zone of recognized validity has become murkier, Panter's own posi-
> tion has become less definite as well. He has moved beyond the basic lines
> of cartoonishness, punk rawness, and gnarly West Coast monster art, fusing

his graphic sensibilities into an intricate and emotionally dense whole and evolving a far greater sophistication in terms of style and substance.[24]

For McCormick, if it was easier to discuss Panter's work previously, when he was more fixedly immersed in the lowbrow sensibilities embodied by cartoons, punk, and monster art, it was, presumably, because that work was more easily regarded as something other than gallery art. However, the changes in the art world that have complicated the discussion of Panter's work have also been met with changes in the work of the artist himself, who is seen to have matured beyond his influences, fusing them into something more sophisticated and more easily assessed as art. In an *Artforum* review of a show in Dallas sixteen years later, Michael Odom found Panter's postmodern palimpsests 'inelegant' but entirely his own, and evinced far less need to adjudicate the work relative to shifting philosophical positions.[25] So entrenched were the presumptions of postmodernism by 2005 that Odom remains free to simply assess the works on what he perceives to be their merits and not discuss their lack of pedigree that is the result of their comics heritage.

Arguably the most discussed comics-rooted painter in the American art press is Panter's one-time colleague Robert Williams. A former illustrator for Ed 'Big Daddy' Roth, and a contributor to the enormously influential underground comics anthology *Zap* from its fourth issue on, Williams turned to easel painting in the early 1970s and is credited, along with Panter, as the key figure in the lowbrow art movement. Williams, like Panter, was the subject of only sporadic attention from the traditional art press – the selected bibliography at the end of *Malicious Resplendence*, the career-spanning overview of his paintings, lists a far greater number of articles in *Hot Rod, Thrasher, High Times*, and *Hustler* than it does in art magazines. Nonetheless, he has received attention in a significant sidebar to an article on the Laguna Art Museum's 1993 show Kustom Kulture in *Artforum*, as well as occasional reviews of his solo shows. In reviewing his first New York solo exhibition, at Psychedelic Solution in 1987, Carlo McCormick recalibrated Clement Greenberg's dismissal of mass culture by noting that, with its 'continual affront to pieties of culture,' Williams's work could 'easily be dismissed as retro kitsch.'[26] Indeed, Ken Johnson, writing six years later in *Art in America*, would do just that. Summoning Greenberg's ghost, Johnson suggests that Williams's work was

thinly painted in a wide range of saturated hues, composed and stylized in a way that calls to mind Mad magazine cartooning, they remain too much

within familiar boundaries or popular commercial illustration to achieve the look of psychotic – or, at least, extremely individualized – expression that they seem to aspire to. Moreover, Williams sees unaware of how conventional his paintings-as-paintings are. Unlike Kelley, Shaw and Pettibon, who appropriate modes of teenage kitsch knowingly and ironically, Williams makes authentic kitsch.[27]

The distinction between the views offered by McCormick and Johnson hinge on the persistence of Greenbergian notions of modernist kitsch in a postmodern period and the ongoing conception of comics-derived work as intellectually and aesthetically debased. In short, what is at stake in their divergent viewpoints is not so much the critical reputation of Williams, but an argument about the very way in which lowbrow art should be assessed – a debate that Williams was more than happy to engage on his own terms.

One year after his work was termed 'authentic kitsch' in the pages of *Art in America,* Robert Williams launched his own art magazine with which to fight back at an art establishment that he felt did not understand his work, or the work of his colleagues and contemporaries. In an editorial ten years later, Williams would proudly proclaim that *Juxtapoz,* the vehicle that he created in 1994 to promote lowbrow art, had passed *Art in America* to become the second best-selling art magazine in the United States. The aesthetic interests of *Juxtapoz* have always been somewhat ambivalent and contradictory. In the first issue, Williams characterized the magazine's interests in a history of the Dadaist magazine *Littérature* and surrealist publications such as *La Révolution surréaliste, Le Surréalisme au servie de la révolution,* and *Minotaure.* Yet, noting that, in this postmodern age, where artists have won the right to 'place a crucifix in a jar of piss or can our feces or whatever,' the only battles remaining to be fought are those that champion 'imagination, forethought and craftsmanship' on behalf of artists who have been 'relegated to the ranks of commercial drones, illustrators, draftsmen and functional lackeys' toiling in the fields of illustration, movie poster design, model makers, tattooists, and, importantly, comic book artists.[28] Williams self-consciously positioned his new magazine 'in the graphic tradition of EC comic books, psychedelic rock posters, side show freak banners, and Zap commix.'[29] Interestingly, by beginning with principles and references (the first issue contained articles on *Zap Comix* #13, auto detailer Von Dutch, *Garbage Pail Kids* creator John Pound, Ed 'Big Daddy' Roth, and a sketchbook section by cartoonist and frequent *Blab!* contributor Spain Rodriguez),

Williams created a magazine that would closely follow the trajectory oc-
cupied by *Blab!* – an originating interest in EC and *Mad*, leading to a
focus on American underground comics (within two years, *Juxtapoz* had
run articles on each of Williams's peers in *Zap*), new wave comics art
(Panter was first profiled in 1996), and the burgeoning comics/illustra-
tion intersection that would come to be known as lowbrow.

Although it prides itself on being a best-selling arts magazine, the edi-
torial position of *Juxtapoz* is strikingly opposed to the art world. Matt
Dukes Jordan argues in *Weirdo Deluxe* that lowbrow is defined by two dis-
tinct styles – one illusionistic and one cartoony – that originate in the
work of Williams and Panter respectively.[30] Lowbrow art, with its origins
in west coast galleries like Zero One and Billy Shire's La Luz de Jesus,
mimics the fine arts tradition and has established its own institutions
and hierarchies. When this subculture crosses over with the dominant or
established arts world, the friction can be palpable. Strikingly, lowbrow,
which can be conceptualized at least in part as a comics – fine arts hy-
brid, seems to engender more forceful opposition when it crosses into
the traditional field of fine arts than do comics. That is likely due to the
fact that lowbrow art occupies a space that is closer in proximity to the
institutions of fine art than comics, which is most often integrated as a
family-friendly or blockbuster exhibition tolerated by the art world inso-
far as it helps to secure the future of highbrow art institutions. In 1992, at
the Los Angeles Museum of Contemporary Art, Robert Williams's work
was picketed by feminist and gay rights organizations during the exhibi-
tion of *Helter Skelter: L.A. Art in the 1990s*. In his review of *Helter Skelter* for
the *New York Times*, Michael Kimmelman disdained its focus on 'adoles-
cent nihilism' and argued, with respect to the protests that arose at least
in part from the fact that the subtitle promised something of a survey of
then-contemporary works, that 'the show deserves to be faulted on po-
litical grounds for including artists like Robert Williams, a co-founder of
Zap Comix, whose paintings full of naked bimbos mark the exhibition's
nadir.'[31]

Faced with such dismissals, the *Juxtapoz* writers responded in their
own pages by inverting existing art world hierarchies with articles such
as 'Three Museums That Don't Suck!' and 'Performance Art and Why
I Hate It.'[32] In an article tellingly titled 'Fighting the Ghost of Dead Art
Critics,' Williams suggested that the intellectual basis of the magazine
could be located in an opposition to the tenets of high modernism es-
poused by Clement Greenberg, Harold Rosenberg, and other members
of New York's 'then-current group of faux intelligentsia' who placed

restrictions on 'dexterity and poetic draftsmanship' in their focus on un-encumbered art.[33] For Williams, the key to the lowbrow movement is the confirmation of the art world as a political game through the process of spotlighting its ostensibly hidden structures. In contrast to the way in which high-art institutions function through the disavowal of economic processes, Williams, as artist and anti-artist, deliberately foregrounds these procedures:

> In a cold and pedantic academic art world, a fixed system of rights and wrongs has been inadvertently established by an authoritarian consensus of museum directors, funding boards, special interest galleries, biased art critics, conforming artists, and a bovine buying market in general. Art purveyance has become (and in most cases always was) a political network, controlling sacred museum real estate and what goes in it. The current attitude of international modern art has shown its favoritism towards artists who practice the doctrine of theoretical assemblage over emotional and technical physically-produced expression. Consequently, artists with hands-on ability and imagination have long ago been encouraged to seek expression in the un-arts (commercial art).[34]

Yet, for all that they are banished to the un-arts, Williams holds out the hope that the lowbrow movement with which he is inextricably connected will ultimately triumph: 'Because of *Juxtapoz*, a number of academic hierarchs, who determine what shall be sanctioned formal art, have come to realize that there is a growing loose-knit 'second world' of art that has a voice, and this magazine is one of its pronouncements.'[35]

Of all the art practices that Williams positions himself against – abstract expressionism, conceptualism, pop art, to name but a few – the one that draws his greatest ire is minimalism. In an interview with Carlo McCormick he described himself as 'intolerant' of minimalism because 'it's diametrically opposed to what people call my work: "maximalism." '[36] The tenets of maximalism, as they are located in Williams's paintings and in the magazine that he founded and edited, concerned an interest in the aesthetics of mass or popular culture often filtered through stereotypes of adolescent and hetero-normative masculine sexuality, and, in formal terms, a fetishization of illustratorly craft within the confines of realism (significantly, *Juxtapoz* introduced a painterly craft column in their Winter 1997 issue). It was through this focus on craft that animators (notably Tex Avery) and comic book illustrators came to be regarded as central touchstones within the lowbrow movement. Williams sharpens the focus

on comic book artists as the important progenitors of the realist and craft traditions in the fine arts that he sees as having been eradicated by the modernist turn towards abstraction when he insists:

> When any academic discussion comes up regarding the use and revival of representational and geometric configurations, modernists brush technical skills aside and ape the old mantra about painting and drawing being dead. However, keep in mind that there hasn't been a serious attempt to reintroduce representational graphics and sculpture since the surrealist movement of the late '30s. There was a brief flirtation with recognizable imagery in the pop art movement of the '60s, but that was only in the most condescending form of rendered witticism.
>
> The only artists that have conscientiously tried to progress the graphic syntax of hand-drawn art are comic book artists and animators. Consequently, the legacy that's been with us since the Paleolithic cave painters has been in the hands of the so-called lowbrow artists for the last 50 years.[37]

In this way, Williams strengthens the specific claim, implicit in *Blab!*'s and, to a lesser extent, *RAW*'s selection of artists, that highbrow comics, those most frequently lauded as masterpieces, are intimately bound to the lowbrow painting movement. If, as he maintains, it was Williams's goal to 'take cartoon imagery and take it up to the level of fine art and create a visual language that would take off in its own direction,' the accomplishment of lowbrow must seem somewhat limited.[38] While it is true that some lowbrow artists, including Williams, have been tentatively welcomed into the field of fine arts, as have some comics artists, it seems equally true that the lowbrow scene evolved in ways not anticipated by Williams and, interestingly, has pulled comics along with it.

While the visual style championed by Williams as maximalism might appear somewhat internally coherent, the same is not really the case with lowbrow generally. While the lowbrow art movement can be defined institutionally around certain galleries and publishing venues like *Blab!* in many ways the movement is best defined by its links to *Juxtapoz*. This narrow conception of the sub-field has, as with comics, contributed to a troubling of the definitional issue that can be most clearly found in the struggle to come to terms with an encompassing label for the movement. The title of Kirsten Anderson's book, *Pop Surrealism,* is one of only several alternatives to lowbrow suggested by critics and artists given the fact that many lowbrow artists reject that label, opting for descirptors as diverse as cartoon expressionism, imagist, narrative noir, pervasivism, cartoon

pluralism, psychedelic punk, kustom kulture, underground, retro illus-
trational, and others.[39] In addition to some of those already listed, Wil-
liams offers outlaw art, alternative art, bad boy art, rat fink art, cartoon
pop, cartoon surrealism, hot rod gothic, veins and eyeball art, melrose
primitive, frozen rock music, post-horror vacua, American gnarly, and
Neo-Bodacious.[40] The naming crisis alluded to with these long lists is
critical in two respects. First, as Williams points out, the lack of unifying
terminology serves as an impediment to the institutionalization of the
movement.[41] That is, without an agreed-upon term the movement he
envisions cannot cohere. The second point is directly related to this first,
insofar as a large number of artists affiliated with the lowbrow move-
ment, to use the most common generic term, actually desire to break
free from its orbit and have actively sought to reposition their work rela-
tive to that of Williams.

Gary Panter, to take an obvious example, though rooted in a comics
aesthetic, has chosen to distance himself from the world of lowbrow art.
For Panter, 'the weirdness of the lowbrow guys is that you have to have
a fancy car to be part of an art movement.'[42] If lowbrow's two distinct
styles are represented by, on the one hand, the painterly and illusion-
istic work of Williams, The Pizz, Anthony Ausgang, and Todd Schorr,
and, on the other, by the looser, scratchier, and more 'purely cartoony'
work of Panter, Georganne Deen, Camille Rose-Garcia, Tim Biskup,
Gary Baseman, and Gary Taxali, it becomes significant that each of the
artists in this latter group have been published in *Blab!*, often repeat-
edly, while none of the former have been.[43] Further, it is the group of
Blab!-published artists in the Panter orbit who are most critical of the
dominant lowbrow art orthodoxies established by *Juxtapoz*. In *Weirdo De-
luxe*, for instance, each profiled artist is asked a series of questions, one
of which inevitably has to do with their relation to the term 'lowbrow.'
Significantly, that term is rejected by the likes of Biskup ('I like the term
"modpop" better. It stands for "modernism and pop" art. I hate the term
"lowbrow"'), Garcia ('I don't see myself as a lowbrow artist mainly be-
cause I think that term refers to a kind of work that came out of car
culture and underground comix . . . My influences are outsider art, art
by insane people, and cartoons and comic books'), and Baseman ('MAD
magazine or Warner Bros. cartoons were more my influences. Rat Fink
and Big Daddy Roth and hot-rod culture is where Robert Williams came
from').[44] Baseman takes his rejection of the lowbrow label further, sug-
gesting that he and artists in the *Blab!* tradition (he cites the Clayton
Brothers, Biskup, and Garcia) are 'trying to distance themselves from

the lowbrow label' because they 'want to be taken seriously in the art world.'[45] Significantly, therefore, an aspirational element enters into the discourse even by those who work decidedly within marginal forms and styles.

When Gary Baseman indicates that he and his peers would like to be taken seriously in the art world, this does not mean that they therefore reject the tenets of lowbrow outright. Rather, these artists have remained aligned with the cartoony visual iconography of comic books and, to varying degrees, embrace visual narratives as well. Like Williams, Baseman champions breaking the boundaries and divisions between fine art and the mass media. In his book *Dumb Luck,* Baseman arranges gallery paintings alongside commercial illustration work in an effort to de-emphasize the distinction between these modes of presentation. Arguing for what he calls 'pervasive art,' he suggests that 'with the turn of the century, more than ever, artists should use ALL mass media as their canvas, and Popular Culture is its language.'[46] As a statement of postmodern aesthetics, Baseman's notion of pervasive art, the blurring of fine and commercial art through the use of diverse media, relies on a conception of art that is fluid and which rejects all notions of purity. This openness to differing media has, notably, brought him into conflict with Williams, who characterizes late-era lowbrow artists as 'chronically cute and politically correct.'[47] For Williams, underground cartoonist and ad man turned countercultural easel painter, the 'new people' are 'bottom-feeders': 'Guys like Baseman who work for Disney know what the average mentality wants. That has nothing to do with lowbrow.'[48] Baseman, of course, is quick to agree. Having convinced Disney to allow him to sign the logo of the cartoon series that he developed for their animation division, *Teacher's Pet,* he finds a particular value in the ability to speak to the broadest possible audience in a wide variety of media. Williams's notion of aesthetic purity and attention to notions of subversion lead him to the conclusion that the lowbrow heirs have 'sold out,' while Baseman, who embraces a greater openness to commerce, maintains: 'As long as you stay true to your aesthetic, you can put your art on anything. People will say, "If you're putting it on fashion, aren't you selling out?" No, if you're not compromising your message, then it's just selling.'[49]

Inaction Figures: The Rise of the Comics Art Toy

One of the things that Gary Baseman is selling is toys. Visitors to the artist's website are presented several options: paintings, store, press, and,

perhaps surprisingly, 'vinyl toy archive.' Rather than focusing on his com-
mercial illustration work, or his work in animation for Disney, Baseman's
site features a wide array of vinyl PVC toys, including the Dumb Luck
limited edition dolls by Critterbox (available in Retro, Japanese, and
New York versions), the Dunces toys by Sony Creative, his contributions
to the StrangeCo-produced Neo-Kaiju series, the Fire Water Bunnies by
Critterbox, his QEE dolls for Toy2R, and the Dunnys that he produced
for vinyl art toy retailer Kid Robot. For Baseman, who argues that 'the art
toy is an extension of fine art multiples,' work in vinyl is simply another
form of pervasive art, offering a different medium to challenge the artist
and through which he expresses his ideas.[50] The concept of the designer
toy, also known as the art toy and conceivable as the highbrow toy, is rela-
tively recent, dating from the late-1990s work of Michael Lau and Eric So
in Hong Kong, and from the designer street wear store Bounty Hunter
in Tokyo. The concept revolves around a designer or artist working with
a toy production company to produce a limited edition collectable toy,
often made from rotocast vinyl. Significantly, it is the status of the artist,
the limited (and thereby collectable) nature of the toy, its high produc-
tion values and high cost, and the method of distribution (through spe-
cialty stores and galleries, as opposed to chain toy retailers), that creates
the distinction between, for example, an inexpensive toy plastic duck
and a collectable toy duck that sells for hundreds of dollars.[51] In the
decade since they first appeared, vinyl art toys have exploded in popu-
larity and interest, with dozens of manufacturers and retailers entering
the market, spawning a related publishing industry featuring magazines
like *Super7*, catalogues like *I Am Plastic* and *Vinyl Will Kill*, and museum
shows like *Beyond Ultraman*, which featured the work of Baseman and
Tim Biskup, alongside several others.

While the vinyl art toy movement had its origins in Asian popular
culture – particularly its fascination with film-related toys (notably Kai-
yodo-produced Godzilla and Kenner's Star Wars toys), corporate adver-
tising mascots, and comic book – derived action figures – as an art form
born in the digital age it was rapidly expanded, internationalized, and
taken up in diverse contexts. *Juxtapoz*, for example, began covering vinyl
toys with regularity in late 2003 in the 'Showroom' feature that opens the
magazine. By mid-2004 vinyl had become a regular feature with articles
about vinyl toys by cartoonists Dan Clowes, Peter Bagge, Kaz and Jim
Woodring, and by lowbrow artists Baseman, Biskup, and Frank Kozik. By
the end of 2004, the magazine was regularly devoting as many as three
pages to vinyl in each issue. For Williams, this was the breaking point in the

lowbrow movement, as what he terms 'popularism' overtakes the autonomous values of craft: 'Now you can see that this thin isthmus between these two cultures is, in reality, a continent apart. When the posters, toys and ephemera get more important than the principle artwork, the philosophy enters a new realm. Whoever can sell the most merchandise becomes the most distinguished artist.'[52] Yet for an artist like Camille Rose Garcia, who produced four vinyl toys with Necessaries Toy Foundation in 2005, vinyl is a source of distinction for her generation of artists: 'I think toys have brought a sense of fun back into things. A lot of the artists in Juxtapoz have characters that could translate into toys. You probably can't have a toy of a Richard Serra sculpture, though.'[53]

For Garcia, the fun involved with vinyl toys stems from the fact that it is character-based, a feature that neatly crosses over to the traditional comics world.[54] Indeed, superhero action figures – from large toy manufacturers Lego, Hasbro, and Mattel, as well as smaller companies such as McFarlane Toys – are a staple of the industry, widely available at toy stores and particularly common as tie-in merchandising released in conjunction with superhero-inspired Hollywood films. These are, however, cheaply made products designed for mass consumption by a predominantly young audience. So while the characters created by alternative cartoonists also lend themselves to adoption by toy manufacturers, it is an entirely different field of production, with the relative scarcity and elite distribution of these limited-edition inaction figures bolstering the distinction between the conception of artists in the mainstream and alternative sectors of the American comic book industry. Significantly, channels of distribution are central to understanding the difference between traditional comics toys and comics art toys, with the former being available in most direct market comic book stores and the latter usually found in even more specialized art stores and galleries. As we saw in chapter 5, the movement of comics into new circulatory regimes, such as the distribution of *RAW* in art book shops and record stores, or *Maus*'s wide-scale success with traditional mass market book retailers has been one of the key functions in altering the cultural status of comics. The same can be said of vinyl toys. Moreover, the transformation of the reputation of toys affects not only the field of lowbrow art but the tangential field of comics as well.

While a number of manufacturers have produced designer toys in conjunction with comics artists, two are particularly notable. Tokyo's Presspop Gallery released its first vinyl toy in 1999, based on the Sof'Boy character from the comics of *Blab!* contributor Archer Prewitt. Since that

time, they have also created toys based on the characters of alternative cartoonists Dan Clowes (Little Enid, Pogeybait), Jim Woodring (Frank, Pupshaw and Pushpaw), and Chris Ware (Jimmy Corrigan). Presspop's toys are notable for their elaborately designed packaging and retro styling, which reflects a fascination with American popular culture of the 1960s.[55] Similarly, Critterbox, based in Santa Monica, California, has, since 2002, produced toys with Dave Cooper (Eddy Table, Pip and Norton), Kaz (Smoking Cat), Tony Millionaire, and Ron Regé, as well as by Baseman and Biskup. For Critterbox, the attraction to cartoonists as toy designers is that 'we like the characters – the connection between characters and story telling – and the fantastic opportunities to bring a characters that seem to live on paper out here into the real world.'[56] Critterbox and Presspop, like *Juxtapoz* and *Blab!* before them, represent a view of the comics world that is multimedia and not bound to the narrow formalist conceptions of what constitutes the acceptable limits of comics as some sort of printed or publishable narrative. It is interesting to note, for instance, that many of the new wave generation of American cartoonists affiliated with *RAW,* the most traditional highbrow comics magazine ever published in the United States, have crossed over to the production of art toys, including Ware, Kaz, Charles Burns (with Sony Creative Products), and, of course, Gary Panter. In this way, the intersection of traditionally neglected popular cultural forms like comics and toys has opened up new avenues for cultural recognition and consecration that might not have been open to either form individually. The intersection of these subcultural arts in the form of new collectables both caters to the emerging 'kidult' sensibility, whose tastes are seen as rooted in arrested adolescence, and rejects the traditional, narrow definition of comics as a cultural form offered by theorists discussed at length in chapter two.[57] The modernist pursuit of the purity of artistic forms that undergirds so much critical thinking on comics from Bill Blackbeard to Scott McCloud can be seen, in the example of vinyl culture, as a lens that has retarded the acceptance of comics as an important art form.

The integration of formerly distinct areas of artistic endeavour – gallery art, commercial illustration, comics, toys – is one of the hallmarks of postmodernism, and is centrally responsible for helping to strengthen the transition of comics into the art world that was initiated by the pop artists of the 1960s. Some will find it strange that the door to the art world would be increasingly opened to comics by vinyl toys and the action figure tradition, an aspect of the comics world that is, to many

purists, peripheral or even trivial. Yet at this particular historical moment it is no longer possible to argue, as Bill North has, that '*BLAB!* is not a comic book, and it is not about comic books' because it most assuredly is both.[58] Indeed, whereas *RAW* actively sought to render comics as akin to art, *Blab!* has rendered comics into art and, arguably more importantly, art into comics. As Panter stated in a *Juxtapoz* profile: 'There is no shame anymore in being a painter who also does comics.'[59] Indeed, as early as 2001 Greg Escalante was free to wonder, 'Are we finally seeing a convergence of the larger art world and the minions of *Juxtapoz?*'[60] While fundamentally undetermined at this point, the answer seems to be heading towards the affirmative.

Which, finally, brings us back to the issue of Gary Panter's Jimbo doll and its phallus. In discussing his paintings and his technique, Panter told Robert Storr that he chose to work with acrylics in art school because he liked the way that it 'gets shiny really quick, and so it tends to look like ugly plastic.'[61] Ironically, it is through the conventions of vinyl sculpting that the artist's attraction to ugly plastic finds its fullest expression, with a doll made up with a skin tone deliberately selected to provide the post-nuclear glow of ecological catastrophe. In the catalogue of his paintings published by PictureBox, Panter includes a short essay on 'Playing with Toys' and several pages of illustrations of toys from his personal collection. He notes that he sees his paintings as akin to toy store windows, and both as akin to cubism insofar as they are carefully arranged shallow spaces.

> The handmade products I make are related to my dime-store childhood and also the mystery of media. You make something very simple and suddenly it speaks louder than anything else in the room. I like doing these prototypes and playing like a mini-corporation. And of course I love picking stuff up off the street that your mom used to say you couldn't. And it's the Duchampian thing of saying 'Whatever I say is art, is art.' I make the rules of the game that becomes my art.[62]

Panter's notion of the Duchampian integration of multiple media is crucial to understanding the collapse of boundaries that have allowed comics to be integrated into the art world in indirect means. In his discussion with Storr, Panter notes: 'After Duchamp you can call anything painting.'[63] To which we might add, 'After Panter you can call anything comics.'

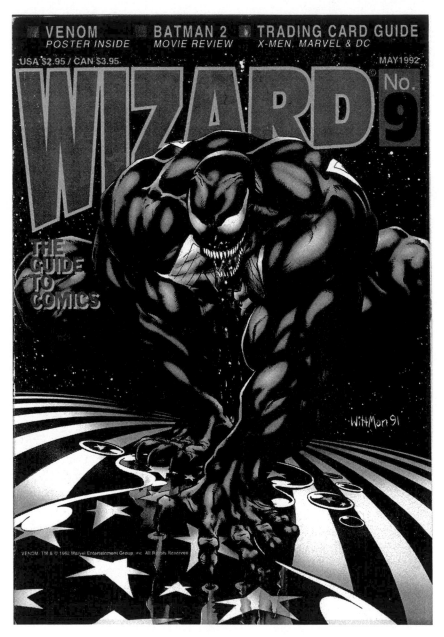

Bart Sears (as Wittman), *Wizard* #9 (May 1992). ©Wizard Magazine.

On Junk, Investments, and Junk Investments: The Evolution of Comic Book Collectables

I have known many adults who have treasured throughout their lives some of the books they read as children. I have never come across any adult nor adolescent who had outgrown comic-book reading who would ever dream of keeping any of these 'books' for any sentimental or other reason.

Fredric Wertham, *Seduction of the Innocent*[1]

An article in the *New York Times* on 6 December 1964 challenged Fredric Wertham's statement from ten years earlier. 'Old Comic Books Soar in Value' was among the earliest articles to address the burgeoning market for comic book collectables, as comic books from the 1940s were reported to be selling briskly at Louis Cohen's 'backdate magazine store' on Sixth Avenue in midtown Manhattan for prices ranging from $2 to $25.[2] The tone of the article, like that of so many similar pieces published in the years that followed, was one of bemused astonishment at the fact that items which 'tidy parents either threw away or sold by the hundred weight to the junk dealer' had suddenly become valuable. What was the source of that value? The buyers provide a strong clue. According to Louis Cohen, customers for the old comics included 'kooks, nostalgic men in their 20's and 30's, pop artists studying the techniques of early cartoonists, and colleges and universities studying the "social attitudes" of the times that are reflected in them.'[3]

Previous chapters have addressed the uses that pop artists and academics found for comic books, and this chapter will focus on the intersection of the first two of Cohen's categories: kooks and nostalgic men. What is of particular note is how nostalgia, the endless pining for a past that can not be recreated, has been structured into the trade in old comics,

thereby transforming an affective (Freudian) fetish into one that is more strictly economic (Marxian).

Previous chapters have drawn upon scholarship pertaining to organized fandom in order to highlight some of the operations of the comics world as they differ from more traditional art worlds. It is necessary, however, to emphasize that fandom is not the only active force in the comics world and also that fandom itself is composed of often diverse sub-groups of individuals with varying interests. American comics fandom designates a community populated by individuals who experience certain forms of popular culture with great personal intensity. Moreover, fannish activity takes on many different forms. One of the most common activities in fandom is collecting, the amassing of large quantities of material pertinent to a fannish interest. Not all fans are collectors, and not all collectors are necessarily fans, although the two positions do overlap within the field to a considerable degree. As the article in the *New York Times* points out, that personal form of investment is often rooted in the affective lure of nostalgia, a position that is closely linked to the second wave of organized comic book fandom in the 1960s and 1970s that the *Times* was unknowingly describing in its reportage. The first wave of comic book fandom, which developed, as has already been noted in chapter 5, around EC comics in the 1950s, was primarily defined by the development of a connoisseurist relationship to specific contemporary comic book production. The second wave, with its origins in the 1960s and fanzines like *Xero* (Richard Lupoff), *Comic Art* (Maggie Curtis and Don Thompson), *The Comicollector* (Jerry Bails), *The Rocket's Blast* (G.B. Love), and *Alter Ego* (Jerry Bails and Roy Thomas), was defined by fans born in the 1930s and 1940s who wrote nostalgically about the comic books that they had read in their formative years.[4] In this way, the second wave of organized comics fandom was considerably more backward-looking than was the first, and, as the *Times* observed, it was focused on the superhero comics of what the fans themselves termed the golden age of American comic book publishing. Moreover, it was this second wave that exerted the greatest influence on the general development of organized comics fandom, creating most of its important institutions including comic book specialty stores, comic book conventions, fan magazines, comic book price guides, and even publishing houses. The strong association between fandom and nostalgia, therefore, has a particular historical origin, even if fandom and nostalgia are not inherently linked. Indeed, readers, fans, collectors, investors, and connoisseurs are all distinct points on a common continuum within the comics world.

Of these groups, the largest is certainly readers. This group encompasses any individual who consumes comics, whether in the pages of the daily newspaper, or in a noteworthy comic book like *Maus*, without developing a strong involvement in the comics world or its specific institutions and rituals. The fan holds a much more clearly developed sense of participation with the object than does the reader. Fans are those who recognize and participate within the logic of fandom, which is to say that fans recognize their own involvement with fandom and generally self-identify as fans. In the comics field, one of the most rudimentary levels of participation is by engaging in collecting. As the comics world is quite large and its publications cover a broad range of interests, most collectors specialize in certain areas. It is common for young comic book fans to develop an interest in certain characters and to seek out and collect comics featuring those characters. In the case of superhero comics with shared storytelling universes, readers may become fans of certain companies and their entire publishing lines. Other fans develop an interest in particular writers or, more frequently, artists and will follow those cultural workers from project to project, company to company. Others develop even more specialized interests, pursuing certain titles from certain eras, for example. The deep personal relationship that the fan develops with his or her obsession almost inevitably seems to manifest itself in the form of a collection, and the collector/fan relationship is so close as to sometimes seem inseparable.

Nonetheless, the position of the collector can be highly contentious within the comics world. For example, in a 1999 article about the ideals of collecting published in the *Overstreet Comic Book Price Guide*, J.C. Vaughn argued, 'It's in there. Somewhere slightly hidden between the ultra-mercenary "What's-it-worth?" sharks and the über-idealistic "Just-read-them!" purists rests the true secret . . . the fun of collecting comics.'[5] Vaughn positions the twinned poles of the comics-buying continuum as readers and investors. The first group pays no attention to the economic value of a comic, while the latter has no interest in the works as cultural objects. Vaughn seeks to sanctify a middle ground, or commonsensical position, separate from both the act of reading and that of consuming. 'Comics,' Vaughn continues, 'are deeply personal to the true collector. They are best enjoyed when collected neither purely for monetary value nor strictly for entertainment.'[6] To make sense of this position, it is necessary to first draw a distinction between comic book readers, comic book collectors, and comic book investors. While a comic book reader may have a significant collection of comic books in his or her

personal library, that person may not cross the threshold to comic book collector if, for example, those comic books are not first editions, are not organized in particular ways, or are not preserved in mylar bags to protect them from the elements. In short, in the fannish logic of Vaughn, the reader is someone who has not matured into the logic of collecting. Readers are undeveloped fans, and their pleasures reside at the level of consumption, as they contribute nothing to the production of value in the comic book market. By 'just reading' their comics, they have, in fact, betrayed the larger purpose of comic book fandom and the comics community.

Of course, from Vaughn's perspective, the 'ultra-mercenary' comic book investors may be even worse. As collectors who have taken their passion too far, they have stripped the human element from the hobby, creating in its place a coldly impersonal, mercantile logic. Lacking the interest in comic books as imaginative stories that animates the idealistic readers, these 'sharks' are depicted by Vaughn as having infested the once quiet waters of comic book fandom, driving up prices on rare books with their predatory interests. Indeed, in the early 1990s this was a particularly widespread fear in comics fandom, as investors, spurred by the creation of new comic book companies and the launch of a multitude of new comic book titles, crossed over from the fields of coin, stamp, and sports card collectables into the field of comic books in significant new numbers. The result was a short-term boom in comic book prices, abetted by the wide-scale media attention paid to first-time comic book auctions at well-established New York auction houses Sotheby's and Christie's. In the longer term, however, this new interest led only to a spectacular crash in that same market, which drove legions of investors, and readers, from the field. The contempt for comic book 'speculators' was so pervasive in this period that megastar comic book creator Todd McFarlane, creator of *Spawn* and a man who contributed to and benefited from the short-lived speculation craze, editorialized in *Wizard Magazine* about 'the pigs of the industry' who had 'raped and pillaged the card market' and now 'jumped into our business.' McFarlane's stated desire – 'I wish I could be the guy standing over them with a butcher knife, so I could gut them and make sure they don't come back' – was rhetorically extreme, yet it represented the widely held sentiment that greed was destroying the innocence of the comic book market in the 1990s.[7] For McFarlane, the problem with comic book investors is that they lack any affective relationship to the comics world itself, seeing it merely as a site that can be exploited for economic profits. The investor,

who might purchase hundreds of copies of a newly released comic book in order to hoard them until a moment in the future when they will have increased in value, is conceptualized as a sort of anti-fan who has absolutely no loyalty to or involvement with the comics field.

Vaughn's search for the 'true' collector who appropriately balances the interests of the market and of the art form speaks to a particularly narrow segment of the overall audience for comic books, as it does for any form of object collecting. Specifically, the true collector seems to balance two distinct conceptions of the fetish that are inherent in the act of collecting. In both the Marxian and Freudian notion of the fetish, the object overcompensates for a missing wholeness that the purchaser is unable to attain by, respectively, marking a site of loss or compensating for it. Following this logic, it is easy to see how nostalgia is the primary motivation of the comic book collector, particularly as that figure was given life in the second wave of comics fandom of the 1960s and 1970s. This is somewhat at odds with collectors in the more traditionally consecrated field of art where investors and connoisseurs play a more important role than do fans.

Indeed, it is difficult to even conceptualize the cultural category of the 'art fan' in a manner that is akin to the comics fan. The related terms that one finds in the art world include patron, aficionado, specialist, authority, and connoisseur, but fandom implies a level of psychological instability that does not properly accord with the collective self-image of the art world. A category such as 'museum-goers' might be an appropriate analogue for the nebulous 'reader' in the comics world, defining a lowest level of affective attachment and commitment to the field. More serious audience members in the field of visual arts include, as in comics, collectors and investors, but there does not exist a direct correlation between these positions in the field of visual arts and the field of comics, largely owing to differences in the prestige accorded each field. For one thing, art collecting is not primarily driven by nostalgia. While a longing for an imagined past may play a role in creating an interest for a particular art style or period, it is neither predominant nor as highly personal. In the field of comics, collectors regularly, although by no means exclusively, focus attention on the comics that they associate with their youth and adolescence. This is generally not the case in, for instance, the visual arts, where collectors tend to organize their buying around different logics. The essential difference is that the traditional art market is highly structured around connoisseurs and investors. The difference between collectors in the art world and the comics world is underscored

by the way in which its collectors are profiled in trade magazines. Just as *ArtNews* regularly profiles exemplary collectors of art and publishes an annual list of the Top 200 Collectors, well-known collectors of comics are routinely profiled in the pages of *Diamond Dialogue,* the monthly trade magazine published by the largest distributor of American comic books. It is seemingly inevitable that the profiles of features in the 'Star Collector' column drift into the area of fetishism, with collectors commenting upon their childhood interest in comic books and their quest for ideal examples of their favourite titles and books. In the comics world, leading collectors seek out the best examples of nostalgic material from their personal past, aligning collecting with fandom. In the art world, on the other hand, the logic of connoisseurship is much more pressing. Each field feels put upon by the influence of investors, those who purchase large amounts of material for purely speculative economic purposes, but otherwise the logics undergirding collecting remain quite distinct. Nonetheless, in the 1990s, efforts were made to bring the comics world more closely into alignment with the traditional art world when New York's leading auction houses, Sotheby's and Christie's, began to auction old comic books and original comic book and comic strip art. Ultimately, these efforts were short-lived, and comics proved largely irreconcilable to the logics of these art world institutions as a result of the inability of the auction houses to imbue comics with a sense of legitimate aesthetic importance. The inability of these venerable art institutions to reconcile comics within their operations has a lot to tell us about the limitations of comics in the contemporary art world. Comic books, it is true, can sell for vast sums, but that in itself is not a sufficient reason to consider them art.

Placing a Value on Comic Books: The Official Overstreet Comic Book Price Guide

On 11 October 1979 the *Washington Post* ran a story on the front page of their Style section that was a variant of the 'goldmine in the attic' stories exemplified by the *New York Times* article from fifteen years earlier. The *Post* reported that John Snyder, a government relations analyst from Alexandria, Virginia, had paid a record $13,000 for a 'near-perfect' copy of *Marvel Comics* #1 that 'he will never read.'[8] Snyder, who approached the collecting of comics as an investment opportunity, told the *Post* that he believed he could sell the same comic in a year's time for $19,000: 'If I put that same $13,000 in certificates,' he noted, 'the best I could hope

for would be $14,300 in a year. You tell me who's crazy.'[9] The economic logic deployed by Snyder accorded nicely with that of well-known comic book collectors of the period. Robert Overstreet, publisher of the annual *Comic Book Price Guide,* was quoted in the *Post* story as saying that 'comic books have always been an excellent investment . . . In recent years they've been averaging more than a 25 percent increase in price per year.'[10] Despite Overstreet's claims, comic books had not *always* been an excellent investment. For much of their history they were considered disposable ephemera, the type of material that is purchased cheaply, read, and disposed of. A 1948 article in the *New York Herald Tribune,* for example, detailed the efforts of Jackie O'Neill, who spent his weekends selling used comic books from a stand in front of his home on New York's Upper West Side. At a time when the market for used comic books had not yet been called into existence, O'Neill had generated revenues of only six dollars in more than a year of selling comic books for prices ranging from one to seven cents.[11] Indeed, it was precisely because the vast majority of the copies of *Marvel Comics* #1 were dismissed as valueless and had been thrown away over the intervening forty years that Snyder's copy was so valuable. Further, it was the regularization of the comic book collecting marketplace, organized largely by the debut of Overstreet's *Comic Book Price Guide* in 1970, that initiated comic books into the realm of investment potential.

Instigated as a guide for nostalgic collectors of the so-called golden age of comic books (comics from the period between 1938 and 1950), the *Overstreet Guide* was selling more than 50,000 copies per year by the late 1970s, when the *Post* article was published.[12] Each annual *Guide* was several hundred pages long, consisting of introductory articles on collecting, grading, buying, and selling comic books, a market report, investor's data, charts of the most valuable comic books (sorted by historical period, or what is known within superhero comics fandom as ages), directories of comic book stores and dealers, and articles and features on a small number of comic books of historic or investment interest. The bulk of the *Guide* consisted of hundreds of price listings for a wide, but not exhaustive, variety of American comic books in different conditions, and the whole package was rounded out by hundreds of advertisements for comic book dealers from around the world. Snyder's record-breaking purchase of *Marvel Comics* #1 was reported in the 1980 edition of the *Guide,* and it was one of the highlights of the annual report, with Overstreet himself noting that the national press coverage generated in the wake of the *Post* story had led to 'many phone calls from newspapers and

television stations about investing in comics,' resulting in a sudden surge of prices on key golden age books.[13] Overstreet's acknowledgment of his personal involvement in the media sensation about the value of comics exploited the media's interest in 'unusual' stories to generate hype for comic book collecting within a larger culture of promotionalism. Further, it allowed him to mobilize what Olav Velthuis terms a 'script,' a set of rules that enables dealers to set prices systematically, in comic book sales.[14] For Overstreet, that script is that comic books are always a good investment and that their value always rises over time even in otherwise hard economic times.

Every annual edition of the *Overstreet Guide* is prefaced by a disclaimer indicating 'everyone connected with the publication of this book advocates the collecting of comic books for fun and pleasure.' Nonetheless, the volume's unrelenting focus on monetary values belies that proviso. Further, each successive edition of the *Guide* carried in it the same script: comic books are now, more than ever, an ideal investment because prices are continuing to climb. Indeed, the *Overstreet Guide* is never the bearer of bad news. The recession of 1979–82 and the record devaluation of the American dollar meant to Overstreet that 'many people began looking for a financial haven in which to place their invested dollars. As a result, the gold and silver markets zoomed as well as all other collectable fields – including comics.'[15] With unemployment topping 10 per cent in 1982, many collectable fields saw prices decline, but Overstreet argued that the comics market 'fared very well' and many titles 'shot up in value due to high demand and low supply.'[16] Similarly, the stock market crash of 1987 'sent investors looking for alternate avenues of investment,' and the recession of 1990–1 did not stop the 'significant upward movement' and 'strong bullish sentiment' in the comic book marketplace.[17] More recently, the collapse of the dot-com bubble was a positive to Overstreet because it led to 'freeing up investment capital for other areas of interest.' Even the events of 11 September 2001 apparently failed to dent the momentum of the market, as by the end of that year Overstreet announced that 'the comic book market [had] rebounded!' with the highlight being the sale of John Snyder's aforementioned *Marvel Comics* #1 for a new record for the most money ever paid for a single comic book: $350,000.[18] In the logic of the *Overstreet Guide,* 'comic book prices in general have proven resistant to economic downturns of the past 20 years! This fact has not gone unnoticed by professionals of other fields. As sales fell in other collectables several new dealers began to enter the comic marketplace. Since the supply of silver and golden age comics is limited,

one can only expect additional price gains due to the increased competition.'[19] Since Overstreet contends that comics are immune to economic downturns, the boom times are even better. Thus, in 1984, 'fueled by the national economic growth and stability of the past year, the comics market responded with large gains in most areas,' while the economic expansion of the dot-com craze in the mid-1990s caused prices to soar 'to new record heights' in 1996, and continued 'unabated' in 1997 as a result of steady interest rates and a climbing Dow Jones industrial average.[20] Thus, according to the script prepared by Overstreet and other prominent comic book collectors and investors, the market benefits from downturns in the stock market, as investors look for safer avenues and higher rates of return, as well as from upturns in that same market as more investment capital becomes available. The growing value of *Action Comics* #1, the first appearance of Superman, and the benchmark for the most valuable comic book in the *Overstreet Guide,* shows that for comic book collectors it is perpetually the best of times and the best of times. In 1977, the year when the *Guide* began an annual listing of the '50 Most Valuable Comics,' it was valued at $4,200. By 1995 it was valued at $125,000. As of 2008, a mint-condition copy is valued by *Overstreet* at over one hundred times its collector value from thirty years earlier, at $475,000.

While *Action Comics* #1 has exceeded its guide price in some instances, very few comics reach that level of value in real or speculated terms, and many never reach any kind of collector value at all. The primary role of the *Overstreet Guide* is to drive investment in golden and silver age comic books; thus it also plays a crucial role in delimiting what counts as a 'collectable' comic and what is merely fodder for readers. In the late 1980s, when comics collecting was at a peak, there was also a tremendous expansion in the number of comics publishers producing cheap black-and-white books, generally with small print runs, for the direct market of comic book specialty stores. When some of these titles, such as Kevin Eastman and Peter Laird's parodic *Teenage Mutant Ninja Turtles,* became cult hits and appreciated quickly in value, new publishers rushed in and flooded the market. To this end, an 'important warning to investors in new comics' appeared in the 1987 edition of the *Guide* about the 'avalanche' of new black-and-white titles that had debuted in recent years. Crucially, the *Guide* noted 'the potential buyer or collector of these new titles should be certain he understands that many of these books are common,' a denigratory term that means widely available but also implies a level of vulgarity that seems curiously out of place in a guide to

popular cultural artefacts.[21] For comic book investors, as with investors in all areas, the most important factors in the value of a comic book are the combination of long-term demand and scarcity. Basic economic theory is enough to demonstrate that the scarcity of a title is of little import if no demand for it exists, and, similarly, significant demand for a title does not drive up its price if the supply is plentiful or even continuous. Thus, from the point of view of investment potential, the turn towards graphic novels that was so critical in terms of legitimating comics as cultural material for adults in the wake of Art Spiegelman's *Maus* has been derided by *Overstreet* as 'a real dilemma for the collector in our hobby' because graphic novels, like prose novels, 'generally do not appreciate in value.'[22] The graphic novel 'dilemma' sits awkwardly with the *Guide*'s previously stated rhetoric about collecting 'for fun and pleasure,' but it is consistent with the *Guide*'s real focus on mercantile issues and aligns neatly with the gatekeeping role that the *Guide* plays in the market. Complaints about titles omitted from the *Guide* have been common throughout the book's history. Dave Sim's long-running self-published title *Cerebus* did not debut in the *Guide* until 1985, eight years into its run, and Wendy and Richard Pini's *ElfQuest* did not find its way into the *Guide* until 1986. Further, many well-established and highly collectable titles from the underground comics movement of the 1960s and 1970s have never been included in the *Guide*. From this standpoint, the *Guide* acts to direct investment interest in the most consecrated areas of American comic book history: the golden and silver ages of the largest and best-known publishing houses. An Overstreet note in the preface to the 1989 edition, at the height of the so-called black-and-white glut, emphasized that the *Guide* is not simply an impartial reporter of comic book prices, but a key arbiter of value itself: 'Just because someone puts out a black and white comic out of their basement does not mean we should acknowledge its existence in this book.'[23] For Overstreet and his *Guide*, with its emphasis on large and well-established publishers, popular comic book characters, celebrated creators, and long-running series, it is clear that golden and silver age comic books are the blue chip investment opportunities in a marketplace that suddenly found itself confused by the rapid proliferation of non-traditional comics in the 1980s.

It is imperative to note the close connection between the *Overstreet Guide* and the second wave comics fandom that spawned it. As second wave comics fandom was primarily focused on a nostalgia for the superhero comic books of the 1930s and 1940s, it is not surprising that these are the works that *Overstreet* tends to prioritize. At the same time,

however, its reluctance to keep pace with developments in the comics world, including the rise of self-published comics, underground and new wave comics, and original graphic novel publishing, resulted in a fissure. The *Overstreet Guide* privileges, above all other comics, cheaply produced genre works produced in the semi-anonymity of the comic book sweat shops of a bygone era and largely eschews interest in comics by artists who have self-consciously sought to align comics with the traditions of the art world. To return to the discussion from chapter 4, *Overstreet* focuses primarily on collectively produced comic books by creators who were not widely conceptualized as artists, even as the *Guide* sees itself as working to correct that historical oversight through such strategies as the provision of story credits on the more valuable comic books listed in its pages. To this end, the *Guide* suggests a resistance to conceptualizing comics as 'Art' and addresses itself almost exclusively to the economically motivated world of collecting in which price, a function of scarcity and desirability, becomes absolutely synonymous with cultural capital. It is true that economic and cultural capital overlap to an incredible degree in traditional art worlds as well. The difference in the comics world, however, is that because it is based around mass-produced objects rather than unique works, scarcity and the condition of the comic book are introduced as overriding conditions in the establishment of prices and, therefore, of values.

The Market for Blue Chip Comics: Sotheby's Auctions in the 1990s

It would be easy to reduce the concept of 'blue chip' comics to those that are both scarce and popular, but to do so would be to underestimate one way in which comic book collecting has sought to mirror the established art market, which is through a focus on condition and, importantly, provenance. Significantly, in the market for old comics, not all copies are created equal. Comics from what are known as 'pedigree' collections are considerably more valuable than are similar copies, particularly as a result of their provenance. A pedigree collection is a rare collection of extremely well-preserved comic books, such as the file copies held by a publisher and, therefore, never damaged by its movement through distribution channels or by having been read. Pedigree collections, the proverbial goldmine in the attic, can be so valuable as to become legendary among comic book collectors. The most famous of pedigree collections is The Mile High Collection. This collection was amassed by Edgar

Church between 1937 and 1953 in Colorado. The quality of the books in the Mile High collection was a result of the fact that they were stored, unread, in stacks approximately eight feet high in a dark room. The low humidity in Colorado, and the compression caused by the weight of the comics placed in stacks, resulted in 'minimal acidification and oxidation of the paper' so that the oldest comics in the collection 'were preserved in an almost anaerobic environment related to the compression and are often as white or even whiter than the later books from the collection.'[24] An article in the 1991 Sotheby's *Comic Books and Comic Art* auction catalogue called the Mile High Collection 'the ultimate pedigree books,' noting that these copies were generally synonymous with the best-known-to-exist copies of key golden age books, and that they sold for as much as ten times the mint value listed in the *Overstreet Guide*. As described by Sotheby's, the 22,000 comics in the collection 'redefined condition standards for comic books from the 1940's. The incredible cover gloss (ink reflectivity), and unparalleled paper whiteness of these books represent features that were thought by most collectors not to exist for comics from the 1940's. These books come as close as physically possible to truly demonstrating what the Golden Age Comics looked like on the newsstand.'[25] To this end, the value of the collection can be seen to reside primarily in nostalgia, as the untouched comic books offer the possibility of recreating the illusory wholeness of an imagined past of dazzling beauty.

Other pedigreed comic book collections include The White Mountain Collection, the San Francisco Collection, the Indian Reservation Collection, the Lamont Larson Collection, the Cosmic Aeroplane Collection, the Allentown Collection, and several others, with new collections added to the pedigree list as they are uncovered and brought to market. The establishment of a comic book pedigree, like the decree of a vintage year in port wine, is not merely a simple naming process, but is the result of long deliberation among experts. In 1995, for example, the New York auction house Sotheby's brought a large number of comics from the Mohawk Valley Collection, which had not previously been declared a pedigree, to market. The auction house asked its Committee for Authenticity, Certification, and Grading to vote on whether or not the collection should be granted a pedigree, with the committee concluding that the collection should be known by name 'due to the generally exceptional cover color and reflectivity.'[26] The seriousness with which Sotheby's sought to add value to the Mohawk Valley Collection by having it declared a pedigree is suggestive of how provenance in the field of

comic book collecting carries an economic value just as it does in other art-related areas at auction.

The auctioning of comic books was not particularly widespread, or widely noted, before Jerry Weist, an artist, comic book store owner, and the former publisher of the EC fanzine *Squa Tront,* convinced Sotheby's to stage an auction for comic books and comic art at their New York offices on 18 December 1991. While established auction houses had sold comics in the past, they were most often included as a subcategory of other specialized auctions, such as Sotheby's auction of Children's Books, Comics and Juvenilia at the London office in March 1977 and Christie's auction of Animation and Comic Art in New York in June 1986. The 1991 auction was the first of its kind devoted exclusively to comics, and its novelty led to a great deal of press coverage, including a preview in *USA Today* and on ABC's *Good Morning America*. Media interest continued after the event itself, spurred in part by the presence of an actor/bidder dressed in a Spider-Man costume who purchased a Harold Foster *Prince Valiant* Sunday page for $10,000.[27] While Spider-Man's presence may have helped spread the word of the auction through the press, it did little to alleviate the suspicion that comic books and comic art were not 'real' art. Indeed, despite the catalogue title, Sotheby's did not present the items as art at all. Weist's introduction to the catalogue holds closely to a conception of comics as nostalgic Americana that is very much in keeping with the legacy of writers such as Maurice Horn, Jerry Robinson, Richard Lupoff, and Don Thompson discussed in chapter 2. Weist concludes his essay on the importance of comics to American culture in general:

> Readers and collectors alike are drawn to comics for their timelessness. Whether they remember treasured weekends spent reading their favorite comics characters' adventures, or the first time they purchased that magical comic book that opened up a new world to them, or how a simple story connected them with their own life experiences, people are drawn to comic books for their ability to satisfy curiosity about the world and their ability to spark imagination from their colored pages. People collect comic books and comic book artwork to celebrate this vast diversity of culture. Some may call it 'Popular Culture' or the culture of 'Entertainment,' however, many others see it as a true reflection of the American Spirit.[28]

What is significant about Weist's rationale is the manner in which Sotheby's positioned comics as something other than art, and the way in which

the rhetoric of their catalogue spoke the language of nostalgic fans more fluently than it did the connoisseurist idioms of collectors of painting, thereby reifying the traditional distance between the comics world and the art world within the confines of an art world institution that might otherwise have contributed to the diminishment of these borders.

The significant accomplishment of Sotheby's and, starting in 1992, its cross-town rival Christie's in the field of comics was to amplify the rationalization of the market for comic books begun by Robert Overstreet in 1970. Further, it is that rationalizing process that greatly contributed to the legitimation of comics in the eyes of other powerful actors in the cultural field, including the press, museum curators, and gallery owners. The sociology of the art world has long focused on the observation that art dealers not only sell commodities but also actively create a membership in a community that adheres to the dealer's particular style. In the case of derivative markets, in which the same works are resold, auctions can be an effective way to sell in markets where there may be as few as a dozen potential customers worldwide. In the case of the most successful artists, media attention can quickly increase the number of potential buyers.[29] In this way the auction, as a tertiary market composed of collectors selling works through an intermediary to other collectors without the direct participation of the artist or the dealer, becomes the site at which the 'wheat' is most clearly separated from the 'chaff' of the art world. These twinned processes – the expansion of narrow markets through promotion and the separating process accomplished by open bidding – can be clearly seen in the shape and direction of the comics market following the inaugural comics auctions of the early 1990s, which not only alerted a new generation of investors to the possibilities of the comics collectables market, but initiated the selective process of placing an economic value on important artists and works that is necessary for their further consecration by, for instance, art museums. So while it is true that Sotheby's initially situated comics within the discourse of collectable Americana, their association with the tradition-honoured auction house served to raise both their economic and cultural capital by virtue of the prestige accorded the institution.

The initial Sotheby's comics auction in December 1991 resulted in soft sales of just over $1.2 million, well below the low estimate for all lots. The highest price paid ($70,000) went for a Frank Frazetta oil painting of Vampirella from *Vampirella* #1, while the highest price paid for a comic book was $50,000 for a copy of *Detective Comics* #27 (the first appearance of Batman), a result that reportedly drew a standing ovation from the crowd.[30] In the years that followed, the comics auction was moved to the

spring and total sales climbed. By 1995 the Sotheby's auction generated nearly $1.7 million in sales, with 91.5 per cent of all lots selling. In 1996 the auction, which *The Overstreet Guide* termed 'the Super Bowl of comics auctions,' passed the $2 million mark as the largest and most successful auction of its type.[31] The economic effect of these sales was dramatic and nearly instantaneous. The 1993 edition of the *Overstreet Guide* credited the 'world-wide publicity' generated by the Sotheby's and Christie's auctions with contributing to the 'strong growth' in the field and noted that new investors were entering the comics market for the first time, many from the then-collapsing sports trading card market.[32] The auctions at Sotheby's and Christie's played a major role in creating not merely an economic value for comics, but a cultural one as well. Pierre Bourdieu's contention that it is the dealer that brings the artist or work into the cycle of consecration is a persuasive one in the context of comics production, particularly insofar as, prior to the inauguration of the comics art auctions in New York, comics retained little cultural value outside a small coterie of fannish collectors.[33] In the 1990s, and despite their focus on comics as the reflection of the 'American Spirit,' it was the auction houses that most visibly occupied the role of the art dealer, thereby lending economic legitimacy and cultural credibility to the processes involved in comic book collecting. From this standpoint, the auctions at Sotheby's and Christie's, which served the process of bringing comics into the machinery of the art market, of separating the wheat from the chaff, and thereby establishing 'blue chip' investment possibilities centred around certain important artists and certain key books, can be seen to have played an important role of shifting the art world's perception of the comics world. The comics world dominated by organized fandom, was relatively powerless to enact these sorts of shifts on their own, and the transformation that did occur resulted in the ability of certain fans (notably Weist) to work with the institutions of the art world as it existed at the time. Indeed, the comic book collecting market that developed and flourished within comics fandom during the period of the New York auctions goes a long way towards demonstrating the vast conceptual gulf that existed at the time between the art world and the comics world.

The New World of Hype: The Rise of *Wizard Magazine*

Many critics of *Wizard Magazine* have accused it of being concerned first and foremost with the opportunistic buck. One of the most polarizing publications in the comics world, and one which cartoonist-turned-filmmaker Frank Miller famously described as a 'monthly vulgarity,'

Wizard was founded in 1991 by Gareb Shamus as a newsletter published by his parents' comic book store.[34] Shortly thereafter it became a nationally published magazine featuring news about comics, movies, trading cards, and video games, but it was best known as the first significant challenge to the hegemony of *Overstreet* in the comics price guide market, as each monthly issue of *Wizard* contained such a guide. It is significant that *Wizard* launched when it did. With its bombastic and adulatory writing style, *Wizard* clearly signalled that it was targeting a younger readership than the more staid *Overstreet,* which catered largely to collectors with an interest in high-end golden and silver age comic books. *Wizard* also catered to new collectors, many of whom were migrating towards comics in the wake of a slowdown in the sports card market. The 1980s had been a period of growth for sports cards, with new companies such as Score and Upper Deck entering the market to challenge the long-standing leader in the industry, Topps, in the late 1980s with innovations such as improved printing quality, holographic logos, and autographed 'chase' cards. These innovations, which boosted the popularity of the hobby over a short period of time before precipitating an over-expansion and collapse, were soon mimicked by the American superhero comic book publishing industry, with *Wizard* playing a key role in the promotion of new collectable gimmicks. *Wizard,* which did not include prices on golden age comics until its 50th issue (October 1995), distinguished itself from *Overstreet* by focusing on silver and modern age comics, especially contemporary publications. One significant advantage that *Wizard* had over *Overstreet* in the eyes of its adherents was the fact that it updated prices monthly rather than annually, so that investors were presented with the illusion – if not always the reality – that newly released comics were growing in value before their very eyes. To augment this illusion, *Wizard* offered monthly columns included 'Crystal Ball,' 'Picks from the Hat,' and 'Top 10,' all of which addressed the investment potential of comic books produced in the 1990s, often recommending a wide-ranging array of comics based on their investment potential. In the ninth issue, for example, *Wizard* recommended fifty-nine different new releases shipping in April 1992 as potentially good investments.[35] Significantly, it was not until the fall of 1993 that *Wizard* began to recommend comics as worthwhile reading material as well as good investments.

The speculation boom in the comics market of the early 1990s was fuelled by a number of factors: new investors entering the comic book market for the first time, the creation of several new comic book companies specializing in superhero comics (Valiant Comics and Image Comics being the most notable), gimmick publishing to attract new readers

and create artificial scarcities that would drive investment prices, heightened media interest in the prices of rare comics in the wake of the first Sotheby's auction, and the arrival of a monthly price guide in the form of *Wizard,* which could react to perceived shifts in the day-to-day comics collecting market in a way that the annual *Overstreet* could not. Indeed, *Wizard* is very much a symbol of a shifting dynamic in the comics world in the early 1990s, where a perfect storm of factors caused a sudden transformation of the field from disposable kid culture to one of lasting import. Thus, the price guides themselves did not generate that boom so much as capitalize on the simultaneity of the other factors, even as they promoted artificially inflated prices.

The launch of the first comics from Valiant Comics in 1990 and the first Image Comics titles in 1992 were much heralded by *Wizard* as the start of the next era of great comic collectables from the stalwart American superhero tradition. In *Wizard* #9 Greg Buls suggested that 'a lot of collectors see the genesis of Marvel Comics in 1961 when they look at Valiant Comics in 1992. The books are extremely enjoyable, and are also extremely collectable.'[36] Similarly, in the next issue, publisher Gareb Shamus argued that Valiant, Image, and Topps Comics, a subsidiary of the sports card industry leader, will lead comics collecting to grow 'at an even more rapid pace over the next year.'[37] *Wizard*'s strong endorsement of new publishers helped to position it against the more staid *Overstreet Guide,* which had a long-established interest in, and connection with, the venerable superhero comic book market leaders, Marvel and DC. Indeed, *Wizard* aggressively promoted Valiant, which was founded by former Marvel editor-in-chief Jim Shooter, and Image, which was founded by seven popular Marvel artists who had left that company. For example, the ninth issue of *Wizard* had an article on the founding of Image Comics, with an interview featuring all of the founders, while the next three issues had lead features on Image founders Rob Liefeld, Todd McFarlane, and Jim Lee respectively. At least in its earliest years, the magazine had much cooler relations with Marvel and DC, only writing about their titles or creators sporadically, and often disparaging the investment potential of popular long-running titles featuring characters like Batman and Superman. To this degree, *Wizard* can be conceptualized as anti-nostalgic, as its strict focus on contemporary comics (new releases) and new characters marked it as a publication for a new generation of comic book fan.

Nonetheless, in many respects the new comic book publishers and Marvel and DC were very much akin during the speculator boom. The speculator boom of the early 1990s resulted from the deliberate

manipulation of the marketplace on the part of the major superhero comic book publishers, who, borrowing from the lessons learned by the sport card industry, sought to spur sales on their titles through the creation of artificial scarcities. Moreover, the boom was enhanced by the fact that it was initiated at a time when the visual aesthetics of the American superhero comic book were undergoing a transformation at the hands of a small number of young artists who were marketed as superstars during this period. The confluence of these forces led publishers to attempt to transform groups of fans who had heretofore primarily been readers and collectors into short-term investors. Absent the ability to expand the audience for superhero comics, the publishers sought to improve their bottom lines by selling more comics, and multiple copies of the same comics, to their existing fan base. One of the factors in the creation of the boom was the publication of several Marvel titles in multiple, or variant, formats that went on to sell millions of copies. In the summer of 1990, Marvel sought to capitalize on the popularity of writer-artist Todd McFarlane by releasing a relaunched *Spider-Man* #1 in four different formats. It became the biggest-selling single issue of a comic book up to that point in history, with many collectors purchasing multiple copies; the comic sold more than 3 million copies, and two subsequent editions (the gold and platinum editions) added to that total. Marvel struck again in June 1991 when they shipped 3.6 million copies of *X-Force* #1, a new X-Men-related title from writer/artist Rob Liefeld. Sales on the title were significantly boosted when Marvel had its trading card licensee, Impel, insert trading cards into pre-bagged copies of the comic. Although there was only one comic book, there were five different cards, which caused many collectors to buy six copies – one for each card, and one to open and actually read. Marvel again topped itself when it released a new, second volume of *X-Men*, with art by Jim Lee. *X-Men* #1 came with five different, or variant, covers, each shipped in a different week. With many collectors and speculators purchasing multiple copies, the book collectively sold more than 8.2 million copies. Other gimmicks released that year included the embossed foil card stock used on the cover of *Silver Surfer* #50, the glow-in-the-dark cover of *Ghost Rider* #15, the die-cut cover of *Wolverine* #50, and the twin gatefold cover of *Hearts of Darkness*. These comic books positioned Marvel as the market leader in artificially boosted sales, although other publishers quickly mimicked their success. While *Wizard* aggressively promoted these publishing gimmicks through their 'Hot Picks,' the magazine also sounded a note of caution. In April 1993, Robert Sodaro noted that 'cynics among us can

only wonder if this is a real marketing technique designed to attract attention to a worthwhile product, or just another ploy to boost sales and disguise shoddy content.'[38] Sodaro demonstrated his prescience when he noted that customers would ultimately tire of the 'tricked-up' material, but suggested that in the interim 'enhancements may be just the ticket to infuse new blood, new life, and perhaps even new customers in what has always been a finite, and ever-shrinking market.'[39]

The gimmicks that took off in the superhero comic book publishing field in 1990 and 1991 reached their crescendo in 1992 when DC Comics decided to kill Superman. *Superman* #75, released on 17 November 1992, was widely described in the media as the fastest-selling comic book in history, with more than 2.5 million copies sold in its first week of release. *Wizard*, which had shown very little interest in comics from DC as investment opportunities, downplayed Superman's death in the months leading up to it, suggesting in their sixteenth issue that 'we don't expect [it] to increase in value overnight,' but that the attention it will garner could lead new customers to 'other eye-catching books on the stands at the same time,' such as Valiant's *Bloodshot* #1, and, in the next issue, predicting that the price of the book would increase in aftermarket sales, 'but there's no way it can last.'[40] After the release of the comic, and wide-scale reports about its dramatic rise in value in the daily press, *Wizard* continued to minimize the event, which it had essentially missed out on reporting, as nothing more than the result of hype:

> When it was first announced six months ago that DC was going to ax Superman, the fans reacted with 'Oh sure, they'll kill him off for a couple of issues and then bring him back,' which is pretty much true. But Joe Schmoe on the street didn't know that. The result? A book that's going nuts in the secondary market. The price is so volatile that on the date of its release, some stores were fetching as high as $35–$40 a copy. Was this dramatic increase in price due to the flock of comic collectors beating down the doors looking for a copy of Supes #75? No. It was because of the media attention surrounding this historic (though temporary) event. The non-comic buying public was worked into a media frenzy over this death issue by the media, and when they book finally hit the stands, they had to own it, no matter what the cost. Store owners realized this, and the uneducated consumer (along with their wallets) got raked over the coals.[41]

Wizard, a magazine that built its reputation and readership through the endless promotion of ostensibly 'hot' comic book collectables, ironically

concluded its attack on the media and 'uneducated consumers' by offering that 'anyone who falls for all that over-hype deserves a slap in the face.'[42]

The media interest in the death of Superman not only anticipated the release of the comic, but grew as reporters covered the frenzied aftermarket activity described by *Wizard*. An article in the *Las Vegas Review-Journal* was typical of the coverage of the secondary story. Warren Bates reported: 'Buying the comic that features the Man of Steel's demise, some believe, is a better choice than stocks,' and that Superman's death had 'created an investment opportunity that would embarrass an insider stock trader.'[43] Bates reported that the ironically named Hit and Run Comics in Las Vegas had a 'few hundred' of the collector's edition of the comic for sale at $30 each, and that the store was buying copies of the deluxe edition back from its customers to service newer customers willing to pay the steep mark-up. Hit and Run manager Tim Boal summed up the day-trading ethos of the moment when he noted: 'People are finding this a better investment than stocks, they were buying a hundred at a time without flinching.'[44] While coverage of the value of comics was nothing new in the annals of American reporting, this focus on the short-term gains to be had were seemingly unprecedented. Nonetheless, this media interest arrived at the peak of the speculative frenzy. The death of Superman did not presage an expansion of the comic book market, but rather signalled the moment at which the bubble burst. By deceiving the public about the collectability of these comics – and about the permanence of Superman's 'death' – comic book publishers, specialty stores, and fan magazines perpetrated a fraud that contributed to a general disillusionment among comic book readers. The Death of Superman hype revealed that the short-term comics investment market popularized by *Wizard* and fuelled by publishers and retailers looking to quickly expand the market was, in reality, little more than a Ponzi scheme. By the time DC brought Superman back to life in 1993 interest in the title had diminished considerably and the air was coming out of the comics speculative bubble. Significantly, in 1994 the American comic book industry entered into a protracted sales recession and has yet to reclaim the artificially enhanced sales peaks that it witnessed briefly in the early 1990s.

To Preserve, Protect, and Grade: Bringing Science to Comic Book Collecting

One final aspect of the *Superman* #75 mania is worth considering in the context of the value – economic and symbolic – of comics, namely the

fact that not all versions of the comic are considered equally valuable. Current *Overstreet Guides* list differing prices for five distinct versions of the comic. In order from least to most valuable, these are: the second through fourth printings of the direct sales editions; the first printing of the direct sales edition; the only printing of the newsstand edition; the collector's edition; and the 'platinum editions,' which were given away to retailers who met certain sales incentives and are, thus, artificially rare. It is a commonplace from the field of book collecting that subsequent editions of printed matter are rarely as valuable as first editions, so it is not surprising that the least valuable copies of *Superman* #75 were those released after the initial wave of excitement. The most valuable edition of the comic that was made available to the general public was the so-called 'collector's edition' sold exclusively in comic book stores. This edition came complete with a poster of Superman's funeral, an obituary from the *Daily Planet,* a postage stamp, and a black armband. These supplemental items were held together with the comic in what is termed a 'polybag,' an inexpensive plastic bag containing the comic and the other material that prevents the book from being read prior to purchase. Of all the gimmicks associated with the speculator market in superhero comics of the early 1990s, none has proven so continuously troubling as the polybagged comic.

In the 1994 edition of the *Overstreet Guide,* published after the collapse of the speculation market, the editors added a new section seemingly inspired by *Wizard.* 'Collecting in the 1990s' noted that, as a result of the flood of new publishers, new artists, new heroes, and new gimmicks, 'comic book collecting has become more fun and exciting than ever before,' but new developments required new policies. Thus, *Overstreet* decreed: 'It is the official policy of Overstreet Publications to grade comics regardless of whether they are still sealed in their polybag or not. Sealed comics in bags are not always in mint condition and could even be damaged. The value should not suffer as long as the bag (opened) and all of its original manufactured contents are preserved and kept together.'[45] This executive fiat from the best-established voice in comics collecting should have served as an important ruling for dealers and collectors, but since collecting is a social process involving a multiplicity of actors, the controversy surrounding polybagged comics persisted nonetheless. As early as 1992 *Wizard Magazine* had called for 'some official rules' to be printed and signed 'in Geneva' ('we will call it the first ever comics treaty'), but *Overstreet*'s treaty was not recognized by all parties.[46] In June 1994, *Wizard*'s Marc Wilofsky noted that while the position advocated by *Overstreet* should become the rule, it unfortunately did not: 'When a

comic is taken out of its bag, it's considered a damaged book' and conse-
quently worth considerably less than a comic still unread in its polybag.
Two months later, a reader responded to this comment by noting that
polybags, which are made of low-grade plastic, 'will turn your pages yel-
low quicker because they have chemicals which make the comic dete-
riorate in time.' By removing the comic from the polybag and placing it
in a Mylite plastic container with an acid-free cardboard backing board,
Pompeo Balbo argued, in the long run collectors will have a pristine
copy when the polybaggers will have an 'unwanted item.'[47] Two months
after that, however, additional readers entered the debate, with Dan
Premo suggesting that a comic removed from a polybag and stored in
Mylite would be the equivalent of a reparation to the book, and that
restored comics are less valuable than unrestored ones in comparable
condition. Seeking to rise above the fray, Wilofsky adopted the position
long championed by *Overstreet* and other price guides: 'You should col-
lect comics for mostly fun and reading!' Sensible advice, were it not for
the key qualifier 'mostly.' Nonetheless, *Wizard* undermined their advice
in their very next sentence: 'BUT – Dan has a viable idea regarding the
similarity between opening a polybag and repairing a book: you're "de-
facing" the book either way, and collectors just want something that's
totally untouched.'[48] What collectors 'just want,' according to this logic,
is a fetishized object of nostalgia rather than the kind of aesthetic experi-
ence that could be provided by an open comic book.

Wilofsky's contention that collectors want something untouched is,
of course, at odds with the recommendation that comics be bought for
'fun and reading,' and it distils the most vexing question pertaining
to the value of comics: condition and readability. It calls to mind the
Washington Post's note about John Snyder's purchase of *Marvel Comics*
#1 in 1979, that it was a comic 'that he would never read.' Further, this
issue cuts to the heart of the questionable status of comics as physical
objects. Are they works of art to be appreciated and enjoyed? Or are
they ephemeral collectables to be preserved unspoiled for future gen-
erations? Susan Cicconi, writing in the 1991 Sotheby's comics auction
catalogue, positioned comics squarely in the latter camp. She suggests
explicitly that comics are not art when she defines ephemera, including
comic books, as 'paper collectables particularly of the 20th century which
are not bound volumes or objects of fine art but objects which have a col-
lectable nature and therefore a value attached to them.'[49] Comics, she
continues, were meant to be disposable like the morning paper and,
as such, were printed on cheap-grade, acidic paper. Nonetheless, with

prices for 'near mint' copies of key comics from the 1930s being sold for tens of thousands of dollars, the question of preservation has become increasingly pressing. The need for conservation is, in Cicconi's reasoning, exclusively economic. Comics are preserved because they sell for vast sums, not because they have a larger social or aesthetic importance.

According to Cicconi, proper preservation techniques for comics include storage in a heat-, light-, and humidity-controlled environment, the use of archival preservation supplies, and, when necessary, acid neutralization of interior pages.[50] The scientization of comic book preservation alluded to by Cicconi with the phrase 'archival preservation supplies' was a long time in developing in the field of comics collecting. In 1977, for example, the *Overstreet Guide* recommended storing comics in 'a dark, cool place with an ideal relative humidity of 50 per cent and a temperature of 40 to 50 degrees or less. Air conditioning is recommended. Do not use cardboard boxes since most contain harmful acids. Seal books in mylar or other suitable wrappings, containers, bags, or cabinets which will protect them from heat, excessive dampness, ultraviolet light (use tungsten filament lights), polluted air, and dust.'[51] At the same time, it seriously entertained the notion of having comics bound as hardback books. Overstreet noted that the drawback is that the comics would be trimmed in the process and would lose their value as individual entities but 'would gain as a bound volume.'[52] This suggestion about binding was quickly dropped in subsequent editions of the *Guide* as the emphasis came to be placed on the importance of condition. As Overstreet himself wrote in 1984: 'The key word is condition and the key condition is Mint.'[53] To keep comics 'mint,' that is, to ensure maximal potential return on investment, it is imperative that they be properly handled and preserved rather than being read and enjoyed. As early as the late 1970s, the *Overstreet Guide* contained lengthy articles on the science of preservation. In 1979, for example, Ernst W. Gerber and William Sarill filled six pages with notes on storage environment, storage devices, plastic bags, mylar bags ('of all the plastics available, virgin polyethylene is the only plastic worth a closer look'), backing boards, and deacidification.[54] With so many factors and choices for the average collector, it is no wonder that Richard D. Smith noted in the 1983 edition of the *Guide:* 'The long term preservation of comic books is a challenge that boggles the imagination.'[55] That article on preservation, the longest and most complete ever published by *Overstreet*, included two engineering charts about the long-term effects of various forms of plastic on comic books and a recommendation to 'chemically deacidify' one's collection; it also offered, for

$2.00 and a self-addressed stamped envelope, a full bibliography of peer-reviewed engineering and chemistry articles pertaining to the evaluation of plastics, cardboard, and other detriments to collectable ephemera.

For those collectors who may have failed to heed the advice of the preservation experts, all was not necessarily lost. A second step beyond preservation is, of course, restoration. The 1977 *Overstreet Guide* again offered a point of view that seems at odds with more contemporary thinking about appropriate restoration in the field: 'The color Xerox which is now available in large cities can be used to replace needed centerfolds, missing pages and covers.'[56] Given the absence of this recommendation in later editions of the *Guide,* it seems plausible to surmise that restoration amounting to forgery was not endorsed in any wide-scale fashion by the collecting community. Rather, by 1980, *Overstreet* positioned the act of comic book restoration – a cross between the 'centuries old tradition of fine arts and book restoration with the latest scientific achievements in the field of paper conservation' – as placing comics firmly within the conventions of the fine arts.[57] Overstreet noted, for example, that Michelangelo's Sistine Chapel 'has been restored completely on average of every forty years, yet tourists continue to admire it as *his* work.'[58] Overstreet's choice of examples may have been influenced by the news coverage that year of preparations for the restoration of the Sistine Chapel and the work that would begin four years later. That that restoration was highly controversial did little to dissuade proponents of comic book restoration in the years to come.

For restored comics, the primary concern was less about the integrity of the artist's vision than about maximizing return on investment through the creation of comics that are as close to 'as new' as possible. Cicconi, in the 1991 Sotheby's catalogue, identified non-abrasive cleaning, tape and stain removal, paper reinforcement/replacement, and colour in-painting as among the roles of the professional comic book restorer.[59] The value of the restorer was underscored by the description in the 1997 Sotheby's *Comic Books and Comic Art* catalogue of a copy of *Superman* #1 with Detached Covers and Missing Centerfold, estimated at $2,000–$3,000 and graded Poor with a score of 4 on the 100-point scale used by the grading committee:

> Many people would comment that the consultant has been too 'brutal' with a grade of poor at 4. With the centerfold missing, one almost has to grade this book low, especially with the covers detached. This said, any experienced collector is going to recognize that the covers are very 'intact' and

with 'brilliant' colors. One just has to find the centerfold, and hand this copy over to Susan Cicconi, to then own a very fine plus to near mint in appearance book once it is restored.[60]

Given the fact that the grading scale used by Sotheby's defined very fine as 75–89 points and near mint as 90–97, and given that the 1997 *Overstreet Guide* indicated that only three near-mint copies of *Superman* #1 were known to exist and that they were valued at an average $110,000, it is clear that the potential value of restoration and the small matter of locating that missing centrefold were quite significant from an investing standpoint. Indeed, buyers at the auction must have concurred, as this copy sold for $9,775 (including the buyer's premium), more than triple the high estimate.

Central to this logic of restoration as the expansion of investment value is the concept, addressed directly in the Sotheby's text, of grading. Indeed, Sotheby's employed an external and impartial grading committee for each of its auctions to make things 'safer, ethical, and more secure for buyers,' and publicized the names of the committee members in each of their catalogues.[61] The issue of grading has been tremendously important for the *Overstreet Guide*, which lists multiple prices for each comic depending on the grade it is afforded, and Overstreet and Gary Carter even published a grading guide in 1992 complete with an OWL card (Overstreet Whiteness Level) depicting various paper colours so that investors could accurately distinguish 'white' from 'off-white,' 'tan,' 'brown,' and 'brittle.'[62] The push towards objective grading criteria in what is a thoroughly subjective process has been paramount in establishing the logic of collecting and has resulted in the plethora of grading guides and grading committees used by major dealers and auction houses to minimize disputes between investors and vendors. In a field in which the number of copies of any particular book can range from fewer than a dozen to more than a million, minimal differentiation of copies becomes paramount in the creation of prestige. Indeed, as has already been illustrated, the very notion of the prestige, or pedigree, collection is dependent on the fact that the comics in the collection are the 'best copies known to exist.'

The evolution of comic book grading illustrates many of the factors that have contributed to the conception of comic books as ephemera rather than fine art. The earliest *Overstreet Guides* in the 1970s used an eight-part rating system (Mint, Near Mint, Very Fine, Fine, Very Good, Good, Fair, and Poor) with written descriptions of the varying conditions. Thus, in

1977, 'mint' condition comics were described as 'Perfect; absolutely like new regardless of age; near white to white cover and pages; no printing or cutting defects . . . A gem by any description.'[63] Two years later, a ninth category, Pristine Mint, was added to denote 'File copies; perfect; absolutely perfect in every way,' and Mint was demoted to 'Almost perfect' until the category Pristine Mint was abandoned as a theoretically impossible standard in 1990.[64] Despite these subtle variations over time, the entry of Sotheby's into the tertiary comics market seemingly provoked a dramatic overhaul of the highly subjective process of comic book grading. Because 'comic book collecting has become a lot more sophisticated, and therefore grading procedures are taken more seriously,' Sotheby's Committee for Authenticity, Certification, and Grading began to use the 100-point system created by the American Association of Comic Book Collectors.[65] Complete details of this grading system were available in the *Overstreet Comic Book Grading Guide* (1992) and were summarized in that year's *Overstreet Guide* as the Overstreet Numerical Equivalent (ONE number), whereby the former eight-part grading system was converted to a 100-point scale with Mint representing 98–100, Near Mint 90–97, and so on down the scale.[66] With this new scale, nuanced and objective comparisons could be made between seemingly similar objects. In 1996, for example, Sotheby's offered two different copies of *Captain America* #1 for sale, one rated 'very fine minus (78)' and the other rated 'apparent fine (65).' The former was estimated between $30,000 and $40,000 and the latter between $700 and $1,000, despite the fact that their overall grades might seem, at first glance, to be reasonably similar with only a thirteen-point differential. Having established the impossibility of an objective grading standard, it is not surprising that at the turn of the century the comic book field opted instead for a 'market-established grading standard.'[67] This was the term used by Sotheby's in the catalogue for their final comic book and comics art auction in June 2000 when describing the services of Comics Guaranty, LLC (CGC). Founded by Steve Borock and Mark Haspel in 2000, CGC promised a uniform assessment of comics sent to its Florida offices for grading. It replaced Overstreet's 100-point scale with its own nearly identical 10-point scale (a 10-point scale with fractions, so an 8.2 rather than 82), in a drive to bring stability to the booming market in internet-based comic book sales.

Significantly, both Sotheby's and Christie's abandoned the comic book auction market at the end of the 1990s. For a time, Sotheby's moved their comic book auction online in conjunction with their partnership with Amazon.com, before eventually moving out of the market entirely.

The reasons for this decision seemed threefold. First, the comic book auction market never developed as fully as the auction houses might have hoped, and while prices continued to rise they still remained relatively depressed in comparison with other art markets. Second, the rise of eBay and other online auction sites allowed collectors and dealers to effectively bypass large institutions such as Sotheby's since, as fans rather than as connoisseurs, comic book collectors derive little added value from the legitimating force of the auction houses and often chafe at paying buyer's premiums. Third, new players such as Greg Manning, Mastronet Inc., and Heritage Auctions entered the comics auction field, often from related fields such as coin collecting, making the market for high-end auction items more competitive. The arrival of these new players, and the rise of internet-based comic book sales, was facilitated by the rise of CGC and their practice of 'slabbing' comics to preserve them in their original state and prevent them from being read or enjoyed by anyone at any time.

The arrival of CGC was triumphantly heralded by the 1999 *Overstreet Guide* in a feature article titled 'The Next Revolution for Comic Books! A New Ten-Point Grading Scale and a Certification Service to Guarantee Grading Consistency!'[68] The CGC business model functions in such a way that dealers or owners of comic books send them to be professionally graded. These comics are examined by five experts and assigned a grade on the ten-point scale used by CGC. Once graded, the comics are enclosed in Barex and then sonically sealed in a hard plastic transparent and tamper-proof container ('slabbed') so that they cannot be altered or, in fact, read. Finally, they are labelled as to grade, specific defects, including restoration, are noted, and the comic is returned to its owner. So long as the comic remains in its hard plastic case its grade is certified by CGC. The theoretical disinterested impartiality of CGC, therefore, has been credited with removing much of the subjective bickering about grading from the buying and selling process, allowing comic book collectables to become that much more liquid as assets in the internet age where transactions often take place between individuals without the mitigation of traditional brokers and experts. The effect of CGC grading and slabbing on the market was instantaneous. In 2001, Robert Overstreet noted that high-grade (above 9.4) golden and silver age books brought 'seemingly insane prices' at auction, and Conrad Eschenberg added 'people are paying stupid money for high grade books.'[69] Further, CGC grading reinvigorated the sagging market for early-1990s comics touted by *Wizard,* particularly those with exceptionally high grades

(9.9 or above), and it largely resolved the polybag debate when CGC refused to grade polybagged comics, in this instance substituting their own hard plastic casing for the one originally supplied by the publisher. Of course, the slabbing phenomenon had its most important impact in establishing beyond any doubt that the primary value of comic books as investment collectables was not, as *Overstreet* and *Wizard* long proclaimed, fun and reading, but pure abstract fetishism. So long as the certified comic book could not be read, or even handled, it served to put the lie to the idea that comic books were really an art form to be enjoyed.

Conclusion

The phenomenon of slabbed comic books reified their position in the realm of pure commerce. Stripped of their status as readable objects by a thick plastic container, comics were firmly placed in the domain of what J.C. Vaughn had termed the 'ultra-mercenaries,' reducing them to little more than easily transacted fetish objects. Moreover, the collector logic that found its ultimate rationale in slabbing fundamentally undermined the argument that comic books themselves might aspire to the status of art. While I have written elsewhere about efforts to bring the comic book more in line with the status of art objects, it is nonetheless clear, particularly in the dominant American tradition, that comic books remain largely outside the prevailing definitions of art.[70] Situated initially by Sotheby's, one of the most powerful actors in the art market, as mere ephemera, comic books struggled to shake this association. Further, when the auction houses turned away from comic books, relegating the tertiary market to the internet, the status of comic books as art objects was further diminished.

Despite the fact that this discussion has focused narrowly on American mass-marketed comic books, not all comics are, in point of fact, comic books. Neither is the art form itself solely defined by these pulpish ephemera. Indeed, an argument can be made that, rather than the published product as a whole, it is the art contained by the comic – whether from strips or books – that is most akin to the traditional art object. Consider this description of the 1996 Sotheby's comics auction published in the 1997 *Overstreet Guide* dealing with original comic book art:

> The first important offering was [Robert] Crumb's original cover for Zap
> #0 from 1967 estimated at $20,000 to $30,000 (collectors should keep in
> mind that this estimate is higher than any estimate for any previous golden

age comic book cover from 'any' Sotheby's auction). The bidding climbed to an amazing $46,000. However, a few lots later, the room was shocked into a hushed reverence when the cover for Fritz the Cat from the 1969 Ballantine paperback book (this original was unsigned!), estimated at an incredible $35,000–$45,000, sold for $56,350! This price stands as a world record for any comic book cover, and is a price most likely to stand for quite some time.[71]

Of course, this notion of the 'hushed reverence' in the presence of record-setting auction prices aligns neatly with traditional conceptions of the auction house as the site where, as Pommerehne and Feld note, buyers separate the wheat from the chaff. It is not entirely surprising, therefore, that the work that would draw the greatest price would not be a copy of a superhero comic book or even the original drawing for its cover, but would go to a work created by the cartoonist who has been most completely integrated into the traditions of the legitimate art market. While the $56,350 paid for an original Crumb might seem a relative bargain in comparison to the price of oil paintings by Mark Rothko or Andy Warhol from the same decade, artists who have attained in the field of painting stature comparable to that of Crumb in comics, the difference, of course, is attributable both to the number of wealthy patrons of each art and to the relative status of each. Given the fact that the 'quality' of an artwork cannot be objectively determined or submitted to any kind of scientific proof, it follows that art prices not only measure but actually construct the value of art.[72] From this standpoint, we can see that while the value of comics art has increased dramatically since the beginnings of organized comic book fandom a half-century ago, it nonetheless continues to fall dramatically short of more traditional artworks from the same period. This pricing difference is, of course, emblematic of the ongoing status distinction between comics and painting owing to the dominance of nostalgia in the comics art market. Indeed, forty-four years after the *New York Times* reported on the exorbitant sums being paid for old comic books, the same newspaper turned its attention to the exploding market in original comic book art pages. Little had changed in the intervening years. While prices for old comics had grown exponentially in the ensuing decades, the perception of the comic book collector was largely unchanged. A 2008 *New York Times* article reported that original art sales were driven by 'an attempt to recapture the collector's childhood,' with Jerry Weist noting: 'An awful amount of the money being spent is certainly connected to the baby-boom generation

and their sense of nostalgia.'[73] What seems clear from this *Times* piece is the fact that with nostalgia as the constant driving force, rather than aesthetic value or cultural significance, comic books are an awkward fit with the art world, as the auction houses learned. To this end, while they seem condemned to reappear from time to time, the subject of bemused reports about the remarkable sums that grown-up investors are willing to pay in order to recapture some small slice of their childhood, the art which they themselves contain has slowly divorced itself from its host medium and has derived a completely different value within a related but distinct world of its own.

Richard Outcault, *Around the World with the Yellow Kid* (28 February 1897).

Crumbs from the Table: The Place of Comics in Art Museums

> For fans of comics the Museum of Art is as foreboding and scary a place as the Comics Convention is for lovers of art.
>
> Raymond Pettibon[1]

In 1897, Richard Felton Outcault toured his signature comic strip character, the Yellow Kid, around the world. Among stops in Venice, Cairo, and Monte Carlo, the Yellow Kid passed a day in 'Parris' at 'd' Louver art gallery.'[2] The cartoon itself is typical of Outcault's work during this period. Originating in 1895 in the colour supplement of Joseph Pulitzer's *New York World,* the Yellow Kid was the star of Hogan's Alley, a place where street urchins gathered in order to poke fun at the issues of the day. A bald Irish boy with enormous ears named Mickey Dugan, the Yellow Kid lacked the ability to speak, and his dialogue was written on the yellow nightshirt that was his visual trademark. When Outcault took the character to William Randolph Hearst's *New York Journal* in October 1896, the strip took on an increasingly vulgar and violent tone. In each iteration, the work was notable for its use of pidgin English and its portrayal of New York's impoverished immigrant population as the very essence of low culture. Thus, when Outcault moved the action to the most famous art museum in Europe, the humour stemmed from the resulting misunderstandings. As Dugan writes in his letter home:

> den we also seen d' statchoos. billy, dey maid me blush. d' clotes wot dem statchoos didn't hav on wud start a hole dry guds store, on me woid uv onner. Dere wuz one statchoo wot had 'er arms cut orf w'en she wuz a child. she didn't stand strait, I gess she had kramps an' dey sed she wuz d' veenis

d. mile O. I sed t' d' mug wot runs d' sho she looks more like a veenis d. haf
mile O. but d' mug didn't ketch on. Dem Parizhiuns is stoopid.

The culture clash that Outcault depicts in this cartoon is the meeting of
old world and new, of educated and uneducated, of adult and child, yet
more than this, the strip can be read as an encapsulation of the place of
comics in museums at the time that it was originally published. So much
of the humour of the piece derives quite simply from the juxtaposition
of the comic strip itself and the famed Greek sculpture, who notes, in a
word balloon, that 'If I had my arms I would spank some of these kids,'
and serves to visualize the vast chasm that existed between comics and
legitimate culture at the end of the nineteenth century.

In many ways, Outcault's ability to find humour in the idea of comics
in an art museum reflects a general defensiveness from the comics com-
munity that would persist throughout the twentieth century. While some
artists, such as Art Spiegelman, long agitated for the place of comics in
museums, others were more resistant, suggesting that the appropriate
place for comics was on the printed page, not on the bare white walls of
the museum. In an essay on comics exhibitions in his book *Objet culturel
non-identifié,* Thierry Groensteen notes that the incorporation of com-
ics in museum exhibitions carries with it the possibility that they will
wind up merely mimicking the forms of painting, stripping comics from
their normal domain and thereby undermining the specificity of the
form. Unlike so much of contemporary art, comics, he notes, are not
produced with the space of the museum in mind, but are intended for
reproduction on the printed page and enter into a distribution network
far removed from the sacralizing tendencies of the art world. Comics in
print and on the wall are, of course, two totally different ways of expe-
riencing the same work. Nonetheless, Groensteen suggests that there
are advantages to be had from the experience of comics in museum set-
tings, not the least of which include proximity, intimacy, the absence of
colour (in many cases), the presence of the artist's marginal notes and
drawings, and the traces of pencil drawings. In short, by highlighting
the process of creation, and by emphasizing visual elements that are fre-
quently obscured on the printed page, comics can be seen in an entirely
different manner in a museum setting.

Perhaps equally important, the museum setting also allows comics to
be seen afresh by the art world as a whole. More than any other cultural
institution, the museum plays a central role in elaborating a definition

of artistic works as they are the primary institutions where the public encounters art. Centrally, they act as chief cultural gatekeepers by filtering the flow of cultural objects as they enter into the museum system. This gatekeeping, of course, has long been used against comics, as well as other undesirable or non-consecrated cultural objects. Museums have historically maintained a reserve of quasi- or non-art objects (crafts, decoration, artefacts, and everyday items) that can be promoted on occasions when secondary arts enjoy a sudden resurgence in popularity. Popular culture, a category that has traditionally contained comics, is one such reserve. As Carter Ratcliff has argued, 'mass culture offers curators and critics an endless fund of images useful in claiming that high art sinks deep, energizing roots into the lowliest muck. This is a primitivizing tactic. To preserve its intelligibility, our museums must draw and redraw the line between high art and mass culture.'[3] Simply put, by mounting exhibitions, museums and other gatekeeping institutions enact their power to define what is – and is not – art. Following this logic it is clear that while comics do not require the sanction of museums to succeed as comics, the same cannot be said if the desire is for them to succeed as art.

Of course, the inverse of this phenomenon is the fact that, in an increasingly mediatized and entertainment-oriented world, museums may find themselves needing comics in order to attract new audiences. The importance of blockbuster museum exhibitions can be dated from the 1976 King Tut exhibition that drew more than eight million visitors to the Metropolitan Museum of Art in New York. Since that time, museums worldwide have competed for big shows that will attract large, and often non-traditional, audiences, boosting revenues through ticket and gift-shop sales, and helping to establish individual museums as brands. Increasingly, blockbuster museum shows have become a central aspect of event tourism, with exhibitions built not only around works by world-famous artists, such as Matisse-Picasso at the Museum of Modern Art, but also topical or nostalgic subjects such as Vanessa Beecroft's use of live female nude models, motorcycles at the Guggenheim, film franchises like Star Wars: The Magic of Myth at the National Air and Space Museum in Washington, and, presently, comics in a variety of venues. Significantly, the opening of the space of the museum to comics coincides with the rise to prominence of both the cultural theory of postmodernism and the economic logic of the blockbuster. It is clear that, in different ways, the limited success of comics in museums is the result of a combination of these, and other, forces.

The Absent Comic

As was seen in chapter 3, the Museum of Modern Art's show High and Low: Modern Art and Popular Culture, which ran from 7 October 1990 to 15 January 1991 before moving on to Chicago and Los Angeles, is, for many both inside and outside the comics world, a focal point for resentment against an elitist art establishment. Writing in *American Art*, Ivan Karp suggested that the show represented a 'definitive moment in which the contrived hierarchy and pristine modernism on which the art world thrives were being challenged within the very precincts of its institutional bastion, the MOMA. Or were they?'[4] Noting the widespread controversy about the show, which found critics on the political left criticizing the exhibition's lack of emphasis on context and the celebration of cultural appropriation, and critics on the right castigating the museum for failing in its mission to elevate public taste, Karp suggests that the show, which he calls 'interesting but not revolutionary,' was unjustly condemned as a result of its choice of inflammatory 'fighting words' in its title and in its organizational logic.[5] Writing in the exhibition catalogue, curators Kirk Varnedoe and Adam Gopnik indicate that they are interested in tracing 'the evolving relationship, from then till now, between modern art and popular culture.'[6] On the one hand, the authors castigate the modernist traditions, exemplified by Clement Greenberg, of dismissing comics and mass cultural other forms as nothing more than 'kitsch.'[7] Nonetheless, in the case of comics, the curators can go only so far: 'Our sense of the achievement of twentieth-century art is incomplete without an appreciation of the work of Winsor McCay, George Herriman, and Robert Crumb.'[8] To call this list of achievers selective would be a vast understatement. For the most part, the High and Low show treated comics as a structured absence, seeking to justify rather than rectify the ongoing exclusion from its collections and shows. As part of the 'low' culture defined by the curators, comics serve not as art in their own right, but as the raw material of art for the likes of Jasper Johns (*Alley Oop*, 1958), Richard Hamilton (*Just What Is It That Makes Today's Homes So Different, So Appealing?* 1956), Andy Warhol (*Popeye*, 1960; *Dick Tracy*, 1960), and, of course, Roy Lichtenstein. In defining the terms 'high' and 'low' the curators were at pains to note they did not want to 'denigrate' objects in the latter category and that the terms themselves were just 'a working, shorthand convention.' Despite these qualifications, in the end they recognized that the 'imperative need to have reliable, solid distinctions between high and low – whether as a challenge for future achievements

or as a lost ideal – haunts the theoretical literature concerned with different levels of culture in modern society.'[9] By positioning comics in this exhibition as a legitimate absence in high-art curatorial practices, they sanctioned a centuries-old bias against the form and demonstrated, perhaps unwittingly, that the need for reliable, solid distinctions haunted more than just the theoretical literature.

While the High and Low show was widely criticized as conservative and elitist, the tendency to regard comics predominantly as inspiration for 'real' art has a legacy that remains very much alive almost two decades after the MoMA exhibition. The principle of excluding comics and comics artists from museum shows about comics has occurred over and over again in multiple venues around the world. Moreover, contemporary comics shows that exclude comics present new ways of conceptualizing the comics–art relationship in formal terms, rather than in the social terms mobilized by Varnedoe and Gopnik. For example, Funny Cuts: Cartoons and Comics in Contemporary Art, an exhibition organized by the Staatsgalerie in Stuttgart from 4 December 2004 through 17 April 2005, brought together the work of more than forty artists influenced by comics art but no artists who actually work primarily as cartoonists. According to the exhibition catalogue, Funny Cuts showcased the way in which artists have 'tackled the "trivial" and commercial worlds of comic and cartoon images.'[10] The curators noted that 'due tribute will indeed be paid to comics: through the admiration shown to childhood heroes, for example, in the work of Mel Ramos,' whose *The Flash* (1962) and *Batman* (1961) rely on the iconography of comics rather than its form, but the museum would stop short of legitimating comics themselves as exhibition-worthy. Similarly, Splat Boom Pow: The Influence of Cartoons in Contemporary Art, staged by the Contemporary Arts Museum Houston in 2003, featured more than forty artists whose work was inspired by comics but, with the exception of David Sandlin, none that work in the field. That catalogue told its audience what it probably already knew when it noted that 'while fine art traditionally has been feted by the arbiters of taste, comics remain at the bottom of the heap.'[11] The two exhibitions shared a number of contributors in common: Ida Applebroog, Arturo Herrera, Roy Lichtenstein, Kerry James Marshall, Takashi Murakami, Yoshitomo Nara, Raymond Pettibon, Sigmar Polke, Mel Ramos, and David Shrigley. With the notable exceptions of Applebroog and Marshall, each of whom produces work in the fine arts field whose sequential narratives place them in quite close relation to narrowly formalist conceptions of comics, the connection between these artists and comics resides at the

level of appropriated iconography (Herrera, Lichtenstein, Nara, Ramos, Murakami, Polke) or the incorporation of textual and often narrative elements within drawings (Pettibon and Shrigley). Interestingly, these exhibitions indicate that it is the iconography of comics, rather than the formal – that is to say sequential – elements that is most commonly appropriated by artists influenced by comics. In other words, the value of comics in the traditional field of fine art is frequently sociological, as they are appropriated as images from everyday life upon which a more meaningful aesthetic and cultural commentary can be imprinted.

The Splat Boom Pow catalogue explicitly suggests that the early efforts by pop artists to incorporate 'existing cartoon iconography' was a 'critique of an increasingly commercial and consumer-oriented society' and that comics are often the subject of that criticism.[12] By the 1990s, however, they suggest that artists began to abandon such strategies in favour of a drive towards the abstraction of the comics form. Thus, an artist like Arturo Herrera uses a Disney-like style of drawing that lacks an explicit referent to a particular source. Ulrich Pfarr argues about Herrera's work: 'The artistic semanticisation of references from comics triggers a mythological chain of signs that refers to purely imaginative qualities.'[13] This drive towards the abstraction of comics iconography was the subject of the exhibition Comics Abstraction: Image-Breaking, Image-Making, organized by New York's Museum of Modern Art in 2007. Featuring the work of Herrera and twelve other artists, Comics Abstraction sought to move the appropriation question away from 'ubiquitous figuration and easily identified pop characters and themes' by refocusing the way artists have 'used the vernacular language of comics as a springboard for abstraction.'[14] With works like Philippe Parreno's *Speech Bubbles* (1997), blank silver helium-inflated mylar bubbles with scalloped-tales that float to the ceiling symbolizing both the act of speaking and its absence, and Rivane Neuenschwander's *Zé Carioca no. 4, A Volta de Zé Carioca* (2004), polymer paint on comic book pages that eradicates the figures and the text of the comic book while retaining the placement of the word balloons and captions, the abstraction of comic book conventions achieves the full-scale erasure of comics themselves. However fascinating or provocative these works might be, it is clear that they reify a logic in which comics per se are placed outside the confines of the museum walls. With these kinds of shows the gatekeeping function of the museum is very much on display, with comics allowed entry only once they have been appropriated, deconstructed, and abstracted by artists working in a fine arts tradition.

Comics and Art: The Dialogue

As Roger Sabin notes in the Splat Boom Pow catalogue, 'controversies remain about who wins and who loses from the relationship [of fine arts and comics], because these two worlds, though locked in a creative embrace, have never been on an equal footing.'[15] While shows that largely excluded comics, such as High and Low, have drawn a lion's share of the critical commentary, a long-standing tradition of placing comics and fine art in dialogue does, in fact, exist. Attempts to place the forms on an equal footing in museums have been occasionally awkward and often tentative. The Whitney Museum's Comic Art Show in the summer of 1983 was among the first exhibitions to feature comics at a major American art museum. Like so many other shows based on comics, the catalogue, produced in conjunction with comic book publisher Fantagraphics Books, emphasized the feminized role for comics as the passive muse that inspires genuine art, by drawing attention to the 'importance that popular art sources have had on the work of some of our most eminent artists,' which can be particularly located in the appropriation of cartoon iconography in the work of artists such as Warhol, Lichtenstein, Ramos, Fahlström, Johns, Robert Rauschenberg (*Tasmanian Devil*, 1975–8), and Claes Oldenburg (*Ice Cream Cone Upside Down with Mickey Mouse Head*, 1963).[16] At the same time, the Whitney show did include works by more than thirty comics artists and the catalogue included four separate essays addressing the history and aesthetics of the comic strip and comic book. Thus, while the Whitney show evinced many of the same biases as High and Low, particularly insofar as it approached the subject from the perspective of the contribution of comics to art rather than from the position of a more balanced dialogue, its inclusion of large quantities of original comic strip and comic book art demonstrated, eight years before the widely criticized MoMA show, that the two forms could be brought into a meaningful interchange.

While the Whitney Comic Art Show did not travel, one of its curators, Sheena Wagstaff, did curate a similar exhibition at the Institute for Contemporary Art (ICA) in London four years later. Comics Iconoclasm featured the work of more than seventy artists as well as examples of comic book and comic strip art. The ICA show was divided into three sections. The first addressed comic characters as icons through the work of Warhol, Lichtenstein, Johns, Peter Blake (*Souvenir for Judith*, 1973), Erró (*Out of the Way*, 1974), Sigmar Polke, Peter Saul (*Donald Duck Descending a Staircase*, 1979), and Jean-Michel Basquiat (*Flash in Venice*, 1983). The

second detailed comics narrative and sequential storytelling including Picasso (*The Dream and Lie of Franco,* 1937), Lawrence Weiner (*Factors in the Scope of Distance,* 1984), Keith Haring, and Jean Dubuffet (*Site Agrest,* 1977). Finally, the use of comics-associated graphic techniques, like drawing, were exemplified by Pierre Alechinsky (*Ce que j'en dis,* 1961), Jim Nutt (*She's Hit,* 1967), Philip Guston (*Cellar,* 1970), and Kenny Scharf (*Cool Zhool,* 1985). Of these, of course, the iconography of characters was, by far, the largest section. Alongside these works, the ICA presented comics not as framed artwork but as printed matter. Iwona Blazwick argued that this choice was made in order to 'resist the museum's impulse to homogenize the comic strip within an institutional framework of presentation,' with the hope that this disparate treatment would emphasize the notion that comics hold a stature that is as 'aesthetically and iconographically complex as fine art practice.'[17]

The separate but equal treatment afforded comics at the ICA show suggests that comics and painting are, in fact, two distinct forms. The tendency to view comics as distinct from other forms, even in museum exhibitions that claim to be doing otherwise, is indicative of how deeply entrenched the high – low dichotomy remains in the museum world. Take, for example, the catalogue for Comic Release: Negotiating Identity for a New Generation, a show held at the Regina Gouger Miller Gallery at Carnegie Mellon University in 2003. This exhibition organized comics and fine artists together around issues of identity. Seemingly, the incorporation of comics within an exhibition that is itself an investigation of a larger theoretical issue might suggest that the form has finally arrived at some sort of cultural legitimacy. Nonetheless, curator Vicky A. Clark, who describes herself as 'a middle-aged curator attempting to come to terms with a changing culture,' notes in her catalogue essay that 'art and comics both question how to affect people' and 'art and comics have been on parallel tracks.'[18] That comics are conceptualized by Clark as something apart from 'art,' as something that can be seen as similar to 'art' but is definitely not art itself, is indicative of the continuing imbalance in the dialogue that some museums seek to establish. In a similar vein, the catalogue for Cult Fiction, curated as a touring exhibition in 2007 by the Hayward Gallery, used as a subtitle 'Art and Comics,' indicating that the latter was not yet a part of the former. Thus, while the curators of that show might argue that the hierarchical distinction implied by the High and Low show 'has largely dissolved,' their insistence on showing 'fine artists and comics artists' on 'equal terms' suggests that its remnants still remain, even in shows with, seemingly, the best intentions.

Mastering the Museum

As we have seen, the dominant means by which comics have been incorporated into art museums is as a structuring absence, as a feminized inspiration for more rugged masculinist art or as the poor cousins to real artists. However, the holy grail for many involved in the comics world continues to be museum shows dedicated exclusively to comics. One of the first such shows was held at the Waldorf-Astoria Hotel in New York in 1922. In 1963, Cavalcade of American Comics was organized in New York, and between 1965 and 1966 the members of SOCERLID (Société civile d'étude et de recherche des littératures dessinées) presented shows in Paris dedicated to the work of Milton Caniff, Burne Hogarth, and Ten Million Pictures. Arguably the earliest significant museum show dealing primarily with comics art was organized in Paris by SOCERLID at the Musée des arts décoratifs, a part of the Louvre, in the spring of 1967, an accomplishment that Milton Caniff called 'an Everest moment for those of us who ply the inky trade.'[19] The exhibition, titled *Bande dessinée et figuration narrative,* featured three sections dedicated to comics strips, primarily American, as well as a section featuring paintings by artists associated with the French narrative figuration art movement of the 1960s, including Bernard Rancillac and Hervé Télémaque. Significantly, the show itself did not feature any original pages of comics art. The sections dedicated to comics art featured ektachromes and photographic enlargements of comics panels placed on boards and on the sides of cubes that were assembled into a variety of arrangements. Images that were originally published in colour were cleansed and presented in black and white in the exhibition. The curators argued that 'this was intended to enable the public really to see the comic strip, to help it distinguish that which is art in the artist from that which is betrayal in the newspaper. Thanks to the quality of the paper and the clarity of the blacks and whites, the photographic enlargement makes it possible to free the comic strip from the small size that stifles it and to exhibit it in the usual dimensions of the works of art to which the public is accustomed.'[20]

The guiding principle of *Bande dessinée et figuration narrative* was to equate the comic strip with a then au courant indigenous art movement by stressing the aesthetic dimension of black and white line drawings. Blowing up reproduced images served the purpose of drawing attention to what the curators termed the 'masterpieces' of comics art, thereby divorcing those examples from the vast bulk of 'dubious examples' and the 'crudest pictures.'[21] The separation of comics panels from the fullness of

their narrative context found its appeal in the recognition that, particularly at that time, there were few suitable frameworks for defining comics as art. As was argued in chapter 2, traditional definitions of comics have long worked against the possibility of regarding comics as a significant art form. Cartoonist Burne Hogarth, writing the introduction to the catalogue, noted precisely this dilemma when he wrote: 'Perhaps the art we are talking about is not art at all, because even among its staunchest protagonists and practitioners there has developed no satisfactory definition that would place the cartoon and the comic strip in relevant context with traditional art as art.'[22] The show at the Louvre was clearly an attempt to rectify this situation by proving that strip artists have drawn upon the classical rules of illustration: 'We believe we have demonstrated, by means of the illustrations in this book, that based on these influences and successive styles the comic strip has created original works of which it can no longer be said that they are not art.'[23]

If the curators of *Bande dessinée et figuration narrative* felt that they had scored the definitive proof of the art status of comics, the art world itself remained seemingly unconvinced. While some comics shows were staged at other museums in the years that followed – the Maurice Horn – curated 75 Years of the Comics at the New York Cultural Center in 1971, Art et innovation dans la bande dessinée européenne at the Musée d'art contemporain in Gand in 1987, and Opéra bulles at the Grande halle de la villette in Paris in 1991 and 1992 – the form remained largely ignored by the art world as a whole. Moreover, as Thierry Groensteen observed with respect to Opéra bulles, the conception of these exhibitions tended to focus largely on the 'culture of entertainment' rather than a culture of high art.[24] Opéra bulles, which was staged in coordination with the Centre national de la bande dessinée et de l'image (CNBDI) in Angoulême and the Salon d'Angoulême, incorporated four separate, and largely unrelated, exhibitions of comics: the work of René Goscinny, comics by Enki Bilal, the collaborative work of François Schuiten and Benoît Peeters, and The French on Vacation. The reason for this strange eclecticism is that the show was mounted quickly to fill a hole in the programming of the Grand Hall after a more classically conceived show was abruptly cancelled. With little time to prepare a major new exhibition, the decision was made by the CNBDI to restage three of their earlier shows and add the fourth (The French on Vacation) to fill the space. The result was a comics exhibition conceived primarily as spectacle – a tendency that François Vié, artistic director of the CNBDI, had helped to regularize through the staging of annual exhibitions by the president

of the Angoulême festival – and frequently managed by exhibition orga-nizers Lucie Lom, the atelier run by Philippe Leduc and Marc-Antoine Mathieu since 1984 (Lucie Lom produced both the Goscinny and The French on Vacation exhibitions at Opéra bulles).

To situate comics squarely in the traditions of fine art, it seemed, would require a concerted effort to refocus the presentation of original comics art in a manner that could be aligned with the most conservative tenden-cies of art history. Significantly, the two exhibitions that most strongly positioned comics as art in the mind's eye of the public were both cen-tred on the search for and celebration of cartoonists deemed 'masters' by their curators. Maîtres de la bande dessinée européenne, presented at Bibliothèque nationale de France (BNF) and later at the CNBDI in 2000 and 2001, and Masters of American Comics, organized by the Museum of Contemporary Art (MoCA) and UCLA Hammer Museum in Los An-geles before moving to Milwaukee and New York/New Jersey in 2005 and 2006, had largely similar goals, but accomplished them quite differently.

Curated by Thierry Groensteen, Maîtres de la bande dessinée euro-péenne brought together sixty-nine comics artists from thirteen Euro-pean nations with a selection of original art and printed examples. While the vast majority of these were extremely well-known, including Rodol-phe Töpffer, Hugo Pratt, Wilhelm Busch, André Franquin, Hergé, and Moebius, others were frequently overlooked pioneers like Mary Tourtel, Storm P., and Antonio Rubino. A final group was composed of artists who were well-known in their home countries but little-known in France, including Marten Toonder, Jesús Blasco, Frank Bellamy, Benito Jacovitti, and Jules Radilovic. The exhibition was not organized chronologically or geographically, but thematically. Each of the sixteen sections brought to-gether a diverse selection of artists around certain styles (*ligne claire,* the Franco-Belgian school), genres (satire, western, adventure) and themes (dreams, personal subjectivity). In his preface to the catalogue, Jean-Pierre Angremy, president of the BNF, indicated that the show allowed the question of the 'genius' of European comics to be posed for the first time.[25] The significant accomplishment of the Maîtres show was not its focus on the concept of 'genius,' the key that opened the door of a con-secrating institution such as the BNF, but, as Groensteen would later em-phasize, the fact that the show presented comics in a complex fashion in which they could be interrogated on historical, sociological, anthropo-logical, literary, and aesthetic grounds.[26] At the same time, however, the notion of 'genius' invoked by Angremy was never far from the surface. Significantly, Groensteen described the show as having been structured

around a 'rich international heritage, diverse and partially unrecognized, affirming a hierarchy among creators, positing the relevance of the original and printed page as complementary documents.'[27] By affirming the notion of the artistic hierarchy within comics, a disposition that was signalled by the title of the exhibition, comics could become an art form so long as a certain number of cartoonists could be conceptualized as artists in the manner suggested in chapter 4.

The 'genius' argument is made even more forcefully by the Masters of American Comics exhibition curated by Brian Walker and John Carlin, co-curator of the Whitney show twenty-two years earlier. The show featured the work of just fifteen American cartoonists, but offered, with 900 pieces, a much larger selection of works than was typical of previous comics exhibitions (the scope of the show was reduced when it left Los Angeles for other locations). The artists were arranged chronologically in two distinct venues, with comic strip artists Winsor McCay, Lyonel Feininger, George Herriman, E.C. Segar, Frank King, Chester Gould, Milton Caniff, and Charles M. Schulz displayed at UCLA's Hammer Museum, and comic book artists Will Eisner, Jack Kirby, Harvey Kurtzman, Robert Crumb, Art Spiegelman, Gary Panter, and Chris Ware showing at the Museum of Contemporary Art. Significantly, the chronology of the two shows bifurcates in the mid-century period with Schulz's *Peanuts,* which debuted in 1950, as the last of the comic strips, and Eisner's *The Spirit,* originating in 1940, as the first of the comic books. This curatorial decision signals the presumption that the vitality of the comic strip form vanished by the 1950s and was superseded by comic books. Such a contentious – some might say arbitrary – timeline reinforces the notion, which runs throughout the literature produced by the show, that the artistic relevance of comics can be charted as a series of formal shifts, with each artist exemplifying one significant innovation. Thus, for example, McCay 'transformed mechanical reproduction into a creative medium for self-expression'; Gould's *Dick Tracy* is 'the best example of a feature that turned the constraints of the medium into its strength'; Caniff was 'one of the greatest storytellers ever to work in the comics medium'; Schulz was a 'master of minimalism'; Crumb's work is 'exceptionally well-crafted'; and Panter expressed 'a new kind of elegance.'[28] The work of the Masters show, therefore, was self-evidently to undertake the sort of legitimizing process that had been long absent in the field of comics. The chosen few were to be justified as 'geniuses,' and the basis for that project would be entirely aesthetic and narrowly formal.

Indeed, the mission of the Masters show could hardly have been rendered more explicit. Visitors entering the first half of the show at the

Hammer Museum were greeted by this straightforward statement of the curatorial goal: '*Masters of American Comics* endeavors to establish a canon of fifteen of the most influential artists working in the medium throughout the 20th century.'[29] While the notion of the 'canon' of artistic creation had been under explicit attack in more consecrated artistic fields for decades prior to the mounting of this show, Carlin and Walker deploy the term in an unproblematized manner that is provocative for both its retrograde sentiment and the narrow range of exhibited artists. The *Maîtres* show, which was organized around the principle of assembling 'comics masterpieces from every age and every nation,' nonetheless created, as a result of its inclusivity, a reasonably complex picture of the breadth of work that has been done in the form.[30] The Masters show, on the other hand, was strikingly limited by its selection of just fifteen male cartoonists. The exhibition was frequently criticized for the contentiousness of its selections (where, it was frequently asked, were Carl Barks, Garry Trudeau, Walt Kelly, Jack Cole, Al Capp, Bill Watterson, Jules Feiffer, or any of dozens of other potential 'masters'?), and, in particular, for its total exclusion of women, even as a possibility based on the show's title. Writing in *Art News*, Carly Berwick paraphrased Linda Nochlin, thirty-four years after her famous essay in that same magazine, asking 'Why Have There Been No Great Women Comic-Book Artists?' while in *LA City Beat* Natalie Nichols asked: 'What becomes a Comics Master most? What else but that all-important authoritative accessory, a penis?'[31] Sarah Boxer, writing of the show in *Artforum*, regarded the gender politics of the event as a reflection of the dynamics of the comics world as a whole:

> Oh, but there are women. They're on the walls, as a perpetual underclass. Every high must have its low, and the unspoken mastery in 'Masters of American Comics' is, it turns out, over women. The misogyny in comics is no big secret, but rather than reflect on it, the curators have simply picked comics entirely by and mostly about males. As a result, viewers may find themselves wondering whether there is something about the very will to fantasize and draw comics that is bound up with antipathy toward women.[32]

Here Boxer recalls the relationship of comics as the feminized muse made pliantly available for masculinist revisioning by pop and other contemporary artists. In attempting to decisively break from that position with a blockbuster museum show, the curators seemingly felt obliged to find a replacement in the degraded position of feminized 'other,' a position that they opt to fill with images of degraded, objectified women.

To this end, the legitimation of the comics world can be seen to be completely dependent on its ability to mimic the worst aspects of traditional art worlds.

For curator John Carlin, the fact that the chosen few were 'mostly white, middle-class, male' was not a significant problem because 'I felt a canon needed to be there, in order to be challenged.'[33] Carlin's teleological proposition, that comics needed to pass through the institutionalizing phase of art history that other modern arts like photography and cinema moved through in the past, affirms the central importance of the art museum and its narrow aesthetic and ideological interests by consenting to the rules of the game, no matter how politically outmoded they might be. The biases of the curatorial selections particularly highlight the fact that the emphasis has been placed predominantly, some might say exclusively, on comics as visual culture, with the artists primarily celebrated for their storytelling (such as Barks) or dialogue (most notably Trudeau and Feiffer), absent from the museum walls. In these ways, the Masters show assents to the formal biases of its museum setting, displaying frustratingly partial stories in the midst of the white cube museum space as if they were paintings. If proof were needed that the MoCA and the Hammer Museum treated comics exactly as they do other kinds and genres of art, one needed to look no further than the benches scattered across the floor space. In both institutions the benches, upon which the visitor could rest in silent contemplation of the works on the wall, were placed at such a distance that it would have been impossible to read the text on the displayed pages. With no concessions made by the institutions to the particularity of the work, comics finally achieved something of the legitimacy they had long sought, at the price of their own formal distinction.

Gathering the Crumbs

Reviewing the smaller New York/New Jersey iteration of the Masters show in the *New York Times*, Michael Kimmelman noted of Robert Crumb: 'He's still the Picasso of comics: the unavoidable influence on all younger artists.'[34] Comparisons to Picasso are difficult to live up to, but Crumb has enjoyed such hyperbolic praise of his work for a long time. In the 1991 High and Low catalogue, Varnedoe and Gopnik celebrated his particular intermingling of nostalgia, as exemplified by his work on delta blues and his use of largely outmoded cartooning styles, and an apocalyptic viewpoint.[35] Fifteen years later, of course, it was a

foregone conclusion that Crumb would be selected as one of the fifteen 'Masters' of American comics as he was already integrated – if somewhat awkwardly – into the traditional art world, and was increasingly regularly featured in major museum shows and discussed by the art press. Nonetheless, it is clear that that press did not always know how to approach his work. *Artforum* contributing editor Katy Siegel, reviewing the 2004 Carnegie International in Pittsburgh, in which his work was centrally featured, inadvertently damned his work with faint praise: 'Crumb's comics and drawings are the strongest figurative work here . . . It's not art (comics are not "lower" than art, simply a different social category of production), but it's better than most of the art here, and that's the problem.'[36] In many ways it is difficult to parse these comments. According to Siegel, comics are no longer 'lower' than 'art,' as Varnedoe and Gopnik, and an entire art historical tradition earlier implied, but they are still most assuredly not 'art.' For Siegel, the problem with the Carnegie International, the reason that it fails in her eyes, is that someone who is arguably not even an artist produced its best material. Her criticisms of the show are harsh and unforgiving. She blasts the exhibition for its post 9–11 sense of seriousness and its self-conscious focus on big issues, which she feels are approached shallowly. Thus, the praise of Crumb as 'better than most of the art here' is meant intentionally as a criticism to the 'real artists,' effectively minimizing his own stature and contribution.

Crumb's participation in the 2004 Carnegie International, for which he also designed the poster and the commemorative coffee mugs, was simply one of his most recent forays into the fine-arts world. Crumb, of course, is the now sixty-something godfather of American underground comics, the cartoonist responsible for comics called *Zap, Snatch,* and *Weirdo,* and the creator of Mr Natural, Whiteman, and Angelfood McSpade. Since his debut as a professional cartoonist in the mid-1960s, Crumb's *Fritz the Cat* has become the basis of a movie, and he has himself been the subject of two significant long-form documentaries and has appeared as a character in the film *American Splendor.* His work has been published in dozens of languages, and his comics were chronologically collected as *The Complete Crumb,* as were his sketchbooks, both published by Fantagraphics. He has participated in a number of exhibitions over the past four decades. His first show was at the Art Museum of Peoria, Illinois, in 1966, and his work was shown at the Whitney in 1969 as part of the show entitled Human Concern/Personal Torment: The Grotesque in American Art. He exhibited at the Berkeley Gallery in 1971, La Hune gallery in Paris in 1986, and in Carcassonne, France, in 1991. The first

major solo retrospective of his work was Le Monde Selon Crumb, as part of the Festival International de la Bande Dessinée in Angoulême, France, in 1992. Angoulême hosted a second retrospective of his work in 2000, when he was elected president of the annual comics festival under the title Qui a peur de Robert Crumb? A year later he displayed his sex-themed work at the Musée de l'érotisme in Paris. While eight solo shows in thirty-five years might not seem like a tremendous amount of attention for an artist who has been compared to Picasso, it is an output unmatched by any other cartoonists. However, as his shows were primarily at comic book museums and sex museums, it is clear that Crumb was not considered in the world of fine art an important artist but merely the most consecrated among the unconsecrated. Varnedoe and Gopnik might have called him the greatest living cartoonist, but because of the distinction between comics and 'real art' identified by Siegel and others, that did not mean that he necessarily belonged among the great living artists.

Recently, however, the reputation of Crumb has begun to change. In 1998 he met New York gallery owner Paul Morris, who included the artist in a group show with Barry McGee and Philip Guston. Since that time, Morris has been Crumb's art dealer. He has arranged a series of shows for Crumb, and handled Crumb's participation in major shows like the Carnegie International. Crumb quickly ascended to the upper rungs of the art world, with five museum shows in 2004, shows at London's Whitechapel Gallery and Rotterdam's Museum Boijmans Van Beuningen in 2005, and inclusion in the 2006 Masters show. From 2007 to 2009 a retrospective, R. Crumb's Underground, showed at the Yerba Buena Center for the Arts in San Francisco, Seattle's Frye Art Museum and Philadelphia's Institute for Contemporary Art, the Massachusetts College of Art and Design in Boston, and the Grand Central Art Center in Santa Ana. In 2010, the 207 pages of Crumb's adaptation of the Book of Genesis were exhibited at the UCLA Hammer Museum, David Zwirner's gallery in New York, and the Portland Art Museum, bringing the total number of major Crumb shows in the decade to seventeen. Three of these exhibitions played especially formative roles in re-establishing his identity in the art world and serve to highlight the shifting discourse that exists around not only Crumb but comics: Yeah, But is it Art? the massive Crumb retrospective at the Museum Ludwig in Cologne, Germany, in 2004; the aforementioned Carnegie International in Pittsburgh, at which Crumb was one of thirty-eight participating artists; and the Whitechapel Gallery retrospective that opened in London in May 2005. Collectively these shows led the transformation of Crumb from what author and Crumb friend Peter

Poplaski has termed 'Loser Schmuck Crumb' to 'Cultural Icon Crumb,' thereby modeling the critical apotheosis of the cartoonist as serious artist suggested by the more limited success of figures like Carl Barks, Jack Kirby, and Charles Schulz, described in chapter 4.[37]

The Cologne show was the most comprehensive solo Crumb show produced to date, and also perhaps the most self-conscious about hanging Crumb on their walls. The catalogue, for example, opens with this seemingly astonished semi-rhetorical question: 'Robert Crumb, founder and "super-star" of the American underground comic movement in the 1960s and 1970s, in Museum Ludwig?' The question mark is key here, suggesting as it does that there is an issue to be resolved surrounding the incorporation of the cartoonist into the field of artistic production. The essay continues, noting that Crumb himself 'knows enough to differentiate between the "fine-art" world and the world of comics and cartoons, fully aware of the chasm between the two.' Here, the curators anticipate a dismissal of Crumb as not-art, and, indeed, incorporate it into their own explanation of the artist's work. So why exhibit Crumb at all? It is noteworthy that of the three shows discussed here, Cologne was the only one to show Crumb's most aggressively racist and sexist images. For instance, Cologne displayed the three-page *When the Niggers Take Over America* (1993), a piece that was subsequently republished, without authorization, in a neo-Nazi magazine. Writing of this work in the Carnegie catalogue, a show that did not display it, Jean-Pierre Mercier writes: 'What Crumb was really doing – much in the manner of Lenny Bruce – was attempting to disqualify the sum total of racist clichés by fusing them into a single concentrated mass of ignominy, and implicitly betting on the potential educational power of what he was saying.'[38] Similarly, Alfred Fischer of the Cologne show writes of this work that he expected to be criticized 'since it had been his intention to underline the urgency of the race problem, to hurt feelings and to direct the hate and indignation towards himself.'[39] In this way, Crumb is positioned as a political art martyr, crucified on the cross of public opinion so that our own collective racism might be washed away. The Cologne curators wanly add that because he is married to a Jewish woman, 'he can hardly be reproached for racism.'[40] In the arena of art history, Crumb's refusal to be bound by social convention comes to signify his importance as an artist because it acts as a guarantor of his authenticity – even in institutions like the Carnegie that cloak the work by not displaying it.

The overt racism and sexism in Crumb's work is the most central debate about the cartoonist's output. Varnedoe and Gopnik, while otherwise laudatory, note 'next to old styles, Crumb's favorite subject is his

own lechery. The disturbing element of misogyny in Crumb's work is never complacently preening, but always placed in a context of misanthropy, frustrated desire, and self-reproach.'[41] Similarly, writing in the *New York Review of Books,* Ian Buruma outlines the standard explanation of Crumb's work:

> To call Crumb a misogynist or a racist is to miss the point of his cartoons. By exposing violent impulses in himself and the society around him, he does not advocate or glorify violence. A man can be a perfectly decent human being and still harbor all kinds of feelings and thoughts that would not pass scrutiny. To be civilized is to keep such instincts under control. Crumb simply shows that he, and by extension all of us, are made of many parts, some of them not so nice.[42]

While this defence of Crumb's sexual and racial politics is extremely common in the literature about the artist – he hates himself, we are told, as much or more as he hates others – his depiction of blacks is, nonetheless, highly problematic and retrograde. Given how much of Crumb's most famous work depends on offensive racial or gender stereotypes, it is not surprising that the issue has vexed his growing reputation. Crumb's naive explanation of these stereotypes ('my personal obsession for big women interferes with some people's enjoyment of my work. Similarly, using racist stereotypes – it's just boiling out of my brain, and I just have to draw it . . . All this stuff is deeply embedded in our culture and our collective subconscious, and you have to deal with it') offers little deep insight to deal intelligently with the issue. Ken Johnson, reviewing the 2008 Crumb retrospective at Philadelphia's Institute of Contemporary Art, positioned him alongside Kara Walker and Robert Colescott as an artist who has 'toyed with racist stereotypes,' suggesting that, despite the many differences in the works of these artists, politically sensitive material is by no means restricted to Crumb.[43] What is striking is that Crumb's political incorrectness has not particularly derailed the process of his legitimation. Indeed, insofar as his chosen form is regarded as just as seedy and deviant as the images that he produces, the process of mutual reinforcement abets his cause by sanctioning his outsider or maverick standing in the art world while serving as a stark reminder of the negative aspects of the long association between comics and the degraded and degrading.

Despite their willingness to display even the most gratuitous of Crumb's excesses, including the cover for the never-published comic titled *Nigger*

(1970), the Cologne curators remained loath to take their support of Crumb too far and seemed especially reluctant when it comes to making grand claims about his artistry. Portraying him as a friend to American blacks despite his racist depictions is one thing, but investing in him as an artist seems to be something else entirely. At the end of their essay, the curators compare him to Warhol, arguing that Crumb is to the pop art master what Henri Rousseau was to Picasso, essentially a forerunner to a greater master who would follow. Further, they argue that the best lens for understanding Crumb's work is that of the naive, folk, or outsider artist whose concerns are those of America generally. Traditionally, outsider art is given far more leeway in portraying degenerate concepts unproblematically, such as Henry Darger's pedophilic images in his *Vivian Girls* series. Following a logic introduced by the High and Low show, which suggested that Crumb presents 'his own story as a folk tale, popular narrative, burlesque humor – as a comic strip,' they write that Crumb is the 'touchstone, the incarnation, of what we consider "American," what we regard to be the essence of America,' but also rhetorically ask: 'Don't we find access to Crumb's work more readily by way of the concept of "folk art" than of the "modern," that is to say, within the "fine-art" establishment?'[44] By conceptualizing his work as folk art, the Museum Ludwig is able to deny certain levels of status to Crumb, and by extension to all of comics and, actually, to all of American culture. At the same time, they were able to host a major retrospective of his work by providing a justification of the importance of his work on primarily sociological grounds. This paradoxical ambivalence similarly marks the Carnegie and Whitechapel shows.

In the Carnegie International, Crumb was identified as a central figure for the contemporary visual arts. Alongside Mangelos (Dimitrije Basicevic) and Lee Bontecou, Crumb was one of the three cornerstone artists of the exhibition. Curator Laura Hoptman chose Crumb because he 'is one of the most subversive and important voices to come out of America in the twentieth century' as well as 'one of the greatest draftsmen of our time.' His work engages with what Hoptman terms 'the ultimates,' the 'largest and most unanswerable questions in life,' by quashing the banal and wrestling with the fundamental mysteries of life. Specifically, Hoptman writes that Crumb is 'dead-on specific to the perspective of a middle-class American white guy born at mid-twentieth century, Crumb's stories are, more importantly, telling portraits of human weakness, cruelty, and stupidity, and indictments of human indifference, superstition, fear, paranoia, and narrow-mindedness,' thereby conflating his highly

idiosyncratic personal world view with a more generalized zeitgeist that holds the potential to undermine the artist's overall significance by diluting its specificity.[45] In her catalogue essay Hoptman writes that Crumb's drawings provide the lexicon for the issues on which the artists in this International meditate, from the search for meaning in the drudgery of the everyday to the nature of evil and love. In this way, Crumb's work is seen to enter into a dialogue with other artists presented in the show – particularly the ceramics of Kathy Butterly, the photography of Saul Fletcher, and the videos of Kutlug Ataman – with whom Hoptman identifies certain affinities. The centrality of Crumb to the organizing thematics of the show was further highlighted by Siegel's *Artforum* review, already quoted. Siegel saw the International as a tale of two 1960s: as a political legacy and a psychedelic impulse. Crumb, Siegel suggests, 'manages to bridge the two modes, making self-absorption not only compelling but also political.'[46] Another reading of the show, however, highlights art historical absences and presences. The other two cornerstone artists in the International are similarly marginal art historical figures in the process of being rediscovered: Mangelos, the Yugoslavian art historian who began making art in the 1940s but who was not exhibited until 1972 and did not become well-known until after his death in 1987; and Lee Bontecou, the 1960s abstract expressionist sculptor who did not exhibit her work for more than thirty years. In a sense, the Carnegie show placed contemporary artists around the work of three artists who were excluded, either by choice or by circumstance, from the institutions of art history in the second half of the twentieth century. Crumb's role is as the artist hidden in plain sight – an artist of tremendous popular renown who nonetheless evolved outside the traditional frameworks of art history.

The challenges faced by Crumb are personal and distinctive, but also reflect upon the art status of comics generally. It is significant that, other than the catalogue for the Masters show, which situates Crumb's work primarily in light of the influence that he draws from and exerts on other cartoonists, most art criticism seeks to situate his work in the traditions of satirical illustration. Most art critics writing on Crumb ignore the influence of other cartoonists on his work, thereby denying the existence of a fully fledged comics world, and opt instead to read his contribution to the art world in light of established masters such as Hieronymus Bosch, Pieter Breughel the Elder, William Hogarth, or Honoré Daumier.[47] Writing in the catalogue for the Whitechapel show, which she co-curated with Anthony Spira, Laura Hoptman notes: 'The thousands of drawings,

comic books, and illustrations that make up his oeuvre can be compared to the works of Hieronymus Bosch, Pieter Breughel the Elder, William Hogarth, James Gilray, or Honoré Daumier.'[48] Similarly, the Cologne catalogue argues: It's 'not that he doesn't greatly admire the great masters in the history of art such as Bosch, Breughel, Hogarth, Daumier, Grosz or Dix and pay their artistic faculty and craftsmanship his highest respect.'[49] Bosch, Brueghel, Hogarth, Daumier – these are names trotted out in the catalogues to carry water for Crumb, but with little or no explanation in the texts themselves.[50] One exception is in a review of the Cologne show in *Modern Painters,* where Amanda Coulson argues that Crumb's connections to Bosch and Brueghel lie 'not only in quite direct references . . . but also in his approach toward the depiction of humanity as flawed, base, lustful, yet always comical.'[51] Coulson, at least, provides examples. The rest simply wave at the references, content that this is sufficiently explanatory.

What these art-oriented catalogues do not address, for the most part, is the flipside of Crumb's influences. In a September 2004 *Art News* cover story, Crumb said: 'The weird thing about museum people is that they know nothing about the tradition I come from, which goes back 500 years – artists like James Gillray, George Cruikshank, and T. S. Sullivant.'[52] The Cologne catalogue touches on this, noting that his real influences are 'those who have been denied recognition altogether,' which, by the way, are also those artists who are themselves not discussed by the article that notes their absence.[53] Nonetheless, these influences seem to be easily enumerated by critics who are well versed in comics, such as Jean-Pierre Mercier, director of France's comic book museum: Walt Kelly, Carl Barks, Jules Feiffer, Bud Fisher, Milt Gross, Elzie Segar, Gene Ahern, Sidney Smith, George Herriman, Frank King, Cliff Sterrett, and Harold Gray.[54] Because these men, for the most part, plied their trade on the pages of America's newspapers in the 1930s, working on popular comic strips such as *Mutt and Jeff, Popeye,* and *The Gumps,* they are altogether absent from the traditions of art history, a history that only barely has room for illustrators such as Thomas Nast, T. S. Sullivant, James Gillray, George Cruikshank, Gustave Doré, and Honore Daumier. By synthesizing 1930s American comic strip traditions with the ragged aesthetic of the 1960s counterculture, and by expanding this work in the 1970s through reference to a nineteenth-century illustration tradition, Crumb becomes a place holder for distinct artistic traditions that have been largely excluded from art history. Significantly, John Carlin, writing in the Masters catalogue, suggests that Crumb's drawing style reflected

traditional American cartooning from Nast to Segar, now welcomed back in a mediated form because it is seen as a genuine expression of American media values filtered through the unrestrained id of the artist who can't control himself.[55]

Although artists are frequently legitimated through reference to critically regarded forebears, influences are not sufficient criteria of value for determining the significance of an artist. For this, other, more direct, claims about genius must necessarily be made. The Cologne show justifies the importance of Crumb through reference to a conception of American folk art and values, and the Carnegie through the argument that his work reflects the values of a particular time and place, mid-century America.[56] In both cases he is taken to be emblematic of a larger social formation, not an aesthetic movement. Crumb's comics, which are highly personal and idiosyncratic, are not easily reduced to, or conflated with, the attitudes of others, and arguments for his consideration as a serious artist nonetheless depend on qualities that define his work. Yet most art historical writing on Crumb from outside the comics world has tended to create a palatable list of aesthetic and intellectual forebears with scant attention paid to those whom he himself has identified. One reason for this may be the fact that so much of the humour in his work is derived, as Varnedoe and Gopnik observe, from 'its monomaniacal dependence on a wistful, secondhand, already defunct comic-strip style.'[57] Similarly, John Carlin argues in the Masters catalogue, 'Crumb transformed the physical humor of old-time comics into a kind of psychological slapstick.'[58] Further, in one of the most convincing essays written on Crumb's importance, Françoise Mouly suggests that in locating his inspiration in the relics of handmade trash culture, he foreshadowed the important architectural elaborations of postmodernism by Robert Venturi and Rem Koolhaas, who called for an embrace of the messy vitality of 'the ugly and the ordinary' and celebrated the function of paradox that so many critics locate in, for example, Crumb's depictions of African American culture. Mouly argues that by embracing the influence of artists like Walt Kelly and E.C. Segar, and by accepting paradox rather than seeking its resolution, 'Crumb undoubtedly propelled comics to their place as a fundamental postmodern art form, central to the culture of the twentieth century.'[59] By combining this postmodern sensibility, rooted in the tension that has long surrounded comics as a hybrid, and therefore suspect, form, with the 'seemingly effortless drawings, worthy of an Old Master,' Crumb is positioned as a significant contemporary

artist and has the potential to open art-world doors for other cartoon-ists.[60] At least that's what others from the upper echelons of the comics world hoped.

Of course, Crumb's victory might prove unwanted. He has never ag-gressively pursued success in the art world and, in fact, has been long dismissive of it. Crumb claims: 'The "fine" art after World War II doesn't do it for me. It just seems lifeless, a posture, a pose. Jackson Pollock, Willem de Kooning, on down to pop art, performance art, minimalism, whatever . . . I don't get what it's about.' His self-image as an outsider – an image that is prevalent particularly through his autobiographical comics work – helps secure his reputation as an autonomous artist, completely unconcerned with the art market. Despite the fact that the sketches that he draws on placemats now sell for as much as $35,000, Crumb, like any modernist fine artist, evinces no interest in the commercial or critical response to his work: 'I'm not interested in a bunch of cake eaters that go sniff around museums. Not at all. It's totally bizarre to me that when my gallery sells my place-mat drawings, they tout the stains and stuff as a selling factor – like, "and look at the *authentic grease mark*" – and it adds to the value. That world is phony, repugnant and sick.'[61] Crumb's statement recalls with great precision Pierre Bourdieu's diagnosis of the autono-mous player in the field of cultural production and his observation that the field is dependent on its own disavowal of the economic function of the work of art. Nonetheless, Crumb's ambivalence about the process of legitimization should not be dismissed as merely a posture, particularly when so much evidence suggests that it is a legitimately held belief. It seems to me, however, that with quotes like this – and they abound in his interviews – Crumb has developed the near perfect habitus for the comics artist seeking to be incorporated into the field of art, whether he is conscious of this or not.

Of course, Crumb's ambivalence about art is mirrored in art's ambiva-lence about Crumb. The canonization of Robert Crumb, at this extremely early moment in the process, remains incomplete. In admitting Crumb into art institutions, the institutions themselves demonstrate their own inflexibilities, limitations, and their difficulty of moving beyond tradi-tional conceptions of artistic practice, providing few new lenses through which to view the artist. It is worth bearing in mind, for example, that the cover story on Crumb in *Art News* was a special issue dedicated to humour in art. So even when he is taken seriously, he is not taken all that seriously. For the artist, this is not such a loss. As Crumb himself says:

'Many people have congratulated me just because my work has appeared on the covers of *ArtForum* and *Art News,* and because the various shows I've had were seriously reviewed in them. What are they saying in these art magazines? Beats the hell out of me! You read it, I can't!'[62]

Conclusion

Reviewing the Masters of American Comics show in the *Los Angeles Weekly,* Doug Harvey attacked the very hierarchy upon which the exhibition is based, asking 'Who are museums to say that comics – or anything else – are Art or not?'[63] For Harvey, the time for a show such as this one had long come and gone:

> If this show had happened 50 years ago, it would have been a courageous compromise on the part of the museum establishment. As it stands, it's a compromise on the part of the comics, abetting the museum's plausible hipness, undoubtedly boosting the market for original comic art, but adding not a cubit to the medium's claim to artistic validity or providing a first-hand experience of its most powerful and convincing manifestation. For that, you have to go to the funny pages.[64]

It should go almost without saying that Harvey's inversion of the hierarchy of legitimacy would, similarly, have seemed more courageous fifty years ago during the waning days of high modernism. In the contemporary postmodern moment, positing the notion that comics have more to offer art museums than vice versa is not particularly outrageous. Harvey's claim that shows such as this one do nothing to add to the form's 'artistic validity' may overstate his case given the importance that has been placed on such shows within the comics world. More importantly, however, his focus on the appropriate manifestation of the comics form pushes aside the larger institutional issues that the museumification of comics raises even as he seeks to touch upon them.

Crucially, the museumification of comics as it has played out in the Masters show, and in the numerous Robert Crumb exhibitions at major art museums, underscores the power of the prevailing museological discourse. It seems terribly significant that the American cartoonist most celebrated by art museums is also the one whose work is most frequently castigated by critics as racist and sexist. Further, the arguments that are made by art historians and curators on his behalf – that his work represents a naively unbridled id, that his concerns parallel those of middle

America more generally – are exactly the same as those initially used to dismiss work in the comics form altogether. In other words, the art world has managed to preserve its old hierarchies while using a more celebratory language in keeping with its own version of postmodernism. The attacks on comics enumerated by highbrow critics in the first half of the twentieth century emphasized the inherent crudity, racism, and sexism that was seen to be closely associated with working-class American interests. Crumb's work, which is steeped in the aesthetics of American mass culture from the pre–Second World War era, embodies the very values for which comics were originally condemned. If, as was argued in the previous chapter, nostalgia is a primary driver for the market in comics collectables, it should come as no surprise that the comics artist who found the greatest success in the art world is also deeply rooted in nostalgia, not only for his own childhood but for the early days of the comics form itself. Nonetheless, in this postmodern period, the ironic persistence of outmoded styles and values become the reason why Crumb is placed as the pinnacle of American cartoonists. That it is Crumb, of all cartoonists, who is best able to cross over into the traditional art world is illustrative of the transformation that has taken place in the cultural field generally. In Crumb, art museums have chosen to honour all of those aspects of comics that they traditionally disdained, thus securing their own supremacy in the hegemonic endgame of cultural value.

Chris Ware, *Wingnutz* (2007). ©Chris Ware,
courtesy of the artist.

By Way of Conclusion: Chris Ware's Comics about Art

Most genuinely talented cartoonists hate it when all this stuff is talked about anyway, as it shoves our (up until now) virtually criticism-free artform out of the open clean air of genuine life and that much closer towards the stifling gascloud of academic talking, thinking and theorizing.

Chris Ware[1]

The tenth issue of Chris Ware's *Acme Novelty Library* (Spring 1998) includes a twenty-four-page story featuring the artist's well-known Jimmy Corrigan character, which itself is framed by a sixteen-page catalogue of goods advertised for sale through Acme Novelty and Co. of Chicago, Illinois. This supplement, which cannily ironizes the structure and rhetoric of early twentieth-century mail order catalogues, provides an extended commentary on the tense relationship of optimism and despair in the American domestic sphere. Offering useful consumer products such as Placebo Birth Control Pills, Large Negro Storage Boxes, Happy Family Appliqués, and a Reason for Living, Ware's product descriptions invoke a particularly masculinist form of irony in order to eviscerate feminized tropes about the conflation of consumerism and self-fulfilment. One catalogue page, however, displays a specific bitterness. Here Ware offers for sale the institutions of the art world: The Art Magazine ($35/yr), The Art Gallery ($875/mo.), The Art Critic (6¢/word), The Art Teacher ($35,000/yr.), The Art Dealer (market price), and, of course, Art ($10/lb.). The text of Ware's description of the Art Teacher is suggestive of the tone of the piece as a whole:

Discover the joys and mysteries of your own 'creativity' with your own **personal art teacher.** Let this desperate soul drag you down in his or her

personal quest of 'grants' and a 'tenured position'; learn lots about yourself in the process. Learn that art is either a strange, exotic, and inexplicable, mystical activity, or a wholly rational, scientific 'investigation,' and that 'talent' is only an impediment to real expression. Learn that 'skill' is only a 'seductive affectation' that fakers use to 'trick' people into thinking that they're good. Learn that if you 'like' something, you've got to be able to detail and outline exactly why. Learn that 'liking something' is bad, anyway.[2]

With this passage Ware places the institution of art training under attack, emphasizing careerism and jealousy as the hallmarks of a fraudulent system. Central to this description is the Nietzschean concept of *ressentiment* that was identified as a hallmark of contemporary comics production in chapter 3. Yet, more than this, Ware's fake ads offer a way to come to terms with the relationship that exists between the comics world and the art world, and the structural subordination of the former to the latter.

In some ways this is a difficult book to conclude. The legitimating process that comics are involved in remains very much ongoing. Throughout the course of this study it has been relatively easy to identify important discursive shifts in the status of comics over the course of the twentieth and twenty-first centuries, and many of these have been outlined in the earliest chapters. Nonetheless, as the example of Robert Crumb in the previous chapter demonstrated, there remains a great deal about the comics and art relationship that is as yet unresolved. Processes of legitimation and canonization are remarkably prone to changing fads and fashions, and predicting the future is a fool's errand. Trends in recent years – from coverage of comics in daily newspapers and the specialized art press, to the creation of courses of study on comics at universities – have been overwhelmingly positive from the point of view of the comics world. Many commentators share the belief that comics has turned the corner and that the form is poised for widescale public acceptance. If this is in fact the case, it is, as has been demonstrated in this book, primarily due to the success of specific individual creators and particular works. To a certain extent, the rising tide of acclaim directed at individual comics world superstars is having the effect of elevating all of the boats in the field as a whole. The case of Chris Ware is extremely instructive to this end. Rather than offer a traditional summation, in the remaining pages of this book I want to examine the specific claims made on behalf of Ware, outlining the trajectory of his rise to fame in both the comics world and the art world, because it serves as an important forecast of the processes that are likely to govern the comics–art intersection in years to come.

Chris Ware is the most influential cartoonist to have arrived on the American scene in the past twenty years, and he is, undoubtedly, the one who most clearly occupies the social space that exists between the two worlds of comics and art as he, more than any other cartoonist, has achieved a high degree of credibility in both arenas. Reviews of his work in the comics and non-comics press have been overwhelmingly adulatory. Take, for example, three successive articles about the artist in the pages of the *New York Times*. In a 2000 review of Ware's best-known book, *Jimmy Corrigan, The Smartest Kid on Earth*, novelist Dave Eggers called him 'the most versatile and innovative artist the medium has known' and the book 'the greatest achievement of the form, ever.'[3] In a 2001 profile, Neil Strauss termed Ware 'one of the best graphic artists of his generation' and added the following affirmation provided by Ware's friend, cartoonist Ivan Brunetti: 'He's changed our assumptions about this humble art form more radically than anyone since Robert Crumb.'[4] Finally, in 2005, writer/actor John Hodgman noted that Ware's 'painstaking draftsmanship, beautiful hand lettering, virtuosic absorption of prewar graphic design and comics history and Rube Goldbergian paneling inspire awe, gratitude and fear.'[5] So positive are these reviews that even the occasional critic who expresses reservations about his work, such as Douglas Wolk, feel compelled to note his 'mastery' of both 'form and style.'[6] What is clear from this critical consensus is the fact that, over the course of the past decade, Ware has become the standard-bearer for the aspirations of comics in the more consecrated fields of art and literature. In these and other critical and popular writings on comics, the ideology of the 'man of genius' is used to explain the success of Chris Ware, who is held to be the best new hope for the comics form, a position previously and, to a degree, currently held by Robert Crumb and Art Spiegelman. However, unlike Crumb, whose exceptional draftsmanship is marred in the eyes of many by his deliberate appeals to vulgarity and shock appeal, or Spiegelman, whose accolades came primarily, although by no means exclusively, from the world of literature, Ware is the first American cartoonist to be considered a true visual artist, celebrated for both technical mastery and conceptual brilliance.

One of the reasons that the ideology of genius is so compelling in Ware's case stems from the fact that his successes have completely overshadowed those of all other comics artists past or present. Significantly, the Masters of American Comics show was organized in such a manner as to culminate with his work, presenting it as the apotheosis of the drive to legitimate the comics form. Ware's bitter remarks about the art world in *Acme Novelty Library* #10 finds purchase with that strand of comics

culture that sees itself as under-appreciated and misunderstood, even as cartoonists like Ware are welcomed into major art museums. It is the type of animosity that one might expect from someone who feels he has never received the respect he felt was his due, and it is hard to make that case here. Ware, a dropout from the School of the Art Institute of Chicago, has particularly benefited from the attention of the art world more than almost any other comics artist of his generation. In 2001, Pantheon released his novel-length portrait of an alienated man meeting his estranged father for the first time, *Jimmy Corrigan, The Smartest Kid on Earth*. It sold more than 80,000 copies and won both the American Book Award and the *Guardian* First Book Award. The next year, Ware became the first comic book artist to have his work exhibited at the Whitney Biennial, a show for which he also produced the poster. In 2003 his work was featured on the cover of *Artforum* and his book *Quimby the Mouse* was selected by that magazine as among the best artworks of the year.[7] In the fall of 2005, at the age of thirty-eight, he was one of only four living artists deemed a 'master of American comics' in the exhibition jointly organized by the UCLA Hammer Museum and the Museum of Contemporary Art in Los Angeles. At the same time, his *Building Stories* was chosen by the *New York Times Magazine* to become the first comics work ever serialized in that newspaper, running for thirty weeks until April 2006. In May 2006, he exhibited his work in a solo show at the Museum of Contemporary Art in Chicago. Also in that year, he was among the inaugural class of artists awarded a $50,000 Hoi Fellowship by United States Artists. In the summer of 2007 he curated a show, Uninked: Paintings, Sculpture and Graphic Work by Five Cartoonists, at the Phoenix Art Museum in Arizona, and in the fall of that year he had a solo show at the Sheldon Memorial Art Gallery at the University of Nebraska. Additionally, he has won dozens of comics industry awards including more than two dozen Harvey Awards, a dozen Eisner Awards, several Ignatzes, and the Alph'Art at the Angoulême Festival.

All of these successes combine to support a reading of Ware as a uniquely inspired genius, unparalleled in the field of comics and paradigm-altering within the art world. Moreover, Ware himself has contributed to the image of his own genius through his interviews, writings on comics, and the publication of two volumes of his sketchbooks, all of which are presented as an outpouring of his direct and unmediated creative process. These books are filled with life-drawing sketches, doodles, and lacerating self-portraits and strips that suggest that the harsh world view evinced in his fiction is not simply a carefully tended persona

or authorial mask. Much of the work in Ware's published sketchbooks depict him as a misanthrope, perpetually unhappy with his life and his work and disappointed with his talent. Comic strips with titles like 'Fuck Comics,' 'Same Old Problems,' and 'I Am Never Going to Be Happy' present Ware not as the critically hailed artist-celebrity that he is, but as an alienated and overlooked genius.[8] Because the *Acme Novelty Date Books* invite autobiographical readings of Ware's work, they tend to bolster interpretive frameworks, such as the one offered by Daniel Raeburn in his short book-length study of Ware as a designer, that emphasize the autobiographical aspect of all of Ware's work.[9] From this standpoint, his comics are read not as products of a particular time or place, but are seen as stemming inexorably from the initial experience of the artist's personal psychic and emotional history. In Ware's case, especially insofar as he comes to occupy the social space between the comics world and the art world almost exclusively, this allows his personal traumas to stand in for, by means of displacement, the social status of comics as a whole. In other words, because he is received as the best and the brightest cartoonist of the current moment, one who has set a new gold standard for comics as art, and because his work is seen as inexplicably linked to his own personal subjectivity as a result of the ideology of personal genius, Ware's issues become those of comics as well.

Not surprisingly, given his own admiration for the work of Robert Crumb and his personal friendship with him, it is nostalgia that largely structures Ware's aesthetic of personal trauma. As we have seen, nostalgia is among the primary drivers of value in the comics world, and the case of Ware takes it to a new level. His visual aesthetic, which is highly influenced by outmoded styles, seems deeply nostalgic for an era in which he never lived. Ware himself has touched on the topic of nostalgia in a number of interviews, suggesting that cartoonists are 'endemically nostalgic people who turn our lives over and over and over again trying to figure out how we went wrong and fix things or control them, make sense of things.'[10] The artist's generalization about his peers might seem unnecessarily far-reaching, but it is, not surprisingly, a view of the profession that is widely shared. Many of Ware's contemporaries and friends are similarly interested in the aesthetics of the past, including Robert Crumb, Dan Clowes, Ivan Brunetti, Seth, and Charles Burns, each of whom has demonstrated a tendency not only to evince a nostalgic tone, but to actually make nostalgia the subject of their art. The direct equation of cutting-edge contemporary cartoonists and nostalgia has the peculiar effect of undermining the strength of claims made about comics

as a form. What sort of art, it can be asked, finds its most progressive artists lost in such a backward-looking aesthetic? Raeburn quotes Art Spiegelman as saying paradoxically that 'the future of comics is in the past.'[11] Ware may be, as Raeburn explicitly argues, the future of comics, but if this is the case then the nostalgia that cuts through his work becomes all the more problematic within the context of the field's quest for cultural legitimation.

Ware, who was born in 1967, told the *New York Times:* 'I'm not nostalgic for any period that I haven't lived in. Mostly I'm nostalgic for when I was 6 years old.'[12] While this might address the affective tone struck in his work, it hardly explains its visual aesthetics, which are primarily drawn from periods in which he never lived. Further, Ware's nostalgia for this period is mitigated by the fact that he describes himself as an unpopular youth ('A real nerd. I kept to myself, afraid of being punched in the hallway between classes') who took refuge in collections of Charles Schulz's comic strip *Peanuts.*[13] Ware's recollections of what he describes as a pitiable childhood in Omaha, Nebraska, serve, in the discourse about his genius, to link him inextricably to comics styles that seem almost quaintly anachronistic in the twenty-first century. It is not only Ware who was ridiculed and overlooked, the logic goes, but also the illustratorly comics style that he has largely come to define in the public mind. That one of Ware's current ongoing serials, *Rusty Brown,* deals with the lives of young comic book nerds growing up in the Nebraska of the 1970s serves only to intensify the autobiographical impulse that has both comics artist and comics art undergoing the same kind of traumatic disappointments in a world that simply refuses to recognize or appreciate their sensitive soul-seeking. In this way, Ware, through his mobilization of autobiographical tropes in his comics and published sketchbooks, is positioned as the exemplary figure in a comics world that itself is riddled with a conflicted mix of nostalgia for a non-existent period of great comics art and disdain for the very idea of art and its practices of consecration. Thus, Ware occupies a unique social and aesthetic space somewhere at the nexus of the comics world and the art world, problematizing both.

The Pathetic Aesthetic: Between the Comics World and the Art World

In an interview with Gary Groth published in the 200th issue of *The Comics Journal,* Ware described his place in comics by saying: 'I'm really pleased I'm "in" comics, actually. If there is such a thing as a "comics world."'[14] Throughout this book, the reality of a 'comics world' that

Ware questions is taken as a given. Nonetheless, it is possible that my primary interest in the intersection of the comics world with more consecrated art worlds has led me to inadvertently provide something of a distorted image of the comics field. While it is true that possibilities open to comics have dramatically shifted over the half-century since the days of the American anti–comic book campaign, that door is open only to a small fraction of comics artists and publishers, far removed from the major publishing centres such as Marvel, DC, and the United Feature Syndicate. Comics at present remain fundamentally rooted in an entertainment tradition that is generally at odds with the world of fine arts. American comic strips remain dominated by short-form gag material crammed onto newspaper pages that promise readers little more than a quick chuckle. The vast bulk of production within the American comic book industry is still composed of serial adventure superhero stories, as they have been since the 1960s. For the most part, and with a few notable exceptions, creators working in these fields have demonstrated little concern with art world acceptance and have oriented themselves primarily to the entertainment-based logic of the marketplace. This pole, economically dominant in the field, is most clearly aligned with the logics of Hollywood, which has increasingly turned to their products as the source material for summer blockbuster films. Creators working at this end of the field seek justification through popularity, measured by their ability to transition to new media forms. They point to such successes as Frank Miller, screenwriter and filmmaker (*Sin City, 300, The Spirit*), and Jeph Loeb, the executive producer of *Heroes,* and mark as their inspirations the unsung heroes of golden age superheroes, including Jack Kirby and Will Eisner. As much as those comics artists who have achieved some art world success may claim otherwise, it is against this comics mainstream that they seek to define their cultural distinction. In his preface to the 2007 edition of *The Best American Comics,* Ware opined: 'with the recent rise of self-revelatory comics have come a requisite experimentation and pushing forward of the means of expression available to every artist, to say nothing of younger cartoonists no longer having to begin with the stone tools of superhero comics to try and chip out a personal story.' This swipe at the most beloved and nostalgic of comics genres makes clear his perception that the best work in the field – past or present – has little to do with the generic tradition that has for so long completely dominated the field as to become virtually synonymous with it.[15]

The polar opposite position in the field of comics, symbolically dominant but economically dominated, is that occupied by a select group of artists, many of whom are friends, which is increasingly centred around

Ware's orbit. At this end of the field, termed 'alternative comics' or 'art comics,' the major players are outlined in the tables of contents of a few select recent anthologies, including *McSweeney's Quarterly Concern* #13 (2004) and *The Best American Comics, 2007*, both edited by Ware, and the two volumes of *The Anthology of Graphic Fiction, Cartoons and True Stories* (2006, 2008) edited by Ware's friend Ivan Brunetti, both of which position Ware as among the most important talents in comics. Relative to the size and scope of the superhero-defined portion of the field, the territory occupied by Ware and his friends is remarkably limited. Notably, reviews of their anthologies have stressed the insularity of the alternative comics scene, defined as it is by only a very small handful of publishers. Thus, and perhaps not unsurprisingly, *Booklist* suggested that the lineup in *The Best American Comics, 2007* was 'dominated by the usual suspects,' and *Publisher's Weekly* noted that it 'is starting to make comics anthologies look like annual class reunions.'[16] Further, the world of alternative comics represents a cluster of widely divergent graphic and narrative styles. While confessional autobiographical comics (such as Spiegelman's *Maus*) are the most durable of all alternative genres, introspective and realist fiction, reportage, essayistic comics, and even gag strips contribute to the heterogeneity of material. Thus it seems that admission to this field has less to do with aesthetic coherence than with a social disposition.

In an essay on the Chris Ware–edited issue of *McSweeney's Quarterly Concern*, Daniel Worden outlines how alternative comics creators, and particularly Ware, seek to legitimize their work by aligning it with the precepts of modernism. Specifically, Worden argues with keen insight that the comics collected in *McSweeney's* exist at the intersection of intimacy, shame, and gender melancholy. In that way, they mobilize their aesthetic case through the tropes of masculinist modernism, including the feminization of mass culture, a focus on what Nina Baym has termed 'melodramas of beset manhood' and a romanticization of the straight, white male subject as the object of societal scorn.[17] Worden argues that intimacy has been seen by creators like Ware as the key to the legitimization of comics as art, and that this affective alliance is formed by the twinned processes, visible in the comments I have already addressed about Ware, of romanticizing the artist as a solitary genius taking on a system that disdains him, and a celebration of the loneliness that is presumed to characterize the comics reader and creator equally. Significantly, masculinist prejudices necessarily underscore this twofold legitimizing strategy, and it is not surprising to find, therefore, that the space

of alternative comics creation is as highly gendered as the field of comics as a whole. The Ware-edited issue of *McSweeney's*, for example, contains the work of only three female cartoonists (out of forty in total). After receiving criticism on that front, *Best American Comics* improved the gender balance (to nine female cartoonists, out of thirty-nine in total), but also included a defensive note about the editor's purported gender blindness ('I am not of the cut of cloth to check an artist's genitalia at the door').[18] The significance of complaints about gender inclusivity have little to do with genitalia, and much more to do with the masculine privilege that encompasses not only the 'mainstream' of the comics world, but also those parts that self-consciously position themselves in opposition to the dominant pole.

Worden's contention that Ware's anthology privileges straight white men as the objects of societal scorn is considerably bolstered by a reading of *Rusty Brown*. Short strips depicting unscrupulous middle-aged G.I. Jim doll collector Rusty Brown taking advantage of his naive friend Chalky White began appearing in Ware's comic series *Acme Novelty Library*, with the tenth issue (1998). These strips focus on the collector as emotionally damaged, with savagely drawn depictions of arrested adolescence and longing for the junk culture of childhood that are particularly resonant with the culture that was described in chapter 7. Beginning with *Acme Novelty Library* #16 (2005), Ware began to collect in serial form the novel-length Rusty Brown story, which focuses on a public school in Nebraska in the 1970s and the generational reverberations of disappointment and loss. In the nineteenth issue of *Acme Novelty Library*, Ware introduces a lengthy flashback sequence depicting the early adulthood of Woody K. Brown, Rusty's father, in the 1950s. Woody is depicted as a lonely, sexually repressed figure with strong antisocial tendencies that manifest themselves when he begins stalking his on-again, off-again lover. These antisocial tendencies are made manifest in his compulsive interest in science-fiction pulp magazines, and in an award-winning short story, 'The Seeing-Eye Dogs of Mars,' that he pens for the fictional *Nebulous* magazine. In the story, Woody Brown channels his sexual and romantic frustrations and failures into a story depicting the desperate loneliness and isolation of a possibly deranged space settler. Later in the story, a now middle-aged Woody is depicted in his office pondering a photograph of his ex-lover and masturbating in his office. The conflation in Ware's work with science-fiction fandom, sexual frustration, and deep personal bitterness drives the narrative of the *Rusty Brown* serial. As with other Ware comics, the temptation to read this material in confessional

terms is bolstered by the sheer variety of ways in which it overlaps with what he has detailed of his own life story in interviews. At the same time, an autobiographical reading is troubled by the fact that Ware includes in the story a fictionalized version of himself: a Mr Ware, who is the school's pretentious art teacher. The Mr Ware of the story is the type of small-town teacher and painter who dabbles in post–pop art, regrets having cut off his ponytail, smokes dope with his students in the back of their cars, and lectures his colleagues about Jacques Lacan and ennui. In other words, Ware depicts himself as the art teacher that he so viciously savaged in the parodic ad discussed at the opening of this chapter. As such, rather than establishing this work as straightforward autobiography, Ware presents a story in which relations between the art world, however peripheral that is in a Nebraska public school, and the traditions of mass culture are arrayed against each other and shown to be mutually corrupt, hollow, and unfulfilling. Throughout *Rusty Brown,* Ware stigmatizes all forms of cultural creation and builds its humour from the audience's experience of Schadenfreude.

Ware's comics truck in desperately isolating narrative tropes (novelist Audrey Niffenegger titled an extremely positive review of one of his joke collections 'Music to Slit Your Wrists By'), but he is most celebrated for his technical skills in rendering an aesthetic of despair.[19] Raeburn, his most consistent defender, has suggested that 'Jimmy Corrigan may be the most physically beautifully book ever written about loneliness.'[20] From this standpoint, Ware's great accomplishment in the field of comics has been to bring the best ideals of design craftsmanship to the comics form, a fact that is reflected in the critical consensus that exists around his work. Thus, in an *Artforum* review, Martha Schwendener praised his 'stiff geometric precision,' and *Booklist* celebrated the 'icy-clear drawings, meticulous compositions, and geometrically varied panels' that comprise his *Building Stories* serial.[21] The focus on geometric design in Ware's work has carried over to scholarly considerations of his oeuvre as well. Thomas A. Bredehoft notes the how Ware deploys the space of the page, arguing that his comics 'are frequently characterized by complex and intricate structures.'[22] Similarly, Jan Baetens draws attention to the way in which Ware 'uses constraints; that is, he reduces the number of units, aspects, colors, forms, etc., to create the possibility of a more complex, multi-layered, poly-sequential writing and reading in which the reader has no right to play freely with the author's arrangement of material, but must scrupulously follow it.'[23] Discussions of complexity and geometric design

in Ware's work almost inevitably turn to the discussion of the technical precision that can be found in architecture, an analogy that he himself repeatedly stresses in interviews and in his own writings ('comics are an art of pure composition, carefully constructed like music, but structured into a whole architecture, a page by page pattern, brought to life and "performed" by the reader').[24] The apotheosis of Ware's architectural and performative approach to the page would be his intricate *Building Stories* work or his spectacularly intricate non-linear cover for *The New Yorker*'s cartoon issue in 2006, which Seth and Art Spiegelman called the 'richest and most complex single page of comics ever made.'[25] To this end, Ware's reputation revolves around the fetishism of craft identified as the hallmark of the illustratorly lowbrow movement enunciated on the one hand by the underground aesthetic exemplified by Crumb and the clarion calls of Robert Williams in the pages of *Juxtapoz*.

Discussing his time at the School of the Art Institute of Chicago in his long interview in the 200th issue of *The Comics Journal*, Ware responded to a question about the 'educational malfeasance' of the faculty by disdaining art teachers who were 'really into theory' and who did 'site-specific installations' and 'forced all that French theory down his students' gullets.'[26] Ware's rejection of theory is closely tied to his personal aesthetic philosophy, expressed in piecemeal fashion in his various interviews and critical writings. Crucially, and not surprisingly, Ware's conception of the role of the artist draws upon Romantic notions of the creator as outsider, hewing to a highly personal point of view. He has suggested that single-author-produced comics are 'even better' than cinema insofar as they are 'entirely the product of a single imagination, not a photograph or an approximation.'[27] Similarly, he holds to an art for art's sake sentiment when he champions work that is created beyond the commercial realm of the marketplace. As he wrote in *The Independent* about his *Building Stories* serial, 'Though I can't claim that the story which will follow over the next few months is a representative or even good example of advancing an experimental or artistic criterion, I can at least say that no one told me what to write and that I followed my own impulses and instincts while working on it, much in the same way that real artists and writers do.'[28] Nonetheless, Ware breaks with the precepts of modernism espoused by Clement Greenberg, a writer he particularly disdains and has parodied in his comics, and other critics with his emphasis on the communicability of human sentiment: 'For myself, I genuinely think that one of the real responsibilities of an artist and writer . . . is a clear, honest

communication of what it feels like to be alive.'[29] In comics, he contends, this is best accomplished through representationalism, a strategy that he feels was driven from the other arts by the demands of modernism.

Ware's rejection of modernist precepts aligns him with a pre-, rather than post-, modern, conception of the artist. Specifically, his self-presentation draws on the tradition of the *artiste maudit* who suffers in this world for glory in the next. A recurring contention in Ware's writing is that comics are an almost impossibly difficult and alienating form in which to work, a theme that he has addressed in *McSweeney's* ('thing is, drawing comics really isn't that easy'), *Best American Comics* ('cartooning takes a really, really long time and is hard, lonely work'), and *The Comics Journal* ('drawing comics is a miserable, lonely endeavor, and I don't know why I do it sometimes').[30] Yet in Ware's world view, the cartoonist is also cursed by his personal failings and by his pathetic stature relative to 'real artists and writers.' To this end, he plays up his own sense of failure and has made self-deprecation a hallmark of his career. Not only does he portray himself in the most unflattering caricature possible in *Rusty Brown,* but in his interviews he routinely apologizes for his perceived inadequacies. Upon winning the *Guardian* First Book Prize he was quoted in that newspaper admitting that 'he can't understand why he is becoming a success.' If he had to describe himself in one word, it would be 'farce,' and he titled the introduction to the catalogue of his one-man show at the University of Nebraska 'Apologies, etc.'[31] In this way, Ware draws the bleakness of his comics onto his own public image, taking on the role of the pathetic artist even as he is held to elevate the status of the most pathetic of all contemporary art forms. Ware's performance of weakness and self-pity is the culmination of the rise of comics through the art world. If he, better than any of his peers, occupies the possible space between the art world and comics world at the present moment, he does so by knowingly playing the fool. Not only are Ware's comics about the type of socially maladjusted losers that stereotypes comics fans, but he himself performs the role of loser savant. He mobilizes a highly self-conscious and deeply ironic degree of illustratorly skill and narrative complexity in order to perform the worst preconceptions about the comics world. Ware reaffirms the supremacy of the art world relative to comics by maintaining and reinforcing existing prejudices about the inadequacies of a form presumed to be inexorably tainted by mass culture and its audiences, and turning the loathing of the form into a highly aestheticized performance of the self-hating artist that makes him all the more acceptable by the art world that he claims to disdain.

In 'The Whitney Prevaricator,' the poster-sized collection of 'art historical quips and gags' that he provided to the 2002 Whitney Biennial, Ware depicts the evolution of art history from ancient Greece to the present day as a series of self-delusions, con games, crippling instances of self-doubt, alienation, and sexual frustration with titles like 'Nobody Will Ever Like Me,' 'Mr Mannerism,' and 'Ain't Life Modern?' Conceived as a series of short gags, two of the central strips focus on the place of comics within the field of art history. In the first, the titular 'Johann Gutenberg, Jr' works at his printing press, bemoaning the fact that all he ever produces are pornography and Bibles. Addressing the mass reproduction so central to the status of comics and other forms of mass culture, Gutenberg asks himself: 'Is there not some means by which to forge the solace of great art via reproduction . . . Which is, after all, a mirror of the very act for which God himself has placed on this earth?' After a pause for reflection, he concludes 'Eh . . . Probably not' and returns to his work. The second strip, 'Still, Nobody Likes Me,' depicts the Swiss cartoonist Rodolphe Töpffer hoping to please the dying humanist Johann Wolfgang von Goethe. 'Perhaps,' he muses, 'I'll combine two disparate fields of civilization into one . . . That sort of trick is all the rage at the moment.' Here Ware references the actual history of Töpffer, whose early experiments in the comics form were said to have pleased Johann Wolfgang von Goethe, who influenced the Swiss scholar's decision to publish what are now widely considered to be the earliest comic books. With these two strips, Ware situates comics squarely in the (satiric) history of Western art, signalling his intention to reconceptualize the place of the form through his own contributions.

It is significant that Ware draws on the sanction of Goethe in his Whitney poster. If Töpffer originated comics, Goethe's blessing did relatively little to consecrate the form at the time. In retrospect, Goethe's interest has nonetheless taken on keen importance for historians of comics, not the least of whom is Ware. In his monograph on Ware, Raeburn raises the spectre of Töpffer in the very first sentence, invoking his work as the source of all comics. Later, Raeburn draws a remarkable equation between the first cartoonist and the man he sees as the best: 'After Töpffer, the majority [of cartoonists] produced comics that were bad beyond all conception. Only a handful have fulfilled Goethe's auspicious prognostication, and the most recent among them is our subject, Chris Ware.'[32] The connection that Raeburn makes is not drawn from thin air. Ware himself has written on Töpffer on two occasions. He included a reproduction of a translation of Töpffer's *Histoire de M. Vieux-Bois* (as *The*

Adventures of Obadiah Oldbuck) in his *McSweeney's* anthology, and he reviewed David Kunzle's monograph on Töpffer and a new edition of the artist's works in English translation in the pages of *Bookforum*. For Ware, the Töpffer conjured by Kunzle – 'believing in the democracy of his art, publicly self-deprecating, prone to magnifying minor slights in solitude' – reminds him of the Charles Schulz painted in David Michaelis's biography.[33] Others, however, might follow Raeburn's lead in finding these Töpfferian attributes in Ware himself, recalling that the cartoonist is an avowed champion of mass-produced art, that he is quick to play the self-deprecating failure in interviews and to despair over negative criticism. The similarities between Ware and Töpffer signalled by Raeburn, and Ware himself, serve multiple purposes. First, they establish a direct historical teleology linking the origins of the comics form with Ware's contemporary work. Second, they consecrate Ware by extension, passing on to him Goethe's blessing, thereby restoring to the comics world the focus on the individual artist/genius that was, for so long, obscured by the evolution of comics as team-based corporate entertainment product.

Final Thoughts

I have chosen to focus in this conclusion on the career of Chris Ware because, in many ways, he has become a synecdoche for the comics world as a whole, and particularly for the aspirations of the comics world relative to the art world. To this end, traces of the historical developments that have been outlined in this book can be seen to structure a great deal of his work. Indeed, I would go so far as to suggest that a full elaboration of how Chris Ware has come to be seen as one of the most important American cartoonists would require moving through each of the arguments that I have presented in this work as he is the artist who best occupies the role of the best and brightest that the comics world has to offer today.

I have already touched on, for example, the ways in which several of his comics demonstrate the *ressentiment* that characterizes the relation of the comics world to pop art. Indeed, more than many of his colleagues and contemporaries, Ware's work evinces a distrust of, and disdain for, the art world. Ware has also been keenly interested in the construction of the image of the artist in the entertainment empire, particularly relative to the work of Charles Schulz. Ware's collection of archival *Peanuts* strips was used as the basis for the Chip Kidd–edited book *Peanuts: The Art of Charles M. Schulz,* and he has helped develop contemporary interest in

the work of Frank King and George Herriman by contributing designs to collections of their work.[34] Jeet Heer, a collaborator with Ware on the Frank King books published by Drawn and Quarterly, argues that with his work on these books the artist is engaged in a process of creating a pedigree and lineage for his own work.[35] It seems true that the recognition afforded Ware at present is intricately bound to his ability to retroactively construct the narrowly cast social position of the comics artist. By bestowing this status on other, historically neglected, cartoonists, he helps to create the very position that he now occupies. Moreover, the tremendous success of *Jimmy Corrigan,* and its widespread inclusion on college and university reading lists, demonstrates that he is the creator of comics masterpieces. The rush towards Ware's canonization is so strong that a 2010 collection of essays appraising his career to date, *The Comics of Chris Ware: Drawing Is a Way of Thinking,* offers four essays on his *Building Stories,* which had not been completed when the anthology was published, suggesting that scholars and critics see the work, as *Maus* was once seen in the period when it was being serialized in *RAW,* as a masterpiece in the process of becoming.[36] Ware's example could also be used to shed light on the other case studies that structure this book. I have already detailed the way in which Ware has been taken up by important American museums, as both an artist and a curator, at a relatively young age, but it is important to note as well that he has been very involved in the construction of highbrow toys, having created a Jimmy Corrigan vinyl toy for Presspop in 2003 and a Rusty Brown lunchbox, itself a comic printed in metal, for Dark Horse in 2002. Further, while his career was not established enough in the 1990s to have been a major figure at art auctions at Sotheby's and Christie's, his original art is highly sought after and he is represented by the Adam Baumgold Gallery in New York and the Carl Hammer Gallery in Chicago. His work on the ongoing serialization of 'Rusty Brown' is, at heart, an extended commentary on the fetishistic drives governing the social behaviour of collectors discussed in chapter 7, and the first page of *Acme Novelty Library* #15 offered a 'Hobbyist's Guide' to the identification and classification of collectors in the field (the six basic types: the reparationist, the historian, the vigilante, the completist, the vindictivist, the researcher).[37] In sum, each of the lenses through which I have examined the relationship between the comics world and the art world pertains to Ware and his work precisely because his position in the field is the culmination of a lengthy process of legitimation and consecration for the comics form that has allowed certain comics and comics artists entrance into the art world.

Ware's embrace by the art world is such a specific reflection of his interests, achievements, and dispositions that some might argue that if he did not exist, the comics community would have had to invent him. Of course, the opposite is actually closer to reality. Insofar as he so perfectly occupies the space allotted to a cartoonist in the art world at this particular moment in time – innovatively cutting edge in formal terms, technically brilliant as a designer and draftsman, but viciously self-deprecating in his willingness to occupy a diminished position in the field, strongly masculinist in his thematic concerns and aesthetic interests, and wilfully ironic about the relationship between comics and art in a way that serves to mockingly reinforce, rather than challenge, existing power inequities – it can be said that if Chris Ware did not exist, the art world would have had to invent him.

Notes

1. Introduction

1 'Lucy McKenzie,' 2006 Tate Triennial New British Art, http://www.tate.org.
 uk/britain/exhibitions/triennial/artists/mckenzie.htm.
2 Sarah Thornton, 'Reality Art Show,' *The New Yorker* 19 March 2007. This essay
 is also included in Thornton's book *Seven Days in the Art World* (New York:
 W.W. Norton, 2009).
3 Thomas Lawson, 'Outside In,' *Artforum* November 2006: 255.
4 'Lucy McKenzie: SMERSH,' Metro Pictures press release, http://www.
 metropicturesgallery.com/index.php?mode=past&object_id=226&view=
 pressrelease.
5 Jerry Saltz, 'Ups and Downs,' *The Village Voice,* 23 September 2005.
6 Lawson 254.
7 Lawson 255.
8 Isabelle Graw, 'On the Road to Retreat: An Interview with Lucy McKenzie,'
 Parkett 76 (2006): 134.
9 Saltz.

2. What If Comics Were Art? Defining a Comics Art World

1 Tim Faherty, 'The Amazing Stan Lee Interview,' in *Stan Lee: Conversations,*
 ed. Jeff McLaughlin (Jackson: University Press of Mississippi, 2007) 73–4.
2 See Bart Beaty, *Unpopular Culture: Transforming the European Comic Book in the
 1990s* (Toronto: University of Toronto Press, 2007).
3 Sterling North, 'A National Disgrace,' *Childhood Education* (October 1940):
 56; Reinhold Reitberger and Wolfgang Fuchs, *Comics: Anatomy of a Mass Me-
 dium* (London: Studio Vista, 1972) 17; David A. Carrier, *The Aesthetics of
 Comics* (University Park: Penn State Press, 2000) 86.

4 Karl E. Fortress, "The Comics as Non-Art" in *The Funnies: An American Idiom,* ed. David Manning White and Robert H. Abel (New York: The Free Press, 1963) 112.
5 Robert Crumb, 'Drawing Cartoons Is Fun!' *Despair* (San Francisco, CA: Print Mint, 1969) n.p.
6 Quoted in Scott Nybakken, 'Bande Dessinee: A Panel Discussion about Graphic Novels,' *The Comics Journal* 149 (March 1992): 71.
7 Thierry Groensteen, *Un Objet culturel non identifié* (Angoulême: Éditions de l'An 2, 2006) 23.
8 Thierry Groensteen, *The System of Comics* (Jackson: University Press of Mississippi, 2007) 14–15.
9 Clement Greenberg, 'Modernist Painting,' in *Art Theory and Criticism: An Anthology of Formalist, Avant-Garde, Contextualist, and Postmodernist Thought,* ed. Sally Everett (Jefferson, NC: McFarland, 1991) 110.
10 Beaty 77–82.
11 Paul Dimaggio, 'Cultural Boundaries and Structural Change: The Extension of the High Culture Model to Theater, Opera and Dance, 1900–1940,' in *Cultivating Differences: Symbolic Boundaries and the Making of Inequality,* ed. Michèle Lamont and Marcel Fournier (Chicago: University of Chicago Press) 21–57.
12 North 56.
13 Groensteen, *Object culturel* 32.
14 For an overview of these concerns, see Patrick Brantlinger, *Bread and Circuses: Theories of Mass Culture as Social Decay* (Ithaca, NY: Cornell University Press, 1983).
15 John Mason Brown, 'The Case against the Comics,' *Saturday Review of Literature* 20 March 1948: 31; Marya Mannes, 'Junior Has a Craving,' *New Republic* 17 February 1947: 20.
16 Fredric Wertham, 'Are Comic Books Harmful to Children?' *Friends Intelligencer* 10 July 1948: 396.
17 M. Thomas Inge, *Comics as Culture* (Jackson: University Press of Mississippi, 1990) xix.
18 In Amy Kiste Nyberg, *Seal of Approval: The History of the Comics Code* (Jackson: University Press of Mississippi, 1998) 48.
19 Martin Sheridan, *Classic Comics and Their Creators: Life Stories of the American Cartoonists from the Golden Age* (Arcadia, CA: Post-Era Books, 1973 [1942]) 18.
20 United States Congress, Senate, *Juvenile Delinquency (Comic Books): Hearings before the Senate Subcommittee on Juvenile Delinquency,* 83rd Congress, 2nd Session, 21–2 April 1954, 24 June 1954, 896.

21 Coulton Waugh, *The Comics* (New York: Luna Press, 1947) 14.
22 Waugh 14.
23 Inge xi.
24 Bill Blackbeard and Dale Crain, *The Comic Strip Century: Celebrating 100 Years of an American Art Form* (Englewood Cliffs, NJ: Kitchen Sink Press, 1995) 10.
25 Jerry Robinson, *The Comics: An Illustrated History of Comic Strip Art* (New York: G.P. Putnam's Sons, 1974) 11.
26 Horn 7.
27 Art Spiegelman, 'The Smithsonian Collection of Newspaper Comics,' *Panels* 1 (Summer 1979): 31.
28 Dick Lupoff and Don Thompson, *All in Color for a Dime* (New York: Ace Books, 1970) 7.
29 Inge xv.
30 David Manning White and Robert H. Abel, *The Funnies: An American Idiom* (New York: Free Press, 1963) 7.
31 This argument is advanced by Joseph Witek, 'Comics Criticism in the United States: A Brief Historical Survey,' *International Journal of Comic Art* 1.1 (Spring/Summer 1999) 4–16.
32 Paul Sassienie, *The Comic Book: The One Essential Guide for Comic Book Fans Everywhere* (Edison, NJ: Chartwell Books, 1994) 9.
33 Reitberger and Fuchs 11.
34 Robinson 14.
35 Robinson 15; Sassienie 10; Groensteen, *System of Comics* 58; Philippe Mellot and Claude Moliterni, *Chronologie de la bande dessinée* (Paris: Flammarion, 1996); George Perry and Alan Aldridge, *The Penguin Book of Comics* (London: Penguin, 1967) 22–3.
36 Scott McCloud, *Understanding Comics: The Invisible Art* (Northhampton, MA: Tundra, 1993) 3.
37 Les Daniels, *Comix: A History of Comic Books in America* (New York: Outerbridge and Diesnstfrey, 1971) 1.
38 David Kunzle, *The Early Comic Strip: Narrative Strips and Picture Stories in The European Broadsheet from c. 1450 to 1825* (Berkeley: University of California Press, 1973) 2.
39 Horn 7.
40 Will Eisner, *Comics and Sequential Art* (Tamarac, FL: Poorhouse Press, 1985) 8.
41 R.C. Harvey, *The Art of the Funnies: An Aesthetic History* (Jackson: University Press of Mississippi, 1994) 9.
42 Harvey 9.

43 Catherine Labio,'What's in a Name? The Academic Study of Comics and the "Graphic Novel,"' *Cinema Journal* 50.3 (2011): 123–6.
44 McCloud 9.
45 Aaron Meskin, 'Defining Comics?' *Journal of Aesthetics and Art Criticism* 65.4 (Autumn 2007): 374.
46 McCloud 164.
47 Greg Cwiklik, 'Understanding the Real Problem,' *The Comics Journal* 211 (April 1999): 66; Scott McCloud, 'First Impressions,' *The Comics Journal* 211 (April 1999): 101.
48 Thierry Groensteen, *System of Comics;* Greg Hayman and Henry John Pratt, 'What Are Comics?' in *A Reader in Philosophy of the Arts,* ed. David Goldblatt and Lee Brown (Upper Saddle River, NJ: Pearson, 2005) 419–24.
49 Arthur Danto, 'The Artworld,' *The Journal of Philosophy* 61.19 (1964): 571–84.
50 George Dickie, *Art and the Aesthetic: An Institutional Analysis* (Ithaca, NY: Cornell University Press, 1975) 34.
51 Dickie 35–6.
52 Howard S. Becker, *Art Worlds* (Berkeley: University of California Press, 1982) 34.
53 Becker 25.
54 Becker 35.
55 Becker 36.
56 Dylan Horrocks, 'Inventing Comics: Scott McCloud Defines the Form in *Understanding Comics,'* *The Comics Journal* 234 (June 2001): 35.
57 R.C. Harvey, 'Round and Round with Scott McCloud,' *The Comics Journal* 179 (August 1995): 75.
58 Harvey, 'Round and Round' 75.
59 Zena Sutherland and May Hill Arbuthnot, *Children and Books,* 7th ed. (Glenview, IL: Scott, Foresman, 1986) 5.
60 Sutherland and Arbuthnot 5.
61 Sutherland and Arbuthnot 5.
62 Barbara Bader, *American Picturebooks: From Noah's Ark to the Beast Within* (New York: Macmillan, 1976) 1.
63 'Caldecott Terms and Criteria,' American Library Association website, http://www.ala.org/ala/mgrps/divs/alsc/awardsgrants/bookmedia/caldecottmedal/caldecottterms/caldecottterms.cfm.
64 Beaty 47.
65 Dick Higgins, 'A Preface,' in *Artists' Books: A Critical Anthology and Sourcebook,* ed. Joan Lyons (Layton, UT: Gibbs M. Smith, 1985) 11.
66 Richard Kostelanetz, 'Book Art,' in *Artists' Books: A Critical Anthology and Sourcebook,* ed. Joan Lyons (Layton, UT: Gibbs M. Smith, 1985) 28.

67 Stephen Bury, *Artists' Books: The Book as a Work of Art, 1963–1995* (Aldershot: Scolar Press, 1995) 1.

68 Lucy R. Lippard, 'The Artists' Book Goes Public,' *Art in America* 65.1 (January-February 1977) 40.

69 Bury 4.

70 Clive Philpott, 'Books by Artists and Books as Art,' in *Artist/Author: Contemporary Artists' Books,* ed. Cornelia Lauf and Clive Phillpot (New York: Distributed Arts Publishers, 1998) 47.

71 Shelley Rice, 'Words and Images: Artists' Books as Visual Literature,' in *Artists' Books: A Critical Anthology and Sourcebook,* ed. Joan Lyons (Layton, UT: Gibbs M. Smith, 1985) 61.

72 Johanna Drucker, *The Century of Artists' Books* (New York: Granary Books, 2004) 259.

73 Drucker 214.

74 Drucker 259–60.

75 Becker 93.

76 Becker 46, 30–2.

77 Eisner 7; Charles Hatfield, *Alternative Comics: An Emerging Literature* (Jackson, MS: University Press of Mississippi, 2005) xiv–xv.

78 Horn 12.

79 R.C. Harvey, *The Art of the Comic Book: An Aesthetic History* (Jackson: University Press of Mississippi, 1996) 3.

80 Fredric Wertham, *Seduction of the Innocent* (New York: Holt, Rinehart, 1954) 121.

81 Fredric Wertham, 'Reading for the Innocent,' *Wilson Library Bulletin* 22 (September 1954): 611.

82 Wertham, *Seduction of the Innocent* 127.

83 Daniels 2.

84 Rob Rodi, 'Why Comics Are Art, and Why You Never Thought So Before,' *Misfit Lit* (Seattle, WA: Fantagraphics, 1991) 5.

85 Roger Sabin *Comics, Comix and Graphic Novels: A History of Comic Art* (London: Phaidon, 1996) 8.

86 Rodi 7.

87 Horn 11.

88 Hatfield xii.

3. Roy Lichtenstein's Tears: *Ressentiment* and Exclusion in the World of Pop Art

1 Quoted in David Hajdu, *The Ten Cent Plague: The Great Comic-Book Scare and How It Changed America* (New York: Farrar, Straus and Giroux, 2008) 163.

2 Friedrich Nietzsche, *The Birth of Tragedy and The Genealogy of Morals,* trans. Francis Golffing (New York: Anchor, 1956) 170.

3 Nietzsche 171.

4 Nietzsche 171.

5 Peter Bagge, ' "Real" "Art," ' *Reason* August-September 2004, http://www.reason.com/news/show/29213.html?pg=2.

6 Bagge.

7 Daniel Clowes, *Art School Confidential, A Screenplay* (Seattle: Fantagraphics, 2006) 184.

8 Clowes 187.

9 Clowes 77.

10 Clowes 86.

11 Clowes 56, 59.

12 On this line of argument, see Dick Hebdige, *Hiding in the Light: On Images and Things* (London: Routledge, 1988) 141.

13 Elizabeth C. Baker, 'The Glass of Fashion and the Mold of Form,' *Art News* 70.2 (April 1971), reprinted in *Roy Lichtenstein,* ed. John Coplans (New York: Praeger 1972) 179.

14 Chris Ware, 'Wingnutz,' in *Uninked: Paintings, Sculpture and Graphic Work by Five Contemporary Cartoonists* (Phoenix: The Phoenix Art Museum, 2007) n.p.

15 Steve Duin and Mike Richardson, 'Novick, Irv,' *Comics between the Panels* (New York: Dark Horse Comics, 1998) 332.

16 Peter Benchley, 'Special Report: The Story of Pop,' in *Pop Art: The Critical Dialogue,* ed. Carol Anne Mahsun (Ann Arbor, MI: UMI Research Press, 1989) 169.

17 Harold Rosenberg, 'Art and Its Double,' *Artworks and Packages* (New York: Dell, 1969) 13–14.

18 Michael Lobel, *Image Duplicator: Roy Lichtenstein and the Emergence of Pop Art* (New Haven, CT: Yale University Press, 2002) 156–7.

19 Kim Thompson, 'Introduction,' in *Misfit Lit: Contemporary Comic Art,* ed. Gary Groth (Seattle, WA: Fantagraphics, 1991) 3.

20 Kyle Baker, *The New Baker* (Woodstock, NY: Kyle Baker Publishing, 2003) 8.

21 John A. Walker, *Art in the Age of Mass Media,* 3rd ed. (London: Pluto Press, 2001) 15.

22 Walker 22.

23 Quoted in Bruce Glaser, 'Oldenburg, Lichtenstein and Warhol,' in *Pop Art: A Critical History,* ed. Steven Henry Madoff (Berkeley: University of California Press, 1997) 145.

24 Alan Solomon, 'The New Art,' in *Pop Art: The Critical Dialogue,* ed. Carol Anne Mahsun (Ann Arbor, MI: UMI Research Press, 1989) 50.

25 Gene Baro, 'Roy Lichtenstein: Technique as Style,' in *Roy Lichtenstein,*
ed. John Coplans (New York: Praeger, 1972) 167; Otto Hahn, 'Roy Lichten-
stein,' in *Roy Lichtenstein,* ed. John Coplans (New York: Praeger, 1972) 136;
Lawrence Alloway, 'Roy Lichtenstein's Period Style: From the Thirties to the
Sixties and Back,' in *Roy Lichtenstein,* ed. John Coplans (New York:
Praeger, 1972) 144–5.

26 Hilton Kramer, 'End of an "ERA": Andy Warhol,' *Encounter* 41 (September
1973): 49.

27 Peter Selz, 'Pop Goes the Artist,' *Partisan Review* 30.2 (Summer 1963): 314.

28 Douglas McClellan, 'Roy Lichtenstein, Ferus Gallery,' *Artforum*
July 1963: 47

29 Max Kozloff, ' "Pop" Culture, Metaphysical Disgust, and the New Vulgar-
ians,' *Art International* 6 (February 1962): 34–6.

30 Allan Kaprow, 'Pop Art: Past, Present and Future,' in *Pop Art: The Critical
Dialogue,* ed. Carol Anne Mahsun (Ann Arbor, MI: UMI Research Press,
1989) 66.

31 Albert Boime, 'Roy Lichtenstein and the Comic Strip,' in *Pop Art: A Critical
History,* ed. Steven Henry Madoff (Berkeley: University of California Press,
1997): 205.

32 Lobel 1–15.

33 Kirk Varnedoe and Adam Gopnik, *High and Low: Modern Art and Popular
Culture* (New York: Museum of Modern Art, 1991) 203.

34 Kozloff 35

35 Sidney Tillim, 'New York Exhibitions: Month in Review,' *Arts Magazine* 37.6
(March 1963): 61.

36 Andreas Huyssen, *After the Great Divide: Modernism, Mass Culture, Postmodern-
ism* (Bloomington: Indiana University Press, 1986) 47.

37 Lucy R. Lippard, *Pop Art* (New York: Frederick A. Praeger, 1966) 2.

38 Lobel 30.

39 Cécile Whiting, *A Taste for Pop: Pop Art, Gender and Consumer Culture* (Cam-
bridge: Cambridge University Press, 1997) 132.

40 Whiting 117.

41 Clement Greenberg, 'After Abstract Expressionism,' *Art International* Octo-
ber 1962: 32.

42 Clement Greenberg, 'Post Painterly Abstraction,' *Art International* Summer
1964: 64.

43 Selz 313–16

44 Harvey Kurtzman and Will Elder, *Playboy's Little Annie Fanny* (Chicago:
Playboy, 1972) 118.

45 Susan Sontag, *Against Interpretation, and Other Essays* (New York: Farrar,
Straus and Giroux, 1966) 278.

46 Sontag 290; Harold Rosenberg, 'The Art Establishment,' *Esquire* January 1965: 46.
47 Sontag 292.
48 Kaprow 68.
49 Varnedoe and Gopnik 208.
50 Glaser 145.

4. Searching for Artists in the Entertainment Empire

1 Richard Kyle, 'Graphic Story Review,' *The Collected Jack Kirby Collector,* vol. 1, ed. John Morrow (Raleigh: NC: TwoMorrows Advertising, 1997) 203.
2 Roland Barthes, 'The Death of the Author,' *Image-Music-Text* (New York: Hill and Wang, 1978) 142–8; Michel Foucault, 'What Is an Author?' in *Language, Counter-Memory, Practice,* trans. Donald F. Bouchard and Sherry Simon (Ithaca, NY: Cornell University Press, 1977) 113–38.
3 Henry Jenkins, *Textual Poachers: Television Fans and Participatory Culture* (New York and London: Routledge, 1992) 1–2.
4 Jenkins 10, 17.
5 Jenkins 18.
6 Pierre Bourdieu, 'The Historical Genesis of the Pure Aesthetic,' in *The Field of Cultural Production: Essays on Art and Literature,* ed. Randal Johnson (New York: Columbia University Press, 1993) 254–66.
7 Jenkins 22.
8 Jenkins 32.
9 For more on this line of argument, see Jenkins 89.
10 Diedrich Diederichson, 'Carl Barks: Die Stadt der goldenen Dächer,' *Artforum* October 1994: 76.
11 Dan Nadel, 'Introduction,' *Art Out of Time: Unknown Comics Visionaries, 1900–1969* (New York: Abrams, 2005) 1.
12 Nadel 1.
13 Quoted in Zack Smith, 'Paying Tribute to Fletcher Hanks,' *Newsarama* 3 September 2007, http://forum.newsarama.com/showthread.php?t=104479.
14 Matt Madden, 'Framing Creatures,' *BookForum* September/October/November 2007, http://www.bookforum.com/inprint/014_03/863.
15 Quoted in Aaron Leitko, 'Civilized Destruction: Paul Karasik on Fletcher Hanks' *Express* 1 August 2007, http://www.readexpress.com/read_freeride/2007/08/civilized_destruction_paul_karasik.php.
16 Quoted in Leitko.
17 Quoted in Leitko.

18 Quoted in Smith.
19 Quoted in Lucienne Peiry, *Art Brut: The Origins of Outsider Art,* trans. James Frank (Paris: Flammarion, 2001) 11.
20 Donald Ault, 'Educating the Imagination,' in *The Carl Barks Library of Walt Disney's Comics and Stories in Color,* vol. 32 (Prescott, AZ: Gladstone, 1997) n.p.
21 Ault, 'Educating' n.p.
22 Donald Ault, 'Introduction,' *Carl Barks: Conversations* (Jackson: University Press of Mississippi, 2003) xiii.
23 Dana Gabbard and Geoffrey Blum, 'The Color of Truth Is Gray,' in *Uncle Scrooge McDuck by Carl Barks,* vol. 24 (Prescott, AZ: Gladstone, 1996) n.p.
24 Michael Pollak, 'Carl Barks, Father of Scrooge McDuck, Is Dead at 99,' *The New York Times* 26 August 2000: B7.
25 Ault, 'Introduction' x–xi.
26 Ault, 'Introduction' xiv.
27 Michael Barrier, *Carl Barks and the Art of the Comic Book* (New York: M. Lilien, 1981) 35.
28 Geoffrey Blum, 'The Cover Story,' in *Uncle Scrooge McDuck by Carl Barks,* vol. 43 (Prescott, AZ: Gladstone, 1998) n.p.; Geoffrey Blum, 'How Short Was My Story,' in *Uncle Scrooge McDuck by Carl Barks,* vol. 46 (Prescott, AZ: Gladstone, 1998) n.p.
29 Barrier 3.
30 Geoffrey Blum, 'Bark's Borrowings,' in *The Carl Barks Library of Donald Duck Adventures in Color,* vol. 22 (Prescott, AZ: Gladstone, 1996) n.p.
31 Barrier 86.
32 Diederichson 75.
33 David Landis, 'Jack Kirby, a Hero among Superheroes,' *USA Today* 8 February 1994: 1D; 'Jack Kirby, 76; Created Comic – Book Superheroes,' *New York Times* 8 February 1994: D22.
34 Mark Evanier, *Kirby: King of Comics* (New York: Abrams, 2008).
35 Tom Ziuko, 'A Man amongst Gods, a God amongst Men,' *The Collected Jack Kirby Collector,* vol. 4, ed. John Morrow (Raleigh: NC: TwoMorrows Advertising, 2004) 5.
36 Frank Miller, 'God Save the King,' *The Comics Journal* 105 (February 1986): 63.
37 Neil Gaiman, 'Introduction,' *Kirby: King of Comics* (New York: Abrams, 2008) 12.
38 Brent Staples, 'Jack Kirby, a Comic Book Genius, Is Finally Remembered,' *New York Times* 26 August 2007: 9.

39 John Morrow, 'Welcome to the Jack Kirby Collector,' *The Collected Jack Kirby Collector,* vol. 1: 22; John Morrow, 'Collector Comments,' *The Collected Jack Kirby Collector,* vol. 4: 159.

40 Gordon Flagg, 'The Collected Jack Kirby Collector vol. 4,' *Booklist* 15 October 2004: 373.

41 See John Morrow, "Would You Like to See My Etchings?' *The Collected Jack Kirby Collector,* vol. 2: 40; John Morrow, 'The Kid From Left Field,' *The Collected Jack Kirby Collector,* vol. 5: 32; Glenn B. Fleming, 'The House That Jack Built,' *The Collected Jack Kirby Collector,* vol. 2: 6.

42 Glen David Gold, 'Lo, From the Demon Shall Come – The Public Dreamer!!' in *Masters of American Comics,* ed. John Carlin, Paul Karasik, and Brian Walker (New Haven, CT: Yale University Press, 2005) 261.

43 R.C. Harvey, 'What Jack Kirby Did,' *The Comics Journal Library: Jack Kirby,* ed. Milo George (Seattle, WA: Fantagraphics Books, 2002) 61; Earl Wells, 'Once and for All, Who Was the Author of Marvel?' *The Comics Journal Library: Jack Kirby,* ed. Milo George (Seattle, WA: Fantagraphics Books, 2002) 87.

44 Nat Freedland, 'Super-Heroes with Super Problems,' *The Collected Jack Kirby Collector,* vol. 4: 159; Kirby's unhappiness with the article is discussed by Ronin Ro, *Tales to Astonish: Jack Kirby, Stan Lee, and the American Comic Book Revolution* (New York: Bloomsbury, 2004) 104, and Evanier 147.

45 Evanier 147.

46 Charles Hatfield, 'The Galactus Trilogy: An Appreciation,' *The Collected Jack Kirby Collector,* vol. 1: 211.

47 Charles Hatfield, 'Kirby's Fourth World: An Appreciation,' *The Collected Jack Kirby Collector,* vol. 1: 100–1.

48 Saul Braun, 'Shazam!! Here Comes Captain Relevant,' *New York Times* 2 May 1971: SM36.

49 See, for example, Mike Gartland, 'Jack Kirby's Inkers Collaborators,' *The Collected Jack Kirby Collector,* vol. 4: 232–3.

50 Ro 157.

51 Arlen Schumer quoted in '50 People Influenced,' *Jack Kirby Collector* 50: 150; Tony Seybert 'Why I Like Colletta's Inks,' *The Collected Jack Kirby Collector,* vol. 3: 104–5; John Morrow, 'Why I Hate Colletta's Inks,' *The Collected Jack Kirby Collector,* vol. 3: 105.

52 Tom Heintjes, 'Marvel to Return Original Art,' *The Comics Journal* 95 (February 1985): 8–9.

53 Tom Heintjes, 'Marvel Withholds Kirby's Art,' *The Comics Journal* 100 (July 1985): 13.

54 'We, The Undersigned,' *The Comics Journal* 110 (August 1986): 27.

55 Kim Fryer, 'Marvel Returns Art to Kirby, Adams,' *The Comics Journal* 116 (July 1987): 15.
56 Dave Sim, 'A Declaration of Independence,' *The Comics Journal* 105 (February 1986): 87–90.
57 Robert L. Short, *The Gospel According to Peanuts* (Louisville, KY: Westminster John Knox Press, 1965) 26.
58 Robert L. Short, *The Parables of Peanuts* (New York: Fawcett Crest, 1968) 14.
59 Short, *Parables* 15.
60 Short, *Parables* 4.
61 Charles M. Schulz, *Peanuts Jubilee: My Life and Art with Charlie Brown and Others* (New York: Penguin, 1975) 100–1.
62 Short, *Parables* 17.
63 Robert L. Short, *Short Meditations on The Bible and Peanuts* (Louisville, KY: Westminster John Knox Press, 1990) 28.
64 Bill Clinton, 'Statement on the Death of Charles M. Schulz, Jr,' 13 February 2000; 'Acts Approved by the President,' 26 June 2000.
65 David Astor, 'Only 17 Comics Reside on the 1,000 Island,' *Editor & Publisher* 17 April 1999: 52; David Astor, ' "Peanuts" Still Holding on to 2,460 Clients,' *Editor & Publisher* 30 October 2000: 29.
66 Chip Kidd, *Peanuts: The Art of Charles M. Schulz*, ed. Chip Kidd (New York: Pantheon, 2001) n.p.
67 Evanier 37–40.
68 David Michaelis, *Schulz and Peanuts: A Biography* (New York: Harper Collins, 2007) 287, 524.
69 Lea Goldman and Jake Paine, 'Top Earning Dead Celebrities,' Forbes.com 26 October 2007, http://www.forbes.com/2007/10/26/top-dead-celebrity-biz-media-deadcelebs07-cz_lg_1029celeb.html.
70 Schulz 181.
71 Schulz 9.
72 Schulz 9.
73 John Carlin, 'Masters of American Comics: An Art History of Twentieth-Century American Comic Strips and Books,' in *Masters of American Comics*, ed. John Carlin, Paul Karasik, and Brian Walker (New Haven, CT: Yale University Press, 2005) 88.
74 John Updike, 'Sparky from St. Paul,' *The New Yorker* 22 October 2007: 164; Chip Kidd, *Peanuts: The Art of Charles M. Schulz*, ed. Chip Kidd (New York: Pantheon, 2001) n.p.; Walter Cronkite, 'Foreword,' *The Complete Peanuts, 1953 to 1954* (Seattle: Fantagraphics Books, 2004) xi; Jonathan Franzen, 'Foreword,' *The Complete Peanuts, 1957 to 1958* (Seattle: Fantagraphics Books, 2005) xi.

75 Michaelis 81.
76 Monte Schulz, 'Regarding Schulz and Peanuts,' *The Comics Journal* 290 (May 2008): 27–78.
77 Monte Schulz 71.
78 Carl Barks, 'Letter to Ron Goulart, March 22, 1961,' in *The Carl Barks Library of Walt Disney's Comics and Stories,* vol. 6: n.p.
79 Barks n.p.
80 Quoted in Greg Sadowski, *B. Krigstein,* (Seattle, WA: Fantagraphics Books, 2002) 123.
81 John Morrow, 'Pop Kirby,' *The Collected Jack Kirby Collector* vol. 2: 67.
82 Christopher Brayshaw, 'The Monument Carver's Stone,' *The Comics Journal Library: Jack Kirby,* ed. Milo George (Seattle, WA: Fantagraphics Books, 2002) 53.
83 Anthony Christopher, 'The Art of Collecting Kirby,' *The Collected Jack Kirby Collector,* vol. 4: 222.
84 Walter Mosley, *Maximum FF* (New York: Marvel Comics, 2006) n.p.
85 Mosley, n.p.
86 Mosley, n.p.
87 Ault, 'Introduction' xxviii.

5. Cartoons as Masterpieces: An Essay on Illustrated Classics

 1 Gary Groth, 'Art Spiegelman,' *The Comics Journal* 180 (September 1995): 70.
 2 Delmore Schwartz, 'Masterpieces as Cartoons,' *Partisan Review* 19 (July–August 1952): 461–71; reprinted in *Arguing Comics: Literary Masters on a Popular Medium,* ed. Jeet Heer and Kent Worcester (Jackson: University Press of Mississippi, 2004) 52–62.
 3 Schwartz 52, 55.
 4 Howard S. Becker, *Art Worlds* (Berkeley, CA: University of California Press, 1982) 134.
 5 Becker 135.
 6 C.J. van Rees, 'How a Literary Work Becomes a Masterpiece: On the Three-fold Selection Practiced by Literary Criticism,' *Poetics* 12 (1983): 397–417.
 7 van Rees 398.
 8 van Rees 403–4.
 9 van Rees 407.
10 See, for example, Craig Fischer, 'Worlds within Worlds: Audiences, Jargon and North American Comics Discourse,' *Transatlantica* (forthcoming).

11 Robert Warshow, 'Woofed with Dreams,' *Partisan Review* 13 (November– December 1946): 587.

12 Warshow 587.

13 Warshow 587–8.

14 Warshow 588.

15 Gilbert Seldes, 'Golla, Golla, the Comic Strips Art!' *Vanity Fair* May 1922: 71, 108.

16 Gilbert Seldes, 'The Kat That Walks by Himself,' in *Krazy Kat: The Comic Art of George Herriman,* ed. Patrick McDonnell, Karen O'Connell, and Georgia Riley de Havenon (New York: Henry Abrams, 1985) 15.

17 Damon Runyon, 'The Brighter Side,' *San Antonio Light* 25 January 1939.

18 e.e. cummings, 'Introduction,' *Krazy Kat, by George Herriman* (New York: Grosset and Dunlap, 1977) 15.

19 Martin Sheridan, *Classic Comics and Their Creators* (Arcadia, CA: Post-Era Books 1973) 64; Coulton Waugh, *The Comics* (New York: Luna Press, 1947) 58.

20 M. Thomas Inge, *Comics as Culture* (Jackson: University Press of Mississippi, 1990) 49; Tim Blackmore, 'Krazy as a Fool: Erasmus of Rotterdam's Praise of Folly and Herriman of Coconino's Krazy Kat,' *Journal of Popular Culture* 31.3 (Winter 1997): 31.

21 Seldes, 'The Kat That Walks' 17.

22 Inge 44.

23 Patrick McDonnell, Karen O'Connell, and Georgia Riley de Havenon, eds., *Krazy Kat: The Comic Art of George Herriman* (New York: Henry Abrams, 1985) 28, 44.

24 Robert Warshow, 'Paul, the Horror Comics, and Dr Wertham,' in *Mass Culture: The Popular Arts in America,* ed. Bernard Rosenberg and David Manning White (New York: Free Press, 1957) 199.

25 Warshow, 'Paul' 200.

26 Warshow, 'Paul' 200.

27 Warshow, 'Paul' 204.

28 Warshow, 'Paul' 206.

29 Warshow, 'Paul' 206.

30 Gary Groth, 'Grown-Up Comics: Breakout from the Underground,' *Print* November-December 1988: 98.

31 See David Hajdu, *The Ten Cent Plague: The Great Comic-Book Scare and How It Changed America* (New York: Farrar, Straus and Giroux, 2008) 184.

32 Hajdu 314.

33 *The National E.C. Fan-Addict Club Bulletin* 1 (November 1953), reprinted in *Squa Tront* 2, ed. Jerry Weist (1970): n.p.

34 Fredric Wertham, *Seduction of the Innocent* (New York: Holt Rinehart, 1954) 269; 'The EC Fanzines Part Two: Potrzebie Bounces,' *Squa Tront* 7 (1977): 36.

35 Harvey Kurtzman, *From Aargh! to Zap!: Harvey Kurtzman's Visual History of the Comics* (New York: Prentice-Hall, 1991) 34.

36 Greg Sadowski, *B. Krigstein* (Seattle: Fantagraphics Books, 2002) 19, 76.

37 Sadowski 119–23.

38 Brian O'Doherty, 'Art: Remembrance of Things Past,' *New York Times* 6 June 1964: 20.

39 For a comparison of the number of pages produced by the EC artists, see 'EC Artists Ranked by Page Count,' *Squa Tront* 12 (Summer 2007): 6; Sadowski 177.

40 Bhob Stewart and John Benson, 'An Interview with Bernard Krigstein,' *Squa Tront* 6 (1975): 4.

41 Stewart and Benson 6–7.

42 John Benson, David Kaskove, and Art Spiegelman, 'An Examination of "Master Race,"' *Squa Tront* 6 (1975): 41.

43 Benson, Kasakove, and Spiegelman 42–7.

44 Benson, Kasakove, and Spiegelman 41.

45 Gary Arlington, 'Letters,' *Squa Tront* 6 (1975): 58.

46 Bhob Stewart, 'B. Krigstein: An Evaluation and Defense,' *EC World Press* 4 (August 1954), reprinted in *Squa Tront* 6 (1975), 41–7.

47 Bill Spicer, 'Letters,' *Squa Tront* 7 (1976): 34; Landon Chesney, 'Letters,' *Squa Tront* 7 (1976): 35.

48 Art Spiegelman, 'Commix: An Idiosyncratic Historical and Aesthetic Overview,' *Print* November-December 1988: 71–2.

49 Art Spiegelman, 'Krigstein: A Eulogy by Art Spiegelman,' *The Comics Journal* 134 (February 1990): 13.

50 Art Spiegelman, 'Ball Buster,' *The New Yorker* 22 July 2002: 72.

51 Gary Groth, 'Grown-Up Comics: Breakout from the Underground,' *Print* November-December 1988: 102.

52 John Benson, 'Art Spiegelman: From Maus to Now,' *The Comics Journal* 40 (June 1978): 36.

53 Bill Sherman, 'Raw Power,' *The Comics Journal* 40 (November 1980): 41; Dale Luciano, 'Raw: Pataphysical Spirit and Graphic Possibilities,' *The Comics Journal* 46 (July 1981): 41.

54 Sherman 41; Carter Scholz, 'Raw Roots,' *The Comics Journal* 46 (July 1981): 34.

55 Luciano 43.

56 Dale Luciano, 'Nostalgia, Mice, and Ducks,' *The Comics Journal* 75 (September 1982): 22–3.

57 Kim Fryer, 'Maus Receives Wave of Publicity; First Printing Sells Out,' *The Comics Journal* 113 (October 1986): 14.

58 Dale Luciano, 'Trapped By Life: Pathos and Humor among Mice and Men,' *The Comics Journal* 113 (December 1986): 43.

59 Luciano, 'Trapped' 43–4.

60 Luciano, 'Trapped' 45.

61 See Harvey Pekar, 'Maus and Other Topics,' *The Comics Journal* 113 (December 1986): 54–7; Harvey Pekar, 'Comics and Genre Literature: A Diatribe by Harvey Pekar,' *The Comics Journal* 130 (July 1989): 127–33; R. Fiore, 'Funnybook Roulette,' *The Comics Journal* 132 (November 1989): 41–8; Harvey Pekar, 'Pekar Contra Fiore,' *The Comics Journal* 133 (December 1989): 29–32; R. Fiore, 'Fiore vs. Pekar, Round Three,' *The Comics Journal* 134 (February 1990): 17–19; and Harvey Pekar, 'Blood and Thunder,' *The Comics Journal* 135 (April 1990): 27–33.

62 Pekar, 'Maus and Other Topics.'

63 Pekar, 'Maus and Other Topics' 54–7.

64 Pekar, 'Blood' 33.

65 Ole Frahm, 'Considering MAUS. Approaches to Art Spiegelman's "Survivor's Tale" of the Holocaust by Deborah R. Geis (ed.),' *Image and Narrative* 8 (May 2004).

66 Dominick LaCapra, *History and Memory After Auschwitz* (Ithaca, NY: Cornell University Press, 1998) 160.

67 Amy Hungerford, 'Surviving Rego Park: Holocaust Theory from Art Spiegelman to Berel Lang,' in *The Americanization of the Holocaust,* ed. Hilene Flanzbaum (Baltimore: Johns Hopkins University Press, 1999) 115–16.

68 Marianne Hirsch, 'Family Pictures: Maus, Memory, and Post – Memory,' *Discourse* 15.2 (Winter 1992–3): 13.

69 Judith L. Goldstein, 'Realism without a Human Face,' in *Spectacles of Realism: Body, Gender, Genre,* ed. Margaret Cohen and Christopher Prendergast (Minneapolis: University of Minnesota Press 1995) 85.

70 Arlene Fish Wilner, ' "Happy, Happy Ever After": Story and History in Art Spiegelman's Maus,' *Journal of Narrative Theory* 27.2 (Spring 1997): 174.

71 Hillel Halkin, 'Inhuman Comedy,' *Commentary* February 1992: 55.

72 Alan Rosen, 'The Specter of Eloquence: Reading the Survivor's Voice,' *Celebrating Elie Wiesel: Stories, Essays, Reflections,* ed. Alan Rosen (Notre Dame, IN: University of Notre Dame Press, 1998) 44.

73 James Young, 'The Holocaust as Vicarious Past: Art Spiegelman's Maus and the Afterimages of History,' *Critical Inquiry* 24 (1998): 676–8.

74 Erin McGlothlin, 'No Time Like the Present: Narrative and Time in Art Spiegelman's Maus,' *Narrative* 11.2 (2003): 179.

75 Hirsch 26–7.
76 Linda Hutcheon, 'Postmodern Provocation: History and "Graphic" Litera-ture,' *La Torre* 2.4–5 (1997): 306.
77 Michael Staub, 'The Shoah Goes on and on: Remembrance and Represen-tation in Art Spiegelman's "Maus,"' *MELUS* 20.3 (Autumn 1995): 33–46.
78 Pekar, 'Pekar Contra Fiore' 32.
79 Joshua Brown, 'Of Mice and Memory,' *The Oral History Review* 16.1 (Spring 1988): 96.
80 Alice Yaeger Kaplan, 'Theweleit and Spiegelman: Of Men and Mice,' in *Remaking History*, ed. Barbara Kruger and Phil Mariani (New York: Dia Art Foundation, 1989) 155.
81 Alan Rosen, 'The Language of Survival: English as Metaphor in Spiegel-man's Maus,' *Prooftexts* 15 (1995): 251.
82 Alan Rosen, 'The Specter of Eloquence: Reading the Survivor's Voice,' in *Celebrating Elie Wiesel: Sories, Essays, Reflections,* ed. Alan Rosen (Notre Dame, IN: University of Notre Dame Press, 1998) 48.
83 Michael Rothberg, '"We Were Talking Jewish": Art Spiegelman's "Maus" as "Holocaust" Production,' *Contemporary Literature* 35.4 (Winter 1994): 671.
84 Rothberg 672.
85 Rothberg 672.
86 Daniel Schwarz, *Imaging the Holocaust* (New York: St Martin's Press, 1999) 288–90.
87 Thomas Doherty, 'Art Spiegelman's Maus: Graphic Art and the Holocaust,' *American Literature* 68.1 (March 1996): 70.
88 Alison Landsberg, 'America, the Holocaust, and the Mass Culture of Mem-ory: Toward a Radical Politics of Empathy,' *New German Critique* 71 (Spring-Summer 1997): 67–8.
89 James E. Young, 'The Arts of Jewish Memory in a Postmodern Age,' in *Modernity, Culture and 'the Jew,'* ed. Bryan Cheyette and Laura Marcus (Stanford, CA: Stanford University Press, 1998) 221.
90 Young 222.
91 LaCapra 139–40.
92 LaCapra 141.
93 LaCapra 175.
94 van Rees 407.
95 Pekar, 'Pekar Contra Fiore' 32.
96 Joseph Witek, *Comic Books as History: The Narrative Art of Jack Jackson, Art Spiegelman, and Harvey Pekar* (Jackson: University Press of Mississippi, 1989) 96–7; Kurtzman 92–4.
97 Adam Gopnik, 'Comics and Catastrophe,' *New Republic* 22 June 1987: 30.

98 Lawrence L. Langer, 'A Fable of the Holocaust,' *New York Times Book Review* 3 November 1991: 1.

99 Elizabeth Hess, 'Meet the Spiegelmans,' *Village Voice* 14 January 1992: 87.

100 Ethan Mordden, 'Kat and Maus,' *New Yorker* 6 April 1992: 90.

101 LaCapra 152.

102 Robert Storr, 'Art Spiegelman's Making of Maus,' *Tampa Review* 5 (Fall 1992): 29; Gopnik 31.

103 William Hamilton, 'Revelation Rays and Pain Stars,' *New York Times* 7 December 1986: 7.

104 Art Spiegelman, 'Commix' 66.

105 Jay Cantor, 'Kat and Maus,' *The Yale Review* 77 (1987): 40.

106 Cantor 30.

107 Sarah Boxer, 'Behind the Balloons,' *New York Times Book Review* 3 November 1991, 1.

6. Highbrow Comics and Lowbrow Art? The Shifting Contexts of the Comics Art Object

1 Gary Panter, 'Gary Panter,' *Blab!* 2 (Summer 1987): 90.

2 Gary Panter, *Gary Panter's Jimbo* (Portland, OR: Dark Horse, 2007) 4–6.

3 Panter, *Gary Panter's Jimbo* 13.

4 Panter, *Gary Panter's Jimbo* 13.

5 Mike Kelley, 'Gary Panter in Los Angeles,' in *Gary Panter*, ed. Daniel Nadel (New York: PictureBox, 2008) 6–7.

6 Andrew D. Arnold, 'Best + Worst 2004,' Time.com, http://www.time.com/ time/bestandworst/2004/comics.html; Andrew D. Arnold, 'Reduction of the Incoherent,' *The Comics Journal* 270 (August 2005): 9.

7 Gary Panter, 'Gary Panter on Gary Panter,' in *Gary Panter*, ed. Daniel Nadel (New York: PictureBox, 2008) 342, 336.

8 An excellent overview of Panter's comics work is provided by Richard Gehr, 'Dal Tokyo Dispatches,' in *Gary Panter*, ed. Daniel Nadel (New York: PictureBox, 2008) 246–8.

9 Panter, 'Gary Panter on Gary Panter' 320.

10 For a more detailed discussion of Panter's influences, see Doug Harvey, 'Pictures from the Psychedelic Swamp: Gary Panter, Narrative, and the Politics of Idiosyncrasy,' in *Gary Panter*, ed. Daniel Nadel (New York: PictureBox, 2008) 9; Kelley 7; Richard Klein, 'Taking Inventory,' in *Gary Panter*, ed. Daniel Nadel (New York: PictureBox, 2008) 202; Byron Coley, 'Mindprobe,' in *Gary Panter*, ed. Daniel Nadel (New York: PictureBox, 2008) 230.

11 Panter, 'Gary Panter on Gary Panter' 308.
12 Robert Storr, 'Painting, No Joke! A Conversation with Gary Panter,' in *Gary Panter,* ed. Daniel Nadel (New York: PictureBox, 2008) 14.
13 *RAW* 2.3 (New York: Penguin, 1991).
14 Michael Dooley, 'Cooking RAW,' *The Comics Journal* 135 (April 1990): 59.
15 'Raw 3: 48 Pages, Including 20-Page Story,' *The Comics Journal* 64 (July 1981): 17.
16 John Tomkiw, 'Look! Up in the Sky! It's a Toon, It's Literature, It's the New Postmodern Comic,' *Playboy* July 1995: 79; Dooley 58.
17 'Tokyo RAW Data,' *RAW* 7 (1985): 50.
18 Monte Beauchamp, 'Destruction of the Innocent,' *Blab!* 1 (Summer 1986): 9, 15.
19 Robert Williams, 'Robt. Williams,' *Blab!* 1 (Summer 1986): 51.
20 Panter, 'Gary Panter' 90.
21 Art Spiegelman, 'Ball Buster,' *The New Yorker* 22 July 2002: 72.
22 A second volume of *Bang!* was produced in 2005 and 2006 in a partnership between Casterman and the magazine *Les Inrockuptibles.*
23 Harvey 9.
24 Carlo McCormick, 'Gary Panter. Gracie Mansion Gallery,' *Artforum* September 1989: 147.
25 Michael Odom, 'Gary Panter. Dunn and Brown Contemporary.' *Artforum* April 2005: 193.
26 Carlo McCormick, 'Robert Williams. Psychedelic Solution,' *Artforum* March 1987: 127–8.
27 Ken Johnson, 'Robert Williams at Bess Cutler,' *Art in America* January 1993: 103.
28 Robert Williams, 'Juztapoz,' *Juxtapoz* 1 (Winter 1994): 1.
29 Williams, 'Juztapoz' 1.
30 Matt Dukes Jordan, *Weirdo Deluxe: The Wild World of Pop Surrealism and Low-brow Art* (New York: Chronicle Books, 2005) 13.
31 Michael Kimmelman, ' "Helter Skelter" Reveals the Evil of Banality,' *New York Times* 22 March 1992: H37.
32 Carlo McCormick, Skylaire Alfvegren, and Elizabeth Pepin, 'Three Museums That Don't Suck!' *Juxtapoz* 5.2 (Summer 1998): 32–7; Nancy Hartman, 'Performance Art and Why I Hate It,' *Juxtapoz* 1.3 (Summer 1995): 68.
33 Robert Williams, 'Fighting the Ghost of Dead Art Critics,' *Juxtapoz* 45 (August 2003): 4.
34 Robert Williams, 'Five Years of Cultural Erosion,' *Juxtapoz* 20 (May/June 1999): 4.
35 Williams 'Five Years' 4.
36 Carlo McCormick, 'Best Intentions: New Work by Robert Williams,' *Juxtapoz* 30 (January/February 2001): 61.

37 Robert Williams, 'Chunks of Tiger in the Dung of Lambs,' *Juxtapoz* 29 (November/December 2000): 4.
38 Quoted in Jordan 185.
39 Jordan 11.
40 Robert Williams, 'Half-Assed or Maybe Three-Quarter Assed,' *Juxtapoz* 3.1 (Winter 1996): 4.
41 Robert Williams, 'A Tan Balloon by Any Other Name,' *Juxtapoz* 25 (March/April 2000): 4.
42 Quoted in Jordan 113.
43 For more on the distinction between the two dominant schools in lowbrow art, see Chon A. Noriega, 'The Dark Weird Stuff,' *The Saddest Place on Earth: The Art of Camille Rose Garcia* (San Francisco: Last Gasp, 2005) 14; Matt Dukes Johnson, 12–13.
44 Quoted in Jordan 59, 79, 48–51.
45 Quoted in Jordan 51.
46 Quoted in Barry Smolin, *Dumb Luck: The Art of Baseman* (San Francisco: Chronicle Books, 2004) n.p.
47 Quoted in Jordan 27.
48 Quoted in Jordan 185.
49 Quoted in Samantha Gilewicz, 'The Insider – Gary Baseman,' *Nylon Magazine* 2 (May 2008), http://www.nylonmag.com/?section=article&parid=1329.
50 Quoted in Jeremy, ed., *Vinyl Will Kill* (System Designs, 2004) 159.
51 Jeremy 5.
52 Robert Williams, 'Crossing the Isthmus of Art,' *Juxtapoz* 53 (December 2004): 4.
53 Quoted in Marisa Solis, 'Army of Darkness' *Juxtapoz* 62 (March 2006): 49.
54 Manuel Bello, 'Interview: Camille Rose Garcia,' Crown Dozen, http://crowndozen.com/main/archives/001359.shtml.
55 Woodrow Phoenix, *Plastic Culture: How Japanese Toys Conquered the World* (Tokyo: Kodansha International, 2006) 56.
56 Quoted in Jeremy 110.
57 On the subject of 'kidults' and vinyl toys, see Donovan Hohn, 'Through the Open Door: Searching for Deadly Toys in China's Pearl River Delta,' *Harper's* September 2008: 47–58.
58 Bill North, 'This Thing Called *BLAB!*: Notes Toward an Understanding,' *Blab! A Retrospective* (Manhattan, KS: Marianna Kistler Beach Museum of Art, 2008).
59 Quoted in Jesse Hernandez, 'Dreamtime on Planet Panter' *Juxtapoz* 48 (January/February 2004): 28–33.
60 Greg Escalante, 'Gloating Overture to a New Era?' *Juxtapoz* 31 (March–April 2001): 4.

61 Storr 13.
62 Gary Panter, 'Playing with Toys,' in *Gary Panter*, ed. Daniel Nadel (New York: PictureBox, 2008) 336.
63 Storr 12.

7. On Junk, Investments, and Junk Investments: The Evolution of Comic Book Collectables

1 Fredric Wertham, *Seduction of the Innocent* (New York: Holt Rinehart, 1954) 89–90.
2 'Old Comic Books Soar in Value,' *New York Times* 6 December 1964: 141.
3 'Old Comic Books' 141.
4 Jean-Paul Gabilliet, *Of Comics and Men: A Cultural History of American Comic Books,* trans. Bart Beaty and Nick Nguyen (Jackson: University Press of Mississippi, 2010) 352–6.
5 J.C. Vaughn, 'Avenues of Collecting: A Walk through the Comic Book Neighborhood,' *The Overstreet Comic Book Price Guide* (hereafter *Comic Book Price Guide*), 29th ed.: 91.
6 Vaughn 91.
7 Todd McFarlane, 'Ending the Speculation,' *Wizard* November 1993: 225.
8 Carol Krucoff, 'The Comic Payoff,' *Washington Post* 11 October 1979: D1.
9 Krucoff D1.
10 Krucoff D1.
11 Edward Sinclair, 'Boy Finds Sale of Used Comics Is a Gold Mine,' *New York Herald-Tribune* 30 April 1948: 7.
12 Krucoff, D1.
13 Robert Overstreet, 'The 1979 Market Report,' *Comic Book Price Guide, 1980–1981:* A20.
14 Olav Velthuis, *Talking Prices: Symbolic Meanings of Prices on the Market for Contemporary Art* (Princeton, NJ: Princeton University Press, 2005) 8.
15 Overstreet, 'The 1979 Market Report' A19.
16 Robert Overstreet, 'The 1982 Market Report,' *Comic Book Price Guide, 1983–1984:* A20.
17 Robert Overstreet, 'The 1988 Market Report,' *Comic Book Price Guide, 1989–1990:* A17; Robert Overstreet, 'Annual Report,' *Comic Book Price Guide,* 24th ed.: A82.
18 Robert Overstreet, 'Will 2001 Be a Comic Book Odyssey?' *Comic Book Price Guide,* 31st ed.: 50; Robert Overstreet, 'Will 2002 See a Continued Hot Market?' *Comic Book Price Guide,* 32nd ed.: 50.
19 Robert Overstreet, 'The 1992 Market Report,' *Comic Book Price Guide,* 23rd ed.: A15.

20 Robert Overstreet, 'The 1984 Market Report,' *Comic Book Price Guide, 1985–1986:* A17; Robert Overstreet, 'Annual Report,' *Comic Book Price Guide,* 26th ed.: A67; Robert Overstreet, 'Annual Report,' *Comic Book Price Guide,* 27th ed.: A38

21 Robert Overstreet, 'The 1986 Market Report,' *Comic Book Price Guide, 1987–1988:* A23.

22 Robert Overstreet, 'The 1990 Market Report,' *Comic Book Price Guide, 1991–1992:* A26.

23 Robert Overstreet, 'Preface,' *Comic Book Price Guide, 1989–1990:* A9.

24 Patrick M. Kochanek, 'The "Mile High" (Edgar Church) Collection: The Ultimate Pedigree Books from the Golden Age of Comics,' in *Comic Books and Comic Art* (New York: Sotheby's, 1991) 10.

25 Kochanek, 'The "Mile High" Collection' 10.

26 'The Mohawk Valley Collection,' *Comic Books and Comic Art* (New York: Sotheby's, 1995) n.p.

27 Joseph Pedoto, 'On the Scene at the Sotheby's Auction,' *The Comics Journal* February 1992: 21.

28 Jerry Weist, 'Introduction,' *Comic Books and Comic Art* (New York: Sotheby's, 1991) 9.

29 Michael Hutter, Christian Knebel, Gunnar Pietzner, and Maren Schäfer, 'Two Games in Town: A Comparison of Dealer and Auction Prices in Contemporary Visual Arts Markets,' *Journal of Cultural Economics* 31 (2007): 249.

30 Robert Overstreet, 'Sotheby's First Comic Auction,' *Comic Book Price Guide,* 22nd ed.: A24.

31 Jerry Weist and Roger Hill, 'Sotheby's Fourth Comic Book and Comic Art Auction, Spring/Summer 1994,' *Comic Book Price Guide,* 25th ed., A63; Jerry Weist and Roger Hill, 'Sotheby's Fifth Comic Book and Comic Art Auction, Spring/Summer 1995,' *Comic Book Price Guide,* 26th ed.: A76.

32 Robert Overstreet, 'The 1992 Market Report,' *Comic Book Price Guide,* 23rd ed.: A15.

33 Pierre Bourdieu, 'The Production of Belief: Contribution to an Economy of Symbolic Goods,' *The Field of Cultural Production: Essays on Art and Literature* (New York: Columbia University Press, 1993) 76–7.

34 Matt Sylvie, 'Wizard Ripped as Pittsburgh Comicon Gains Prominence,' *The Comics Journal* 233 (May 2001): 16.

35 'Picks from the Wizard's Hat,' *Wizard* 9 (May 1992): 80–6.

36 Greg Buls, 'The Wizard's Crystal Ball' *Wizard* 9 (May 1992): 76.

37 Gareb Shamus, 'The Way I See It,' *Wizard* 10 (June 1992): 74.

38 Robert J. Sodaro, 'Foiled Again,' *Wizard* 20 (April 1993): 71.

39 Sodaro 72.

40 William Christensen and Mark Seifert, 'The Wizard's Crystal Ball,' *Wizard* 16 (December 1992): 77; 'Wizard Market Watch,' *Wizard* 17 (January 1993): 111.

41 'Wizard Market Watch' *Wizard* 18 (February 1993): 109.

42 'Wizard Market Watch' 109.

43 Warren Bates, 'Superman Death Issue Hot Property,' *The Las Vegas Review-Journal* 28 November 1992.

44 Bates.

45 Robert Overstreet, 'Collecting in the 1990s,' *Comic Book Price Guide,* 24th ed.: A24.

46 Benjamin Biggs, 'Collecting Comics in the 90s' *Wizard* (September 1992): 54.

47 Pompeo Balbo, 'Dear Market Watchers,' *Wizard* (August 1994): 144.

48 Marc Wilofsky, 'Market Watchers,' *Wizard* (October 1994): 140.

49 Susan Cicconi, 'The Conservation of Ephemera,' *Sotheby's Comic Books and Comic Art* (New York: Sotheby's, 1991) 13.

50 Cicconi 14.

51 Robert Overstreet, 'Storage of Comic Books,' *Comic Book Price Guide, 1977–1978:* A7

52 Overstreet, 'Storage' A7.

53 Robert Overstreet, '1983 Market Report,' *Comic Book Price Guide, 1983–1984:* A23.

54 Ernst W. Gerber and William Sarrill, 'Storage, Preservation, and Restoration of Comic Books,' *Comic Book Price Guide, 1980–1981:* A10–15.

55 Richard D. Smith, 'A Summary for Collectors,' *Comic Book Price Guide, 1983–1984:* A15.

56 Robert Overstreet, 'The 1976 Market Report,' *Comic Book Price Guide, 1977–1978:* A8.

57 Robert Overstreet, 'Restoration,' *Comic Book Price Guide, 1980–1981:* A14.

58 Overstreet, 'Restoration' A14.

59 Cicconi 13.

60 'Superman No. 1 with Detached Covers and Missing Centerfold,' *Comic Books and Comic Art* (New York: Sotheby's, 1997) Item 24.

61 Jerry Weist, 'Sotheby's Second Comic Auction, Fall 1992,' *Comic Book Price Guide,* 23rd ed.: A21.

62 Robert Overstreet and Gary Carter. *The Overstreet Comic Book Grading Guide* (New York: Avon Books, 1992).

63 Robert Overstreet, 'Condition of Comic Books,' *Comic Book Price Guide, 1977–1978:* A6.

64 Robert Overstreet, 'Grading Comic Books,' *Comic Book Price Guide, 1979–1980:* A7.

65 Gary M. Carter, 'A Word About the AACBC Grading Committee,' *Comic Books and Comic Art* (New York: Sotheby's, 1992) n.p.
66 Robert Overstreet, 'Grading Definitions,' *Comic Book Price Guide*, 22nd ed.: A10.
67 'Comics Guaranty, LLC Introduction,' *Comic Books and Comic Art* (New York: Sotheby's, 2000), 5.
68 Bruce Hamilton, 'The Next Revolution for Comic Books! A New Ten-Point Grading Scale and a Certification Service to Guarantee Grading Consistency!' *Comic Book Price Guide*, 29th ed.: 1999
69 Overstreet, 'Will 2001 Be a Comic Book Odyssey?' 51, 53.
70 See, for example, Bart Beaty, *Unpopular Culture: Transforming the European Comic Book in the 1990s* (Toronto: University of Toronto Press, 2007), particularly chapter 2.
71 Jerry Weist, 'Sotheby's Sixth Comic Book and Comic Art Auction, June 28th and 29th, 1996,' *Comic Book Price Guide*, 27th ed.: A60.
72 H. Bonus and D. Ronte, 'Credibility and Economic Value in the Visual Arts,' *Journal of Cultural Economics* 21 (1997): 104.
73 George Gene Gustines, 'From Trash to Auction, Faster Than a Speeding . . . Well, You Know,' *New York Times* 30 June 2008, http://www.nytimes.com/2008/06/30/arts/design/30comi.html?_r=2&scp=1&sq=x-men&st=nyt.

8. Crumbs from the Table: The Place of Comics in Art Museums

 1 Raymond Pettibon, 'Eisner by Pettibon,' in *Masters of American Comics*, ed. John Carlin, Paul Karasik, and Brian Walker (New Haven, CT: Yale University Press, 2005) 248.
 2 R.F. Outcault, 'Around the World with the Yellow Kid,' *New York Journal* 28 February 1897. This cartoon is reprinted in *R.F. Outcault's The Yellow Kid*, ed. Bill Blackbeard (Northampton, MA: Kitchen Sink Press, 1995) n.p.
 3 Carter Ratcliff, 'Domesticated Nightmares,' *Art in America* May 1985.
 4 Ivan Karp, 'High and Low Revisited,' *American Art* 5.3 (Summer 1991): 12.
 5 Karp 14.
 6 Kirk Varnedoe and Adam Gopnik, *High and Low: Modern Art and Popular Culture* (New York: Museum of Modern Art, 1990) 15.
 7 Varnedoe and Gopnik 18.
 8 Varnedoe and Gopnik 154.
 9 Varnedoe and Gopnik 16.
10 Christian Von Holst, 'Foreword,' *Funny Cuts: Cartoons and Comics in Contemporary Art*, ed. Kassandra Nakas (Stuttgart: Staatsgalerie Stuttgart, 2004) 8.

11 Roger Sabin, 'Quote and Be Damned . . .?' In *Splat Boom Pow! The Influence of Cartoons in Contemporary Art,* ed. Valerie Cassel (Houston, TX: Contemporary Arts Museum, 2003) 11.

12 Valerie Cassel, ed., *Splat Boom Pow! The Influence of Cartoons in Contemporary Art* (Houston, TX: Contemporary Arts Museum, 2003) 49.

13 Ulrich Pfarr, 'Comics as Mythology of the Modern Age: Myths in a Rationalised World,' *Funny Cuts: Cartoons and Comics in Contemporary Art,* ed. Kassandra Nakas (Stuttgart: Staatsgalerie Stuttgart, 2004) 123.

14 Roxana Marcoci, 'Comic Abstraction: Image-Breaking, Image-Making,' *Comic Abstraction: Image-Breaking, Image-Making* (New York: Museum of Modern Art, 2007) 9.

15 Sabin 11.

16 Tom Armstrong, 'Foreword,' *The Comic Art Show: Cartoons in Painting and Popular Culture,* ed. John Carlin and Sheena Wagstaff (New York: Whitney Museum/Fantagraphics Books, 1983) 7.

17 Iwona Blazwick, 'Preface,' *Comics Iconoclasm* (London: Institute for Contemporary Art, 1987) 6.

18 Vicky A. Clark, 'The Power of Suggestion . . . The Suggestion of Power,' in *Comic Release: Negotiating Identity for a New Generation,* ed. Vicky A. Clark and Barbara Bloemink (New York: Distributed Art Publishers, 2003) 27, 28.

19 Milton Caniff, 'Preface,' in *A History of the Comic Strip,* ed. Pierre Couperie, Maurice C. Horn, Proto Destefanis, Edouard François, Claude Molterni, and Gérald Gassiot-Talabot (New York: Crown, 1968) 3.

20 Pierre Couperie, 'Production and Distribution,' in *A History of the Comic Strip,* ed. Pierre Couperie, Maurice C. Horn, Proto Destefanis, Edouard François, Claude Molterni, and Gérald Gassiot-Talabot (New York: Crown Publishers, 1968) 145.

21 Pierre Couperie, 'Foreword,' in *A History of the Comic Strip,* ed. Pierre Couperie, Maurice C. Horn, Proto Destefanis, Edouard François, Claude Molterni, and Gérald Gassiot-Talabot (New York: Crown Publishers, 1968) 4.

22 Burne Hogarth, 'Introduction,' in *A History of the Comic Strip,* ed. Pierre Couperie, Maurice C. Horn, Proto Destefanis, Edouard François, Claude Molterni, and Gérald Gassiot-Talabot (New York: Crown Publishers, 1968) 5.

23 Pierre Couperie, 'Esthetics and Signification,' in *A History of the Comic Strip,* ed. Pierre Couperie, Maurice C. Horn, Proto Destefanis, Edouard François, Claude Molterni, and Gérald Gassiot-Talabot (New York: Crown Publishers, 1968) 219

24 Thierry Groensteen, *Un Objet culturel non idenifié* (Angoulême: Éditions de l'An 2, 2006) 163.

25 Jean-Pierre Angremy, 'Preface,' in *Maîtres de la bande dessinée européene,*
 ed. Thierry Groensteen (Paris: Bibliothèque nationale de France / Seuil,
 2000) 9.

26 Groensteen 166.

27 Groensteen 166.

28 Brian Walker and John Carlin, *Masters of American Comics Program Guide,*
 2005, n.p.

29 Walker and Carlin n.p.

30 Groensteen 164.

31 Carly Berwick, 'Why Have There Been No Great Women Comic-Book
 Artists?' *Art News Online,* http://www.artnewsonline.com/currentarticle.
 cfm?art_id=1924; Natalie Nichols, 'Where the Girls Aren't,' *LA City Beat,*
 http://www.lacitybeat.com/article.php?id=3321&IssueNum=141.

32 Sarah Boxer, ' "Masters of American Comics": UCLA Hammer Museum /
 Museum of Contemporary Art, Los Angeles,' *Artforum* April 2006.

33 Quoted in Berwick.

34 Michael Kimmelman, 'See You in the Funny Papers,' *New York Times*
 13 October 2006, http://www.nytimes.com/2006/10/13/arts/
 design/13comi.html.

35 Varnedoe and Gopnik 213.

36 Katy Siegel, '2004 Carnegie International,' *Artforum* January 2005: 175.

37 Peter Poplaski, 'A Well Plowed Field,' in *The R. Crumb Handbook,* ed. Robert
 Crumb and Peter Poplaski (London: Whitechapel Gallery, 2005) 12.

38 Jean-Pierre Mercier, ' "Remember Folks, It's Only Lines on Paper": Robert
 Crumb and the Art of Comics,' in *54th Carnegie International,* ed. Laura
 Hoptman (Pittsburgh, PA: Carnegie Museum of Art, 2004) 116.

39 Alfred M. Fischer, '*Yeah, But Is It Art?*' *R. Crumb Drawings and Comics*
 (Cologne: Museum Ludwig/Verlag der Buchhandlung Walther König,
 2004) 20.

40 Fischer 20.

41 Varnedoe and Gopnik 214.

42 Ian Buruma, 'Mr Natural,' *New York Review of Books* 6 April 2006, http://www.
 nybooks.com/articles/18834.

43 Ken Johnson, 'Mr Natural Goes to the Museum,' *New York Times* 4 September 2008.

44 Varnedoe and Gopnik 218; König and Fischer 9.

45 Laura Hoptman, 'The Essential Thirty-Eight,' in *54th Carnegie International,*
 ed. Laura Hoptman (Pittsburgh, PA: Carnegie Museum of Art, 2004) 19.

46 Siegel 175.

47 Hoptman 19.

48 Laura Hoptman and Anthony Spira, 'A Chronicle of Modern Times,' in *The R. Crumb Handbook,* ed. Robert Crumb and Peter Poplaski (London: Whitechapel Gallery, 2005) iii.

49 König and Fischer 6.

50 Robert Hughes, quoted in *The R. Crumb Handbook,* ed. Robert Crumb and Peter Poplaski (London: Whitechapel Gallery, 2005) 294; Varnedoe and Gopnik 213.

51 Amanda Coulson, 'Robert Crumb,' *Modern Painters* (Autumn 2004): 129.

52 Pernilla Holmes, 'A Funny Thing Happened to Robert Crumb,' *Art News* September 2004: 127.

53 König and Fischer 6.

54 Mercier 108.

55 John Carlin, 'Masters of American Comics: An Art History of Twentieth-Century American Comic Strips and Books,' in *Masters of American Comics,* ed. John Carlin, Paul Karasik, and Brian Walker (New Haven, CT: Yale University Press, 2005) 124.

56 Hoptman 19.

57 Varnedoe and Gopnik 214.

58 Carlin 125.

59 Françoise Mouly, 'It's Only Lines On Paper,' in *Masters of American Comics,* ed. John Carlin, Paul Karasik, and Brian Walker (New Haven, CT: Yale University Press, 2005) 282.

60 Mouly 279.

61 Holmes 124.

62 Poplaski 300.

63 Doug Harvey, 'Comic Genius,' *LA Weekly* 9 December 2005, http://www.laweekly.com/ink/06/03/art-harvey.php5.

64 Harvey.

9. By Way of Conclusion: Chris Ware's Comics about Art

1 Chris Ware, 'Preface,' in *Uninked: Paintings, Sculpture and Graphic Works by 5 Contemporary Cartoonists* (Phoenix, AZ: The Phoenix Art Museum, 2007) i.

2 Chris Ware, *Acme Novelty Library* 10 (Seattle, WA: Fantagraphics Books, 1998): 11.

3 Dave Eggers, 'After Wham! Pow! Shazam!' *New York Times Book Review* 26 November 2000: 10.

4 Neil Strauss, 'Creating Literature, One Comic Book at a Time,' *New York Times* 4 April 2001: E1.

5 John Hodgman, 'Righteousness in Tights,' *New York Times* 24 April 2005.

6 Douglas Wolk, 'The Inimitable Chris Ware,' Salon.com, 2 September 2005, http://www.salon.com/books/review/2005/09/02/ware.

7 Pamela M. Lee, 'Best of 2003,' *Artforum* December 2003: 128

8 Chris Ware, *Acme Novelty Date Book,* vol. 2: *1995–2002* (Amsterdam: Oog and Blik, 2007) 182, 198.

9 Daniel Raeburn, *Chris Ware* (New Haven, CT: Yale University Press, 2004).

10 Aida Edemariam, 'The Art of Melancholy,' *The Guardian,* 31 October 2005.

11 Raeburn 9.

12 Strauss.

13 Edemariam.

14 Gary Groth, 'Understanding (Chris Ware's) Comics,' *The Comics Journal* 200 (December 1997): 171.

15 Chris Ware, 'Introduction,' in *The Best American Comics, 2007,* ed. Chris Ware and Anne Elizabeth Moore (Boston: Houghton Mifflin, 2007) xxi.

16 Gordon Flagg, 'The Best American Comics, 2007,' *Booklist* 1 October 2007; 'The Best American Comics, 2007,' *Publisher's Weekly* 6 August 2007.

17 Daniel Worden, 'The Shameful Art: *McSweeney's Quarterly Concern,* Comics, and the Politics of Affect,' *MFS: Modern Fiction Studies* 52.4 (Winter 2006): 894.

18 Ware, 'Introduction' xxiii.

19 Audrey Niffenegger, 'Music to Slit Your Wrists By,' *EBR* 6 (Winter 1997–8), http://www.altx.com/EBR/reviews/rev6/r6nif.htm.

20 Raeburn 21.

21 Martha Schwendener, 'Chris Ware,' *Artforum* January 2006: 226; Gordon Flagg, 'The Acme Novelty Library #18,' *Booklist* 15 March 2008: 39.

22 Thomas A. Bredehoft, 'Comics Architecture, Multidimensionality, and Time: Chris Ware's Jimmy Corrigan: The Smartest Kid on Earth,' *MFS: Modern Fiction Studies* 52.4 (Winter 2006): 876.

23 Jan Baetens, 'New = Old, Old = New: Digital and Other Comics Following Scott McCloud and Chris Ware,' *Electronic Book Review* 1 January 2001, http://www.electronicbookreview.com/thread/webarts/graphic.

24 Chris Ware, 'Introduction,' *McSweeney's Quarterly Concern* 13 (2004): 11–12.

25 In Bruce Grenville, 'Chris Ware,' in *Krazy! The Delirious World of Anime + Comics + Video Games + Art* (Vancouver, BC: Vancouver Art Gallery, Douglas and McIntyre, 2008) 48.

26 Groth 168.

27 Ware, 'Introduction,' *McSweeney's Quarterly Concern* 8.

28 Chris Ware, 'Building Stories – The Introduction,' *The Independent* 1 October 2006.

29 Ware, 'Introduction,' *Best American Comics* xviii.
30 Chris Ware, 'Introduction,' *McSweeney's Quarterly Concern* 8; Chris Ware, 'Introduction,' *Best American Comics* xix; Groth 149.
31 Emma Brockes, 'I Still Have Overwhelming Doubt about My Ability,' *The Guardian* 7 December 2001; Chris Ware, 'Apologies, etc.,' *Chris Ware* (Lincoln, NE: Sheldon Memorial Art Gallery, 2007) n.p.
32 Raeburn 9.
33 Chris Ware, 'Strip Mind,' *Bookforum* April/May 2008.
34 Chip Kidd, *Peanuts: The Art of Charles M. Schulz* (New York: Pantheon Books, 2001); see also George Herriman, *Krazy and Ignatz* (Seattle: Fantagraphics Books, 2000–present) and Frank King, *Walt and Skeezix* (Montreal: Drawn and Quarterly, 2005–present).
35 Jeet Heer, 'Inventing Cartooning Ancestors: Ware and the Cartooning Canon,' in *The Comics of Chris Ware: Drawing Is a Way of Thinking*, ed. David M. Ball and Martha B. Kuhlman (Jackson: University Press of Mississippi, 2010) 4.
36 See Daniel Worden, 'On Modernism's Ruins: The Architecture of "Building Stories" and *Lost Buildings*'; Matt Godbey, 'Chris Ware's "Building Stories," Gentrification, and the Lives of/in Houses'; Margaret Fink Berman, 'Imaging an Idiosyncratic Belonging: Representing Disability in Chris Ware's "Building Stories"'; Peter R. Sattler, 'Past Imperfect: "Building Stories" and the Art of Memory,' in *The Comics of Chris Ware: Drawing Is a Way of Thinking*, ed. David M. Ball and Martha B. Kuhlman (Jackson: University Press of Mississippi, 2010).
37 Chris Ware, 'Collectors: A Hobbyist's Guide,' *Acme Novelty Library* 15 (Seattle: Fantagraphics Books, 2001).

Index